# Fiction, Film, and Indian Popular Cinema

This book analyses the novels of Salman Rushdie and their stylistic conventions in the context of Indian popular cinema and its role in the elaboration of the author's arguments about post-independence postcolonial India. Focusing on different genres of Indian popular cinema, such as the 'Social', 'Mythological' and 'Historical', Stadtler examines how Rushdie's writing foregrounds the epic, the mythic, the tragic and the comic, linking them in storylines narrated in cinematic parameters. The book shows that Indian popular cinema's syncretism becomes an aesthetic marker in Rushdie's fiction that allows him to elaborate on the multiplicity of Indian identity, both on the subcontinent and abroad, and illustrates how Rushdie uses Indian popular cinema in his narratives to express an aesthetics of hybridity and a particular conceptualization of culture with which 'India' has become identified in a global context. Also highlighted are Rushdie's uses of cinema to inflect his reading of India as a pluralist nation and of the hybrid space occupied by the Indian diaspora across the world. The book connects Rushdie's storylines with modes of cinematic representation to explore questions about the role, place and space of the individual in relation to a fast-changing social, economic and political space in India and the wider world.

**Florian Stadtler** is Lecturer in Global Literature at the University of Exeter, UK. Previously Research Fellow at The Open University, he has published on South Asian writing in English, Indian popular cinema and British Asian fiction and history. He is Reviews Editor for *Wasafiri: The Magazine of International Contemporary Writing*.

# ROUTLEDGE RESEARCH IN POSTCOLONIAL LITERATURES

Edited in collaboration with the Centre for Colonial and Postcolonial Studies, University of Kent at Canterbury, this series presents a wide range of research into postcolonial literatures by specialists in the field. Volumes will concentrate on writers and writing originating in previously (or presently) colonized areas, and will include material from non-anglophone as well as anglophone colonies and literatures. Series editors: Donna Landry and Caroline Rooney.

1. *Magical Realism in West African Fiction: Seeing with a Third Eye* by Brenda Cooper
2. *The Postcolonial Jane Austen* edited by You-Me Park and Rajeswari Sunder Rajan
3. *Contemporary Caribbean Women's Poetry: Making Style* by Denisede Caires Narain
4. *African Literature, Animism and Politics* by Caroline Rooney
5. *Caribbean–English Passages: Intertextuality in a Postcolonial Tradition* by Tobias Döring
6. *Islands in History and Representation* edited by Rod Edmond and Vanessa Smith
7. *Civility and Empire: Literature and Culture in British India, 1822–1922* by Anindyo Roy
8. *Women Writing the West Indies, 1804–1939: 'A Hot Place, Belonging To Us'* by Evelyn O'Callaghan
9. *Postcolonial Pacific Writing: Representations of the body* by Michelle Keown
10. *Writing Woman, Writing Place: Contemporary Australian and South African Fiction* by Sue Kossew
11. *Literary Radicalism in India: Gender, Nation and the Transition to Independence* by Priyamvada Gopal
12. *Postcolonial Conrad: Paradoxes of Empire* by Terry Collits
13. *American Pacificism: Oceania in the U.S. Imagination* by Paul Lyons
14. *Decolonizing Culture in the Pacific: Reading History and Trauma in Contemporary Fiction* by Susan Y. Najita
15. *Writing Sri Lanka: Literature, Resistance and the Politics of Place* by Minoli Salgado
16. *Literature of the Indian Diaspora: Theorizing the Diasporic Imaginary* by Vijay Mishra
17. *Secularism in the Postcolonial Indian Novel: National and Cosmopolitan Narratives in English* by Neelam Srivastava
18. *English Writing and India, 1600–1920: Colonizing Aesthetics* by Pramod K. Nayar
19. *Decolonising Gender: Literature, Enlightenment and the Feminine Real* by Caroline Rooney
20. *Postcolonial Theory and Autobiography* by David Huddart
21. *Contemporary Arab Women Writers* by Anastasia Valassopoulos
22. *Postcolonialism, Psychoanalysis and Burton: Power Play of Empire* by Ben Grant
24. *Land and Nationalism in Fictions from Southern Africa* by James Graham
25. *Paradise Discourse, Imperialism, and Globalization: Exploiting Eden* by Sharae Deckard
26. *The Idea of the Antipodes: Place, People, and Voices* by Matthew Boyd Goldie
27. *Feminism, Literature and Rape Narratives: Violence and Violation* edited by Sorcha Gunne and Zoë Brigley Thompson
28. *Locating Transnational Ideals* edited by Walter Goebel and Saskia Schabio
29. *Transnational Negotiations in Caribbean Diasporic Literature: Remitting the Text* by Kezia Page
30. *Representing Mixed Race in Jamaica and England from the Abolition Era to the Present* by Sara Salih
31. *Postcolonial Nostalgias: Writing, Representation and Memory* by Dennis Walder
32. *Publishing the Postcolonial: Anglophone West African and Caribbean Writing in the UK 1948–1968* by Gail Low
33. *Postcolonial Tourism: Literature, Culture, and Environment* by Anthony Carrigan
34. *The Postcolonial City and its Subjects: London, Nairobi, Bombay* by Rashmi Varma
35. *Terrorism and Insurgency in Indian-English Literature: Writing Violence and Empire* by Alex Tickell
36. *The Postcolonial Gramsci* edited by Neelam Srivastava and Baidik Bhattacharya
37. *Postcolonial Audiences: Readers, Viewers and Reception* edited by Bethan Benwell, James Procter and Gemma Robinson

38. *Culture, Diaspora, and Modernity in Muslim Writing*, edited by Rehana Ahmed, Peter Morey, and Amina Yaqin
39. *Edward Said's Translocations: Essays in Secular Criticism*, edited by Tobias Döring and Mark Stein
40. *Postcolonial Memoir in the Middle East: Rethinking the Liminal in Mashriqi Writing* by Norbert Bugeja
41. *Critical Perspectives on Indo-Caribbean Women's Literature* edited by Joy Mahabir and Mariam Pirbhai
42. *Palestinian Literature and Film in Postcolonial Feminist Perspective* by Anna Ball
43. *Locating Postcolonial Narrative Genres* edited by Walter Goebel and Saskia Schabio
44. *Resistance in Contemporary Middle Eastern Cultures: Literature, Cinema and Music,* edited by Karima Laachir and Saeed Talajooy
45. *The Postsecular Imagination: Postcolonialism, Religion, and Literature* by Manav Ratti
46. *Popular Culture in the Middle East and North Africa: A Postcolonial Outlook*, edited by Walid El Hamamsy and Mounira Soliman
47. *The Ethics of Representation in Literature, Art, and Journalism: Transnational Responses to the Siege of Beirut* edited by Caroline Rooney and Rita Sakr
48. *Fiction, Film, and Indian Popular Cinema: Salman Rushdie's Novels and the Cinematic Imagination* Florian Stadtler

**Related Titles:**
*Postcolonial Life-Writing: Culture, Politics, and Self-Representation* by Bart Moore-Gilbert

# Fiction, Film, and Indian Popular Cinema

Salman Rushdie's Novels and the Cinematic Imagination

## Florian Stadtler

NEW YORK AND LONDON

First published 2014
by Routledge
711 Third Avenue, New York, NY 10017

Simultaneously published in the UK
by Routledge
2 Park Square, Milton Park, Abingdon, Oxfordshire OX14 4RN

First issued in paperback 2015

*Routledge is an imprint of the Taylor & Francis Group, an informa business*

© 2014 Taylor & Francis

The right of Florian Stadtler to be identified as author of this work has been asserted in accordance with sections 77 and 78 of the Copyright, Designs and Patents Act 1988.

All rights reserved. No part of this book may be reprinted or reproduced or utilised in any form or by any electronic, mechanical, or other means, now known or hereafter invented, including photocopying and recording, or in any information storage or retrieval system, without permission in writing from the publishers.

**Trademark Notice:** Product or corporate names may be trademarks or registered trademarks, and are used only for identification and explanation without intent to infringe.

*Library of Congress Cataloging-in-Publication Data*
Stadtler, Florian.
  Fiction, film, and Indian popular cinema : Salman Rushdie's novels and the cinematic imagination / by Florian Stadtler.
    pages cm. — (Routledge Research in Postcolonial Literatures ; 48)
  Includes bibliographical references and index.
  1. Rushdie, Salman—Criticism and interpretation.  2. Motion pictures—India—History.  3. Postcolonialism in literature.  I Title.
  PR6068.U757Z877 2013
  823'.914—dc23
  2013019870

ISBN13: 978-1-138-93695-9 (pbk)
ISBN13: 978-0-415-80790-6 (hbk)

Typeset in Baskerville
by IBT Global.

*To Christa and Michael Stadtler
for making things possible*

# Contents

|  | *List of Figures* | xi |
|---|---|---|
|  | *Acknowledgements* | xiii |
|  | Introduction | 1 |
| 1 | Creating 'Imaginary Homelands' | 7 |
| 2 | Heroines, Mothers and Villains: Cinema and Postcolonial National Identities in *Midnight's Children* and *Shame* | 36 |
| 3 | Filming Rushdie: From Documentaries, Film Criticism to Screenplays | 67 |
| 4 | *The Satanic Verses* and *Shree 420*: Negotiating Identity through Indian Popular Cinema | 85 |
| 5 | *The Moor's Last Sigh*: Rewriting *Mother India* | 110 |
| 6 | *The Ground Beneath Her Feet* and *Fury*: Bollywood, Superstardom and Celebrity in the Age of Globalisation | 133 |
| 7 | Rushdie's 'Mission Kashmir': *Mughal-e-Azam* and *Shalimar the Clown* | 154 |
|  | Conclusion | 178 |
|  | *Notes* | 183 |
|  | *Bibliography* | 197 |
|  | *Index* | 209 |

# Figures

| | | |
|---|---|---|
| 2.1 | A young Naseem Aziz (Neha Mahajan) discovering her husband through the perforated sheet in the 2012 film adaptation. | 38 |
| 2.2 | Jamila (Soha Ali Khan) performing for the Pakistani elite in the 2012 film adaptation. | 55 |
| 3.1 | Amina Sinai (Shahana Goswami) and the indirect kiss in the Pioneer Café. | 81 |
| 3.2 | Saleem (Satya Bhabha) reveals the truth to Shiva (Siddharth). | 83 |
| 3.3 | Saleem (Satya Bhabha), his ayah Mary (Seema Biswas), Picture Singh (Kulbushan Kharbanda) and young Aadam (Mohamed Safran Sarron) celebrating Saleem's birthday and India's thirtieth anniversary of independence. | 83 |
| 4.1 | Raj (Raj Kapoor) on his journey from the countryside to Bombay, singing 'Mera Joota Hai Japani'. | 91 |
| 4.2 | Actors Shah Rukh Khan and Manisha Koirala performing the song 'Satrangi Re' from *Dil Se*. | 101 |
| 5.1 | Radha (Nargis) imploring the villagers in *Mother India* not to leave the land. | 115 |
| 5.2 | Mogambo (Amrish Puri) in his villain's den. | 129 |
| 7.1 | Anarkali (Madhubala) dancing before Prince Salim (Dilip Kumar) and Akbar (Prithviraj Kapoor). | 163 |

# Acknowledgements

Many people have helped to bring this book to fruition, generously shared expertise and commented on drafts of the manuscript. My thanks to Caroline Rooney, Rachel Dwyer, Rajinder Dudrah, Rod Edmond, Elleke Boehmer, Vybarr Cregan-Reid, Alex Padamsee, Petr Barta, Jo Collins, Jeffrey Mather, Maria Ridda, Cary Shay, Smitha Campbell, Rehana Ahmed, Sumita Mukherjee, Mala Pandurang, Nilufer Bharucha, Harish Trivedi, Mark Stein, Nisha Jones Obano, Claire Chambers, Peter Morey, Amina Yaqin and Rozina Visram; my colleagues at The Open University, especially Alex Tickell, Shaf Towheed and David Johnson. I have benefited greatly from their input.

I would like to acknowledge especially Abdulrazak Gurnah and Lyn Innes who have helped me nurture this project from its early beginnings at the University of Kent in 2003. Their generous collaborative spirit and insightful guidance have been of immense help to develop this book and motivated me to persist with this subject. Special thanks is also due to Susheila Nasta for her kind support and mentorship—her astute reading and commentary on the draft of the book have been invaluable.

I would also like to recognise the helpful guidance and support of the archivists and librarians, at the Manuscripts, Archives and Rare Book Library at Emory University, Atlanta, especially Liz Chase, Erika Farr, Sara Logue and Kathy Shoemaker for their infectious enthusiasm and assistance while researching the digital and physical Rushdie collections and for making this a very enjoyable experience.

Research for this book has been generously supported by the Arts and Humanities Research Council [2005/113678/University of Kent at Canterbury], the Colyer Ferguson Fund at the University of Kent and the Arts Faculty at The Open University. I am also grateful to the series editors, Caroline Rooney and Donna Landry, and the editorial and production staff at Routledge, especially Liz Levine and Emily Ross for their advice and guidance, and Rachel Goodyear for her help with the index. A special thank you to Sharmilla Beezmohun, whose meticulous initial copy-editing helped to eradicate many faults. I would also like to thank Julian Felice, who first introduced me to Rushdie's work back in 1999 when we were English literature

xiv  *Acknowledgements*

undergraduates, Kevin Walsh and Charlotte McKinley for their encouragement and friendship. Finally to my family, Christa, Michael and Alexander Stadtler and Katja Klauer for their loving support and advice while writing this book.

Sections of this book have appeared previously as essays and chapters. Since their first publication they have been substantially revised, updated and expanded in different contexts. I would like to acknowledge their previous publication and thank the following editors and publishers:

Gubir Jolly, Zenia Wadhwani and Deborah Barretto, eds., *Once Upon A Time in Bollywood: The Global Swing of Hindi Cinema* (Toronto: TSAR Publications, 2007).

Ana Mendes, ed., *Rushdie and Visual Culture: Celebrating Impurity, Disrupting Borders* (New York: Routledge 2011).

# Introduction

This book seeks to open up a new interpretative framework for Salman Rushdie's fiction in the context of South Asian popular culture and, in so doing, to relate how the global circulation of his fiction and Indian popular cinema reveal in complex ways how people reconceive notions of national identity and communal belonging. Rushdie has described his work as a 'post-colonial novel, a de-centred, transnational, inter-lingual, cross-cultural novel' (2003, 57). Intimately linked to this is his longstanding interest in cinema, about which he has written extensively in his fiction and non-fiction. Over his long career as a writer, Rushdie has developed a cinematic visual style of storytelling and this monograph examines the process of how he translates and adapts this visual idiom in his writing. In particular, an examination of the *filmi* style of Rushdie's fiction, borrowed from Indian popular film and its visual culture, illuminates how Rushdie has used cinema both as metaphor and structuring device to inflect his reading of India as a pluralist nation and the in-between space of the Indian diaspora (Nasta 2002). Focusing, then, on the interwoven relationship between cinema and fiction in Rushdie's imaginary, the book highlights how he connects his storylines with modes of cinematic representation to explore questions about the role and place of the individual in relation to a fast-changing social, economic and political space in India and abroad.

Through global circulation, the process of imagining community has become deterritorialised and this study will trace how such borders have been subsumed in his fiction and Indian popular cinema alike. Moreover, as Rajinder Dudrah has suggested, there is a need 'to think imaginatively about cinema as a global industry, films as popular cultural texts, and the relationships that are possible between cinema and its audiences' (2006, 26). Considering Indian popular cinema's shift into the mainstream, I investigate how far the contemporary Indian novel in English uses the vocabulary and devices of that genre for its own narrative structuring and themes.

As we see from films like *The Reluctant Fundamentalist* (2012) the South Asian novel in English has increasingly caught the eye of Indian and British filmmakers who, while not necessarily producing commercial Hindi films,

use some of its unique style. Danny Boyle's adaptation of Vikas Swarup's 2005 novel *Q and A* into the multi-award-winning *Slumdog Millionaire* (2008) is a good example, as is Deepa Mehta's adaptation of Bapsi Sidhwa's 1988 novel *Ice-Candy-Man* which she filmed as *1947-Earth* (1998) and which starred one of the Bombay film industry's major stars, Aamir Khan, with music by legendary film score composer A. R. Rahman.

This book focuses on Indian popular cinema's syncretism, building on the seminal work on Indian popular cinema by Sumita S. Chakravarty, Rachel Dwyer, Vijay Mishra, Ashis Nandy, Ashish Rajadhyaksha and Ravi S. Vasudevan. It analyses the process by which this cinema becomes an aesthetic marker in Rushdie's fiction, allowing him to elaborate on his argument about the multiplicity of Indian identity both on the subcontinent and abroad. I illustrate how Rushdie uses Indian popular cinema in his narratives to express an aesthetics of hybridity and a particular conceptualisation of culture with which 'India' has become identified in a global context. For Rushdie, the novel 'is part social enquiry, part fantasy, part confessional. It crosses frontiers of knowledge as well as topographical boundaries' (2003, 58). This book lays particular emphasis on how Rushdie uses Indian popular cinema of the 1950s and early 1960s in his fiction to deconstruct mythic conceptualisations of the nation—especially of India, Pakistan, Britain and the United States.

The readings of Rushdie's major novels offered here, from *Midnight's Children* to *Shalimar the Clown*, are positioned at the interstice of postcolonial, literary, film and cultural studies. By crossing these disciplinary boundaries, I aim to link the analysis of Rushdie's filmic aesthetic with key debates on colonialism, postcolonialism and globalisation, at the same time drawing comparisons to Indian popular cinema's own engagement with these concerns. This comparative analysis of Rushdie's highly visual narratives informed by their cinematic contexts will offer new insights into these sources and how they impact on the way he constructs his political arguments. In this respect my analysis contributes to and extends the discussion of Rushdie as a postcolonial novelist of the South Asian diaspora (Morton 2008) as well as studies of cinematic conventions and their aesthetic influence on the Indian novel in English as a genre.

To date, no single-author full-length study of Rushdie's work has been published that discusses his central engagement with cinema, and Indian popular cinema in particular, in any detail. Some previous studies mention cinema as an intertext, like Catherine Cundy's *Salman Rushdie* (1996), yet she does not explore this aspect of his writing in further detail. Roger Y. Clark's *Stranger Gods: Salman Rushdie's Other Worlds* (2001) explores cosmology, mythology and mysticism in Rushdie's novels, but does not focus on cinema at all. A few journal articles and essays highlight specific filmic intertexts with individual novels (Chordiya 2007; Fischer and Mehdi 1990; Rombes 1993). Abdulrazak Gurnah's *Cambridge Companion to Salman Rushdie*

(2007) includes a comprehensive overview essay on 'Rushdie and Bollywood Cinema' by Vijay Mishra that discusses Rushdie's fiction's relationship with the genre. P. Balaswamy's essay on *The Moor's Last Sigh* and *Mother India* in Mittappalli and Kuortti's two-volume essay collection, *Salman Rushdie: New Critical Insights* (2003), takes up some of the issues of the novel's connection to the trope of 'Mother India'. This book distinguishes itself from previous analyses by offering a coherent chronological analysis of the development of this element of his work, privileging Rushdie's engagement with Indian popular cinema and culture, an area that has thus far received little attention in studies of his fiction.

The intersection of discourses of nationhood in relation to identity formation of the individual in Rushdie's writing, Indian popular cinema and postcolonial discourse provides a space for analysis that opens up new ways of reading Rushdie's novels. Rushdie uses Indian popular cinema as part of his own aesthetic in his negotiation of an Indian and diasporic identity. His narrators adopt a cinematic point of view in their articulation of hybrid lives, for which they make recourse to the archive of Indian popular cinema. The following chapters concentrate on this process and detail how Indian popular cinema becomes in Rushdie's fiction a signifier for the state of postcoloniality itself.

A major hallmark of Rushdie's storytelling has been a complex visual sensibility informed by a range of cinemas from across the world including Hollywood, European Art House and Indian popular cinema. The chapters present the novels in chronological order and trace significant cinematic intertexts to highlight the evolution of his visual cinematic style. I take as my point of departure Sumita S. Chakravarty's contention that, for Rushdie, the All-India talkie functions as 'the displaced site for national exploration' (1993, 4) and trace this trajectory from *Midnight's Children* to *Shalimar the Clown*. The historical novel *The Enchantress of Florence* (2008) lies outside the remit of this book, as do some of the shorter fictions, though these are referenced where appropriate.

The first chapter, 'Creating "Imaginary Homelands"', outlines the aesthetic conventions of Indian popular cinema by focusing on its melodramatic staging and attractions, detailing how the visual culture of Indian popular cinema is instrumental in articulating a conceptualisation of Indian self- and nationhood. Subsequent chapters will expand this further in the context of Rushdie's fiction. I introduce three genres of Indian popular cinema, the 'social', 'mythological' and 'historical', all relevant in the context of Rushdie's novels, and evaluate the importance of urban spaces for the imaginary world of these films and similar representations of the cityscape in Rushdie's narratives. It also considers other important popular cultural intertexts such as *The Wizard of Oz*, a significant influence on Rushdie's imagination. It concludes with an evaluation of postcolonial aesthetics and how they are reflected in Indian popular cinema. I argue that these are intimately interrelated to Rushdie's novels.

4   *Fiction, Film, and Indian Popular Cinema*

Chapter 2, 'Heroines, Mothers and Villains: Cinema and Postcolonial National Identities in *Midnight's Children* and *Shame*', is concerned with the ways cinematic devices are instrumental for Rushdie in debunking myths of the nation. It looks at how Rushdie develops the notion of multiplicity, pluralism and hybridity with which he associates India, and how he draws here on the multiple genres which make up the 'All-India' talkie to narrate a crowd of stories. The chapter analyses how *Midnight's Children* and *Shame* are informed by Indian popular cinema, reflecting and parodying its use of stock narrative devices. It argues that the novels' protagonists resemble character types in Indian popular cinema through whom Rushdie develops an aesthetic argument about realism and fantasy. Central to the discussion is an analysis of cinematic conventions and, how they are translated into writing. It argues that cinema becomes in *Midnight's Children* a central metaphor through which Saleem narrates his life story. The chapter compares Rushdie's deconstruction of India's myth of nation with fictional representations of Pakistan. This comparative reading of the novels explores parallels in the cinematic conceptualisation of female protagonists in relation to ideas of nation and argues that these 'larger-than-life' characters are constructed in filmic parameters to become emblems of the postcolonial nation.

Drawing on archival materials and unpublished novels, Chapter 3 provides a commentary on Rushdie's own critical writing on film and engages with the numerous screenplays of his fictional works, including *The Ground Beneath Her Feet* and 'The Courter'. Furthermore, it discusses his documentaries, particularly focusing on *The Riddle of Midnight*. The chapter concludes with an in-depth analysis of three adaptations of *Midnight's Children*: as a television series, the Royal Shakespeare Company stage dramatisation and the 2012 film adaptation. I outline here Rushdie's complex relationship with Indian popular cinema and his engagement with art house and commercial cinema from across the world. The chapter argues that Rushdie's own experience of work in advertising and fringe theatre, as a scriptwriter and as a documentary filmmaker have all contributed to his development of a distinctively filmic and *filmi* sensibility. This ranges from subject matter to stylistic devices with which the narrative is translated from the page, visualised and focalised by the reader and the camera lens.

Chapter 4, '*The Satanic Verses* and *Shree 420*: Negotiating Identity through Indian Popular Cinema', discusses cinema as central to Rushdie's argument for hybridity in *The Satanic Verses*'s exploration of migrancy to the metropolis. It focuses on cinema as a narrative device by emphasising how Rushdie uses elements of Indian popular cinema such as the song sequences to structure Hindi film superstar Gibreel Farishta's dream sequences, which echo filmic song picturisation. It pays particular attention to the movie intertext *Shree 420* and its engagement with migration, dislocation and identity in relation to Bombay and compares it to similar concerns in the novel with transglobal migration to London. It argues that Indian popular cinema fulfils here

several functions: memory trigger, a way of imagining home and a medium for the portrayal of the effects of alienation for the characters in an epic story of good versus evil. The chapter also discusses representations of the religious and the profane through the prism of the fictionalised version of the 'mythological' and concludes that *The Satanic Verses* extends the preoccupations with journeying and multiple identities already prevalent in *Midnight's Children* to the global arena.

Chapter 5, '*The Moor's Last Sigh*: Rewriting *Mother India*', reads this major novel through two filmic intertexts, *Mother India* (1957) and *Mr. India* (1987), to show how Rushdie constructs in the character of Aurora Zogoiby an urban version of the trope of Mother India. *The Moor's Last Sigh* is presented here as a companion volume to *Midnight's Children* and pays particular attention to the way Rushdie revisits Bombay and perceives the changes that have transformed the city since the 1992/93 riots and bomb blasts. It also explores how Bombay is portrayed as a metaphor for modern India. It connects the novel thematically with Rushdie's earlier fiction and compares it to representations of the metropolis in Indian popular cinema. It argues that the novel's narrator uses Indian popular cinema, gossip and hearsay as a narrative tool in the construction of celebrity of his mother-as-artist, transforming her into an urban, eclectic version of 'Mother India', which resonates with similar constructions of the 'star as text' in Indian popular cinema.

Chapter 6, '*The Ground Beneath Her Feet* and *Fury*: Bollywood, Superstardom and Celebrity in the Age of Globalisation', looks at how Rushdie adapts cinematic storytelling in his construction of a postmodern reworking of the Orpheus myth in contexts of globalisation and transglobal migration. The chapter explores the implications of superstardom and celebrity and how the star becomes a screen upon which the public projects its own aspirations, extending here the notion of the 'film star as text'. It argues that the characters in *The Ground Beneath Her Feet* and *Fury* use the 1990s construct of 'Bollywood' to define their Indian identity in the context of a globalising world to comprehend the process of migration to three metropolitan centres—Bombay, London and New York. Both novels explore characters of South Asian origin who now live in the diaspora and develop a complex relationship with 'home', and this chapter makes comparisons to several characteristic Bollywood movies, such as *Kal Ho Naa Ho* (2003), which have taken up this issue.

Chapter 7, 'Rushdie's "Mission Kashmir": *Mughal-e-Azam* and *Shalimar the Clown*', discusses *Shalimar the Clown* in relation to the 'historical' film, *Mughal-e-Azam* (1960) and highlights how the film functions in the novel as an important intertext and reference point for his characters. Rushdie uses the 'historical' film genre to make a wider argument about Kashmiri tolerance through allusions to Mughal rule in India. The chapter also focuses on the cinematic nature of writing and its intertextual relationship to the genre of the Hollywood thriller through filmic intertexts *Vertigo* (1958) and

*The Manchurian Candidate* (1962). It argues that, in *Shalimar the Clown*, Rushdie deploys cinematic strategies, creating a panoramic screen to explore the politics of globalisation, nationalism and terrorism. I highlight how Rushdie examines this in different localities, time periods and through a cast of characters with different backgrounds, ranging from diplomat, documentary filmmaker and dancing girl to clown story performer and assassin. The chapter links Rushdie's arguments to films that have dealt with the Kashmir conflict such as *Roja* (1992), *Dil Se* (1998) and *Mission Kashmir* (2000). The chapter analyses how the 'historical' as a genre inflects the realities of post-independence India and argues that, through analogies with historical representation, both film and novel offer a version of reality where the present is retold through the prism of the past.

Indian popular cinema and the brand 'Bollywood' with which it is now recognised as a global commodity is a postcolonial, transnational and multicultural medium. It is deployed as such in Rushdie's fiction, functioning as an idiom through which 'India' and its diaspora is interpreted. In this respect, Rushdie's understanding of Indian popular cinema as an aesthetic and cultural-political marker leads him to instrumentalise it as a way to explore the meaning of Indianness central to his characters' identity negotiations and their definitions of selfhood in a postcolonial reality. This book seeks to open up Rushdie's fiction and non-fiction in the different context of Indian popular film, its politics of cultural production and the wider implication this has on expressions of local and global notions of Indian selfhood and identity, to provide a new and multi-dimensional entry point to Rushdie's work.

# 1 Creating 'Imaginary Homelands'

In *The Moor's Last Sigh*, the painter Vasco Miranda sees himself and Aurora Zogoiby as 'exponents of an "Epico-Mythico-Tragico-Comico-Super-Sexy-High-Masala-Art" in which the unifying principle was "Technicolor-Story-Line"' (Rushdie 1996b, 148–149). Vasco's claim aptly describes Salman Rushdie's own method of writing with its emphasis on the epic, the mythic, the tragic and the comic brought together in a high-octane storyline narrated within cinematic parameters. This book sets out to examine this process and will focus on the *filmi* style of Rushdie's fiction that is borrowed directly from Indian popular cinema and its visual culture. This distinctly *filmi* style is reliant on film sets, location and costumes and the way they are depicted by a particular cinematography. The reach of Indian popular cinema is all-pervasive and films permeate the nation's culture through advertising, film music and promotional material. Together they form part of what Rachel Dwyer and Divia Patel have called the visual culture of Indian popular cinema (Dwyer and Patel 2002, 8). Rushdie draws directly on this visual culture for his narratives of and arguments about independent India and its position in a globalising world. Thus Vasco Miranda's assertion serves as a succinct description of the visual aesthetic and culture that this monograph addresses.

Crossing disciplinary boundaries between literary, postcolonial and film studies, this book brings together debates about colonialism, postcolonialism and globalisation while focusing in on Rushdie's engagement with Indian popular cinema in his fiction. Frequently, Rushdie uses Indian popular cinema intertextually as a reference point to highlight his own philosophical and political arguments. In this respect, the *filmi* style of Indian popular cinema is adapted by Rushdie to serve as a visual narrative strategy in his description of independence movements and nationalisms in South Asia, the role of women in relation to emergent discourses on nationhood, transglobal migrancy, hybridity, globalisation and terrorism. This chapter will discuss more broadly the aesthetic conventions and concepts with which this book is concerned. It will focus on the importance of the city, in particular Bombay, for the imaginary world of Rushdie's fiction and for Indian popular cinema, the relationship between Rushdie's fiction and postcolonial

discourse analysis, and different genres of Indian popular cinema—the 'All-India' talkie, 'mythological', 'social' and 'historical'. By analysing the visual aesthetics from which Rushdie's fiction and Indian popular cinema draw, there emerge several sites of engagement for Rushdie's hard-hitting critique of the postcolonial nation state and a globalising world. Rushdie's fiction and Indian popular cinema circulate across the world and impact in complex ways on how people imagine national identity and communal belonging. The process of imagining community has become deterritorialised through global circulation and this book will trace how such borders have been subsumed. Indian popular cinema becomes in this respect a crucial reference point in the creation of 'Imaginary Homelands'.

## From Indian Popular Cinema to Global Bollywood

Indian cinema celebrated its centenary in 2013 with the release of the first full-length feature film, *Raja Harishchandra* (1913). Yet perhaps less known is that the development in India of cinema as a medium of visual artistic expression is closely tied to the development of cinema as a whole. Indeed, Marius Sestier, who worked for the Lumière brothers, screened the first film at Bombay's Watson Hotel in 1896. Although showcasing the invention to a British audience and not to Indians, the medium's potential was widely recognised as a new and interesting way of depicting the world in moving images and, in 1898, Hiralal Sen started making films in Calcutta (Rajadhyaksha and Willemen 2002, 17). By 1906, J. F. Madan and his Bombay-based Elphinstone Bioscope Company had established a dominant position in the marketplace. Yet the development of the Indian film industry was hampered by a restrictive quota system during the final decades of the Raj and the lack of official recognition as an industry post-independence, which impacted greatly on its financing—the sector was only accorded industry status in 2001.

The evolution of a domestic Indian film market and industries in different regional centres is a multi-dimensional and complicated process and does not fit any neat, coherent historical trajectory (Dudrah and Desai 2008, 3–4). Yet there are recognisable groundbreaking moments which have shaped the style, form and conventions of Indian popular cinema, such as the advent of sound and the emergence of studios including Wadia Movietone and Bombay Talkies in the 1930s, landmark films, directors and producers and as already mentioned, recognition of cinema production as an industry. However, it is also important to understand Indian popular cinema in the wider context of Indian popular culture (Dudrah and Desai 2008, 5). Indian popular cinema has developed its own distinct style, drawing from a range of Indian and European influences and traditions. It continues to dominate the domestic film market in India. The largest internal market exists for Hindi-Urdu language cinema, produced mainly in Bombay,[1] which dominates local distribution and has led to heated debates about the increasing dominance of

Hindi as a national language (Trivedi 2006, 51–86). Ravi Vasudevan (1989) and Rosie Thomas (1985) have pertinently pointed out that, in any analysis of Indian popular cinema, its own traditions and aesthetics must be factored in. Moreover, Indian popular film defies linearity and can be at once discursive—commenting on ethical, political and philosophical issues—as well as marked by emotional excess, comedy and song and dance (Vasudevan 1989, 30). As I discuss later in more detail, the genre has evolved an 'omnibus' form of storytelling, blending tragedy, comedy, music and dance. It finds its roots in nineteenth century Parsee theatre which drew on South Asian and Western source materials, including mythology, epics, history and legends, as well as English novels, plays and farce (Vasudevan 1989, 31). Indeed mid-nineteenth century Victorian melodrama and innovations in staging which emphasised spectacle can be seen as a 'prelude to the cinema' (ibid). Though other theatrical and oral storytelling traditions have also influenced narrative structuring in Indian popular cinema, the influence of Parsee theatre is illustrative of the cross-fertilisation across genres and highlights 'the difficulty of defining cultural specificity' (ibid). As Ranjani Mazumdar succinctly puts it, Indian popular cinema 'is an evolving, unabashedly hybrid cultural form that narrates the complicated intersection between tradition and modernity in contemporary India' (2007, xvii).

Though film technology was imported from Europe, it soon emerged as a medium of storytelling catering to Indian audiences in its own right. However, in the early years of silent cinema, imported films by far outnumbered local productions. Nevertheless, Indian films, by developing their own style of storytelling, proved to be successful box-office draws for local audiences. Yet, it took until the 1930s and the advent of sound for locally produced Indian language cinema to supplant foreign imports, leading to the formation of a number of studios and production companies in Bombay, Pune, Madras and Calcutta.

Any descriptor for the Indian film industries is riddled with shortcomings and inadequacies. Indeed, even in the early years of cinema many different regional centres for film production existed, ranging from Pune in Maharashtra to Calcutta in Bengal. Bombay-based Hindi-Urdu language films only started to dominate the field in the early 1950s (Vasudevan 2000a, 382). Yet since the 1980s this tendency has been challenged by regional language cinema in Telugu, Tamil and Malayalam which, added together, supersede the amount of film releases from Bombay (ibid).

Much recent scholarship has focused on the emergence of 'Bollywood' as a subject of study and whether it subsumes previous designations such as Indian popular cinema, Hindi-Urdu or Hindi cinema, or Bombay cinema. In this study I privilege the term 'Indian popular cinema', which to me still encapsulates best the film industry, its mode of production and the narrative style with which this book is concerned. Within the context of an analysis of Rushdie's fiction, the focus in the main is on pre-1990s Indian popular

cinema, which renders 'Bollywood' inaccurate and anachronistic, though Chapter 6 does focus on its emergence and how this type of cinema works within the wider context of Rushdie's narratives. Furthermore, Indian popular cinema as a term describes better the cinema on which Rushdie draws, which is not simply the films produced in the dream factories of Bombay, but also those from southern India's regional cinema. I recognise that 'Bollywood' has increasingly dominated as a label to describe India's commercial film industry originating in Bombay/Mumbai. Indeed, much scholarly literature on the subject has been published in recent years (see Dudrah 2006, 2012; Dudrah and Desai 2008; Dwyer 2005; Dwyer and Pinto 2011; Gehlawat 2010; Gopal and Moorti 2008; Jolly, Whadwani and Barretto 2007; Kaur and Sinha 2005; Mishra 2002; Roy and Huat 2012). It is also a term with which India's popular culture is increasingly associated in the mainstream press in the USA, UK and South Asia as a shorthand descriptor for Indian popular cultural productions ranging from film, music, fashion and theatre.[2]

Nevertheless, the usage of 'Bollywood' and its signification in popular cultural and academic discourse remains vexed (Vasudevan 2011a). A composite of the 'Bo-' in Bombay grafted onto the '-llywood' of Hollywood, the term has become a popular designation for the Indian film industry, which is contested by critics and practitioners in the Indian film industry alike (Prasad 2003; Rajadhyaksha 2003, 2009; Dudrah and Desai 2008), as the moniker implies that Indian popular cinema is derivative of Hollywood (Kabir 2001, 21). The term is often used as a blanket generalisation that amalgamates the various regional, art house and middle cinemas, which is then perpetuated by satellite television channels catering for India's diaspora and by the British terrestrial television Channel 4 in its annual Indian film season. The history of the term itself is contentious and it is not quite clear from where it originated, although it has been suggested that it was coined by journalists writing for the film magazines *Cineblitz* and *Screen*. M. Madhava Prasad traces the lineage back to 1932 and the American engineer Wilford E. Deming who was assigned to help produce one of India's first talkies in the Calcutta suburb of Tollygunge, which he and his colleagues renamed 'Tollywood'. It seems more plausible, Prasad argues, that the term 'Bollywood' was coined by this linguistic detour (2003).

Yet wider questions remain about what 'Bollywood' might actually mean. For Rajadhyaksha, Bollywood 'occupies a space analogous to the film industry' but represents 'a more diffuse cultural conglomeration involving a range of distribution and consumption activities' (2003, 27). For him, Bollywood describes a larger culture industry, in existence since the early 1990s, of which film makes up just one significant aspect, and has a much longer and complex history of development than the term 'Bollywood' can do justice to. In this respect it is more useful to see 'Bollywood' as 'an export-orientated, transmedia product', a significant part of Indian popular cinema, but by no means its totality (Dwyer and Pinto 2011, xiv). If anything, Bollywood has

become a brand with which India is becoming increasingly associated in the global arena. In his essay 'The Meaning of "Bollywood"', Ravi Vasudevan provides some useful historicisation of the Bollywood phenomenon, seeing its emergence linked to the reorientation of India from nation state into global nation. This happened through processes of economic liberalisation during the 1990s and new modes of distribution of Hindi cinema through DVDs, satellite television, digital media and multiplex cinemas. He situates the currency of the term with the release of Aditya Chopra's *Dilwale Dulhania Le Jayenge* (1995) and the films that follow, which thematise the Indian diaspora (Vasudevan 2011a, 4–5). Indian cinema defies any 'essentialist' definitions, considering how much its development is bound up with histories of the Indian state, its transition from colonialism to independence and Partition, competing regions and languages. In this respect any descriptive attempt remains flawed and requires a recognition and constant awareness of inherent multiple meanings in the terminology used and its inevitable shortcomings (Rajadhyaksha and Willemen 2002, 9). It raises the spectre of having to confront a cultural form which contains too much diversity and, consequently, defies simple categorisation. Indeed, Aijaz Ahmad has raised this issue in relation to descriptions of Indian literature, too often marked by empirical and theoretical deficiencies (1994, 285). Ahmad contends that 'cultural productions everywhere greatly exceed the boundaries set by the colonial state and its policies so that the highly diverse historical trajectories may simply not be available for generalizing theoretical practices and unified narratives' (1994, 244). It seems to me that this applies similarly to a critical analysis of Indian popular cinema and has a bearing on the way writers make recourse to it in their fiction.

## Indian Popular Cinema and Rushdie's Fiction: An Aesthetic of the City?

Rushdie's fiction grows out of a specific location—Bombay. The 1950s and 1960s, when Rushdie was growing up there, were a particularly exciting time for the city. Spurred by the optimism of the first decade of Indian independence, many consider it Bombay's 'golden age'.[3] *Midnight's Children*, *The Moor's Last Sigh* and *The Ground Beneath Her Feet* in particular celebrate this time. For Rushdie, Bombay during this period is an emblem of the 'All-India' idea, a cosmopolitan city and a cultural interstice. As Rushdie has eloquently explored in his seminal essay 'Imaginary Homelands', the urge to write about his childhood in Bombay was the major driving force behind *Midnight's Children*, to enable him, now living in Britain, to retrieve home from a clouded past and faded memories (Rushdie 1982b, 18). Rushdie's project, then, is related to memory and remembering, a process of recuperation that takes place solely in his imagination, triggered by visual images such as family photographs. Yet, through imagination and writing, Rushdie

wants to go beyond the black-and-white image of the family photo album to make the images come alive 'in CinemaScope and glorious Technicolor' (ibid). The cinematic imagination is the method by which the memories contained in the photos are reanimated, and subsequent chapters will analyse in detail these cinematic-narrative processes with which Rushdie articulates the cityscape of Bombay, and later London and New York.

For Rushdie, Indian popular cinema is an obvious source, considering that, like his novels, it belongs to the urban culture of modern India that he considers intimately intertwined with Bombay, which, in his own words,

> is full of fakery and gaudiness and superficiality and failed imaginations, it is also a culture of high vitality, linguistic verve, and a kind of metropolitan excitement that European cities have for the most part forgotten. And this is true of that over-painted courtesan Bombay, as it is of Ray's Calcutta. (Rushdie 1990, 9)

Rushdie's imagining of Bombay springs from the tension between the city's garish flamboyance and superficiality and its vigour and dynamism, which drive Rushdie's urge to retrieve the city in cinematic terms, in a need to bring it to the big screen. This tension, then, allows for a textured image of the city to emerge through the orchestration of plots along the principles of Indian popular cinema's syncretism, which I discuss later in further detail.

Rushdie's preoccupation with Bombay marks him out as an author primarily concerned with the metropolis and the urban centres rather than rural India, setting himself apart from a previous generation of Indian authors writing in English such as Mulk Raj Anand or Raja Rao.[4] Rushdie explores different ways of expressing an urban sensibility, translating the bustling, teeming, noisy metropolis, its argot and its culture not only into fiction, but also into English. Here Indian popular cinema becomes an important tool for his imagining of the city as it provides a template and rich source for a stylised portrayal, recuperated from his memories (Rushdie 1982b, 18). In this respect it is useful to think about the presentation of urban spaces in Rushdie's fiction in filmic parameters. These spaces serve as a setting and represent a heightened version of reality as backdrops against which his narratives unfold. In *The Satanic Verses* and *Fury*, London and New York read more like dressed sets in movie studios. London in particular becomes ephemeral, an imagined city that comes alive as the Emerald City of 'Vilayet', which in reality is a harsh, unyielding, challenging, hostile and confrontational space.[5] Rushdie's Bombay is also a stylised version of the city, however meticulously observed, which powerfully encapsulates the city's diversity and sprawling scope. Yet Rushdie only engages with fragments of it, privileging a camera focus on Bombay's upper middle class and its experience of the city during a narrow period in time.

While Rushdie writes about different metropolitan centres, Bombay remains a key focal point throughout his oeuvre. For Rushdie, his characters operate

as a lens that filters different and often conflicting urban realities in the city. Bombay represents modernity in the context of India, and one way of expressing that modernity in his fiction is through the deployment of Indian popular cinema, its styles and conventions. Both Indian popular cinema and Rushdie's writing embrace quintessential local forms of storytelling and transform them through the prism of the metropolis. Increasing mobility and social diversity through the process of migration creates in any city a new sense of dynamism, which clearly influences social and cultural developments and innovations, and these are culturally reflected in art, particularly film and literature (Mazumdar 2007). This period of transformation in Bombay culminated at the advent of independence and paved the way for Bombay's boom during the following decade. Rushdie's treatment of Bombay in his novels needs to be read as an engagement with, even a response to, this changing cultural landscape of the city. In this context it is worth considering Raymond Williams's argument in his 1989 book, *Politics of Modernism: Against the New Conformists*, which analyses the specific location of the artist in relation to the changing cultural milieu of the metropolis. Although Williams writes about the Western centres, there are some correlations with Bombay, a city that, although situated in India, has always been looking to the West. Williams argues:

> It [the metropolis] was the place where new social and economic and cultural relations, beyond both city and nation in their older senses, were beginning to be formed: a distinct historical phase which was in fact to be extended, in the second half of the twentieth century, at least potentially, to the whole world. (Williams 2007, 44)

Rushdie traces these developments in his writing of and engagement with the metropolis—and it is this experience of living in the city that he captures by using cinematic visualised storytelling and the techniques of cinema as key elements of his prose.

Indian popular cinema creates a stylised myth and anti-myth of the city and Rushdie often transposes that fantasy onto his imagining of Bombay, London and New York, which is in turn filtered by the perceptions of his narrators and characters. In so doing, Rushdie confronts his readers with differing versions of the city (Stadtler 2012). While an urban landscape is a site of modernity and progress which facilitates the process of identity formation and the discovery of selfhood, it also contains a dark other. Salahuddin Chamchawala's relationship with London in *The Satanic Verses* is a clear example of this as he descends from an official, respectable London into the shady world of the illegal immigrant hiding in bedsits. Moraes Zogoiby's experience of 1990s Mumbai/Bombay in *The Moor's Last Sigh* also echoes this. In both protagonists' journeys, the discovery of community—for Salahuddin that of the Bangladeshi immigrant community in Brickhall, for Moraes the politician Mainduck's gang in the city's slum—provides the impetus for their transformation.

The representation of the different aspects of the urban environment—the city, the slum and the village within—is also an important feature of Indian popular cinema. Bombay, where the Hindi film industry is based, functions as the embodiment of an Indian modernity, a process which began during British rule and continued apace after independence. The 1930s and early 1940s in particular saw an unprecedented building boom, economic growth and accelerated activity in the move towards independence, which paved the way for the city's prosperity.

The emblem of this move to modernity was the adoption and adaptation of the Art Deco style to build the city's apartment blocks, cinemas and department stores. According to Sharada Dwivedi and Rahul Mehrotra in *Bombay: The Cities Within*, from 1933 to 1942 the building boom climaxed as the population of Bombay increased to 1.49 million with the need for space and land escalating (2001, 242). The expansion coincided with Art Deco becoming the prevalent style. Dwivedi and Mehrotra note: 'In many ways this unique style became symbolic of the last burst of westernisation that engulfed the city before India gained independence in the following decade' (2001, 246). Part of the successful adoption of Art Deco and its representation in interiors and architecture was due to Bombay's social and cultural scene, dominated by the city's business and upper-class community. Art Deco was highly influential in the transformation of the old Fort Area of the city as well as the Back Bay reclamation scheme between Marine Drive and Churchgate. Its application was consistent with the original style, although less elaborate than in New York. According to Dwivedi and Mehrotra, 'the development of Art Deco rapidly replaced Bombay's image from a Victorian to a cosmopolitan and modern city' (2001, 247). The style was readily adapted to local needs and to the available technology in Bombay (ibid), creating an Art Deco Bombay style which impacted greatly on the design and look of the city and which is captured by early post-independence cinema of the 1950s.

In these films, representations of Bombay focus on the city's wealth—its houses, streets, hotels and nightclubs as well as its public buildings (Dwyer and Patel 2002, 65). Yet Indian popular cinema of the time needed to tackle the separation between the urban and the rural. This distinction rested on the separation between a 'timeless' village and the city, representing modernity and progress (Dwyer and Patel 2002, 63). For instance, Mehboob Khan's *Mother India* (1957) initially depicts a romanticised version of the village and its community, before detailing the problems that beset the villagers, falling victim to a usurious moneylender and caught in vicious cycles as victims of natural disasters. Nehruvian modernity is presented in this instance as the solution to some of the villagers' misfortunes, highlighted here in the opening and closing shots of the film with the inauguration of the village's new irrigation system.

Yet Indian popular cinema also transposes the trope of village-as-community into certain parts of the city, for example, in the films of Raj Kapoor. Kapoor depicts the rural environment as 'a pure, unsullied India, exemplified

by the village women whom he portrays in his films as innocent and pure' (Dwyer and Patel 2002, 64). By contrast, he sets up the city as both an inhuman place of corruption and a glamorous place of urban sophistication and a space of opportunity. The city thus functions as a space that is threatening and problematic which 'can be dehumanizing and lacking in human values' (Dwyer and Patel 2002, 65). In *Shree 420* (1955) Raj, who has become a fraudster, enters a glamorous jet-set world. He is forewarned of the city's corruption by the street sign that points to the direction of Bombay—Bombay 420, also the section in the Indian Penal Code associated with small-scale fraud. He can only find solace in the city slum, which becomes a stand-in for the village-as-community, idealised as a lost paradise, a romanticised depiction of the poorest part of the metropolis. In these cultural representations, then, the slum serves as an invocation of a remembered village (Nandy 2001, 20).

In *Midnight's Children*, this is echoed in Saleem's journey across the subcontinent, his exile and return to Bombay and, very explicitly, in his experience of community—a remaking of family in the magicians' ghetto in Delhi's Chandni Chowk. Ashis Nandy suggests that Indian literature has had an uncomfortable relationship with this movement between spaces:

> Such negotiation with the city has all the elements of the lowbrow and the maudlin and uses too narrow a range of psychological shades. But perhaps for that very reason, popular cinema has turned it into an overused, proforma cliché. (2001, 26)

Raj Kapoor was a master in picturising these negotiations in his films *Awaara* (1951), *Shree 420* and *Jagte Raho* (1956). Rushdie adapts these preoccupations of Indian popular cinema to find an idiom with which to represent the many facets of the city by reworking the trope of the journey between spaces for his first-person narrators. Rushdie's engagement with an urban environment is intricately connected to cinema, especially in the representations of the city as a microcosm of the nation, which in turn contain parallel contrasts between the city and the village, and the city and the slum. As Nandy explains elsewhere:

> Both cinema and the slum in India showed the same impassioned negotiation with everyday survival, combined with the same intense effort to forget that negotiation, the same mix of the comic and the tragic, spiced with elements borrowed indiscriminately from the classical and the folk, the East and West. (2002, 2)

Nandy pertinently alludes here to the complex ways in which Indian popular cinema blends different genres in its depiction of everyday life, a process with which Rushdie also modulates his narratives. Moreover, Nandy suggests that these influences are neither contained in one locality nor in one mode of

representation nor one genre. Rushdie's novels follow similar trajectories, and in the process, it becomes obvious how Indian popular cinema in its depiction of the urban environment impacts on Rushdie's fiction.

In the Indian context, Indian popular cinema like no other medium has depicted the process of urbanisation and has expressed a version of modernity. In this respect, as M. Madhava Prasad argues in 'Realism and Fantasy in Representations of Metropolitan Life in Indian Cinema', Indian popular cinema functions in a similar way to the nineteenth century novel by portraying the metropolis as a site of conflict between 'opposing forces and desires, hopes and projections' (2004, 83). These are often expressed as class conflict and detail the complex interrelationship between different sections of society. The tension within the city is further complicated by the opposition between the rural and the urban, the village and the city, which elides the internal complexity inherent in the city. In this respect, Prasad distinguishes different perspectives. In the first instance, the city is 'internally split into a rational grid aspiring to a universal rationality, and the everyday life, with its teeming diversity, which defies this logic' (2004, 84). The external perspective is also demarcated by two aspects, 'firstly the city as site of attractions [ . . . ], an object of imagination and fantasy; and second the city as a logic of urbanization, which extends beyond the territorial limits of the city' (ibid). In Rushdie's representation of the urban, these shifting perspectives are articulated by his narrators, who are increasingly aware of this internal and external split. Bombay functions, both in Indian popular cinema and in Rushdie's novels, as a default city, which has become increasingly decentred by international locations, especially London and New York. Prasad suggests that '"Bambai" serves to signify the generic metropolitan other, rather than the specific entity that the city of Mumbai is' (2004, 87). So narrative and filmic representations of Bombay visualise, as an urban prototype, a stylised, imagined space and version of the city, which bears some resemblance to the actual city but positions itself at an angle to reality. Bombay represents in Indian popular cinema an actual physical location, while also depicting a visual quality and fulfilling a narrative function, which has shifted and continues to shift over time, influenced by changing socio-economic and political realities:

> The relationship of characters to the cityscape, the way the city figures, as metaphor as well as site of unfolding of events, in effect the city as horizon of a representational project: all undergo a significant transformation as we move from one to the other, a shift that must be assumed to relate to the changing aesthetic concerns of the Bombay cinema as much as to the social transformations that have altered the image of the city in public discourse. (Prasad 2004, 87)

As Prasad has outlined, both Indian popular cinema and Rushdie's fiction articulate a specific discourse of the city and narrate a particular version of

Bombay. Rushdie's characters all have a distinctive relationship with and connection to the city. Saleem Sinai's experience of 1950s Bombay differs from his experience of post-Emergency Bombay. Similarly, Moraes Zogoiby's experience of 1960s Bombay is very different from communal Mumbai of the late 1980s and early 1990s. Their changing experiences, linked to their own social transformations, impact on their aesthetic engagement with the city and their narration of it. The city and how it figures, either as metaphor or site of unfolding events, remains a focal point throughout my discussion in the following chapters as I consider the narrative of the urban cityscape and its connection to the socio-political arguments of Rushdie's narratives.

## Rushdie's Postcolonial Aesthetic

The questions Rushdie has addressed in his fiction and non-fiction have been of major interest to colonial and postcolonial discourse analysis. His concerns with Indian nationalism in relation to the emergent nation states of the subcontinent and the position of the individual in society are the most obvious markers for how his fiction engages with the process of decolonisation and its aftermath. These larger issues about nation, nationhood, the individual in society and the role, space and place of culture in relation to definitions of selfhood are my prime concerns here. The trajectory of his novels trace a shift in focus from discussions of the postcolonial nation state to migration and dislocation and its effects on the individual, which will be charted in the chapters that follow. I read the narrative arc from *Midnight's Children* to *Shalimar the Clown* as a progressive engagement with and argument about the role, place and space of the individual in relation to a fast-changing social, economic and political space that ranges from the postcolonial nation state, the former centre of Empire, to a globalising world.

Out of Rushdie's engagement with transglobal migrancy and diaspora emerges his own theory of cultural hybridity which captures a particular moment in time in the closing years of the twentieth century and the beginning of the twenty-first. As is now well known, this particular moment has been described by a variety of terms, most often beginning with the prefix 'post', such as 'postcolonial' or 'postmodern'. These designations, despite their currency, remain ambiguous and controversial in meaning. However, what these terms and the meaning of the prefix suggest is a form of transit, a form of going 'beyond'. Rushdie's novels have been read as postmodern and postcolonial texts; however, in my discussions of Rushdie I privilege a postcolonial over a postmodern reading.[6] Rushdie's texts are rooted in an investigation of modernity in the context of Bombay and India and of bourgeois middle-class Bombayites, such as Saleem Sinai and his family, Gibreel Farishta and Salahuddin Chamchawala, the Zogoiby clan, Rai Merchant and Ormus Cama as well as Malik Solanka. Thus his novels, I would suggest, do not originate from a deep questioning of Western modernity per se.

Although postmodern and postcolonial strategies of reading are not mutually exclusive, the emphasis is different, and I will return to this point later on in this section (see Appiah 1991).[7] Inherent in postcolonial strategies of reading and more broadly postcolonial criticism is what Homi Bhabha describes in his essay 'The Postcolonial and the Postmodern: The Question of Agency' as a witnessing of 'the unequal and uneven forces of cultural representation involved in the contest for social and political authority within a modern world order' (1994, 171). Rushdie takes up these questions and explores the effect this contest has on his protagonists' lives, many of whom are trampled underfoot or emerge fundamentally transformed at the end of their journey. As Mishra and Hodge argue, the focus in such an investigation should be on postcolonialism as 'a radical political act of self-legitimation and self-respect locked into practices which antedate the arrival of the colonizer, and bracket it with postmodern practices generally' (1993, 283).

Postcolonial reading strategies must always be challenging in their attempts to deconstruct, explode and subvert preconceived binaries of North and South, East and West, revealing more complex interconnections between different parts of the world. Rushdie's fiction is postcolonial and, by extension, postmodern in its rejection of binaries and hierarchies, instead advocating a complex formation of a hybrid subjectivity. In this respect, Rushdie's writing illustrates well the fluidity of the 'postcolonial' both as reading practice and theoretical concept. As Benita Parry argues:

> postcolonial criticism has come to be identified as postmodernist in its orientation [ . . . ] One consequence of this is that there has been a fluid, polysemic, and ambiguous usage of the term 'postcolonial' within and beyond specialist circles. The plenitude of signification is such that 'postcolonial' can indicate a historical transition, an achieved epoch, a cultural location, a theoretical stance. (2004, 66)

If the postcolonial is postmodernist in orientation, as Parry suggests, how do we need to understand postmodernism and postmodernity in the context of the postcolonial and Rushdie's writing? Furthermore, how does this impact on the novels' engagement with history and historical representation?

In his introduction to *The Location of Culture* Bhabha sees the 'post-' of postmodernity, postcolonialism or post-feminism as a gesture to the beyond (1994, 1). It is up to the critic to invest them with meaning. According to Bhabha, the 'post-' in these terms can 'only embody its restless and revisionary energy if they transform the present into an expanded and ex-centric site of experience and empowerment' (1994, 4). Following on from Bhabha, I argue that Rushdie's writing about the metropoles of Bombay, London and New York imaginatively responds to this intensified modernity rooted historically in a postcolonial moment; it becomes a cultural location in a period of historical transition. The tension between conflicting realities and their

challenge to absolutes—the grand narratives of religion, history, nationhood, of the universal humanism of the Enlightenment—which are fractured into more complex micro-narratives, are the hallmarks of postmodernism, and Rushdie's writing and his characters engage with these. In this respect, I read his eccentric characters as the agents that highlight the transformation of the present into an ex-centric site—of which Salahuddin Chamchawala and Gibreel Farishta in *The Satanic Verses*, Aurora Zogoiby in *The Moor's Last Sigh*, Vina and Ormus in *The Ground Beneath Her Feet* are only a few examples, and this issue will be explored further in later chapters.

Postcolonial discourse analysis has long been preoccupied with the individual's position in different cultural and 'in-between' spaces that produce new interstices of cultures. Bhabha explains:

> It is in the emergence of the interstices—the overlap of domains of difference—that the intersubjective and collective experience of *nationness*, community interest, or cultural value are negotiated. How are subjects formed 'in-between', or in excess of, the sum of the 'parts' of difference (usually intoned as race/class/gender, etc.)? (1994, 2)

Bhabha refers to many of Rushdie's crucial sites of engagement—the intersubjective and collective experience of *nationness*, community interest or cultural value—especially regarding nation formation of newly independent colonies and in relation to the position of minority communities in the former metropolitan centres of Empire. This is further complicated in Rushdie's fiction by the process of subject formation within emerging nationalisms and the questions of identity that it engenders—which is itself then made more complex as the world integrates ever more quickly and the global flow of migration leads to a continual reconfiguring of selfhood.

For Rushdie's fiction, the crucial site of engagement of postcolonialism is the discourse of nation, nationalism and nationhood. His texts portray the involvement of the bourgeois Indian elite in the struggle for independence and clearly describe what independent India should represent. He shares the vision of a free India as Nehru outlined it in his 'Tryst with Destiny' speech on the eve of independence on 14 August 1947 and in much greater detail in *The Discovery of India*. Saleem in *Midnight's Children* and Moraes and Aurora Zogoiby in *The Moor's Last Sigh*, as well as some of Rushdie's other narrators, hold the subcontinent's elites to account, accusing them of having betrayed Nehru's dream. Rushdie holds Indira Gandhi and the 1975 Emergency especially responsible for the decline and dismantling of the Nehruvian vision of the nation as democratic, secular and socialist in outlook. In *Midnight's Children*, he portrays her as an annihilating widow, the antithesis of Mother India, destroying India's postcolonial secular ethos; in *The Moor's Last Sigh* he blames her for opening the Pandora's box of communal violence. Through her manipulative electioneering which often played

off one religious community against another, she allowed an essentialising nationalism based on religious exclusivity to emerge and become dominant. In this respect, Rushdie's fiction offers a hard-hitting critique of a particular exclusionist nationalism that threatens Nehru's founding principles for the country, a stance he maintains to this day.[8]

Rushdie does not reject nationalism per se. He makes it clear that an Indian nationalism based on the principles of secularism, which enshrines democracy and plurality through respect of religious diversity and promoting equality via a socialist ethos, is the only solution for a multi-ethnic and multi-religious country like India. Rushdie writes against a particular 'nativist' nationalism that, in the example of the *Hindutva* movement and its search for a pure ancient Hindu past, is ethnically, culturally and religiously absolutist and ultimately reveals fascist tendencies. This becomes clear in the narrative argument of *The Moor's Last Sigh* and is also dramatised in *The Satanic Verses*, which challenges a unitary interpretation of religion and will be discussed in further detail in later chapters.

Rushdie asks hard-hitting questions about the political direction of India and Pakistan as postcolonial regimes. He highlights abuses of power in both countries, be it Indira Gandhi's 1975 Emergency or Pakistan's succession of civil and military autocratic governments. Ultimately his judgement of Pakistan is much bleaker than of India, but even about India he seems to be despairing. The question of nationhood and self-governance is further complicated by Rushdie's engagement with how postcolonial countries are positioned in a global economic network. Rushdie makes this apparent in *The Ground Beneath Her Feet* and *Shalimar the Clown*. In the former, the photographer Rai exposes how the United States forces less developed nations into new forms of economic dependency which echo colonial oppression; in the latter, Rushdie investigates how a formerly colonised country like India can be similarly repressive on its 'separatist' periphery where the unity of the state is challenged.

Wider considerations of tradition and modernity in the context of postcolonial nation-building are important here, as they relate directly to the circulation and consumption of cultural productions and find their way explicitly into Rushdie's fiction (Stadtler 2012, 115–127). Cultural productions including novels, newspapers, film, paintings and theatre remain crucial instruments in the forging of such an identity. Until recently, the power of Indian popular cinema in this regard was much neglected and underestimated. Rushdie engages with these formations in his novels, for example in Nadir Khan's poetry or Hanif's movies in *Midnight's Children* or the art Aurora Zogoiby produces in *The Moor's Last Sigh*. Rushdie's insistence on India's multiplicity in *The Moor's Last Sigh* in the wake of the destruction of the Babri *Masjid* in Ayodhya in 1992 and the rise of Hindu fundamentalism also illustrate this powerfully. Rushdie provides an artistic counterargument by demonstrating it is possible to write an epic novel that draws a complex panoramic picture

of India from its most marginalised communities. *The Moor's Last Sigh* shows precisely the intersubjective experience of nationness and how subjectivity can never be solely defined in unitary terms, but always in excess of the sum of the parts of difference. Yet the text also allows the fissures and exclusions to surface whenever national discourse strives for a unitary vision of nationhood. The novel thus debates the complexities of representation by looking at different modes of it such as realism, melodrama, surrealism and collage, representations often mediated by the idiom of Indian popular cinema. Rushdie's method privileges the sweeping panorama through writing epics marked by excess, a crowd of stories that the reader needs to negotiate. This is particularly evident in *Midnight's Children*, *The Satanic Verses*, *The Moor's Last Sigh* and *The Ground Beneath Her Feet*.

Thematically, Rushdie's fiction investigates and questions the emergence and definition of national communities in cultural terms and how they produce national, regional and migrant minority identities, which are themselves defined through discourses of social differences. As Bhabha suggests,

> they are the signs of the emergence of community envisaged as a project—at once a vision and a construction—that takes you 'beyond' yourself in order to return, in a spirit of revision and reconstruction, to the political conditions of the present. (1994, 3)

Rushdie's fiction is not only rooted in particular places and spaces, but also in a particular historical moment to which he responds. He begins in *Midnight's Children* with the subcontinent's experience of and liberation from British colonial rule which led postcolonial India to adopt a particular form of direct and liberal democracy, investigating how this democracy developed over the first three decades after independence. In *Shame*, he engages with postcolonial Pakistan and its succession of autocratic civilian and military governments through the eyes of a London-based author in exile. In *The Satanic Verses* he shifts his attention to the South Asian diasporic community in London, while *The Moor's Last Sigh* brings the political themes of *Midnight's Children* up to date. In *The Ground Beneath Her Feet* and *Fury* Rushdie returns to the subject of transglobal migration in the context of globalisation, and *Shalimar the Clown* investigates separatism, terror and terrorism in Kashmir. Central to all his novels is the birth of India and Pakistan as independent nation states through the partition of British India. A study of Rushdie's writing cannot escape this particular historical moment. Furthermore, Rushdie's fiction concerns itself with a narrow section of Indian society—the urban middle classes of Bombay.[9] This group was central to the negotiations leading to Partition and independence and the construction of a particular idea of nation that, in India, defined itself initially under Nehru's premiership along universal discourses of humanism, liberal democracy, socialism, modernity and progress (Sahgal 2010). Rushdie's texts sharply investigate anti-colonial

movements and discourses of nationalism and nationhood, often decentring, questioning and exploding these 'grand narratives'. In Rushdie's fiction, then, we can find postcolonial discourse's post-structural methodology fused with an investigation of anti-colonial discourses out of which the field originally emerged.

Both the postcolonial and the postmodern are intrinsic challenges to dominant discourses. According to Bhabha, the wider importance of postmodernity is its consciousness that the epistemological limitations of the ethnocentric notions it critiques also limit the space of enunciation of other disparate and dissident histories and voices (1994, 4–5). Furthermore, the heterogeneity of nation states has put into question the whole concept of homogenous national cultures and identities. As Bhabha argues in his introduction to *The Location of Culture*, 'the consensual or contiguous transmission of historical traditions or "organic" ethnic communities—*as the grounds of cultural comparativism*—are in a profound process of redefinition' (1994, 5). This process of redefinition is often perceived as crisis, as ongoing debates about Britishness, Englishness and multiculturalism have shown (Nasta 2002). In this respect, Rushdie's fictional work arguably belongs, albeit not exclusively, to what Bhabha calls 'the history of postcolonial migration, the narratives of cultural and political diaspora [ . . . ] the poetics of exile, the grim prose of political and economic refugees' (1994, 5). Rushdie engages with a process of displacement and its inherent discontinuity, where the sovereignty of an overriding national culture defined in terms of modernity and progress is challenged (Bhabha 1994, 6).

Through these ruptures and interventions the cultural space of a national consciousness is severely questioned as the production of art on the margins and its perceived newness becomes what Bhabha calls 'an insurgent act of cultural translation' (1994, 7). Bhabha observes that, after having written on the nation state (India and Pakistan in *Midnight's Children* and *Shame*), Rushdie's marked shift in *The Satanic Verses* serves as a reminder that the most acute observation comes out of the migrant's double vision (1994, 5). My focus on Rushdie's deployment of Indian popular cinema in the novel accentuates this 'double vision' that the author adopts. In Rushdie's fiction, national identity is central to how characters define their sense of self. In this respect I argue that, in Rushdie's fiction, Indian popular cinema shapes an 'insurgent act of cultural translation'. Thus the aesthetic and ideological conventions of Indian popular cinema fulfil an important function in these debates and affect Rushdie's arguments.

## Indian Popular Cinema and Rushdie's Visual Aesthetic

In *Midnight's Children*, Saleem Sinai states that 'nobody from Bombay should be without a basic film vocabulary' (Rushdie 1995a, 33). Indeed, Bombayite Rushdie's engagement with cinema as a visual aesthetic goes beyond 'basic'. Rushdie references particular filmic texts, such as *Shree 420, Mother India*

or *Mughal-e-Azam* (1960), which feature as specific and direct intertexts in *Midnight's Children*, *The Satanic Verses*, *The Moor's Last Sigh* and *Shalimar the Clown*. These films were released post-independence during Nehru's term in office as prime minister. This period is also regarded as Indian popular cinema's 'golden era', with the films of Raj Kapoor, Mehboob Khan and K. Asif, superstar actors such as Dilip Kumar, Madhubala, Nargis and Dev Anand, making a huge impact on the style and aesthetics of post-independence Indian popular cinema.

Rushdie's engagement with Indian popular cinema needs to be read against one quintessentially American filmic text, which is central to understanding Rushdie's visual aesthetic—the MGM film version of Frank Baum's children's novel *The Wizard of Oz* (1939). The film had a huge impact on Rushdie as a child and is a reference point throughout his fiction. In his monograph on the film for the British Film Institute, Rushdie writes how it inspired him to write his first short story at the age of ten. The story was lost, but Rushdie recalls that '*The Wizard of Oz* (the film, not the book, which I didn't read as a child) was my very first literary influence' (1992b, 9). His fiction is littered with references to the iconic film: Indira Gandhi appearing green and black and black and green, transmuting into the Wicked Witch of the movie in Saleem's nightmares in *Midnight's Children*; the 420 ruby slippers of Hind; yellowbricklane in London in *The Satanic Verses*; and the Tin Man in *The Moor's Last Sigh* to name but a few. It is clear the film has a special place in Rushdie's imagination and he writes: 'When I first saw *The Wizard of Oz* it made a writer of me' (1992b, 18). The book that Rushdie wrote for the BFI Film Classics series establishes in interesting ways Rushdie's relationship with cinema and its importance in his work. The book was published in 1992, three years after the *fatwa*, and it enabled Rushdie to reflect differently on his altered relationship with 'home' as well as to clarify his thoughts about India's commercial cinema.

The plot of *The Wizard of Oz* resonates throughout Rushdie's fiction, especially in relationships between parents and their children and the dramatisation of them. For Rushdie, the film's main narrative thrust revolves around the inadequacy of the adult world:

> *The Wizard of Oz* is a film [about] [ . . . ] how the weakness of grown-ups forces children to take control of their own destinies, and so, ironically, grow up themselves. The journey from Kansas to Oz is a rite of passage from a world in which Dorothy's parent-substitutes, Auntie Em and Uncle Henry, are powerless to help her save her dog Toto from the marauding Miss Gulch, into a world where the people are her own size, and in which she is never, ever treated as a child, but as a heroine. (Rushdie 1992b, 10)

Dorothy becomes a heroine accidentally when her house crushes the Wicked Witch of the East as it lands in Oz. Many of Rushdie's protagonists, too, seem

like accidental or reluctant heroes and he often repeats, adapts and subverts the pattern of a rite of passage in his multi-layered plots. Saleem's ejection from his family and his journey to his uncle's house which prefigures a more permanent and harsher exile after a bomb kills his family illustrates this pertinently. Salahuddin Chamchawala's uneasy relationship with his father, his journey, transmutation and the reconciliation with his father at the end also have echoes of Dorothy's journey to Oz, as do Rai's journey in *The Ground Beneath Her Feet* and Moraes's relationship with his family in *The Moor's Last Sigh*. In many ways, the villainous father, Abraham Zogoiby, could be read as an inversion of the figure of the Wizard, who is unmasked as an incompetent bumbling fool with no powers at all. Rushdie's novels are distinctive in terms of how often the end of the hero's journey is a reconciliation with their parents, especially the father figure. This rite of passage plotline is familiar from many epics as well as the nineteenth century Bildungsroman. Rushdie often stages these incidents melodramatically and reveals interesting connections with filmic texts from both the canon of Indian popular cinema and Hollywood.

*The Wizard of Oz* provides a useful way to start unpacking Rushdie's argument about journeying, the discovery and reconfigurations of selfhood, and notions of belonging, home and uprootedness. After her adventures in the Technicolor world of Oz and her return to black-and-white Kansas, the adults surrounding Dorothy intimate that Oz was just a dream, despite her protestations. Ironically, for the viewer, as much as for Dorothy, dreary Kansas cannot compete with colourful Oz. The latter seems a heightened, if surreal, reality, which Rushdie connects to the transition from childhood to adulthood and to the idea of home and homelessness:

> the truth is that once we have left our childhood places and started out to make up our own lives, armed only with what we have and are, we understand that the real secret of the ruby slippers is not that 'there's no place like home', but rather that there is no longer any such place *as* home: except, of course, for the home we make, or the homes that are made for us, in Oz: which is anywhere and everywhere, except the place from which we began. (1992b, 57)

Rushdie's view of the film's conclusion very clearly aligns with the journeys of his characters, in particular his transglobal migrants. These deliberations are important for practically all of Rushdie's heroes: for Saleem Sinai who after his journey finds respite in the arms of his ayah in the Braganza pickle factory; for Salahuddin who after his reconfiguration of selfhood rediscovers a different version of home through the love of Zenat Vakil; or for Rai who remakes home together with Mira and Tara in New York. The reassertion of home, enshrined in Dorothy's exclamation 'There's no place like home', is reworked through Rushdie's use of the maudlin Chaplinesque tramp iconically depicted by Raj Kapoor in films such as *Awaara*, *Shree 420* and *Jagte*

*Raho*. In the conceptualisation of homelessness and dislocation, which features so prominently in Rushdie's writing, *Shree 420*, in particular, resonates through the song 'Mera Joota Hai Japani', belted out mid-air by Gibreel Farishta as he tumbles down to England (Rushdie 1998, 5)—which could almost intersect with 'Somewhere over the Rainbow' as theme tunes for Rushdie's transglobally migrating hero.

Dorothy's message in relation to Rushdie's heroes unmasks the fragmentary nature of identity and the possibility of infinite rearrangements. It also points to the transient nature of home and how the creation of any sense of home relies on a physical and metaphoric journey to the self. This often painful process is closely related to the birth of India as an independent nation and the partition of British India into the political entities of India and Pakistan. The rupture along which Indian nationhood has been defined is one of the reasons why a key feature of 1950s Hindi cinema was the 'fragmented Indian' in search of the meaning of his Indianness. This image relates directly to the formation of a new national identity through cinematic representation. As Sumita S. Chakravarty points out, in the wake of Partition, Indian popular cinema's large audiences 'also constituted the new citizens of India and as such faced the problems of developing some notions of social responsibility, of building community and solidarity that went beyond the "traditional" loyalties to family and caste groups' (1993, 133). Rushdie draws on this representation of the Indian self in *Midnight's Children* through the narrator-protagonist Saleem, who is on the verge of cracking up, and his grandfather, Aadam Aziz, who discovers his national identity after he sees his future wife completely for the first time, no longer in fragments through a perforated sheet. Rushdie plays with the question of a fractured and fraught national identity by reworking similar tropes from Indian popular cinema. He then further complicates this process by relating it directly to the reality of the transglobal migrations of his urban middle-class Indians.

Rushdie speaks pejoratively of Indian popular cinema and likens its consumption to the pleasure of eating fast food: 'The classic Bombay talkie uses scripts of appalling corniness, looks by turn tawdry and vulgar and often both at once, and relies on the mass appeal of its stars and its musical numbers to provide a little zing' (1992b, 13). Contrasting it with *The Wizard of Oz*, he argues that the latter uses its best elements: 'It takes the fantasy of Bombay and adds high production values and something more; something not often found in any cinema. Call it imaginative truth' (ibid). Rushdie's generalisation is sweeping and reductive and shows his limited intellectual engagement with the genre. Yet cinema and, in particular, Indian popular cinema features throughout his fiction, either explicitly—through direct references to films which provide analogies with his own narratives—or implicitly in his use of a cinematic vocabulary, such as fade-ins and fade-outs, montages, dissolves, superimpositions, wide-angle shots and song-and-dance sequences, integral to the visual aesthetic and cinematic attractions of Indian popular

cinema. I asked Rushdie to clarify the influence of cinema and Indian popular cinema on his writing at the Edinburgh International Book Festival in August 2005. He replied:

> I was very affected by the movies. I was young and I was forming my ideas about art and about writing at a time when the movies were unusually exciting. [ . . . ] I have always thought that I got a lot of my education from people like Fellini, Buñuel, Bergman, Godard and Orson Welles. [ . . . ] So, yes, I have been very influenced by the movies but not particularly by Indian movies except in one regard. That is the regard [ . . . ] in which the Indian commercial cinema [ . . . ] is everything at once. [ . . . ] It can be an adventure story, a love story, a comedy and a musical all at the same time. I pinched that portmanteau idea of what a work can be, so in that sense I was influenced by the Bombay movies. (Rushdie and Koval 2005)

It is worth considering this 'portmanteau idea' further. Film critic Nasreen Munni Kabir (2001, 14–20) explains that the intermingling of genres developed gradually and became prominent in the 1970s with films such as *Amar Akbar Anthony*. Rushdie first uses the 'multi-genre' concept of Indian popular cinema in *Midnight's Children* and develops, reworks and manipulates it in his later novels. The syncretic portmanteau idea of Indian popular cinema relates directly to its melodramatic mode, from which Rushdie extensively draws, and to the treatment of realism and the surreal in his fiction. He debates this question of realist aesthetics and fantasy incisively in *The Moor's Last Sigh* and in his article 'Satyajit Ray' (1990, 9).

Rushdie sees the discrepancy between the Indian art house and popular cinema as a clash between two different urban cultures: 'the cosmopolitan, brash bitch-city of Bombay versus the old intellectual traditions of Calcutta' (1990, 9). Indian cinema, like Rushdie's novels, allows for a strong streak of fantasy and requires the audience to suspend its disbelief. In Rushdie's fiction the magical elements serve as intensifications of the real, while the treatment of realism is intertwined with the question of postmodern and postcolonial aesthetics. In a 1984 interview with Kumkum Sangari, Rushdie firmly rejects the postmodernist label insofar that he believes postmodernism refuses to accept that literature is 'referential' and only exists as a text which remains unrelated to the outside world (Rushdie and Sangari 1984, 251). Rushdie also rejects realism as a school of writing as it requires a level of consensus on what reality is. Indeed, his fiction presents the reader with multiple realities which his audience needs to navigate. According to Rushdie, this consensus has been eroded over the past century through political processes and the advent of mass migration and dislocation (ibid). In this respect, Rushdie's 'realism' needs to be rerouted through a different idiom and, arguably, Indian popular cinema is instrumental here, as its syncretism

generates a productive space for the debate and potential resolution of this conflict of description. The escapist, fantastical elements of Rushdie's fiction underpin and intensify the impact of the socio-political argument he makes and provide a response to India's post-independence modernity and to transglobal migration.[10] Indeed recent Bollywood cinema has increasingly tackled these diasporic themes (Dudrah 2012). I will analyse this process further in the discussion of the novels to show that Rushdie's blending of genres is similar to that of the masala film, creating a sense of streams of stories merging and diverging, which leads to the impression of interconnections between his fictional worlds.

Indian popular cinema's form is a syncretistic intermingling of different cultural, cinematic and aesthetic modes. Its similarities in form make it a necessary reference point for Rushdie's own vision of syncretism and cultural eclecticism. As Vijay Mishra has pointed out,

> how and why Bollywood is to so many a signifier of the cultural logic of Indian modernity are questions whose answers may be discovered in the Rushdie corpus. [ . . . ] It was, finally, a form that mediated how Indians, both homeland and diaspora, read quotidian life. (2007, 15)

For Mishra, the synchronicity of Indian popular cinema's form, which is capacious enough to agglomerate different narrative modes, allows film in Rushdie's fiction to fulfil the role of India's quintessential aesthetic as well as to become the prime marker of Indian culture. Thus, for Mishra, 'cinema, as text, provides Rushdie with both a context (cinema as social fact) and a language (cinema as a particular discourse, a particular representational technique) with which to write national allegory' (2007, 17). My discussion takes up Mishra's argument that, in Rushdie's fiction, Indian popular cinema is deployed towards a postmodern aesthetic by referencing a cinematic form which, by its very nature, was postmodern before postmodernity, responding to a particular Indian postcolonial modernity (2007, 25–26).

Rushdie mediates his concern with an Indian national identity through his engagement with Indian popular cinema in *Midnight's Children*, *The Moor's Last Sigh*, *The Ground Beneath Her Feet* and *Shalimar the Clown*. The coalescence of realism, myth and the surreal as they feature in both Rushdie's novels and Indian popular cinema reveal the process of how national identity formations are constructed, questioned and subverted. Chakravarty argues that such myths produce 'a dynamic textual process where meanings are inherently unstable' (1993, 121). She shows how Indian popular cinema of the 1950s concerned itself with the production of a mythic tradition that reflected contemporary issues and the secular ethos of the newly independent nation (1993, 125). The instability of such myths similarly preoccupies Rushdie in his fiction and marks the 1950s Bombay film as a particularly useful intertext.

The three specific cinematic texts Rushdie references repeatedly—*Shree 420*, *Mother India* and *Mughal-e-Azam*—link his fiction directly to what Chakravarty terms the romantic-mythic tradition of Indian popular cinema. It functions within melodramatic parameters to provide the drama of heightened feeling as intensifications of the real. Rushdie's novels filter this interrelationship between melodrama, realism and an aesthetic of excess through Indian popular cinema by deploying the visual as a mode of storytelling which Rushdie's narrators adopt. In this respect, the role of a visual aesthetic requires some further definition, especially in relation to the position of the spectator and spectacle. As Rachel Dwyer notes:

> there is no defined aesthetics of Hindi cinema. But Hindi cinema shares noticeable features such as the use of melodrama and heightened emotion, especially around the family, an engaging narrative, stars, a certain *mise en scène*, usually one of glamour, grandiloquent dialogues and the all-important songs. (2005, 1)

These elements are also integral ingredients of Rushdie's novels. In *Midnight's Children*, Saleem Sinai references the Bombay talkie at various stages in order to further explain his own situation and, in the process, emotionally involve his audience (Chordiya 2007; Stadtler 2012). In *The Moor's Last Sigh*, Moraes Zogoiby uses the aesthetics and idiom of Indian popular cinema to make sense of the relationship with his father, the underworld don, and his mother, the prolific artist Aurora Zogoiby. In *The Satanic Verses*, the dream sequences of Gibreel Farishta also borrow the cinematic visual aesthetic that is derived from Indian popular cinema's song-and-dance sequences. Rushdie's narrators become spectators of their own stories. Marginalised and sidelined, they observe through the filmic idiom what has happened and been done to them as though it were a cinematic spectacle on a movie screen. Throughout the discussion of the novels, I will be focusing on such elements which shape Indian popular cinema's visual aesthetics and how Rushdie adapts and manipulates these for his narratives.

One major device Rushdie deploys to great effect is melodrama, in particular in the context of staging his narrator-protagonists' families. While melodrama is an important hallmark in Indian popular cinema, the melodramatic mode also has important nineteenth century literary antecedents (Gabriel 2010; Vasudevan 2011b). In *The Melodramatic Imagination: Balzac, Henry James, Melodrama, and the Mode of Excess* Peter Brooks associates melodrama with a fundamental desire to express all, as characters who are cast in primary psychic roles such as father, mother, son or daughter reveal their deepest feelings in heightened and polarising dialogue, which leads to the subsuming of the world that is split into binaries (1995, 4). In this respect, Brooks argues, 'the narrative creates the excitement of its drama by putting us in touch with the conflict of good and evil played out under the surface of things' (ibid).

According to Brooks, it is important to note that melodrama is rooted in the real where the reality of the everyday becomes an important reference point. Yet there is a clear function of reality in the melodramatic mode, 'using the things and gestures of the real world, of social life, as kinds of metaphors that refer us to the realm of spiritual reality and latent moral meanings' (Brooks 1995, 9). In Rushdie's novels melodrama produces a heightened sense of reality and allows for the projection of the surreal, which finds its literary antecedent in the novels of Charles Dickens. Rushdie has mentioned that his fascination stems from how Dickens manages to combine a hyper-realist background in which his surrealist foreground, like the Circumlocution Office in *Little Dorrit* or the Jarndyce and Jarndyce court case in *Bleak House*, is embedded in the narrative (Rushdie and Ball 2000, 106–107; Rushdie and Pattanayak 1983, 20). This applies equally to Dickens's larger-than-life characters, such as Fagin in *Oliver Twist* or Jaggers in *Great Expectations*. Rushdie is influenced by the way Dickens grounds character and surreal imagery in a sharply observed background, out of which 'the comic and fantastic elements of his work seemed to grow organically, becoming intensifications of, and not escapes from, the real world' (Rushdie 2006a, xii).

The connection between melodrama, its relationship with the epic and the way it becomes a marker for a postcolonial Indian modernity interests Rushdie because it has a particular impact on urban mass culture. Rushdie's protagonists all come from a middle-class urban background and they draw from the urban mass culture as it is produced in the dream factories of Bombay; in this respect, these narrators have no time for the more highbrow, serious and realist auteur cinema. Rushdie's protagonists reject a certain realism and instead opt for what Moraes Zogoiby calls 'unnaturalism', which becomes inflected through the melodramatic mode of Indian popular cinema (Rushdie 1996b, 5).

Indian popular cinema subverts what Ashish Rajadhyaksha terms 'a *realism* of perception' that undermines the camera's objectivity (1993, 57, original italics). For example, Rushdie takes up this notion through an incisive questioning of reality and the way it is offered up for consumption through images in *The Ground Beneath Her Feet* as narrated by Rai, who uses a distinctly visual narrative style. He works as a news photographer, visualising and aestheticising the reality of war across the world, while also delving into fashion and celebrity photography to counter the excessive realism he is exposed to in the war zones of the world. Though working in an entirely different medium, Rai's strategies find some analogy in Indian popular cinema, where realist depictions are countered and subverted and offer up the world as spectacle. As Rajadhyaksha with reference to Fernando Solanas and Octavio Gettino argues, 'the cinema becomes a "spectacle aimed at a digesting object" in which man is accepted "only as a passive and consuming object"' (1993, 57). In this instance the visual becomes a particular aesthetic. Vijay Mishra explores this further in his reading of Raj Kapoor as auteur

and voyeur (2002, 98–112). Mishra defines the genre of Bombay cinema as 'sentimental melodramatic romance linked to dharmic codes' (2002, 99), which is reflected in the films of Raj Kapoor and the representation of the hero in his films. Kapoor works within the melodramatic mode, but 'manipulates the politics of desire and the subject/self/spectator's insertion into that desire' (ibid). Rushdie extrapolates this for his own heroes/narrators, who all are spectators and voyeurs and use this paradigm for their own fictionalised visual aesthetic. Kapoor implicates the audience/reader in a viewing pleasure of excessive and heightened drama which is structured around the image of 'Woman', and I argue that this deployment of what M. Madhava Prasad has discussed as the 'absolutist gaze' is intrinsic to the melodramatic staging of family and romance in Rushdie's novels.

For Mishra, melodrama is a reworking of a female agenda into the filmic text achieved through the destabilising effect of emotional excess (2002, 110). It can confront a patriarchally conditioned rigid worldview that allows for a degree of female spectatorial engagement. In this respect, the desire of a male voyeuristic gaze plays an important part in how women are read in Indian popular cinema. Rushdie parodies this in his own fiction. Saleem's accident in a washing chest where he becomes privy to his mother's sexual desire for her former husband, Nadir Khan, or his spying on his mother's blossoming love affair at the Pioneer Café are only two examples (Rushdie 1995a, 160–162; 216–218). This is further accentuated by the Peeping Tom, Omar Khayyam Shakil, gazing on Farah Zoroaster through his telescope, which pre-empts his career as a doctor, a profession described as 'legitimised voyeurism' (Rushdie 1995b, 49). Gibreel Farishta too becomes a voyeur in his filmically realised dreams where he features as the archangel Gabriel. Through the prism of Indian popular cinema, then, women in Rushdie's fiction become not only sexual objects of desire upon whom a particular body politics is enacted, but also the site where a social politic is debated in the coding of women as grandmothers, mothers, wives, daughters, sisters, sisters-in-law and courtesans, which has deliberate echoes of Indian popular cinema. As Peter Brooks has remarked so pertinently in 'Melodrama, Body, Revolution', 'the melodramatic body is a body seized by meaning' (1994, 18). The body politics of a text becomes the text's central defining feature insofar as melodrama is concerned with acting out what otherwise might be repressed. Brooks argues that, in the context of melodrama, there is a 'constant recourse to acting out, to the body as the most important signifier of meanings' (1994, 19). Similarly Rushdie's novels prominently feature fragmenting male and female bodies that transform into sites upon/through which meaning is defined and where the identity politics of Rushdie's narratives converge.

Yet melodrama in Indian popular cinema has played an important role in the negotiations of masculinity and femininity and their regulation into heteronormative received codes (see Gabriel 2010), which revolve around

conceptualisations of family and its centrality in nationalist discourse. For example, Ashish Rajadhyaksha associates the emergence of a form of 'epic melodrama' in Indian popular cinema with the wider contexts of India's nationalist movement insofar as both make recourse to the trope of family as a stand-in for the nation (1993, 59). Thus the family becomes a site where the formation of subjectivities is shaped by the historical moment and conflicting attitudes as they are developed in the movies. According to Rajadhyaksha,

> film puts the scale up to the entire question of indigenous modernism in India, racked as it has been by the question whether/if/how it relates/ should relate to the 'tradition' even as each constantly perceives the other in its image. (ibid)

Indian popular cinema, then, debates the dialectics of modernity and tradition on the site of the family through 'epic melodrama' and becomes an important intervention in the imagination of 'traditional' and 'modern' India (ibid). This emerges clearly in the films Rushdie chooses as direct intertexts for his fiction and is realised through the staging of patriarchal family structures by his narrators. As Rajadhyaksha remarks, in Indian popular cinema, a heightened form of realism that becomes melodramatic and epic is a subterfuge that allows for the reconfiguration of earlier genres, such as the mythological and the historical, as they are retold and become 'a major cultural hegemony within a broader ideological container of the nationalist allegory and its several more abstracted metaphors' (1993, 60). It is in this context that Rushdie's use of the idiom of Indian popular cinema needs to be read. It echoes, for instance, his representation of the Aziz/Sinai family and Sabarmati case in *Midnight's Children*, the feudal landowning Shakil family in *Shame*, the Zogoiby-da Gama clan in *The Moor's Last Sigh* and the Camas in *The Ground Beneath Her Feet*.

In Indian popular cinema, the interaction between realism and melodrama opens up a route by which a postcolonial consensus is arrived at for independent India. Rushdie uses filmic texts from the 1950s and 1960s. In this period, Indian popular cinema still took on and reworked the narrative themes of the colonial era through the genres of the historical, mythological and social film. It sought to engage with issues about how India as an independent nation might be imagined, what Indian self-governance may entail and what challenges the new country would have to confront. The historical allowed for a depiction of an imaginary past, the mythological retold the epics and often narrated them as allegories for contemporary Indian society, while the social films deployed a contemporary setting for their melodramatic narratives about family and community, thereby reformulating a realist aesthetic into a melodramatic template (see Jaikumar 2006, 205). Within this melodramatic staging, scriptwriters, directors and actors articulate and uphold a particular moral universe, which Rushdie uses and subverts in his narratives. Rosie Thomas's

observations are useful in this regard. For her, Indian popular cinema explores this moral universe within a framework that debates, contests and renegotiates concepts of tradition, modernity and Indianness:

> Film should be seen as an arena within which a number of discourses about female chastity, modern nationalism, and morality intersect and feed upon each other, with significant political effects, and that this broader text offers fissured, contradictory, and partial representations and identifications. (Thomas 1995, 159)

For Thomas, the construction of an Indian identity in Indian popular cinema is achieved through a series of conventions that deploy strategically nationalist and patriotic themes and feature an 'ideal moral universe' (ibid). Similarly, the notion of the novel as an arena for discourses becomes so crucially evident when discussing Rushdie's fiction, and the manner in which these debates are played out emulate the space set up in Indian popular cinema and finds itself in the melodramatic staging of the family in the novels. Aurora Zogoiby, for instance, though likened to the iconic figure of 'Mother India', is unlike Indian popular cinema's traditional mother. A foul-mouthed adulteress and a heavy drinker, she leads a bohemian lifestyle. However, she still maintains a distinctive moral code which leads to the expulsion of Moraes from the family home. Similarly, Saleem Sinai is exiled from home after doubts about his parentage emerge and his mother is accused of adultery. Rushdie distorts the boundaries between patriarchal-sexual codes of virtue, good and evil, especially on discourses of motherhood, questioning received moral codes. While Rushdie blurs these boundaries, the moral universe of his novels becomes markedly bound up with debates of nationalism, modernity and tradition that clearly demarcate between villain and hero, those who seek to destroy the nation and those who want to uphold its values.

The role and function of the hero, particularly in *Midnight's Children* and *The Moor's Last Sigh*, is ambivalent, considering that more often than not he is a victim rather than proactive participant and can be read as a subversion of the function of the hero in Indian popular cinema. Ravi S. Vasudevan highlights well how a melodramatic routing is important in the way it complicates the hero's identity in Indian popular cinema's social films:

> It is the hero's very mobility between spaces, spaces of virtue (the 'mother's' domain), villainy and respectability (the 'father's' domain) which problematizes social identity. Often the street, the space of physical and social mobility, is also the space of the dissolution of social identity, or the marking out of an identity which is unstable. (2000b, 110)

The journeys of Rushdie's heroes are very much encapsulated in Vasudevan's description—for instance, Saleem's journey across India and up and down the

social ladder, from middle-class respectability into the slum. Similarly, Salahuddin Chamchawala, the successful voice-over artist, becomes a refugee after the loss of his passport and ends up in the shadowy immigrant world in London. Vilified as an alien, he transmutes into a devilish creature. The reader is confronted with what Vasudevan calls 'a drama of downward social mobility', which may lead to social renewal and the recovery of his virtues (2000b, 110–111). Rushdie generates a moral universe which bears the hallmark of Indian film, but subverts and explodes it by undermining it with characters who are recognisable as a type, but act against that very type. In this respect, his novels push the boundaries of a moral framework which is directly related to quintessential debates and questions about a society in transition.

The mapping of a national consciousness in Rushdie's fiction can also be linked to similar attempts in Indian popular cinema's social film of the 1950s. Vasudevan analyses the genre of the 'social' in the context of an emerging national cinema for post-independence India and looks specifically at its mapping of a 'nation space' (2000a). In *Midnight's Children* this is reflected in the career of Saleem's uncle Hanif, who tries unsuccessfully to blend a socially conscious cinema with the commercial.[11] Vasudevan points out that the social film played an important role in identity negotiations for its spectators: 'the mass audiences earlier conceived of as being attracted only by sensation and themes of moral affirmation were now being solicited by an omnibus form which also included a rationalist discourse as part of its "attractions"' (2000a, 387). In these instances, Indian popular film combined a rhetoric of morality and identity in its discourse of social transformation (Vasudevan 2000a, 387–388). In this respect, films had to involve themselves in the construction of overarching cultural norms, which 'suppressed the representation of marginal currents in Indian narrative and aesthetic traditions' (Vasudevan 2000a, 394). Cinema, then, can function as a tool to reformulate culture within a national context and, as part of this process, is involved in undermining 'space for marginal discourses' by exercising control over the ambiguity between the relationship of gender and power (Vasudevan 2000a, 395). *Midnight's Children*, *Shame* and *The Moor's Last Sigh* in particular dramatise similar negotiations, a point to which I will return in subsequent chapters. Vasudevan's argument illustrates how the social film of the 1950s became the prime vehicle by which the Bombay film industry engaged with the challenges of modernity and modern life in post-independence India, which links up to similar preoccupations in Rushdie's fiction (Vasudevan 2000b, 105).

As has been established, Indian popular cinema is marked by its heterogeneity, which Rushdie likens to the portmanteau, where the form itself can be loosely defined as 'epic melodrama' (Rajadhyaksha 1993), 'feudal family romance' (Prasad 1998) and 'sentimental melodramatic romance' (Mishra 2002). Emblematic of Indian popular cinema's aesthetics, Rushdie uses it for his own narratives in the staging of his urban upper-middle-class families and through characters directly linked to the film industry. For example,

Saleem's uncle Hanif, his aunt Pia, Homi Catrack, Whisky Sissodia, Gibreel Farishta and Pimple Billimoria are all associated with it as directors, actors and producers. Rushdie taps into key paradigms of Indian popular cinema, such as the conflict between tradition and modernity within a nationalist project prevalent in the films of the 1940s and 1950s. In its highly stylised way Indian popular cinema addresses social and political issues which become split into oppositional forces. Mishra defines them as 'good and bad, sanctity and scandal, dharma and adharma, indeed [...] a Manichean world order' (2002, 16). The body becomes the site upon which this drama is enacted and becomes a marker of this discourse (Mishra 2002, 38). In this respect, Rushdie's fiction through the idiom of Indian popular cinema presents that discourse through the melodramatic and the sentimental to articulate the novels' particular moral universe.

Indian popular cinema fulfils a crucial function in the way it presents a narrative of the nation, and it is here that one can most explicitly trace intertextual links to Rushdie's fiction. Representations of the nation in the cinematic as well as in Rushdie's text become a discursive formation articulated as a site where a national imaginary as allegory is expressed. Indian popular cinema became an indigenised form of storytelling that found its antecedent in India's oral storytelling tradition, a tradition which is also a precursor of Rushdie's idiom. This allowed the Indian filmmaker Dadasaheb Phalke, who directed the first mythological film *Raja Harishchandra* in 1913, to argue that his films were *swadeshi*, home-grown indigenous entities in terms of content and mode of production (Mishra 2002, 13). In many ways post-independence Hindi cinema engaged with a concept of Indian nationhood that was based on the Nehruvian vision of the nation—secular, democratic and socialist in outlook. Films like *Mother India* and *Awaara* highlight questions about an Indian modernity and the conflict between progress and tradition. These debates have been shaped by the colonial moment and Indian popular cinema's productions of the 1930s and 1940s already started to develop the themes that have so distinctively influenced post-independence Indian popular cinema. Films from the 1950s and 1960s concerned themselves with the ideas of nationhood and citizenship for newly independent India and strived through a melodramatic routing to create a sense of belonging by championing a particular idea of Indianness based on Nehruvian ideals (Virdi 2003).

In *Cinema at the End of Empire: A Politics of Transition in Britain and India* Priya Jaikumar suggests that, in the period preceding independence, 'films became figurations of the internal polarizations of India's nationalist discourse when they attempted to reach for multiple and potentially contradictory nationalist appeals to create a cinematic vision' (2006, 234). The Nehruvian vision of the nation defined itself against imperialism on the one hand and, on the other, developed in conjunction with other forms of nationalisms that took account of region, caste and language. Indian popular cinema needed to account for this issue and resolve it through its deployment of

multiple genres in the omnibus form of the social film. Mythologicals and historicals also adapted their narrative forms, in one way idolising a pre-modern past with shared values while in another distinguishing the enlightened and reformist ruler from the evil feudal landowners. As Jaikumar observes, 'each genre provided a template for the uneven assimilation of modernity within the colony. Melodramatic socials were to become independent India's dominant cinematic form for manufacturing an imaginary civic society' (2006, 235). As the following chapters will demonstrate, Rushdie's deep questioning of India's civic society makes Indian popular cinema an obvious site of engagement for his fictional worlds by offering alternative ways of imagining society through its representational apparatus.

# 2 Heroines, Mothers and Villains
## Cinema and Postcolonial National Identities in *Midnight's Children* and *Shame*

In *Midnight's Children* Rushdie expands and refines his specific mode of cinematic storytelling in a narrative that historically maps the birth and progress of the subcontinent post-independence in the wake of British imperial domination. The novel was to win Rushdie the Booker Prize in 1981 and was key to establishing his reputation. Its enduring popularity saw the book receive the 'Booker of Bookers' in 1993, commemorating the award's twenty-fifth anniversary, and in 2008, the 'Best of Booker' by public vote, to mark the prize's fortieth anniversary. The novel has had a lasting impact on Indian writing in English, particularly in the West. Perceived as a trailblazer, it has been said to pave the way for a younger generation of novelists from the subcontinent. The idea for the novel initially lay with Rushdie's preoccupation of restoring his childhood Bombay to himself. The publication of his first novels, *Grimus* and *Midnight's Children*, had in fact been preceded by three unpublished novels, *The Antagonist*, *The Book of the Pir* and *Madam Rama* (see Chapter 3). All three of these contain important elements which Rushdie would use and rework in *Midnight's Children*, although he had not yet found a sustained narrative voice. In *Midnight's Children* Rushdie develops his hallmark style of multi-layered storytelling, teeming, turbulent and ever-digressing, the first signs of which can be seen in his unpublished novels and his debut, *Grimus*.

*Midnight's Children* has been influenced by a wide range of novels, writers and literary styles. Several of these influences have been traced to Western literature, such as Günter Grass's *The Tin Drum*, Laurence Sterne's *Tristram Shandy* as well as Charles Dickens, while Rushdie himself has volunteered others such as Gogol, Cervantes, Kafka, Melville and Machado de Assis. Scholars have also drawn links between Rushdie and the South American Magical Realist tradition, most notably Gabriel García Márquez and his groundbreaking work, *One Hundred Years of Solitude*.[1] While my discussion acknowledges these influences, I will focus on Rushdie's subcontinental heritage and will emphasise the influence of India's narrative tradition on the novel, a tradition which finds its expressions in different media—oral storytelling, folklore, visual art, music and film.

## Heroines, Mothers and Villains

*Midnight's Children* draws on the conventions of Indian popular cinema, reflected in the way the novel uses stock narrative devices and often parodies them. How do the cinematic devices function and how do they help Rushdie and his narrator to unravel and expose India and Pakistan's 'myth of nation'? How does the cinematic medium and camera lens construct a particular representation of women in coded roles such as mothers, sisters and daughters? In this respect Indian popular cinema's devices in *Midnight's Children,* and to a lesser degree in *Shame,* reveal the feminine as a trope how nationhood is imagined.

Furthermore, Indian popular cinema's representation of the urban environment, particularly Bombay as the epitome of an Indian modernity in comparison to the visual representations of Bombay in the novel, which Rushdie extends beyond the urban landscape to the whole of India, allow him to question how India's postcolonial promise was broken in the wake of the Emergency. Cinema is intricately woven into the plotline of *Midnight's Children,* and its visual scope is further highlighted when comparing and contrasting Rushdie's 1997 screenplay with the novel for the television adaptation and the 2012 Deepa Mehta film (see Chapter 3). The novel first explores Rushdie's idea of multiplicity, pluralism and hybridity with which he associates India and to which the divisive politics of communalism are diametrically opposed. Rushdie uses a distinctly visual and cinematic style borrowed from the Bombay-based syncretic Indian popular film to convey the main thrust of this argument. *Midnight's Children,* then, reflects artistically, intellectually and structurally on how the dream of a nation expressed by Nehru on the eve of independence could turn into a nightmare through the despotic streak of his daughter and her declaration of a state of internal emergency in 1975. Against the historical backdrop of thirty years of Indian independence Rushdie, through his narrator Saleem, spins a digressive tale, at the centre of which lies the epic saga of the Sinai family.

### Salman and the Sea of Stories

*Midnight's Children* is a novel of interlinked streams of stories held together through an array of recurring leitmotifs and objects, such as the silver spittoon, the Fisherman's pointed finger, the Midnight's Children, pickles and the activity of pickling, the perforated sheet and the cinema screen. The perforated sheet is perhaps the sturdiest of these recurring motifs closely linked to Rushdie's narrative method and cinematic storytelling. It has its role, on the one hand, as a concrete object and, on the other, as a metaphor for his narrative method. As Rushdie explains,

> having found the image of the sheet with the hole, [ . . . ] it became helpful to me as a way of understanding how to write the book. To fall in love with something seen only in little bits and to make the composite figure

in your imagination, and then fall in love with it, seemed not unlike what I was trying to do. (quoted in Reynolds and Noakes 2003, 12)

Rushdie's observations regarding the perforated sheet are striking as they reveal how concrete objects take on larger symbolic meaning in the fabric of the narrative, linked for instance to perceptions of reality through the falsifications of memory. Yet the meaning of this object shifts and, as a motif, recurs in different guises. It is introduced when the Heidelberg-educated young doctor Aziz is called to the landowner Ghani's house to examine his daughter who is suffering from an upset stomach. However, because she is in purdah, her father cannot permit the doctor to see his daughter and instead places her behind a sheet with a big hole in the middle. The doctor then has to specify which part of the patient he wishes to see for his diagnosis.[2] Through this process, Aziz accumulates a fragmentary image of Naseem, puzzled together slowly as she develops different ailments and only completed when she finally reveals her face after developing a headache. The sheet's link to Naseem and notions of fragmentation and wholeness is extended to Aziz discovering and imagining his national consciousness.

As an object, the perforated sheet mirrors Saleem's shifting narrative perspective, which switches back and forth from the panoramic and sweeping to the up-close and personal—a storytelling strategy he deploys throughout the book. However, the shift in perspective is most crucial and noticeable in the third section of the novel. Saleem's focus becomes narrower and narrower the more he realises he is not central to the history of the country but, rather, that this role belongs to Indira Gandhi, fictionalised in *Midnight's Children* as the Widow and reimagined in Saleem's mind as the Wicked Witch of the East. She appears green and black and black and green in Saleem's nightmare in an obvious nod to *The Wizard of Oz* (Rushdie 1995a, 207–208).[3] By

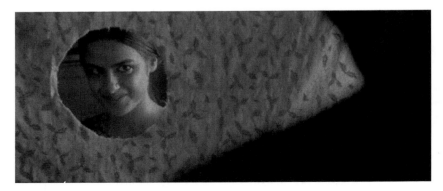

*Figure 2.1* A young Naseem Aziz (Neha Mahajan) discovering her husband through the perforated sheet in the 2012 film adaptation.

the end of the novel, Saleem has become marginal in his own story, which is also his initial position of enunciation, writing down his life story in his ayah's pickle factory, to record his suffering for posterity before disappearing into a multitudinous crowd. From the beginning the reader is made aware of the position he writes from and tells his tale, which raises several questions about his role as narrator. Does he try to reclaim his central role in the story of his life, or is his act of writing his autobiography a form of confessional, his way of conceding in the end his own marginality? Bearing these concerns in mind, what strategies does Saleem use to keep his audience captivated, interested and on his side? How believable is he, especially since he hints constantly at his own unreliability? He creates this impression through his ever more elaborate attempts to maintain his centrality in his story. Some answers to these questions can be found in the way cinema becomes the idiom and guiding motif through which Saleem recounts his story.

The metaphor of the Midnight's Children is intrinsically linked to Saleem's realisation of marginality and closely connected to the examination of the politics of the novel in its firm and uncompromising critique of Indira Gandhi and her declaration of a state of internal emergency in 1975. The novel charts, albeit loosely and in fragments, India's history, or to be more precise, writes a version of Indian history from the last years of the Raj, beginning in 1915, to the lifting of the Emergency in 1977, ending with the country's thirtieth anniversary of independence. Initially, the novel examines the struggle for independence, in which Saleem's grandfather takes an active part, and explores possible alternatives to the partition of the subcontinent. All these debates, which dominate the first part of the novel, come to nothing—as reflected in the name of the Rani of Cooch Naheen, Hindi for the Rani of 'nothing at all', under whose patronage these discussions take place.

With an agreement on Partition, the countdown begins towards the Midnight Hour of 14 August 1947, at which India makes its tryst with destiny and 1001 Midnight's Children are born. Symbolising the country's hopes and possibilities associated with hard-won independence, the Midnight's Children are also linked to other connotations of the Midnight Hour and its association with witchcraft and magic. Yet the novel later examines the darker symbolism of Midnight as the hour of nightmares, when Saleem connects the Oz-like Wicked Witch of the East, Indira Gandhi and her declaration of the Emergency with the witching hour. Saleem parallels and diametrically opposes two Midnight Hours, India's arrival at independence and the inception of the Emergency when Indira Gandhi assumes autocratic rule over the country. Saleem presents this as the end of democracy and associates it with a polarisation of society and the death of an idea of India as outlined by Nehru in his 'Tryst with Destiny' speech on the eve of independence, which is intercut with Saleem's birth.[4] Similarly, the birth of the Emergency is intercut with the birth of Parvati's child. The dismantling of the rule of law and the assumption of autocratic rule bring with it heavy press censorship,

which is reflected in baby Aadam's two-year refusal to utter a single word, slum clearances as part of city beautification programmes and an extreme form of birth control.[5] The forced sterilisation, the performance of a variety of '-ectomies', transforms the metaphor of the Midnight's Children into one of betrayed hope and aborted possibilities.

Rushdie permits Saleem to self-consciously use a film vocabulary. This underlines his consumption of popular culture and the cinematic way in which he perceives his own positionality in the world (Stadtler 2012, 115–127). He uses several devices to emphasise this, such as montages, close-ups, fade-outs, intercuts, dissolves, sometimes he portrays the action in the style of a documentary, sometimes a Bombay film melodrama or action movie. The novel teems with cinematic visuals and they produce a very striking effect. For example, a distinct documentary style allows for a more immediate portrayal of the horrors of the Amritsar massacre, while melodramatic tropes from Indian popular cinema form an important template in portraying the larger-than-life characters in his family. The action sequences in his confrontation with Shiva also bear traces of the 1970s action dramas in Indian popular cinema and seem like an indirect comment on the films produced in Bombay at the time. These too reflected the heightened tensions and aggression during the Emergency and distinctly highlight how these popular cultural productions mirrored contemporary politics, albeit in coded forms, but immediately recognisable to its audiences (see Rushdie 1995a, 347). Indeed, the rebellious Shiva is an implicit reminder of the cinematic hero of the 1970s, 'the Angry Young Man' (see Mazumdar 2000). In *Midnight's Children*, Rushdie strategically deploys Bombay cinema's stock devices, such as the character of the good ayah, the conceit of children switched at birth or the centrality of family, to melodramatic and comedic effect as Saleem consistently undercuts, refashions and reframes these tropes. Nevertheless, he deploys them always in view of underlining the vision of Nehru and his ideal of postcolonial independent India's eclecticism.[6]

Rushdie highlights the heterogeneity of Saleem's identity by using a common trope of Indian popular cinema, that of children switched at birth. This makes Saleem a motley agglomeration of dubious and multiple parentage and ancestry, mirroring the subcontinent's 'birth' of the nascent nation states India, Pakistan and Bangladesh. Saleem is and is not his parents' son. He is the bastard child of the departing British colonialist William Methwold who has acquired a taste for lower-class Indian women and has an affair with the wife of the street singer, Wee Willie Winkie. Because of Mary Pereira's act of switching him and Amina Sinai's child, spurred on by her crazed love for the Marxist petty criminal, Joe d'Acosta, Saleem leads the privileged life of the little rich kid, while his rival Shiva, whose place Saleem has involuntarily usurped, has the tough life of a street beggar. Saleem's identity is patched together and all these elements are part of his fragmentary self. Rushdie notes that, for Saleem, the hit song 'Mera Joota Hai Japani' from *Shree 420*

could also be his theme tune (Rushdie 1992a, 11).[7] The motley agglomerated self of *Shree 420*'s lead character Raj and the manner in which he defines his identity in the metropolis acquires further thematic significance in *The Satanic Verses*.

Saleem's quest for identity shadows that of the nation. Rushdie suggests that India is made up of a patchwork of cultural signifiers—religious, popular cultural, national—mirrored in the linguistic plurality of the country. Saleem, Midnight's Child, switched at birth by the woman who later takes on the role of his Christian ayah, is raised a Muslim, not a Hindu. He is committed to secularism through his parents' upbringing, yet his narrative swarms with references to the key Hindu religious texts, the *Mahabharata* and the *Ramayana*. The importance attached to the Sabarmati case in *Midnight's Children* highlights this well. Saleem stages the Sabarmati case by tapping into melodrama to raise important questions about modernity and tradition in a rapidly changing society. The episode is a good example of the interplay between the relationship of the moral code promoted in Indian popular cinema to which Saleem subscribes and social views of morality within the narrative which are equally shaped by religious traditions. Rosie Thomas underlines the connection between the *Ramayana* and *Mahabharata* and the moral universe of Indian popular films from which Saleem draws. Beyond the fact that their tales are known throughout the subcontinent, 'they offered the framework for melodrama, within which the perennial battle between good and evil could become the arena in which the "modern" can be constantly negotiated' (Thomas 1995, 180).

Indeed, Rushdie's reworking of the Nanavati case that held India spellbound with its obvious overtones of the story of Sita and Rama underlines this point. In 1959/60 Parsee Indian naval commander Kawas Manekshaw Nanavati was tried for the murder of his wife Sylvia's lover Prem Ahuja. He had shot him three times after confronting him about the affair with his wife. After the shooting Nanavati immediately gave himself up to police. In the subsequent trial the jury had to deliberate whether the gun went off by accident—which would be accidental homicide and had a sentence of ten years under the Indian Penal Code—or whether his actions were premeditated, which would have meant the death sentence or life imprisonment for murder. His defence argued for the former, the prosecution for the latter. In the event, the jury acquitted Nanavati 8:1, upon which the judge referred the case to the Bombay High Court for a retrial. It was obvious that the intense media attention and public support had influenced the jury. At the retrial, Nanavati was sentenced to life imprisonment but, after continuous lobbying by the media and the public, Nanavati was pardoned by the Governor of Maharashtra and was released after serving only three years. He, his wife and three children subsequently migrated to Canada, where Nanavati died in 2003.

The Nanavati case, which Rushdie adapts as the Sabarmati case, was associated in the popular imagination with the abduction of Sita by the evil demon

king Ravana and her restitution to Rama. It underlines the way Rushdie uses and reworks mythology in the novel in the context of Indian modernity, where the legendary story of Rama and Sita retains factuality in contemporary cases. As Rushdie remarked in an interview with T. Vijay Kumar for the *Deccan Chronicle*'s Sunday Magazine in 1983, 'India found itself having to choose between the rule of heroism and rule of law, between its mythical past and present' (Rushdie and Kumar 2001, 34). These questions also recur in Indian popular cinema as it reworks many elements of such myths for a contemporary audience well acquainted with the stories and thus capable of de- and recoding them in the present. Saleem actively engages in this process, infusing his story with these references and transposing them onto his characters. On the one hand, he stresses India's and his family's secularism. On the other, he demonstrates how the mythology of an independent, secular, democratic India relies on ancient religious stories to create a new 'secular' mythology.[8]

This clear link between myth and secular modernity opens up further important connections between Rushdie's novels and Indian popular cinema. For example, the 1977 Amitabh Bachchan star vehicle, *Amar Akbar Anthony*, one of the first 'masala' formula films, which accumulated a string of episodic highlights edited to form a seemingly organic entertainment spectacle, tells the story of three brothers separated from their mother and each other by a combination of fate and villainy after their father becomes the fall guy for somebody else's crime. The sons are raised as Amar by a Hindu policeman, Akbar by a Muslim tailor and Anthony by a Catholic priest. The separated brothers meet again under a statue of Mahatma Gandhi, underscoring the gravitas for which the film strives in a portrayal of the secular, religiously tolerant society post-independence India was meant to be. Rachel Dwyer suggests that the director Manmohan Desai turned the trope of familial separation and reunion into its own genre; 'one of the earliest films was about a Partition separation. His films showed characters from different religions, his most famous being *Amar, Akbar, Anthony*, which is now a byword in religious plurality' (2006, 144). As Meenakshi Mukherjee notes, the film is intertextual with *Midnight's Children* in the way it echoes Rushdie's imagining of India's secular modernity:

> There may be an element of comic and parodic exaggeration in the rendition of an easy co-existence of diversity in the land of his birth, encapsulated for example in *Amar-Akbar-Anthony* fashion, in the varieties of mothers Saleem has: biological, adoptive and nutrient—Vanita, Amina and Mary Pereira, and the many fathers he acquires through life—British, Hindu, Muslim, Sikh—but this playfulness does not go against the central project of the novel. (2000, 177)

These parallels are also revealing with regard to the way Rushdie portrays Saleem's conflicted relationship with his family and here the representational

and narrative apparatus of Indian popular cinema is an important tool-kit for Saleem/Salman.

## Mythic Nations, National Myths

*Midnight's Children* is not only concerned with the birth of a nation but also an ideal of India that Nehru described in his 'Tryst with Destiny' speech—a country that is free, secular, democratic and socialist in outlook.[9] These principles are further developed in *The Discovery of India*, which Nehru wrote during his five-month imprisonment in 1944. Nehru seeks here to answer two specific questions: 'What is my inheritance? To what am I an heir?' (Nehru 2004, 25). By looking at India's past, he seeks to make sense of his position in relation to India so it will allow him a better understanding of what it means to be 'Indian' and, by extension, how India can build a better future for herself. Nehru likens this to a journey of discovery. He finds a common mythic bond that all Indians share:

> Every people and every nation has some such belief or myth of national destiny and perhaps it is partly true in each case. Being an Indian I am myself influenced by this reality or myth about India, and I feel that anything that had the power to mould hundreds of generations, without a break, must have drawn its enduring vitality from some deep well of strength, and have had the capacity to renew that vitality from age to age. (Nehru 2004, 47)

For him, this myth about India is enshrined in her diversity and her elusiveness:

> India with all her infinite charm and variety began to grow upon me more and more, and yet the more I saw of her, the more I realized how very difficult it was for me or anyone else to grasp the ideas she had embodied. (2004, 51)

Nehru describes a country held together by a strong age-old cultural background out of which a common outlook emerges, which he calls 'the spirit of India' (2004, 52). He sees India as a country that is, on the one hand, defined by its diversity, but on the other, through a common cultural bond, retains a unity through a shared national heritage as well as moral values derived from popular philosophy, tradition, history, myth and legend. Nehru concludes:

> Some kind of a dream of unity has occupied the mind of India ever since the dawn of civilization. That unity was not conceived as something imposed from outside, a standardization of externals or even beliefs. It was something deeper and, within its fold, the widest tolerance of belief

and custom was practiced and every variety acknowledged and even encouraged. (2004, 55)

He maintains that, despite variety and diversity among the peoples of India, there is a quintessential Indian quality bonding them together and giving rise to a dream of unity, of cultural synthesis.[10]

*Midnight's Children* takes up Nehru's rhetoric and themes and pursues a similar argument about the idea of India as a collective dream that the Indian nation decided to dream and which is realised at the arrival of independence in 1947, then tracks its subsequent decline and betrayal by India's political elite, culminating in Indira Gandhi's declaration of a state of internal emergency in 1975. In *Midnight's Children*, the birth of the nation is associated with the mythic events of the past to highlight the magical hour of that birth, anticipated the night before in the mythic dreams and nightmares of the residents of Methwold Estate and the Sinai family (Rushdie 1995a, 111). This new myth is the collective dream of independent India:

> it was a mass fantasy shared in varying degrees by Bengali and Punjabi, Madrasi and Jat, and would periodically need the sanctification and renewal which can only be provided by rituals of blood. India, the new myth—a collective fiction in which anything was possible, a fable rivalled only by the two other mighty fantasies: money and God. (Rushdie 1995a, 112)

Saleem then turns away from these sweeping statements about the new nation, focusing on the microcosm of his family and his birth, sidelining the bloody riots and mass exodus brought on by Partition in Bengal and the Punjab.

While Amina is in labour, Saleem surveys different locations, not only in Bombay (Narlikar's nursing home, Colaba Causeway) but also his grandparents' home in Agra, before returning to the violence in the Punjab, 'the green flames of blistering paint and the glaring saffron of fired fuel, like the biggest dias in the world' (Rushdie 1995a, 115). Saleem contrasts sharply the optimism associated with the new myth of India with the many-headed monster of the crowd, in one location celebrating, in another butchering each other. Right at its inception, the reality of the new India unleashes dream-like images of hope and nightmarish images of despair. The positive and negative connotations of dreams in association with the Midnight Hour suggest from the start the fragility of the magical possibilities of that hour.

Saleem points out from the outset the precariousness of this new vision of India and that some of its citizens are excluded or peripheral within it. In this respect, it is interesting to note which historical events Rushdie chooses to feature and which to exclude from his novel. For instance, Rushdie marginalises the narrative of Partition, despite it being one of the most traumatic and pivotal events in the subcontinent's history. Yet, while these events may seem

sidelined, the nature and outcome of Partition are woven intricately into the fabric of the novel, both through imagery and through Mian Abdullah's Free Islam Convocation, which imagines a different alternative to the division of British India, and are strengthened further when considering *Midnight's Children* and *Shame* alongside each other.

## Interconnected Stories—*Midnight's Children* and *Shame*

In *Shame*, Rushdie presents Pakistan at an angle to reality, describing a fictionalised version of the country as a bleak dystopia, and overarching thematic links between the story worlds of *Midnight's Children* and *Shame* become apparent. They detail a cinemascope, widescreen angle of vision. Like *Midnight's Children*, *Shame* engages with ideas of nationhood, history and historiography, society and the individual, and the role of women in a patriarchal system. Central to the novel is the rivalry between a prime minister and a military leader, closely paralleling the rise and fall of Zulfikar Ali Bhutto and Zia-ul-Haq. Rushdie directly attacks both leaders' styles of government and, more broadly, Pakistani politics of the 1970s. Rushdie also focuses on migration and debates more incisively notions of home and homelessness, which he goes on to develop into the central themes of *The Satanic Verses*.

On many levels, *Shame* is a parallel narrative to *Midnight's Children* and relates to the Pakistan sections of the previous novel. Rushdie presents Pakistan and Karachi as the antithesis to Bombay and India, and the constant inventiveness and potential of regeneration he associates with India are absent in the representations of Pakistan. Rushdie stresses Pakistan's singularity rather than its multiplicity. Women play a central role in Rushdie's exploration of the theme of shame—*sharam*—and honour. Indeed, elements that would find their way into *Shame* were initially developed by Rushdie as an idea for a film (Rushdie Papers, Box 60, Folder 9). The novel is centred around women who attain mythic stature through their suffering, and these 'larger-than-life' characters are often constructed in filmic parameters parallel to the imagining of women in Indian popular cinema. Undoubtedly, *Shame* is a polemic fiction, a sharp indictment of the postcolonial state in decline and of the subcontinental patriarchal system where conceptualisations of shame and honour converge on the imagining of the feminine. Rushdie's female characters are instrumental in shaping the narrative and lead us to question different modes of representation and storytelling. Like *Midnight's Children*, *Shame* is a highly visual narrative and it borrows not only from cinematic representational styles, but also from India's oral storytelling traditions. Although its main narrative thrust centres on the postcolonial politics of Pakistan, the novel tentatively marks a shift in subject matter in Rushdie's fictional work away from a central preoccupation with the postcolonial nation state—India in *Midnight's Children*, a version of Pakistan in *Shame*—towards the former centre of Empire, a version of Britain in *The Satanic Verses*.

After *Shame*, Rushdie focuses his attention on transglobal migration and the position of the migrant as outsider in London and New York. However, in *Shame*, Rushdie begins to dramatise the difficult relationship between the migrant and the home he has left behind through the narrator's position in exile. In this respect, as Martine Hennard Dutheil de la Rochère points out, both *Midnight's Children* and *Shame* are 'the story of an impossible farewell' where 'each novel represents a new beginning, conceived of as a tentative departure from the past and the mother country' (1999, 23). *Shame*'s narrator is in exile, preoccupied by the need to come to terms with the place he has left behind. Not until *Fury* does Rushdie break that pattern.[11] Thus Rushdie dramatises identity negotiations associated with the process of migration through his detached narrator, a marked contrast to Saleem, whose self-delusional voice seems to have wrestled the storytelling process from his author. *Shame* can be read as Rushdie's attempt at finding an alternative strategy to those techniques in *Midnight's Children* with an author-narrator who holds the reins firmly in his hands and a peripheral, marginalised and sidelined hero, denied his own opinions and interventions.

### Inscribing Nationhood: Imaging Pakistan

The narrator of *Shame* judges Pakistan's myth of nation as a failure of the imagination—'a picture full of irreconcilable elements, midriffbaring immigrant saris versus demure, indigenous Sindhi shalwar-kurtas, Urdu versus Punjabi, now versus then: a miracle that went wrong' (Rushdie 1995b, 87). The narrator holds the country's political elite responsible for this failure and links it directly to the country's bloody birth as an independent nation resulting from the partition of British India into India and Pakistan. Yet myths of nation are interlinked to processes of writing history within nationalist movements. As the Bengali intellectual Bankim Chandra Chattopadhyay noted in the late nineteenth century, 'we must have a history' (quoted in Khilnani 1999, 159). By the 1920s, projects of writing a history for the Indian subcontinent became one of the main preoccupations of nationalist intellectuals (Khilnani 1999, 159), producing a variety of competing stories, all wrestling for authority. From this process, an Indian history emerged that was divided into Hindu, Muslim and British periods where the classic era of Vedic culture and the Gupta Empire, which lasted from the fourth to the seventh century, was portrayed as the defining historical moment of ancient Hindu India and where the Muslim period from the eleventh century was depicted as a period of decline that made the subcontinent vulnerable to British conquest (Khilnani 1999, 160). This extremely sanitised and skewed version of Indian history focused on a skilfully customised idea of Hinduism.[12] According to Khilnani, it emphasised 'territorial origin and broad cultural commonalities rather than ritual practices, caste exclusivities or particular gods' (ibid). This search for a seamless Hindu past, which to this day is conducted by

Hindu nationalist organisations such as the Rashtriya Swayamsevak Sangh (RSS), has had an important impact on the later stages of British India's move to independence, as these histories proposed and defined an exclusive and excluding definition of Indianness and made 'Hindu nationalism [ . . . ] a real mover in the agitation for Partition' (1999, 161). Khilnani proposes a different reading of the processes that led to Partition. He sees Jinnah's political project as a response to the more hard-line attitudes and actions of the Hindu majority and some elements within the Indian National Congress in the 1930s. Initially, Jinnah saw the Muslims of India forming a single community that co-existed alongside the Hindu community within a united, confederal India. It was not until the late 1930s that calls for a separate Muslim state gathered momentum. According to Khilnani, this coincided with an 'erosion of trust that fanned a desire to redescribe a "minority" within British India as a separate "nation", and to take it outside the boundaries of India' (1999, 163). A definition of Indianness with an exclusive sense of culture and historical past can, therefore, be seen as one of the decisive factors on the road to Partition and the creation of Pakistan, ultimately defined along ethnic-religious lines.

The historical narrative of Partition links *Shame* most explicitly to *Midnight's Children*. And an important marker is the inclusion in both novels of Rushdie's invented fictional film *Gai-Wallah*. In *Midnight's Children* Rashid, the rickshaw wallah, is on his way home from the cinema where he has seen the movie and emulates the antics of the star on screen while riding his bicycle. Spurred on by his enthusiasm for the action of the film, he saves Nadir Khan from the assassins who have butchered Mian Abdullah. In an aside in brackets, Saleem explains that the film addresses a mainly Hindu audience and is the cause of communal violence in Delhi, triggered by members of the Muslim League driving cows past cinemas to the slaughter house, who were consequently being assaulted (Rushdie 1995a, 50). Rushdie recycles this episode in *Shame* and the riots the film provokes in Delhi illustrate how divisive art can be. Furthermore, he highlights the wide reach of the mass medium of cinema among Hindu-Muslim communities. In *Shame*, the attack on the Empire cinema in Delhi, owned and managed by Bilquìs's father, becomes a metaphor for the dissolution of the Raj and the violence it engendered. Bilquìs and her father will not yield to threats and so have their livelihood burnt down, with a scorched Bilquìs emerging from the smouldering embers of the ruins as the victim, her eyebrows burnt and her clothes torn off by the hot wind that fanned the flames engulfing her father's cinema after the bomb goes off in the Empire. Homeless, Bilquìs survives without even the clothes on her back and becomes, along with a large part of India's Muslim community, a refugee. This episode occurs roughly at the same time as Amina Sinai witnesses the pre-Partition sectarian violence in Delhi in *Midnight's Children*, which further accentuates the interconnection between the texts. When the Empire cinema burns, the Muslim Amina Sinai transforms herself

into the spectre of Mother India, announcing her pregnancy to her predominantly Muslim neighbourhood to protect the Hindu Lifafa Das. At the same moment, her Muslim husband and his business partners are held to ransom by the Hindu Ravana gang.

So, repetition of the fictional cinematic text *Gai-Wallah* is a cross-over that not only signals the texts' relationship, but is also one which Rushdie deploys as an illustrative tool to explore the momentary madness that leads to horrific acts of violence, triggered by a film which, by all accounts, was meant as mere entertainment for its audiences. By reusing this episode Rushdie incorporates a narrative close-up of the violence in Delhi in the lead-up to independence and Partition, sidelined in *Midnight's Children* by Saleem's own self-important privileging of his birth. This link between novels gestures towards wider interconnections between Rushdie's fictional worlds and counterbalances the lack of narration of Partition violence in the earlier novel. For Bilquìs, this experience proves to be the defining moment of her life.

*Shame* details the birth of Pakistan and its journey from independence to the early 1980s. It centres around the fraught relationship between Iskander Harappa and Raza Hyder. A political thriller, the novel focuses on how the protégé displaces his mentor in a reversal of fortunes that turns the tables of power. The duel between Iskander and Hyder for political dominance has as its backdrop the national crisis triggered by the secession of Bangladesh in the political landscape of Pakistan. *Shame* climaxes in the aftermath of Pakistan's defeat and Bangladesh's independence, an event that also features prominently in *Midnight's Children*.

In *Midnight's Children* and *Shame* Rushdie portrays competing religious, cultural and national identities. In the former he imagines an alternative to Partition in the Free Islam Convocation. In the latter he presents the unitary vision of 'insufficiently imagined' Pakistan as a Muslim state that can only lead to annihilation. In both novels, he concludes his narratives of Pakistan with an apocalyptic explosion. While *Midnight's Children*, too, is an indictment of the politics of postcolonial India and the negative effects of Indira Gandhi's Emergency, the way the novel is written is the implicit counterargument to the bleak picture at the end, hinting at India's potential for regeneration and renewal. For Pakistan, Rushdie does not imagine a similar outcome; instead he concludes that the country and its citizens are trapped in a cycle of shame and shamelessness perpetuated by its political elite, which breeds violence and culminates in both novels in the explosion of Pakistan.

*Midnight's Children* and *Shame* portray Pakistan as a barren landscape. *Shame* maps out a country and political system which has closed in on itself and trapped the protagonists. Thus, as Aijaz Ahmad convincingly claims, the reader is confronted with a distinctive version of Pakistan: 'a space occupied so entirely by Power that there is no space left for either resistance or its representation; whoever claims to resist is already enmeshed in relations of Power and in the logic of all-embracing violences' (1994, 127). This has

a significant bearing on any writing of history as it is systematised into discourse, which leaves no room for individual resistance and which is only ever self-serving or futile. In this respect, the machine of history in the novel is totalising and all-encapsulating and does not allow for any form of meaningful resistance, which becomes clearer in my later discussion of Bilquis and Sufiya Zinobia. A 'history of all-encompassing Power' does not leave any room for the individual and becomes a violator in its own right as it excludes those who are powerless (Ahmad 1994, 130–131).

Ahmad's useful description of processes of historiography and the machinations of political power within a postcolonial context in *Shame* is analogous to Gayatri Spivak's conceptualisation of 'epistemic violence' that leads to an objectified construction of the other in the imperialist project and denies the subaltern colonial a place, space, role and voice outside distinctively defined prescriptive parameters. As Spivak concludes, 'between patriarchal subject-formation and imperialist object-constitution, it is the dubious place of the free will of the sexed subject as female that is successfully effaced' (1985, 144). Spivak talks about the colonial context when the positionality of women in nationalist discourse was contested. As Partha Chatterjee has shown in 'The Nationalist Resolution of the Women's Question' in relation to the Bengali Renaissance in the nineteenth century and debates around social reform, these concerns were crucial in determining the place of women within nationalist ideology and in opposition to colonial governance in British India: 'the resolution of the women's question was built around a separation of the domain of culture into two separate spheres—the material and the spiritual' (2001, 155). These deliberations are important for an understanding of *Midnight's Children* and *Shame* because nationalism on the subcontinent was not only about gaining independence from the British colonial power, but was also intertwined with an idea of independence that impacted on all aspects of the life of the people (ibid). In this respect, these views have shaped the position of women in India, Pakistan and Bangladesh in its gendered separation of responsibility for social space, split into home for women and world for men—*ghar* and *bahir* (Chatterjee 2001, 156). The nationalist project envisioned for postcolonial Indian women a pseudo-emancipation where a woman's femininity was fixed in terms of precise culturally visible spiritual qualities (Chatterjee 2001, 162). This spilt of spiritual home (the female domain) and the material world (the male domain) is all-pervasive in *Shame* and is one of the crucial determining structural devices of the novel. Furthermore it finds filmic representation in 1950s/60s Indian popular cinema. Rushdie returns to these concerns in the narrative argument of *The Moor's Last Sigh*, as Chapter 5 will highlight.

Rushdie develops a deep questioning of this discourse through his strong female characters. Are Sufiya Zinobia, Rani Harappa and the Virgin Ironpants examples of a possibility of resistance, or, as Bilquis and Omar Khayyam exemplify, is resistance futile in the face of an all-encompassing

power of the state that is rooted in an exclusionist patriarchal, religious, ethnic and nationalist discourse that justifies autocratic rule? Ultimately, the violating forces of history can only be countered by further violence, yet even this destructive force leads to nothing but annihilation. History in *Shame*, then, must be read as teleological, predetermined and closed to change, only a cycle of shifting power relations, interlinked by the shameful and shameless behaviour of a political elite.

## Filmic Narrativisation in *Shame*

The urge of *Shame*'s narrator to make visible what, especially to his Western implied readership, is invisible, is perhaps one of the imperatives for him to write his story using strikingly memorable images. *Shame* is a less self-consciously cinematic novel than *Midnight's Children*. The narrator, unlike Saleem, makes no recourse to a film vocabulary. However, we do once again encounter an intensely visual language in the narrator's descriptions, by intercutting scenes, throwing in elements of thriller, melodrama and comedy, leading to the final showdown in 'Nishapur', worthy of any 1970s Bombay masala film. The novel makes very interesting use of flashback, a staple of Rushdie's writing—*Midnight's Children* is entirely told in flashback, so is *The Moor's Last Sigh*—and the constant time-shifts in the narrative counter attempts at linear storytelling. The narrator often anticipates, similar to a movie trailer, events that have happened, but should not yet be narrated. He repeats the same event from different perspectives, emulating different camera angles focused on the same event, creating simultaneity as well as suggesting how, in the process of retelling, what is considered 'truth' can alter. This is especially apparent in the doubly narrated execution of Iskander Harappa, but also in Bilquìs's story during the Partition riots in Delhi. These devices work as conscious disruptions which force the reader to question the reliability of the narrator's perspective.

The connection to the world of cinema is most overtly dramatised through Bilquìs, daughter of a Delhi cinema owner who, influenced by her staple diet of cinema viewing, displays all the qualities and tantrums of a film starlet. There seem to be echoes of Pia Aziz in Bilquìs, yet she cuts a much more tragic figure, more akin to the actress Meena Kumari, popularly known as the 'tragedy queen'. Trapped in her roles as daughter, wife and mother, the way in which Bilquìs acts these out resonate with their representation in Indian popular cinema. For example, the courtship of Bilquìs and Raza is narrated with the coyness of a Bombay film melodrama against the backdrop of the violent upheaval of Partition. Mahmoud Kemal, nicknamed Mahmoud the Woman, is the owner of Empire Talkies, a 'rut putty' cinema in Delhi, and Bilquìs is the maharani of this Empire where the big screen dramas provide momentary respite from the harsh realities of the outside world (Rushdie 1995b, 60). However, for Bilquìs, film viewing is a character-

forming experience: 'And in the darkness of his Empire, night after night, she studied the giant, shimmering illusions of princesses who danced before the rackety audience beneath the gold-painted equestrian figure of an armoured medieval knight' (Rushdie 1995b, 61). Bilquìs and her life are thrown off course by the communal violence of which she is a victim. She becomes a tragic heroine in the melodramatic sense as her husband sacrifices his love for her for his ambitions. In spite of his neglect, however, she remains the dutiful wife. Yet mentally she seems to disintegrate further and further as the novel progresses and her husband attains more power. She fades away and turns into a ghost of her former self. Bilquìs's fate is her submission to Raza Hyder, which leads to the effacement of her own selfhood. Bilquìs, the maharani of the former Empire cinema who worshipped the silver screen, becomes a faded figure who haunts the presidential palace in Islamabad. A queen without power, she discovers the hollowness of life:

> Things had been chipping away at Bilquìs for years, [ . . . ] but the worst thing of all was to be there, in that palace, that queenly residence of which she had always dreamed, and to discover that that wasn't any good either, that nothing worked out, everything turned to ashes. (Rushdie 1995b, 208)

This crushing realisation that nothing around her can flourish and her deep-seated disillusionment leads her to further self-effacement, as she starts to wear a black burqa in her own home. Her retreat from life is mirrored in her speech, which becomes cloaked in metaphor; she 'became less than a character, a mirage almost, a mumble in the corners of the palace, a rumour in a veil' (Rushdie 1995b, 209).

Rani Harappa, on the other hand, bears the infidelities of her husband by engaging herself stoically in her needlework (Rushdie 1995b, 152). Rani has earned her self-respect through her dignified and honourable conduct in the face of her husband's shameful behaviour, leading the narrator to contrast them as follows:

> both women had husbands who retreated from them into the enigmatic palaces of their destinies, but while Bilquìs sank into eccentricity, not to say craziness, Rani had subsided into a sanity which made her a powerful, and later on a dangerous, human being. (ibid)

The narrator reveals further parallels. Hyder replaces Iskander as leader, Rani and Arjumand are kept under house arrest, and Bilquìs is shut away by her husband for fear of her embarrassing, shaming him. Rani immortalises the memory of her husband in her embroidery of eighteen shawls, which become her legacy to her daughter in an attempt to account fully for her husband's life:

> Eighteen shawls locked in a trunk: Rani, too, was perpetuating memories. Harappa the martyr, the demigod, lived on in his daughter's thoughts; but no two sets of memories ever match [ . . . ] An epitaph of wool. The eighteen shawls of memory. [ . . . ] Rani would put a piece of paper inside the trunk before she sent it off to her newly powerful daughter. [ . . . ] [H]er chosen title: 'The Shamelessness of Iskander the Great.' And she would add a surprising signature: *Rani Humayun.* Her own name, retrieved from the mothballs of the past. (Rushdie 1995b, 191)

The shawls are tableaux of the career of Iskander Harappa. In the act of sewing, Rani is performing some kind of exorcism, banishing the oppressive burden put upon her by becoming his wife and, in the process, reclaiming her selfhood and possibly setting herself free. Rani channels her own fury into her embroidery, thereby expressing artistically what Sufiya Zinobia, Hyder's and Bilquìs's daughter, articulates through outbursts of violence.

Arguably then, in *Shame* art becomes an expression of a feminine regenerative possibility, even in the face of hopeless desolation and desperation. Rani's embroidery most crassly shows the opposition of imagination and reality, of art and politics (see also Rushdie 1992a, 122). The fact that Arjumand rejects her mother's gift of the trunk with the shawls is insignificant, as it has allowed Rani to recuperate her name and the sense of self that Iskander had denied her by consigning her into prescriptive gendered roles in the private space of the family home at Mohenjo. Her embroidery is her way of unravelling the fabric of her life in which Iskander, whom the narrator describes as the assassin of possibility, is immortalised on a cloth in all his debauched shamelessness (Rushdie 1995b, 194). Empowered by her own artistic vision, she is the contrasting counterpoint to Bilquìs.

Like Sufiya, Bilquìs becomes a version of the madwoman in the attic. Bilquìs sewing shrouds is perhaps a similar attempt to Rani's to regain a sense of self, but it is doomed to failure. Bilquìs is only sewing veils, which allow her and her husband to escape, but firmly enshrine her retreat from public life and mark the erasure of her self.

The political rivalry between Hyder and Harappa adds another tragic dimension to the narrative, the former initially being the protégé of the latter and then, in a reversal of fortune, the protégé becoming the executioner. Obvious parallels can be drawn here between Bhutto and Zia but, for the novel itself, the grotesque tragedy of their relationship is more significant. Their story is one of betrayal, culminating in the final resolution of their struggle in Iskander's execution—which later finds a perverse doubling in the three sisters' execution of Raza Hyder, cut to bits in the dumbwaiter in 'Nishapur'. For Sara Suleri the novel is a soap opera, a television miniseries where the story of Bhutto/Harappa and Zia/Hyder is devoid of all resonance. In this respect, she argues, '*Shame* is perhaps best described as a televised narrative, fully equipped with commercial interruption and a will

to remote control' (2005, 182). Rushdie presents a tale where the career of both politicians is narrated as a power struggle in elite and family circles and the true failure of the novel is its incapability of addressing the obvious question: 'Why did such powerfully secular figures exert considerable influence over their Muslim constituencies?' (Suleri 2005, 182–183). Suleri continues: '*Shame* censors the curiosity of its own story, relying instead on the more lurid language of feud and vendetta' (2005, 183). She makes an important point, drawing attention to the fact that *Shame* does not answer the crucial question for Pakistan, which is an obvious flaw. Though Rushdie is aware of the effects this power struggle has on the country, he is ultimately more interested in the rivalry of both men and their to-the-death struggle for power. In a 1985 interview with *Scripsi*, Rushdie offers his own reading of the Zia-Bhutto relationship:

> Zia was entirely Bhutto's creation. He made him out of nothing on the grounds of his stupidity. Then you get this bizarre relationship where the protégé becomes the executioner. *That* is what I wanted to write about because it's at the same time a tragic and comic relationship—the situation is tragic but the figures are comic. Zia is a kind of menacing comic grotesque and it seemed to me that here was a Shakespearean tragedy in which all the roles were cast with second-rate music hall comics [ . . . ] I would write a book whose story was more or less unrelieved tragedy but I would write it as a farce. (Rushdie 1985a, 108–109)

His description of *Shame* as 'unrelieved tragedy' written as farce creates the distinct impression of a Bombay B-movie. Bilquìs transforms from the vampish heroine into a deranged tragedienne of a mother who loses not only the love of her husband, but also has to bear the shame of a still-born son and an insane daughter who takes the place of the first-born child. Rani Harappa, too, is another of the long-suffering mother figures, with a daughter who wants to be a boy, and, as Iskander's wife, she has to bear her husband's affairs, debauchery, corruption and humiliations. Both are women who are devoid of agency, but accept their prescribed roles. Within these oppressively restrictive parameters they rescue some kind of dignity, Rani in her stoic embroidery, Bilquìs in her sewing of shrouds.

## *Laj, Izzat* and *Sharam*—Sufiya Zinobia

The scope of *Shame*'s politics, argument and engagement with the role of women within conceptualisations of nationhood are summed up by the narrator's introduction of Sufiya Zinobia (Rushdie 1995b, 59), the only female character to attain some form of agency. Yet the representation of her actions is problematic, considering Sufiya is mentally impaired and not aware of them. Sufiya as the personification of Shame becomes the corporeal embodiment of the title of the

novel. However, as Aijaz Ahmad has highlighted, the conceit of her mental illness—at the age of nineteen she has the mental capacity of a six-year-old due to her contracting a brain fever as a child—is tricky. Ahmad writes: 'the problem with this metaphor of mental illness is that the pressures and processes of gendering [...] are given to us in the form of a *physiological* insufficiency on *her* part' (1994, 145, original italics). I agree with Ahmad that this is a major shortcoming in the novel's argument as it rejects any possibility of redemption, despite the fact that the violence produced by the co-joining of shame and shamelessness through the union of Sufiya Zinobia and Omar Khayyam Shakil is meant to be exactly that. Rushdie's own criticism of Terry Gilliam's film *Brazil* (1985) can, therefore, equally apply to his dystopian Pakistan in *Shame*:

> it is too easy [...] to create a dystopia in which resistance is useless; that by offering only token individual resistance to the might of the state one falls into a sort of romantic trap; that there has never in the history of the world been a dictatorship so overpowering that it became impossible to fight against. (Rushdie 1985b, 52)

The problem is that, as *Shame* progresses, the concept of shame is more and more detached from the woman Sufiya. The representation of Sufiya and her actions in their grotesque brutality and sexual violence bred by her mental deficiency is contentious as it strikes the reader as misogynistic. Yet, this misogyny is inherent and all-pervasive in the system Rushdie describes in his fictionalised Pakistan, where women are denied political agency in the public sphere and become mere tokens in manly displays of honour and shame.

Both *Midnight's Children* and *Shame* engage with the conceptualisation of a code of female honour formulated in patriarchal-sexual terms. The trope of Mother plays an important role in developing this, highlighted in the transformation of Indira Gandhi from benevolent Mother to Widow, as well as in the metamorphosis of Naseem into Reverend Mother in *Midnight's Children*. In *Shame*, mother figures are marginalised and sidelined yet, crucially, they appropriate the narrative in their own right. And *Shame*, like *Midnight's Children*, needs to be read with the tropes of Mother and Nation in mind, as both indicate how central the conceptualisations of gender are to the social imaginary that constitutes nationhood. Rushdie already makes evident the formative role women play for nationalist subjectivities. Jamila Singer's transformation from brass monkey to daughter of the nation of Pakistan through her singing, but also the recognisably codified role she chooses to adopt, illustrates this most potently. As Nalini Natarajan observes in her essay 'Woman, Nation, and Narration in *Midnight's Children*', within these conceptualisations, the female body 'becomes a focus for the symbolisms of cultural and religious reaction' (2003, 171).[13] Here, any sense of empowerment is premised on women's adoption of patriarchally codified roles, thus putting their actual and perceived power into question.

*Shame* shows the other side of the argument inherent in the story of Jamila Singer. *Midnight's Children* chronicles a myth of nation in decline. In *Shame*, nation is not mythic, but insufficiently imagined. The dream image of woman as a unifying principle of the nation where all her dharmic virtues come together is shown as absurd as it transforms into a nightmare spectre, with Partition and war exposing a much more realistic image of women, no longer idealised but victimised by the brutal realities of their lives (see Natarajan 2003, 177). Jamila Singer sacrifices herself to the idea of nation, giving her voice to Pakistan, but veiling her self with a burqa.

She escapes, in the end, into the sisterhood of a convent, retreating from her official role as the veiled embodiment of the state. Sufiya Zinobia, on the other hand, bursts out of her seclusion as an avenging angel, challenging the position women are forced into, no longer posing as dutiful daughter and wife. Sufiya's stirring violence is uncontrolled and uncontrollable; it is demonic, gruesome, perverse and unconscious, presented as acts of irrational outrage. Sufiya should therefore be read as the embodiment of more than shame, that of fury, acting for the marginalised women—humiliated Bilquìs Hyder, sexually crushed Naveed, betrayed Rani Harappa. She works in unison with the other furies, the three Shakil sisters, who avenge the loss of their second son by executing Hyder, and one might therefore see Sufiya's destructive impulse as a form of Shakti and her transformed self as the embodiment of Kali. The violence inflicted by Sufiya is empowering through what it denies; as the men in the novel deny female power, they enrage the wrath of Kali and she unleashes her destruction. The analogy might also be apt, because Shiva was the only one who could tame Kali and she is often depicted dancing on his dead body, which seems to echo the ending of the novel. In the final union with Omar Khayyam, Sufiya annihilates history as real time and mythic time collapse into the abyss. Sufiya becomes an emblem for the shame of women, blushing for being 'the wrong miracle', which the narrator contrasts

*Figure 2.2* Jamila (Soha Ali Khan) performing for the Pakistani elite in the 2012 film adaptation.

with Arjumand Harappa, the 'Virgin Ironpants', who is ashamed of being female, trapped and constrained by her sexuality: '"This woman's body," she told her father on the day she became a grown woman, "it brings a person nothing but babies, pinches and shame"' (Rushdie 1995b, 107).

It could be said then that Sufiya embodies female fury. As the narrator explains, he based the character of Sufiya Zinobia and the violence that shame engenders in her on two actual incidents, firstly an honour killing in the East End of London, where a Pakistani father killed his daughter because she had a white boyfriend, and secondly, a racist attack on a young woman on the London Underground, which she was too ashamed to report to the police.[14] Both stories outline the connection between honour and shame; in so doing they illustrate why the figure of Sufiya Zinobia overshadows the whole novel:

> We who have grown up on a diet of honour and shame can still grasp what must seem unthinkable to peoples living in the aftermath of the death of God and of tragedy: that men will sacrifice their dearest love on the implacable altars of their pride. (Rushdie 1995b, 115)

This also links the novel to the pogroms during Partition where men from one religious community would kill their own daughters and wives in desperate attempts to protect their honour, rather than risk them being assaulted by members of other religious communities. The narrator maintains: 'Between shame and shamelessness lies the axis upon which we turn [ . . . ] Shamelessness, shame: the roots of violence' (Rushdie 1995b, 115–116), and goes on to underline the connection between the three concepts with one of the novel's most powerful images:

> Wanting to write about shame, I was at first haunted by the imagined spectre of that dead body, its throat slit like a halal chicken, lying in a London night across a zebra crossing, slumped across black and white, black and white, while above her a Belisha beacon blinked, orange, not-orange, orange. I thought of the crime as having been committed right there, publicly, ritually, while at the windows eyes. And no mouth opened in protest. [ . . . ] And the father left with blood-cleansed name and grief. (Rushdie 1995b, 116)

Is Sufiya Zinobia the narrator's way of recuperating the lost voice of that murdered girl? Sufiya transforms into a silky seductive beast, the spectre of a white panther that rips off its male victim's head and pulls up his entrails through his throat. Sufiya is Shame's avatar, mutating into the exterminating, avenging angel as she becomes instrumental to the narrative in the imaginary depositioning of the despotic Raza Hyder.

Rushdie imagines a violent resolution, a disillusioned dissolution of his fictional Pakistan. Raza Hyder, Bilquìs and Omar Khayyam are violently

butchered in 'Nishapur'. His wife Sufiya Zinobia prowls towards her husband, readying herself for the apocalyptic union of shame and shamelessness, Kali dancing on her Shiva's body. As 'Nishapur' explodes, the reader is presented with a mythic outburst of violence that springs from a long history of humiliations. The violence brought about by such persecution is seen by the narrator as redemptive and cleansing. However, while Omar Khayyam, by giving himself to his wife even though he knows it means his death, might be redeemed, the explosion of 'Nishapur' suggests that redemption might be an impossibility for the world at large (see also Ahmad 1994, 145). The ending could, then, be read as an admission of imaginative failure, of the narrator's incapability of finding an idiom with which to express any concept of shame. Indeed, as Sara Suleri argues, 'the reader too is forced to read the text's vision of apocalypse from the point of view of a male terror as it watches the bestiality of the approaching female' (2005, 187). In this respect, the cinematic details of the final scene are focalised entirely through a male voyeuristic gaze.

Rushdie returns to the redemptive power of violence in *The Satanic Verses*. Salahuddin Chamchawala, the perfect mimic man, morphs into a devilish beast, the stigmatised and demonised migrant in Thatcher's Britain, and transforms back into a human being in the Hot Wax Club after the beast is exorcised. However, *The Satanic Verses* marks a shift from the redemptive power of violence to that of love, as Salahuddin reclaims his sense of self in the arms of Zenat Vakil. In *Shame*, Rushdie imagines a tragedy acted out by characters devoid of any tragic stature where the symbolic landscape of Pakistan becomes nothing more than a barren wasteland.[15] *Shame* examines the role of women within discourses of nationalism, which explicitly link the novel to similar explorations in *Midnight's Children* and *The Moor's Last Sigh*. Rushdie develops such considerations in the context of how women participate in the public sphere and, in these instances, the stereotyped, gendered roles women play in Indian popular cinema provide numerous templates for him.

## *Filmi* Clichés and *Midnight's Children*

The novel reflects heterogeneity in the mixture of genres on which Rushdie draws, bringing together different narrative elements from a variety of popular media. Thus, as Martin Zerlang notes, 'Entertainment is key to the understanding of *Midnight's Children*' (2004, 110). This is realised in the filmic picturisation of the novel's sweeping family melodrama, its panoramic landscapes of Kashmir, the Indo-Gangetic plains, the cityscapes of Amritsar, Delhi, Dhaka and Bombay, the aural/oral/verbal entertainment of Saleem's power of description and storytelling inventiveness. Saleem finds a language with which to evoke powerful images for his audience and, in this respect, he is not merely concerned with telling the story but with visualising the tale.

Saleem's moral code is shaped by Indian popular cinema and is intricately tied to his relationship with his mother and its Oedipal undertones, and his film starlet aunt, who provides for Saleem his moment of sexual awakening. Aunty Pia is married to his uncle Hanif, who works as a film director and who tries to combine a commercial aesthetic with social-realist subjects, a project in which he fails. Free of Reverend Mother's influence, he follows his dream to make his name in movies. As a young director, Hanif devises the indirect kiss for his film *The Lovers of Kashmir*, introducing the erotic into his films through suggestion in order to avoid censorship (Rushdie 1995a, 142). Saleem replicates this device when he narrates the meeting between his mother and Nadir Khan, her former husband, in the Pioneer Café, observing their courtship through the dirty window outside the café, which transforms into his cinema screen. The incident when Saleem discovers what he presumes is her infidelity and betrayal of his father is one of the most filmic moments and also finds its way into the 2012 movie adaptation. In the novel, Saleem follows his mother by hiding himself in the boot of her car and likens their love scene to a cheap replica of the one in his uncle's film:

> Unable to look into my mother's face, I concentrate on the cigarette-packet, cutting from two-shot of lovers to this extreme close-up of nicotine. [ . . . ] [W]hat I'm watching here on my dirty glass cinema-screen is, after all, an Indian movie, in which physical contact is forbidden lest it corrupt the watching flower of Indian youth; and there are feet beneath the table and faces above it [ . . . ] faces tumbling softly towards faces, but jerking away all of a sudden in a cruel censor's cut. (Rushdie 1995a, 216–217)

Ten-year-old Saleem takes on the guise of a camera and director, further complicated by the fact that this scene is relayed to us by his thirty-year-old self writing down the story in the pickle factory. The censorship and editing of the scene is his own and is premised by his confusion over his mother in the role of a lover. Before Saleem slips back to the car to stow away in the boot again, he witnesses this 'movie's' climax as his mother passes a glass of lassi over to Nadir, imitating the indirect kiss and the subliminal eroticism of Hanif's film (Rushdie 1995a, 217).

The cinematic theatricality of the novel and its larger-than-life characters are all rooted in a specifically Hindi-film cinematised popular cultural idiom which, focalised through Saleem, Rushdie uses for the plotline as much as the structure of the novel. For example, Saleem makes recourse to this kind of dramaturgy in the narrative framing of the discovery that his blood group does not match either of his parents':

> I leave you with the image of a ten-year-old boy with a bandaged finger, sitting in a hospital bed, musing about blood and noises-like-claps and

the expression on his father's face; zooming out slowly into long-shot, I allow the sound-track music to drown my words, because Tony Brent is reaching the end of his medley [ . . . ]

(Fade-out) (Rushdie 1995a, 237)

Saleem strategically deploys filmic devices (long-shot and fade-out) here and follows his summary of events with a slow-moving end to this scene, the future uncertain. He further accentuates the filmic nature of this passage by underscoring it with a soundtrack, Tony Brent's rendition of 'How Much is that Doggie in the Window', before Saleem drowns himself out with 'Good Night, Ladies'. Rushdie mixes here filmic visualisation with the storytelling drive of the novel. Following this episode, Saleem is exiled from the family home to his film director uncle and movie star aunt. Important for Saleem's own story is his musing on mutilation and fragmentation. The cracks that are appearing are, after all, a visual realisation. As he reminds us, they are not metaphorical cracks that afflicted his grandfather, foreshadowing his mutilated, severed finger, the loss of his hair and the '-ectomies' in the Widow's Hostel. Saleem's mutilations need to be understood in conjunction with the visualisation of his story through the perforated sheet, shifting between the full panorama and the intensely private close-up. In this passage, then, the narrative is suspended in time and becomes rooted in the moment—a moment charged with the Hindi-film-style melodrama of a father rejecting his son, presuming his wife's unfaithfulness, when she has been virtuous all along.

His stay with his aunt and uncle further heightens the *filmi* nature of the novel since, deprived of starring roles, Pia Aziz has turned her real life into a feature film, where Saleem is cast in supporting roles opposite her, his favourite being that of son to her mother (Rushdie 1995a, 240–243). A clear image emerges here, where Saleem processes his relationship with the women in his family—his mother, his aunt, and later his sister with whom he falls hopelessly in love—through the idiom and societal tropes of Indian popular cinema. However, for the reader the inherent irony is not lost when considering, for example, Saleem's obsession with wreaking revenge on his mother, rather than defending her honour. Hanif and his aesthetics, too, serve to subvert the Hindi film idiom on which the novel relies so much. Deciding to dispense with fantasy, instead Hanif favours substituting it for realism, vehemently arguing against 'the entire iconography of the Bombay film' (Rushdie 1995a, 244). Saleem, aware of his mythic-magical abilities, realises the tension between fantasy, myth and reality, and tries to hide his embarrassment before his uncle. Saleem is conscious how he needs to modulate these elements in his story, which is where Indian popular cinema provides him with a useful set of tools and devices—though, as he comes to realise, these too have their limits.

The heightened emotions of these filmically narrated scenes serve the purpose of propelling the narrative forwards and underpinning the novel's

tensions between the mythic and the real. In this respect Indian popular cinema develops into an important narrative strategy and trope. For Saleem, cinema is a central metaphor for the negotiation of his shifting perception of reality, truth and history:

> Suppose yourself in a large cinema, sitting at first in the back row, and gradually moving up, row by row, until your nose is almost pressed against the screen. Gradually the stars' faces dissolve into dancing grain; tiny details assume grotesque proportions; the illusion dissolves—or rather, it becomes clear that the illusion itself *is* reality. (Rushdie 1995a, 165–166)

This movement up the seat rows mirrors the narrative trajectory of the novel and reaches its climax in the Widow's Hostel in Benares when, after the forced sterilisations he endures, he and his audience find themselves in too close proximity to the cinema screen. This move to the front of the cinema is particularly relevant in the context of the adult Saleem's experiences in Book III. Saleem Sinai suffering from memory loss after his family is wiped out can be read as the partial erasure of his self, becoming dissociated from history, just living in the present moment. The only remaining link he maintains with his past is the silver spittoon. The erasure of self is marked by the shift from a first-person narrative to the third person. Thus the narrative becomes detached from Saleem as he becomes detached from his self. Saleem also connects his amnesia with the Bombay talkie:

> With some embarrassment, I am forced to admit that amnesia is the kind of gimmick regularly used by our lurid film-makers. Bowing my head slightly, I accept that my life has taken on, yet again, the tone of a Bombay talkie; but after all, leaving to one side the vexed issue of reincarnation, there is only a finite number of methods of achieving rebirth. So, apologizing for the melodrama, I must doggedly insist that I, he, had begun again; [ . . . ] To sum up: I became a citizen of Pakistan. (Rushdie 1995a, 350)

In his amnesiac state, Saleem detaches his self from himself for his journey through the horror of the war of secession of East Pakistan. The horrific events and descriptions are reminiscent of the Vietnam War movies of directors like Oliver Stone or Francis Ford Coppola. Saleem points out that amnesia might be a melodramatic cliché, but it serves the purpose of his story, so has no problem using it. Here Saleem plays with the camera lens and shifts focus and perspective, switching from first- to third-person narration to offer, on the one hand, a depersonalised and detached account of the horrors of the Bangladesh war. On the other, Saleem uses amnesia, so often a plot device in Indian popular cinema, as a specific conceit to reorientate his character and open up new directions, including his return to India. Interestingly, Saleem

gives up his Indian citizenship and plays on the irony of the meaning of the name Pakistan, the 'Land of the Pure'. After all, through his sexual longings for his sister Jamila as well as his search for sexual experiences in the redlight district of Karachi, Saleem has entered a state of impurity. His amnesia, his horrific experiences of guerrilla warfare and his adoption of Pakistani citizenship could then be read as a purgatorial journey, a cleansing process Saleem needs to go through so that he may regain his sense of self. Therefore, the Bombay talkie cliché of amnesia transforms into a specifically ironic device and offers for Saleem a narratorial technique to describe how, in the absence of family, his sense of self is erased and remade. Ultimately, Saleem needs to re-establish himself in a community with familial affiliations, which he finds in Parvati the Witch, another Midnight's Child, and later his ayah, who enable him to remake family beyond blood ties to recuperate a sense of stability.

## Family Matters

Family is a microcosm of the nation and plays a central role in the imagining of nationhood in the novel. As much as being tied up with Indian history, Saleem also links his story to that of his family, and the importance of the Aziz/Sinai clan is established early on (Rushdie 1995a, 14). Family is also a central aspect of Indian popular cinema, reflecting its significance in the social fabric of the Indian nation. The role of mothers and fathers, grandmothers and grandfathers, brothers and sisters and daughters and sons, often defined in patriarchal sexual terms, have a bearing on the moral conceptualisations on which Saleem pronounces. Saleem channels these through melodrama where the family unit becomes a microcosm on which nationhood is mapped. Yet this is not without irony, especially since Saleem is of multiple parentages and deliberately blurs the notion of traditional family values.

Family and dynasty figure prominently in Indian public life, for instance the Nargis/Dutt, Kapoor or Bachchan families in the Indian film world, or in politics, where Indira Gandhi stepped into her father's shoes and became prime minister, grooming her son Sanjay to succeed her. As Rushdie sees it, the close relationship between mother and son was at the root of the autocratic policies of the Emergency and the free rein given to Sanjay and the Congress Youth Movement he headed. Though *Midnight's Children* is clearly an intricately interwoven family saga and historical epic, Saleem's own conceptualisation of it is loose as he seeks to remake kinship ties in his renegotiation of belonging and home. While family is paramount for Saleem, by collecting a string of father and mother figures, he destabilises the conceptualisation of family in the social fabric of India. The novel investigates family as a societal trope, which can be set up in the public sphere as dynasty, a theme Rushdie returns to in subsequent novels, especially in *The Moor's Last Sigh*.[16] In his introduction to Tariq Ali's *The Nehrus and the Gandhis: An*

*Indian Dynasty*, Rushdie states that, by the time of Indira Gandhi's assassination in 1984, the Nehru-Gandhi family had been completely mythologised, the trials and tribulations of the clan becoming an ever-engrossing saga and obsession: 'we dreamed them, so intensely that they came to life' (Ali 1985, np). Rushdie surmises:

> In this version—the dynasty as collective dream—Jawaharlal Nehru represents the dream's noblest part, its most idealistic phase. Indira Gandhi, always the pragmatist, often unscrupulously so, becomes a figure of decline, and brutal Sanjay is a further debasement of the currency. (ibid)

Rushdie suggests that the crucial relationships in the Nehru-Gandhi family have always been between parents and their children—father and daughter, mother and son respectively—and it is upon this rock that the attraction of dynasty-as-myth relies (ibid).

Many rumours have contributed to India's first family transcending into myth, aided by a number of factually recorded scandals.[17] Sometimes the trials and tribulations of the clan read more like the ingredients of a soap opera fuelled by a never-ending stream of gossip (ibid); Rushdie writes that 'the story of the Nehrus and the Gandhis has provided more engrossing material than anything in the cinemas or on television: a real dynasty better than *Dynasty*, a Delhi to rival *Dallas*' (ibid). This process has also been aided by one of self-mythologisation, reflected in Indira Gandhi's election slogan 'India is Indira and Indira is India', in which she sets herself up as the embodiment of the state and the land, Mother Indira as Mother India. Through the election slogan Indira Gandhi casts herself as a protean, nurturing Mother India, exploiting the image of the Hindu Mother goddess and her symbols and the idea of *shakti*. *Midnight's Children*, in its representations of motherhood and Indira Gandhi as the Widow, provides a countermyth to the self-mythologisation of the Nehru-Gandhi dynasty.

Rajeswari Sunder Rajan's observations in *Real and Imagined Women: Gender, Culture and Postcolonialism* are useful here in unpacking further Rushdie's hard-hitting critique of Indira Gandhi as 'Mother India/Indira'. Her argument focuses on two aspects—the conceptualisation of subjectivity and the issue of power. She argues that, in an identification such as 'India is Indira', 'the female subject is no longer perceived in metonymic relationship to the nation, as its leader, but as an actual metaphor for it, its equal and its visible embodiment' (1993, 109). According to Sunder Rajan, in this representation the female leader can 'reconcile aspects of nurturing and service in opposition to the authority of the father, as well as to subsume both parental figures into a single complex authority figure' (ibid). As mythic and symbolic precedents already existed and were rooted in the people's consciousness, Indira Gandhi only needed to tap into and remake them for a modern context. The dynastic familial element is of considerable importance here. Indira Gandhi herself

used every opportunity to flaunt her actual Nehru identity as daughter, as well as her symbolic maternal concern for the people of the nation, and the two were intertwined. Similarly, Rajiv Gandhi stressed during the 1985 election campaign 'I am her son, she was my mother'. Thus, as Sunder Rajan points out, 'gendered family identities—especially motherhood—are culturally capable of sustaining metaphoric expansion to embrace dimensions of leadership' (1993, 110). Arguably, the 'Mother India' trope, which will be explored further in Chapter 5, became instrumental for Indira Gandhi in this regard and *Midnight's Children* must be read as a hard-hitting critique of this image.

## The Self-Deception of Memory, the Consolation of Memory

Saleem's story is a narrative from memory, a memory that is affected by Saleem's own physical disintegration. Rushdie concretises the fragmentary nature of memory and its inherent unreliability, raising further questions about Saleem's method of writing and why he feels the urgent need to record his version of events. Is Saleem deceiving himself by writing his story? Is he, through the act of writing, ultimately fighting only his fear of meaning nothing? Or, alternatively, does writing provide consolation? He can after all reconnect in his imagination with his family, Parvati the Witch, the Midnight's Children and reclaim his lost home city, Bombay.[18] Saleem's process of narration and the consolation it can provide is linked to memory and remembering as well as forgetting. The connection between these two aims might seem paradoxical, but Saleem defends his story:

> 'I told you the truth,' I say yet again, 'Memory's truth, because memory has its own special kind [ . . . ] but in the end it creates its own reality, its heterogeneous but usually coherent version of events; and no sane human being ever trusts someone else's version more than his own.' (Rushdie 1995a, 211)

Saleem only offers a version of facts, his account of his family's and his own life, which is bound together with the history of the subcontinent through the accident of his birth. This strategy is perhaps a safeguard for Rushdie so that the book is not read merely as an exotic guide or history book that pronounces on post-independence India.

Saleem makes errors—some are intentional, others are not only those of Saleem but those of Rushdie as well, as he admits in '"Errata": Or Unreliable Narration in *Midnight's Children*'. One can be found in the description of the Amritsar Massacre, where General Dyer enters the Jallianwala Bagh followed by 'fifty white troops'—the order to shoot was given to Indian troops (see Rushdie 1992a, 23). Any trained historian like Rushdie would be annoyed by his own oversight, but in the hands of Saleem such errors take on different meaning in his drive to tell his story, his attempt at making

sense of what has happened to him during his eventful life, a last quest to conquer his fear of absurdity. Truth and historical accuracy need to be subservient to his desire, where truth falsified through memory transforms into his personalised version of events. These errors raise the reader's suspicions, alerted to Saleem's distortions to a greater or lesser degree by himself. On the discovery of the error in chronology regarding Mahatma Gandhi's death he surmises: 'Am I so far gone, in my desperate need for meaning, that I am prepared to distort everything—to re-write the whole history of my times purely in order to place myself in a central role?' (Rushdie 1995a, 166). His exaggerations grow increasingly elaborate the more he realises that he is peripheral and not central to the events of his country.

The novel develops an interesting argument about history, where facts are not readily established and are open for interpretation in different ways. Rushdie proposes that Saleem's unreliable narration might be a useful analogy, a reflection, of our own attempts to 'read' the world. Rushdie's argument is not entirely persuasive. Harish Trivedi has accused Rushdie of not having done his homework properly and many of his Indian readers have pointed out to Rushdie the numerous errors in the book. In 'Salman the Funtoosh: Magic Bilingualism in *Midnight's Children*' Trivedi argues that, in appearance as in speech, Rushdie's sense of cultural hybridity is more dramatic and performative and not fully meditated and realised (1999, 69–94).

However, the serious questioning of the pitfalls of memory and the process of remembering in conjunction with that of historiography politicise Rushdie's argument and significantly complicate it. Saleem's unreliability undermines the official version of history through a process of continual contestation. So, while history might be the scaffolding around which the narrative of *Midnight's Children* is built, Saleem plays with established facts to offer his personalised version of history, each chapter dealing with an important episode in Indian history. Saleem likens this to pickling, giving further meaning to the framing narrative, which situates Saleem writing his life story in the Braganza pickle factory under the auspices of Padma. Padma and Saleem both disrupt the linearity of the narrative and, through their interruptions, further upset the flow of the story. This is ironic insofar as Padma continually insists on Saleem telling a straightforward tale, rather than constantly digressing, over-cramming it with, in her view, unnecessary details. Beyond Rushdie's own admission of factual errors lies a deeper engagement with not only historiography and memory but also a process of reclamation, similar to the one in which Dr Narliker and Ahmed Sinai engage.

*Midnight's Children* is Rushdie's first novel anchored in the urban environment of Bombay. While the city is a meticulously observed backdrop to large sections of the narrative, Bombay is also reflected in the storytelling energy of the novel.[19] Saleem's tale is marked by its excess, a multitude of stories shoved together side by side. Rushdie explains:

when I wrote *Midnight's Children*, one of the ideas I had about it was that [ . . . ] the first thing to think about India is its multitude, its crowd and I thought: 'how do you tell a crowd of stories?' 'What is the literary equivalent of that multitude?' One strategy that was adopted in that book was deliberately to tell, as it were, too many stories, so that there was a jostle of stories in the novel. Your main narration, your main storyline, had to kind of force its way through the crowd as if you were outside Churchgate Station trying to catch a train; and you had to really do some work. (Rushdie and Niven 2004, 129–130)

The readers have to carve out a space for themselves within this multitude of stories and the process of reclamation of memories. This reclamation often happens through the idiom of Indian popular cinema, for example photographs coming to life and talking to Saleem or big swooping wide-angle shots of the city. This shift from the close-up to the panoramic becomes apparent in Saleem's lavish distribution of the factual and the remembered, further highlighting that Saleem has a tendency to privilege memory over facts.

Before writing down the events in the Widow's Hostel, Saleem states that a climax should not be written from fragments of memory (Rushdie 1995a, 426). But these 'pieces' make this section of the novel so evocative as, out of the scraps, a whole emerges which unravels the full horror of what happens to Saleem and the Midnight's Children at the hands of the Widow—the physical destruction of what they symbolically stand for, hope and possibility. As the realisation of being peripheral registers with Saleem, the sweeping panoramic view of events narrows down to these fragments. It is also striking that the events in Varanasi in the Widow's Hostel are devoid of irony and tongue-in-cheek humour. Saleem has to force himself to narrate the horrific tortures he endures under which he breaks, leading to the forced sterilisation of the Midnight's Children as all hope is drained and they are robbed of their magical capabilities.[20] Subsequently Saleem has to face the question of guilt and concedes, 'I refuse absolutely to take the larger view; we are too close to what-is-happening, [ . . . ] right now we're too close to the cinema-screen, the picture is breaking up into dots, only subjective judgements are possible' (Rushdie 1995a, 435). Saleem at his most close up and immediate, confronted with his own shame, addressing the Midnight's Children directly, asks for forgiveness that he knows cannot be granted. Cinema serves here as an analogy of what effect Saleem as narrator is trying to produce. Saleem provides us with the most immediate indictment of Indira Gandhi's Emergency rule, which is clearly embedded in the direct and indirect treatment of history in the novel as a whole and its critique of India's political elite. By the end of the novel, when in its climax Saleem is confronted with the figure of Indira Gandhi, the Midnight's Children are invested with meaning through their destruction at the hand of the Widow. Saleem loses the fight for centrality and brings about the destruction of the Midnight's Children and

their magical gifts, but at the same time allows them to become an evocative symbol of hope betrayed and possibility denied, preventing them from becoming an absurd, meaningless group. For Saleem, the Emergency essentially destroyed what modern India, according to its founding fathers, should have been. It is the antithesis to the hopes expressed by Nehru on the birth of the nation. Ironically, it is Nehru's own daughter—who, through marriage, holds the name of the man associated with bringing India its independence—who is the destroyer of that dream of diversity. Saleem's tale is a challenge to that episode in history, turning historiography inside out by simply narrating his story.

# 3 Filming Rushdie
## From Documentaries, Film Criticism to Screenplays

Rushdie's relationship with Indian popular cinema is both intriguing and complex. On the one hand he regularly made disparaging remarks about the development of the film industry in the 1970s and 1980s; on the other, he has repeatedly returned to three key cinematic texts, *Shree 420*, *Mother India* and *Mughal-e-Azam*, which feature exponentially as reference points throughout his fiction. Over the years, these three movies have become classics in their own right and epitomise the golden age of Indian popular cinema.

Rushdie's links to the movie world are more than referential. He has family connections to the Bombay film industry, most notably through his aunt, the actress Zohra Segal. Starting her career in Uday Shankar's dance troupe, which toured Europe extensively in the 1930s, she worked in theatre, including the Indian People's Theatre Association, and as a movie actress—she was in films such as the Palme d'Or-nominated *Neecha Nagar* (1946) directed by Chetan Anand and written by K. A. Abbas—and choreographer for Dev Anand's *Baazi* (1951). She moved to Britain in the 1960s, working for a while as a dance teacher for Ram Gopal, and went on to star in many British Asian films, including *Bhaji on the Beach* (1993) and *Bend It Like Beckham* (2002). In the late 1990s, she also featured increasingly in Hindi movies, such as Mani Ratnam's *Dil Se* (1998), Yash Chopra's *Veer-Zaara* (2004) and Sanjay Leela Bhansali's *Saawariya* (2007). Her sister, Uzra Butt, was also a legendary actress, though she mainly worked in theatre.

Rushdie's filmic vocabulary and sensibility has been shaped by an eclectic viewing of cinema, and regularly draws on popular and art house films from across the world. European auteur cinema in particular has profoundly influenced the way Rushdie visualises and focalises his narratives. Furthermore, Rushdie's own experience of work in advertising and fringe theatre, as a scriptwriter and documentary filmmaker have all contributed to his development of a distinctively filmic and *filmi* sensibility. This ranges from subject matter to stylistic devices with which the narrative translates from the written page and is visualised and focalised by the reader often through the lens of Rushdie's first-person narrators.[1]

Evidence of this engagement with cinema is well documented in Rushdie's private papers, now deposited in the Manuscript, Archives and Rare Books

Library at Emory University, Atlanta. Most revealing is the 1975 typescript of his unpublished novel, *The Antagonist*, which first featured a character named Saleem Sinai. The novel is set in 1947/1974 and includes as one of its main protagonists a half-Pakistani filmmaker, Trevor Gutte, who seeks to make a documentary film of the 1974 general election and the state of Britain. Here Rushdie is already viewing the action through a roving camera eye. The novel develops a backstory to Saleem and a duality with his sworn enemy in Bombay who calls himself 'black Saleem' and writes to him a series of threatening letters. The notion of children switched at birth at the Midnight Hour on 14/15 August 1947, for instance, which Rushdie would use in much revised and adapted form in *Midnight's Children*, also has its origin in this novel. The novel is set in Britain and India, and takes account of the legacy of Indira Gandhi. Furthermore, it seeks to unravel the interconnection between those two countries and the possibilities of a bridge between cultures, and this version of Saleem is thus seen as analogue to a modern-day version of the nineteenth century Indian reformer, Ram Mohan Roy (Rushdie Papers, Box 43, Folders 1–3). By exploring the intimate linkage between postcolonial India and Britain, this unpublished work already highlights many plot points Rushdie would reformulate in *Midnight's Children* and *The Satanic Verses*. Though Rushdie has disowned the novel as a failure, and it is certainly flawed, it evidences his first experiments with cinematic storytelling. He uses jump cuts in his narration of the actress and lover of Saleem, Vanilla Icequeen. In her interactions with Saleem's family, some dialogue is rendered in the form of a film script and he uses white fades and fade-ins, integrating a cinematic language into the narrative:

> A slow zoom down from our heights brings us to the roof of the Breach Candy hospital, and by magic through the roof into the small room where Sinai sits, and now we close in on his face, which looks at us—no, not at us—which looks at something through, close right in on them now, through those eternal staring eyes. (Rushdie Papers, Box 43, Folder 3, 331)

Another unpublished novel, *Madam Rama* (1976), a satire on Indira Gandhi and her political career set in the Bombay film world, is marked by its crassness and led to its rejection even by the author (Rushdie 2012, 51). Yet Rushdie would also raid this abandoned novel for *Midnight's Children*. The novel charts the career of Vista Rama, daughter of the film producer and studio owner, D. W. Rama. Indeed, in *Midnight's Children*, D. W. Rama Studios is a co-financier of Saleem's uncle Hanif's film *The Lovers of Kashmir* (Rushdie 1995a, 142). The story is told in retrospect by Vista, now imprisoned in a Widow's Hostel in Varanasi. It maps her relationship with her father, which has obvious overtones of the relationship between Jawaharlal Nehru and Indira Gandhi, with the movie studio and its successes and failures bearing some analogy to those of the Indian nation. Vista Rama is an unreliable narrator,

who embellishes and falsifies her story in retrospect. Her background as an actress and filmmaker leads her to adopt the focal point of a camera lens, where the reader views the world entirely through her eyes (Rushdie Papers, Box 44, Folder 13). The novel echoes *Midnight's Children* in its deployment of fictional films—here *The Price of Mangoes*, which features an earlier version of the indirect kiss and which Rushdie uses to great effect in *Midnight's Children* and the novel's film version (Rushdie 1995a, 142–143; 216–218). In the earlier film the protagonists kiss and pass across a mango, not a glass of lassi.

The novel also plays with the idea of multiple and dubious parentages, a common motif of Indian popular cinema that Rushdie would later use and adapt for *Midnight's Children* and *Shame*. Furthermore, it features a movie mogul, I. S. Nayar, who sports the bendy cane made famous by Charlie Chaplin and Raj Kapoor, and prefigures Vasco Miranda's use of the prop in *The Moor's Last Sigh* (Rushdie 1996b, 151).

In the telling of her life story, Vista Rama makes recourse to many devices of Indian popular film. The novel takes a bizarre turn as Vista realises that she is growing a penis, which prompts her to visit the gynaecologist, Dr Narliker, who Rushdie would later transplant into *Midnight's Children*. In *Madam Rama*, he appears as a child-hating birth control fanatic. Yet here too he is involved in the tetrapod scheme, a plot point Rushdie later featured in *Midnight's Children* (Rushdie 1995a, 175–176). The novel also deploys some of the same locations, for instance, the Pioneer Café, here a favourite haunt for talent scouts in their search for film extras. *Madam Rama* climaxes with a celebration of Holi at the film studio, where Vista is framed by her daughter and then banished to Benares. It concludes with an equally bleak vision to *Midnight's Children*, where 'India is a place where versions of reality fight each other to the death' (Rushdie Papers, Box 44, Folder 14, 224). The novel is an example of Rushdie's familiarity with Bombay's commercial film industry, its production processes and star system, which he would deploy to great effect in his later novels.

## Rushdie as Scriptwriter and Filmmaker

Rushdie has not only engaged with film in his career as a novelist, but also as critic and filmmaker. Again his archive is illuminating in this regard, featuring script drafts and fragments, for example for his documentary, *The Riddle of Midnight*, commissioned by Farrukh Dhondy, editor for multicultural programmes for the British public broadcaster Channel 4, which transmitted the documentary in 1988. The documentary opens with a voiceover of Nehru delivering his 'Tryst with Destiny' speech to India's constituent assembly on the eve of independence. It then fast-forwards forty years and sets out his quest to illuminate the idea of India, what it means to be Indian and what independence has delivered for its citizens through interviews with people from the whole spectrum of society across political divides—including men,

women, industrialists, politicians, craftsmen, labourers, artists, farmers and slum dwellers, who, like Rushdie, were all born in 1947. Structured into three parts, Rushdie initially focuses on the city. He conducts interviews with a Shiv Sena politician, a slum dweller and a Parsee industrialist, before enlarging his vision from Bombay, which many perceive as a microcosm for India, to the wider country. The riddle Rushdie tries to answer is the question of how a country that never previously existed as a nation state can become independent and generate a sense of identity. Rushdie's documentary moves to Ahmedabad, Gujarat to interview Kartikeya Sarabhai, working in environmental development in the Rann of Kutch. Rushdie then travels to Kerala where he talks to a rice farmer about her working conditions. He is puzzled by the fact that, despite her village's support for the Marxist party, they continue worshipping at the local temple and celebrating the south Indian harvest festival, Onam. Rushdie goes on to interview John Anthony, who had worked on construction sites in the Gulf for four years before his return home to buy and run three fishing boats. Though he was able to set himself up in business, his catch is decreasing. He highlights the environmental toll of economic development and a titanium factory polluting local rivers and the seashore, as well as the threat to fish stocks from increasing use of industrial fishing. In its third movement, titled 'The Gods', Rushdie probes further into what it means to be a 'real' Indian by visiting Kashmir, from where his own family hails, and looking at the increasingly exclusionist Hindu visions supplanting the secularly defined idea of India. Rushdie investigates the growing religious tensions in 1980s India and their explosive potential to threaten the Indian Union. He also explores this in the context of Delhi and two men working in textiles, one Hindu, the other Muslim, the former working in the predominantly Muslim Chandni Chowk, the latter in the Hindu-majority Pahar Ganj. Both men detail the increasingly strained relations between religious communities. After a reprise summarising how his interviewees define their understanding of being Indian, the documentary concludes with Rajiv Gandhi's 1987 speech on the anniversary of independence, a display of empty rhetoric exposing the mismatch between the optimism and promises and the often desperate situation in which India's citizens find themselves. The film closes with a profound warning that the religious divisions and communal violence that ripped the country apart at Partition slumbers and that its spectre still remains. These deep divisions, often exploited by politicians for their own ends, can still break out at any moment, shockingly exemplified by testimony of a Sikh woman whose husband and children were massacred in the aftermath of the assassination of Indira Gandhi by her Sikh bodyguard in 1984.

Rushdie's assessment of India's first four decades of independence offers a mixed account of its achievements and highlights many challenges the country faces. While by the end of the film he is no closer to solving India's Riddle of Midnight, his focus on religious divisions, exposing secularist

ideals on which India was founded as a myth and the violence it may unleash would be the prime subject preoccupying him in his fictions on India that followed—*The Moor's Last Sigh* and *Shalimar the Clown*. Indeed, how the partition of British India has affected Rushdie is evident from another undated typescript, *After Midnight: 40 Years of Partition*. A proposal for a documentary film and the original idea for the documentary that was to become *The Riddle of Midnight*, it seeks to understand the aftershock of the division of India from an immediately personal and political point of view. Rushdie's family originated from Kashmir and lived in Bombay for many years, before migrating to Pakistan in 1964. Rushdie grapples here, on the one hand, with the pain it has caused on a familial and personal level and, on the other, presents it as a political unchangeable reality that needs to be accepted. In his consideration of Partition, Rushdie also seeks to evaluate the third partition of the subcontinent, in the secession of East Pakistan to become independent Bangladesh. Rushdie proposes to visit the areas which have been most deeply scarred by the events of Partition— Kashmir, the Punjab, West Bengal and Bangladesh as well as Hyderabad, exploring both the fissures and ongoing cultural connections (Rushdie Papers, Box 48, Folder 7).

Rushdie also proposed a television treatment, *Mr. Kipling and the Bandar-Log*, as a seventy-five-minute programme, which discussed Rudyard Kipling's engagement with India. It followed Kipling's trajectory from his childhood in India and his return to work as a journalist, looking at how his life in India impacted on his writings. The programme also sought to explore Kipling in contemporary contexts of Britain's attitudes towards and engagement with Empire in the early 1980s, which was tinged with 'Raj nostalgia'. The script highlights and deconstructs many of the controversial literary debates around Kipling's work, its quality and retrospective significance. Rushdie proposed the film be shot on location at Sezincote, Gloucestershire, India—Bombay and Simla in particular—and a studio. In this thirteen-page treatment Rushdie uses several cinema-inspired narrative devices, for example title cards as used in silent films. Structured as a television essay, the script focused in particular on Kipling's split Indian and British identities and his conflicting attitudes towards Indians (Rushdie Papers, Box 58, Folder 12).

Beyond documentary filmmaking, Rushdie's private papers reveal a keen interest in writing film screenplays, for example a 1984 typescript for a film, *The Silver Land*, set in Argentina, Goa and England. Rushdie would recycle some of this material in *The Satanic Verses* for the 'Rosa Diamond' sections (Rushdie 1998, 143–156). The action is split between a seaside town on Britain's southern coast in 1983 and late 1930s Argentina. The film explores the wider questions of memory, imagination and dreams and how individuals create their own reality out of personal fantasies which, with a strong will and belief, transmute into truths (Rushdie Papers, Box 60, Folder 12).

Rushdie has also been involved with many attempts at adapting his literary work for film. In 2002, the Illuminated Film Company, a London-based animation studio, proposed a computer-animated version of *Haroun and the Sea of Stories* (Rushdie Papers, Box 66, Folder 4). Another ill-fated attempt was the film adaptation of *The Ground Beneath Her Feet*. According to the British newspaper *The Guardian* in March 2000, Rushdie sold the film rights of the novel to small Paris-based production house Gemini, which that year released a film version of Proust's *Time Regained*. The film's budget was a modest $15 million. *The Ground Beneath Her Feet* was described 'as Rushdie's most accessible and purely filmic novel', with its 'lead female character [ . . . ] allegedly loosely based on Madonna'.[2] At the helm of the film was the experimental Chilean director, Raoúl Ruiz, who drafted the initial screenplay with Argentinian screenwriter, Santiago Amigorena. The production was set to star the Mexican-born actress Salma Hayek and shooting was slated to start in April 2002 with additional funding from Studio Canal and Pathé Pictures, but it never came to fruition. From his papers it is obvious that there were some stark creative differences between the director, scriptwriters and the author. After receiving the English translation of the proposed script, which had been originally adapted from the French version of *The Ground Beneath Her Feet* and then retranslated into English, Rushdie was less than impressed and suggested major restructuring of the narrative to streamline it. He also went on to prepare his own draft, rewriting much of the narrative and dialogue to make it more suitable for popular audiences (Rushdie Papers, Box 51, Folder 12). Rushdie's comments, suggestions and eventual rewrites demonstrate a keen eye for narrative clarity to find a through-line to the multi-dimensional plots of his novel. In the event, the movie never went into production and the film company's option lapsed.

Rushdie's digital files also contain a film script he drafted based on his short story 'The Courter', included in his 1994 collection, *East, West* (see Rushdie Digital Files nd). *The Courter* was supposed to be produced by Warner Sisters with director Jane Wellesley, but it ran into difficulties after two script discussions. Rushdie, who was commissioned to write the screenplay, was unhappy with the way the project was developing. Though this is another of Rushdie's failed film projects, a screenplay and outline sketch exist. Rushdie already had a specific cast in mind for the film including his aunt, Zohra Segal, Max von Syndow, Ben Kingsley, Rohini Hattangady, Indira Verma, Shabana Azmi and Shashi Kapoor. The story is based on Rushdie's own experience in 1960s London, when his family moved there briefly before migrating to Pakistan. The screenplay also further emphasises autobiographical incidents which Rushdie relates in greater detail in his memoir, *Joseph Anton*. The short story is a first-person narrative, while the film is narrated by Ronny Merchant in flashback and begins with his childhood in Bombay, before he accepts his father's offer to go to boarding school in England. The film then shifts to England, Ronny's first visit to

London with his father, his first football match at Tottenham, his experiences at boarding school and his friendship with the Jewish boy, Isaac Solomon who, like him, is an outsider at school. The action moves to Kensington and Waverley House in 1964 where the family takes up residence after his father sells their Bombay home. It then refocuses on the family ayah, Ronny's close relationship and adolescence in swinging '60s London and the ayah's blossoming relationship with the Courter, her homesickness and subsequent return to Bombay. Interestingly, in scene 116—a dream sequence—Mary's longing to return to India is made concrete in a montage from *Mother India*, *Mughal-e-Azam* and *Shree 420*, with the films functioning as a stand-in for home. As the dream sequence fades, a smile passes Mary's face and she falls asleep. Film in this instance functions as a comforting memory trigger that provides respite from the pressures of everyday life as Indian popular cinema's song sequence become the visual-aural expression of her yearning and an emblem of her reconfigured distanced relationship with her homeland. This aspect of filmic representation would take on even further significance in the different reincarnations of *Midnight's Children* as a television serial, a stage play and a movie.

## Adapting *Midnight's Children*

Of all of Rushdie's novels, *Midnight's Children* has been adapted most often. This is no doubt because of the novel's international popularity and numerous awards since publication in 1981. In the early 1980s, Rushdie voiced his own scepticism about the possibility of adaptation: 'My feeling is that it's very hard to get it into a feature film and that, if it is at all possible, it would have to be something longer, like a television series' (Rushdie, Tripathi and Vakil 2000, 81). I will briefly delineate and compare three such attempts with which Rushdie was involved: the 1997/98 television screenplay, on which Rushdie worked for the British Broadcasting Corporation (BBC); the co-authored play version with Tim Supple and Simon Reade for the Royal Shakespeare Company, which premiered at London's Barbican Centre in 2001; and the movie adaptation released in the UK in 2012 for which Rushdie penned the screenplay and which was directed by acclaimed Canadian Indian filmmaker, Deepa Mehta. These three projects highlight in different ways the challenges translating and visualising an already highly visual novel for the screen and stage, an often fraught process in the context of different media that elicit varying audience responses. As lyricist and scriptwriter, Javed Akhtar has put it so eloquently, 'when you read [ . . . ], you are the director, you are the cameraman and the editor. [ . . . ] While you're reading the novel, you're doing the casting, you're deciding the frame compositions, the locations, the sets are being designed by you' (Akhtar and Kabir 2003, 11)—whereas in cinema, the director, producer and screenplay writer offer its audience a pre-packed final end product.

## The Television Screenplay of *Midnight's Children*

After the novel won the Booker of Bookers in 1993, Salman Rushdie was approached by the BBC and Channel 4 to produce a TV mini-series of the novel.[3] The project was never completed due to several obstacles the production encountered, which Rushdie recorded in his introduction to the screenplay published by Vintage in 1999. Rushdie recalls it as a mammoth project involving 'two writers, three directors, at least four producers and a whole passionately dedicated production team [ . . . ], and which foundered for political reasons when everything was in place and the beginning of principal photography was only a few weeks away' (Rushdie 1999, 1).[4] Rushdie favoured the BBC because of its ability to fund and produce the serial itself as well as the presence of Alan Yentob, a friend of Rushdie's who was head of drama at the BBC. The agreed format was a feature-length first episode followed by four fifty-minute episodes, a running length of about five hours in total. This painstaking process from scriptwriting to casting is documented in his private papers at the Manuscripts, Archives and Rare Book Library, Emory University, Atlanta. The original screenwriter attached to the project was Ken Taylor, best known for his adaptation of Paul Scott's *Raj Quartet* as the 1984 mini-series *The Jewel in the Crown*, for which he won the Royal Television Society's Writers Award and was nominated for an Emmy. Rushdie and Taylor worked closely on the script until the end of 1996 but, after some drafting difficulties, Rushdie took over sole control of the process, reshaping and rewriting it completely (Rushdie Papers, Boxes 53–58). The only thing he retained was the dialogue already lifted directly from the novel. Rushdie also reordered many scenes, added new dialogue and delivered the final script in November 1997 (Rushdie Papers, Box 56). The drafts reveal Rushdie's keen eye for reshaping his novel for television with a view to increasing narrative clarity for the viewer. Some characters have been cut, such as Mian Abdullah or peripheral characters—snake expert Dr Schaapsteker, Evie Burns and the Narliker women—as well as long sequences like the war in the Rann of Kutch. This simplified many of the storylines that digress in the novel, while still retaining its essence and arguments. Most striking is the way Rushdie kills off his characters and readjusts the storyline and their life stories to fit into the narrative structure of a fifty-minute episode.

Rushdie, as the adaptor of his own novel, makes ruthless changes in order to construct a dramatic arc within each episode as well as over the whole miniseries, yet he is careful enough with the original to maintain the essence of the novel, such as its preoccupations with memory and childhood in Bombay, the pressures of family life, unrequited love, as well as the politics of postindependence India and the analogous birth, adolescence and emergence into adulthood of its hero and narrator, 'handcuffed to history' (Rushdie 1999, 18). These are not easy to juggle and condense; yet the TV screenplay shows a keen awareness of what is effective on screen and more effective on the page within the confines of a book. Rushdie has made some tough choices. For example,

the Amritsar massacre in 1919, the first instance in the novel where Saleem overtly uses cinematic visuals in his descriptions, happens off-stage in the screenplay. It seems to be a reminder and makes concrete Saleem's observation that '[m]ost of what matters in our lives takes place in our absence' (Rushdie 1995a, 19). Perhaps it is also a statement against visualisations of the massacre in films such as Richard Attenborough's *Gandhi* (1982). Rushdie's choice has a great impact, much like the power of atrocities off-stage in Shakespearean tragedy where the horror is reinforced through suggestion and therefore takes place in the viewer's imagination. Especially in times of overvisualisation of shocking historical events, this seems to be effective.

In the novel, Saleem adopts a documentary style to narrate this incident and for the first time uses technical terms of film production. Saleem describes his grandfather watching a street scene in Amritsar on 7 April 1919. He has an olfactory attack on his senses by the pungent smell of excrement while his wife suffers from a headache. One week before the actual massacre, Aziz has a sense of the tensions in the air, the itch in his nose forewarning him that 'something was not right here' (Rushdie 1995a, 32). Saleem then cuts to a close-up of his grandfather's right hand. Between thumb and forefinger he is holding a pamphlet. Saleem now cuts to a long-shot, asserting, 'nobody from Bombay should be without a basic film vocabulary' (Rushdie 1995a, 33).[5] He goes on to describe the events of April 13 in the Jallianwala Bagh. After Saleem cuts to his long-shot, he intercuts events in the hotel room with events elsewhere. In the hotel room Aziz appeals to Naseem: '"Start thinking about being a modern Indian woman." . . . While in the Cantonment area, at British Army H.Q., one Brigadier R. E. Dyer is waxing his moustache' (Rushdie 1995a, 34). Saleem shifting from one scene to another is denoted in the text by ellipses, but the reader, made aware by the narrator of the filmic connection, triggers the effect as we visualise the events as film. Furthermore, by adopting a documentary camera gaze in Amritsar, Saleem's intrusive narratorial voice becomes detached and allows for a seemingly neutral depiction of events as the true horror unfolds. This form of narration foreshadows that of later incidents, such as the events in the Sundarbans and the forced sterilisations in the Widow's Hostel in Benares. These nuances do not translate easily and are lost in a visualisation on screen.

The screenplay needed to condense the action, while staying true to the original and translating the material imaginatively. This is largely achieved through structure as well as adapting storylines to enhance some of the impact of events on screen. The longer first episode covers events from Aadam Aziz's return from Heidelberg to Saleem's birth. The second episode is concerned with Saleem's childhood in Bombay and ends with the discovery that Saleem's blood group does not match either of his parents'. Episode three narrates Saleem's exile in Pakistan and his return to Bombay, his stay with his Uncle Hanif, as well as his revenge on his mother by sending the anonymous letter to Commander Sabarmati. The episode ends with

the death of Hanif and Aadam Aziz and the family deciding to move from Bombay to Pakistan as Methwold Estate is demolished to make way for high-rise developments. In the fourth episode, Saleem discovers his sense of smell, falls in love with his 'sister' who embarks on her singing career, and ends with the wiping out of his family in the 1965 Indo-Pakistan War. The narrative then skips forward to the war of secession of Pakistan's east wing where Saleem, suffering from memory loss and becoming a man-dog, joins the Pakistani Army's canine unit. The episode finishes with the independence celebrations of Bangladesh, the defeat of the Pakistani Army by India and Saleem's rediscovery of his name through the chance meeting with Parvati the Witch who takes him with her to Delhi. The final episode deals mainly with the Emergency. Saleem arrives back in India, marries Parvati the Witch and becomes aware of a plot to eliminate the Midnight's Children. Captured by Shiva during a slum clearance, he is abducted to Benares, imprisoned in the Widow's Hostel and tortured into betraying the whereabouts of all the Midnight's Children, who are subsequently rounded up, forcefully sterilised and drained of their magical gifts. The episode ends with the now broken Saleem's return to Bombay with baby Aadam and, after the competition in the Midnight's Confidential Club, he seeks out the Braganza Pickle factory where he is reunited with his ayah.

Every single episode of the series is structured around a climax: episode one around India's arrival at independence; episode two around the first ten years of independence and events such as Mahatma Gandhi's assassination and the partition of the state of Bombay; episode three around the coup in Pakistan; episode four around the Indo-Pakistan War and the secession of Bangladesh. The final episode climaxes with the Emergency and the perpetrated atrocities in the Widow's Hostel in Benares. Rushdie arranges his narrative around these crucial events, thus 'handcuffing' Saleem to history. Lifafa Das and his Peepshow machine play a more prominent role in the screenplay, effectively introducing each episode and giving a short preview of what the viewer can expect in the episode as a series of black-and-white postcards is shown. Indeed, the increased role of Lifafa Das in the television screenplay, where his introductions serve as a trailer of what is to come—a function that Saleem as master of ceremonies fulfils in the novel with his constant summaries and prospective outlooks—are all part of Rushdie's organisation of the multitudes of tales that he agglomerates.

The first episode commences, unlike the novel, with Ramram Seth's prophecy and then cuts to Amina giving birth. As a voiceover Saleem explains his and the Midnight's Children's unique position: 'All over India, in that midnight hour, children were born who were also children of the time: fathered, you understand, by history. It can happen. Especially in a country which is itself a sort of dream' (Rushdie 1999, 17). In a montage, the faces of baby Saleem and Shiva and then of other babies are mixed together in a composite, undulating like a banner behind which flies the saffron, white and green

flag of independent India. Then the scene shifts to the thirty-year-old Saleem in the Braganza Pickle factory writing his memoir and narrating his story to the intrusive Padma. From the beginning, Rushdie highlights the centrality of Midnight's Child and the birth of independent India that is later paralleled with the birth of baby Aadam at the inception of the Emergency. These flashbacks, as well as skipping forwards in time, are more obvious in the screenplay, perhaps due to an increased narrative drive and call for linearity within the structure of the screenplay.

Through visualisation, Rushdie's critique of post-independence India's politics becomes more pronounced. If anything, because of the death of Indira Gandhi in 1984 and of her son Sanjay in 1981, Rushdie can now be even more hard-hitting in his criticism of the Emergency. Indira Gandhi sued Rushdie and his publisher successfully over a passage in *Midnight's Children* that Rushdie had to delete from subsequent editions of the novel.[6] In the screenplay, however, Rushdie increases his criticism of Sanjay Gandhi. Indira Gandhi hovers over the Emergency like an invisible presence, while the perpetrators of the slum clearances and mass sterilisations all have a resemblance to Sanjay Gandhi. Rushdie remains ambiguous about who is in control of the proceedings, although it becomes clear that all the orders go back to the highest government offices and, ultimately, Indira Gandhi is held responsible. Thus the visualisation of the Emergency—Indira Gandhi's ultimate betrayal—can be handled with even greater directness.

Rushdie has also made bold choices in partly rewriting characters' lives and plotlines to fit in better with the dramatic arc of each episode. Rushdie has a knack for ruthlessly dispensing with his characters when they have lost their apparent usefulness and the screenplay is no exception, where even characters who survive in the novel—though their whereabouts remain unknown—are killed off to provide unambiguous closure to the narrative threads. For instance, Saleem's sister Jamila does not find refuge in a convent but is wiped out in the Indo-Pakistan War of 1965 together with her aunt Pia and Reverend Mother inside their petrol station. General Zulfikar, his aunt Emerald's husband, has an extended lease of life in the screenplay, commanding Pakistan's troops in Bangladesh, only to be assassinated when he surrenders to the Indian army. Most strikingly, Shiva dies in the screenplay in a motorcycle accident, the only Midnight's Child not subjected to the '-ectomies' performed in the Widow's Hostel, but one of the most loyal henchmen of the government. The events in the Widow's Hostel are played out like the final showdown between Shiva and Saleem as Shiva wreaks his revenge on the little rich boy who took his place, which meant that he lived a life in poverty. In the end, Shiva is crushed by a truck while on the run, after Indira Gandhi has been unceremoniously kicked out of office in the general election held after the Emergency. Perhaps a screen adaptation needs a certain level of closure, but it is significant that the whereabouts and fate of Shiva remain unknown to reinforce the unresolved dualism between the

two. Saleem imagines him to be dead, but is not certain. Indeed, in the novel he admits that he made his demise up in order to lull himself into a false sense of security, which is further proof of his unreliability as a narrator.

The ending of the television screenplay diverges from the novel, which finishes with Saleem disappearing into the crowd on his own. In the screenplay, he walks into the crowd hand in hand with Padma to celebrate India's anniversary of independence, where they are separated and swept in opposite directions, both disappearing in a mass of humanity.[7] In this way, like the book, the screenplay does not necessarily pronounce on the future, but hints only at the possibility of marriage between Saleem and Padma.

On the other hand, the screenplay is even more infused with elements of Indian popular cinema than the novel. There are song-and-dance sequences, overpowering larger-than-life villains, the melodrama of family life is further accentuated, the high romance of star-crossed lovers is much more foregrounded and the screenplay deploys all of them to great effect. In the novel they form part of a whole series of stories that come together in Rushdie's examination of India's politics from the birth of the nation at independence to the Emergency.

The shoot was proposed to take fourteen weeks on location in Sri Lanka, beginning on 26 January 1998 under the cover name 'Saleem's Story'. The director attached to the project was Tristram Powell and Nic Knowland was cinematographer. Nasreen Munni Kabir and her company Hyphen Films were also involved with the project as researchers (Rushdie Papers, Box 60, Folder 5). The series was supposed to include a cast of 114 actors, including many British Asian and South Asian stars, such as Rahul Bose as Saleem Sinai, who would be cast in the 2012 version as General Zulfikar, Roshan Seth as Ahmed Sinai, Ayesha Dharker as Jamila, Arun Bali as Dr Aziz, Gopi Desai as Reverend Mother and Zohra Segal as the Rani of Cooch Naheen. Saeed Jaffrey was to play Dr Narliker and Jimi Mistry Joe D'Costa. Ace Bhatti had the role of Shiva and Seema Biswas, who went on to play Mary in the 2012 film, was cast as Parvati, with Kulvinder Ghir as Ismail Ibrahim—he would go on to play Aadam Aziz and Picture Singh in the play version. Aileen Gonsalves, cast as Mary Pereira, went on to assist director Tim Supple in the RSC stage adaptation of *Midnight's Children* (Rushdie Papers, Box 60, Folder 5).

## Staging *Midnight's Children*

Based on the draft screenplay of *Midnight's Children*, which provided a template and a feasibility study for the possibility of adapting the novel, the Royal Shakespeare Company (RSC) commissioned the development of a play with Tim Supple as director, who had previously collaborated with Rushdie on a stage adaptation of *Haroun and the Sea of Stories* for the National Theatre in London, working alongside Simon Reade as dramaturge. The play marked

the return of the company to the Barbican Centre for the first time since giving it up as its permanent base and was the flagship production of its season, budgeted at some $3 million. It brought together the RSC with three American university partners, Columbia, Michigan and Ann Arbor. After its London premiere in January 2003, following in the wake of the A. R. Rahman-composed and Andrew Lloyd Webber-produced *Bombay Dreams*, the play toured in the USA and regionally in the UK.

Rushdie, Supple and Reade worked together on the theatre adaptation, condensing a 600-page novel into a 119-page script with a running time of about three hours and fifteen minutes. The play used the screenplay as a model, particularly in terms of dialogue and dramaturgy. It retained the framing device of Saleem telling his story to Padma in retrospect in the pickle factory. The play included over twenty actors playing more than seventy characters and received a mixed reception from audiences and critics. Epic in scale, it compressed too much of the novel's plot and, as a consequence, except for the ever-present Saleem, the audience was not given the opportunity to spend enough time with other characters to empathise or care what happens to them. As Michael Billington described so eloquently in his review for the *The Guardian* newspaper on 30 January 2003, 'it is an evening of memorable moments in which huge narrative gallons are squeezed into a pint pot'. As soon as a character was established, they would disappear from the narrative while storylines would be laid out but quickly abandoned without necessarily driving the action forwards. Despite foregrounding the politics, the stage version lost some of the anger of the book—the betrayal of hope at independence—through the hurtling pace of the play.

Yet the production did use video and computer graphics in interesting ways. It allowed the director to clearly indicate to the audience key historical moments through documentary archive footage, such as Nehru's 'Tryst with Destiny' speech. It also opened up the possibility of actors interacting with a version of themselves on screen, an effective feature used in the scenes of the Midnight's Children's conference. Another such instance is the film screening of Hanif's film *The Lovers of Kashmir*, which he attends with his sister Amina in January 1948. As in the novel, the film screening is interrupted by an announcer to inform the audience of the death of Mahatma Gandhi but, in the stage version, the actors on screen interrupt what they are doing and observe the announcer before reacting in shocked horror at the news. The play was also held together because of a bravura performance by Zubin Varla as Saleem, who carries the audience through the abundant plot. In this respect, while not an entirely successful venture, the stage version proved yet again that a further distillation of the material was possible, although the significant poignancy of Saleem's story was lost on stage, which might suggest that the novel is perhaps better suited to be a TV mini-series than a production to be seen in one sitting. However, the 2012 film adaptation of the novel took a more straightforward approach to the narrative, plotlines and

list of characters to provide a clearer through-line to the multi-dimensional plots of the novel.

### *Midnight's Children* from Page to Screen—Adapting the Film

As already mentioned, Rushdie had been approached previously regarding the film rights to the novel, and another such enquiry was made by Danny McCurry with a script, *Midnight's Child*, which focused solely on the story of Ahmed and Amina Sinai up to Saleem's birth in 1947, turning the book into a story of the departing Raj and the ensuing chaos and violence of Partition (Rushdie Papers, Box 66, Folder 8). Rushdie declined and the project did not get off the ground.

In 2008, while promoting his novel *The Enchantress of Florence*, Rushdie was invited to dinner with Deepa Mehta in Toronto. They talked about several possible projects, including a film of *Shalimar the Clown*, and she also asked him who owned the film rights to *Midnight's Children*, to which Rushdie responded that these were available. They signed a deal for the film at that very moment. The film, produced by Mehta's husband David Hamilton, was financed independently which meant that creative control was entirely in the hands of the director, producer and writer, yet also limited the budget of the movie. Rushdie wrote the screenplay in collaboration with Mehta and also provided the voiceovers for the film. Shot entirely on location in Sri Lanka, the filmmakers recruited a stellar cast from independent Indian, Indian popular, British and Hollywood cinema including Anupam Kher, Shabana Azmi, Charles Dance, Seema Biswas, Siddharth and Soha Ali Khan. In the autumn of 2012, *Midnight's Children* received its world premiere at the Toronto International Film Festival and its European premiere at the British Film Institute's London Film Festival.

Rushdie worked on the project while writer in residence at Emory University where he also taught a course and delivered a lecture on 'adaptation' in 2009, subsequently published in *The Guardian* as 'A Fine Pickle'. For Rushdie, most crucially, the issue of essence 'remains at the heart of the adaptive act: how to make a second version of a first thing, of a book or a film' so that, on the one hand, it is something new but, on the other, it still carries the essence of the original (2009, 2). This issue, which has analogies with Saleem's own process of pickling and is echoed in the title of Rushdie's essay, seems an apt descriptor for the task of reimagining the novel for cinema.

The result was perhaps more mixed than Rushdie had anticipated. The film, despite offering a somewhat potted history of the subcontinent post-independence, which does not always integrate well into its dramatic narrative drive, features well-rounded performances, notably by Darsheel Safary and Satya Bhabha as the young and adult Saleem respectively. Yet, due to the fact that Rushdie chose to focus on individual melodramatic personal stories of his characters, with the politics of the three South Asian nations only a

backdrop, the film loses the notion of Saleem being 'handcuffed to history' and only realising at the end that he is peripheral rather than central to the story of the nation. In this respect, the tragic occurrences in the Widow's Hostel lose some of their power. Saleem is a more sympathetic character in the film as his megalomania is downplayed. Saleem remains the film's central focus—yet, as this is Saleem's story, the choice of Rushdie as narrator/voiceover seems ill judged. Any heavy reliance on voiceover can be an irritant in a film, as it should show rather than tell the story. But linking it so distinctly to the book's author disconnects the viewer from the central character, overemphasising the closeness between film and book and denying Saleem the authoritative voice the film needs. Moreover, it becomes difficult to dissociate Rushdie's distinctive speaking voice from that of his first-person character, and in this respect it might have been better if the voiceover had been delivered by Satya Bhabha.

The film effectively features Mehta's characteristic hand-held camera work, while the Sri Lankan locations and its decaying colonial architecture capture well the Indian, Pakistani and Bangladeshi settings of the film. Many of the filmic scenes of the novel feature, for example, Amina Sina meeting her former husband Nadir Khan in the Pioneer Café, where Saleem looks on through the window as his mother and ex-husband perform the indirect kiss, setting up the dramatic tension in the relationship between Saleem and her. The film also quotes Indian popular cinema, such as the song 'Aao Twist Karein' from the 1965 film *Bhoot Bangla* to which Saleem and Jamila dance on the veranda or Wee Willie Winkie dressed like Raj Kapoor's tramp in *Shree 420*, in turn inspired by Chaplin. Outside the Pioneer Café the wall is adorned with a poster of *Mother India*, across which the camera pans, clearly dating the action to 1957, moving to then focus on the scene of the clandestinely meeting lovers inside. The scene between Nadir and Amina is performed without the irony the episode has in the book and is in fact neutral

*Figure 3.1* Amina Sinai (Shahana Goswami) and the indirect kiss in the Pioneer Café.

in the sense that what the viewer is presented with is a genuine expression of love between the two.

The camera first shows Amina drinking from a glass of lassi, which she puts down on the table. The camera then closes on their hands and the playful caress of their fingers, before zooming out as Nadir picks up the glass and kisses it; after he has put it down, Amina picks it up and kisses the glass in return. The scene's effectiveness is further enhanced by Nitin Sawhney's lush romantic score. It is not until Amina has returned home and discovered her irate son in the boot of her car that Saleem's strong feelings of disgust and betrayal are voiced. In this respect, despite both scenes being cinematically visualised, the perspective of the film differs from the book. Indeed, importantly, the camera eye Rushdie used as a focalising device in the novel has in the film become detached from Saleem and serves as a good example how the novel is more effective in enabling audiences to access a character's consciousness.

Mehta's film allows each scene to play out and the film moves at a leisurely pace over its two and a half hours, covering a lot of ground geographically and temporally from 1919 Kashmir to 1977 Bombay. Nevertheless, the action feels slightly over-crammed, and the viewer is still not given enough time to fully relate to and empathise with characters, for example Shabana Azmi's excellent Reverend Mother. In this respect, a five-part television series might have been the better medium to translate the novel onto screen. Yet the film works best when it moves away from the larger narrative to the personal detail: for example, Aadam Aziz falling in love with his wife through the perforated sheet; Nadir Khan hiding in the Aziz cellar and Amina falling in love with him; the relationship between Emerald and Zulfikar and their rise to power in Pakistan; and the scenes between Saleem and Jamila in Bombay and Karachi, Saleem and Parvati and the triangle between them and Shiva.

The film's dramatic arc, which revolves around the duality between Saleem and Shiva, is well constructed and the main focus. Switched at birth by Mary Pereira, Shiva is excluded from the affluent, middle-class, Bombay Malabar Hill children, instead working with his father, Wee Willie Winkie. He then appears in Saleem's imagination during the Midnight's Children conference, threatening to violently take it over. Once Saleem moves to Pakistan, this storyline becomes subordinate to the plots for power of his uncle Zulfikar. Shiva returns to the narrative during the Bangladeshi war of independence when this thread regains its primacy. It builds up to a climax in the Widow's Hostel. To heighten the drama, in a change to the plot of the novel, in a final act of defiance Saleem reveals that he has stolen Shiva's life—Shiva should have been the '*sala* rich boy' rather than him.

Tortured into confessing the whereabouts of all the Midnight's Children, Saleem can do nothing to stop Shiva. After the end of the Emergency, as the 420 inmates of the hostel emerge into the sunlight, Shiva is

Filming Rushdie 83

*Figure 3.2* Saleem (Satya Bhabha) reveals the truth to Shiva (Siddharth).

unceremoniously killed off, dying in a motorcycle accident after a head-on collision with a truck.

Saleem returns to Delhi in search of Parvati. Found by Picture Singh, he is reunited with his son Aadam and, after tasting Mary's pickles in a restaurant, decides to go to Bombay where he reconnects with his ayah.

The film ends on an uplifting note, on the rooftop of the Braganza pickle factory with Saleem, Mary, Aadam and Picture Singh celebrating Saleem's thirtieth birthday—a more positive finale than the book suggests and less focused on India's uncertain future. Whereas the play and the TV adaptation conclude with Saleem's fear of being trampled underfoot, unable to live or die in peace, the film ends with Rushdie's voiceover: 'A child and a country were born at midnight once upon a time and our lives have been in spite of everything acts of love'. This rather too upbeat ending, especially in the context of Saleem's tortuous journey, re-emphasises the melodramatic, when something grittier is called for.

*Figure 3.3* Saleem (Satya Bhabha), his ayah Mary (Seema Biswas), Picture Singh (Kulbushan Kharbanda) and young Aadam (Mohamed Safran Sarron) celebrating Saleem's birthday and India's thirtieth anniversary of independence.

While any adaptation of the film cannot be a straight page-to-screen transposition, given the very different demands of the medium, one of the major cruxes of adaptation is whether or not it captures the spirit of the book. Here the film is perhaps less successful, with its emphasis on the personal dramas of the characters and focus on the themes of family and love, while Saleem's aggrandised view of being handcuffed to history and in effect responsible for the nation's history is only marginally explored. In this respect the viewer is presented with a potted history of the postcolonial subcontinent. The film veers off too glibly into sentimental melodrama, thereby eschewing the larger political and metaphysical questions the novel poses. Perhaps cinema shows itself as too unforgiving a medium than the novel in its manifold devices which allow us to enter a multitude of consciousness. In its final edit, the film still feels episodic and disjointed, never quite settling into an organic flow with a clearly defined storyline, and the constituent elements do not quite come together to form a coherent enough sum total of its parts. The novel has psychological complexities which can be more readily expressed through the written word and are perhaps not as easily brought to life on screen.

Rushdie has found a way of condensing his novel into a screenplay but, as he has already expressed in interviews, 'books and movies are different languages, and attempts at translation often fail' (Rushdie 1999, 2). Elsewhere he sounds more optimistic: 'I would think that there always is a solution with film' (Rushdie, Tripathi and Vakil 2000, 81). As film editor and sound designer, Walter Murch expressed in a conversation with Michael Ondaatje: 'As a rule, when you're adapting a novel to film, you have to ask, What's the short story of this novel? And then make certain fateful decisions. The obvious truth about film is that it's highly redundant visually' (Ondaatje 2003, 126). Thus, in adapting the novel for cinema, Rushdie had to cut through the visual redundancy of film on top of the novel's abundance of story, while staying true to the spirit of the book. In the process, the film adaptation loses some of the central metaphoric value—the question of perspective and its shifts, which is a guiding principle for the reader in the book.

# 4  *The Satanic Verses* and *Shree 420*

Negotiating Identity through Indian Popular Cinema

*The Satanic Verses* marks a major shift in Rushdie's oeuvre. With the exception of *Grimus*, it is his first novel not to be entirely set on the Indian subcontinent. Most of the action takes place in the metropolitan centre of the former Empire, Ellowen Deeowen—London. Predominately focusing on 'The City Visible but Unseen', Rushdie conflates into Brickhall the actual neighbourhoods of Southall, Brixton and Brick Lane, areas which are home to London's South Asian, Caribbean and African migrant communities. *The Satanic Verses* engages with the experience of migration and uprootedness in the British context of Thatcherite Britain and how individuals from different regional and class backgrounds have to come to terms with their displacement and dislocation. This narrative strand is interlinked with the dream imaginary of ailing Bombay movie star Gibreel Farishta, who, in his dreams, believes himself to be the archangel Gabriel in the town of Jahilia.[1] As the narrative develops multiple strands, loosely linked through dream sequences and a proliferating doubling of names, Rushdie's use of a variety of cinematic strategies becomes increasingly evident.

In *The Satanic Verses*, we enter a narrative in which worlds collide, heaven and hell meet and a cast of characters embark on journeys of epic proportions with life-changing consequences for all involved, and which evokes a filmic landscape. Cinematic sensibilities are tangibly evident throughout *The Satanic Verses* on all levels and it is this filmic vision that aids Rushdie in making an argument for hybridity in his negotiation of migrancy. Rushdie explores here on the one hand the film-viewing practices of his cast of characters, drawn in varying degrees from Indian popular cinema, but also crosses over and fuses with European auteur cinema, in particular Fellini, Buñuel and Godard. Rushdie once noted that 'films, in *The Satanic Verses*, are invented to serve the purposes of the story. So they're an amalgam of all kinds of notions. But I think they do come out of a memory of the Indian cinema which was rather more innocent' (Rushdie and MacCabe 1996, 53). While this may be the case, Rushdie's use of the well-known story of Amitabh Bachchan's accident while shooting *Coolie*, the inclusion of contemporary gossip about movie stars and his knowledge of the complex star system of commercial Indian cinema,

reveal a deeper understanding of the industry. Rushdie also avails himself of the staple narrative elements of Indian popular cinema for his plot, such as including song sequences to structure Gibreel's dream sequences. More generally, cinema functions specifically as a structuring device and one could argue that the novel's composite parts loosely resemble the structure of a popular Indian movie.

*The Satanic Verses* is Rushdie's most hotly contested novel. In the early years of the *fatwa*, many critics took great pains to deliberately discuss the novel as a work of art independent of the controversies it sparked. This seemed a necessary step if the novel was to be debated as more than the cause of *The Satanic Verses* affair. In 1998, the Iranian government distanced itself from the *fatwa*. This has not only restored the author's but also the novel's freedom for it to be analysed as a text in literary-critical terms, not just as a controversy.[2] Yet in many popular cultural evaluations of Rushdie, the *fatwa* remains the main defining moment, rather than his wider body of literature, as was exemplified by the episode on Rushdie in the BBC radio series, 'The New Elizabethans'— also published as a book (Naughtie 2012, 268–273). A lot has been written about Ayatollah Khomeini's *fatwa*, sentencing the author, his publishers and translators to death, and about the controversy and the offending passages of the novel. Rushdie has now added his own account in his memoir, *Joseph Anton* (2012). This chapter will touch only marginally on the controversy itself.[3] Instead, by focusing on the relationship between cinema and the novel, I will draw out the politically polarising effect of its aesthetics.

## *The Satanic Verses* and Indian Popular Cinema

One of the first critics to note the intricate relationship between the novel and cinema, Sumita S. Chakravarty, opens her study, *National Identity in Indian Popular Cinema, 1947–1987*, with a short summary of the filmic elements in *The Satanic Verses*. She highlights the role the syncretic Hindi film plays in the author's imagination and, by extension, for South Asian subcontinental and diasporic audiences. As Chakravarty points out, in the whole controversy surrounding *The Satanic Verses*, little has been made of the fact that Gibreel, the dreamer of the offending passages which outraged many Muslims, was in fact a former Bombay film star. She notes further, considering the popular nature of Indian popular cinema, that to use it as 'the vehicle for one of the most evocative explorations and allegorical representations of the postcolonial consciousness' is particularly daring (1993, 1). The hybrid nature of the medium of film as an exponent of a national culture provides the perfect starting point for my discussion of the novel in the context of Indian popular cinema. And, in this respect, it is ironic that Rushdie initially considered the novel as his 'least political' (Rushdie and Wachtel 2001, 131).

In the book, Rushdie presents the preoccupations of high art—issues such as double alienation, religion, history and fiction, dreams, identity and

hybridity—through the prism of popular culture. He avails himself of the genre of the 'mythological' film, which he fictionalises as the 'theological', and its impact on the worldview of the fictional Bombay film superstar Gibreel Farishta. Although the 'theological' is Rushdie's own invention, India's commercial cinema has a long tradition of mythological films that narrate stories from the Indian epics such as the *Mahabharata* and the *Ramayana*, while other genres of film draw heavily on mythological and classical literary texts whose references are immediately obvious to South Asian audiences (see Pauwels 2007). First appearing in the era of silent films, 'mythologicals' are unique to Indian cinema; a notable early example is Dadasaheb Phalke's *Raja Harishchandra* (1913). As Rachel Dwyer has observed, 'filmic ways of viewing religious symbols and practices became part of the visual culture of Indian cinema and indeed of Indian culture' (2006, 7). This process began in the early days of cinema and continues to hold sway today, even though the production of mythological films has waned in past decades.

Cinema and cinematic storytelling are integral to the plot of *The Satanic Verses*. Both main protagonists work as actors though they have carved out differing careers for themselves: Gibreel Farishta as a mega movie star in Bombay, and Salahuddin Chamchawala in England as a radio and television actor of Indian origin, known as the man of a thousand and one voices. Many characters loosely connected with the film industry feature in the narrative, but cinema permeates the novel on many other levels as Rushdie imagines the cityscape of 1980s London like a movie set, reminiscent of film adaptations of Dickens and more contemporary imaginings of the city.[4] Rushdie writes sections of the novel in the language of cinema, using close-ups, fade-outs, montage and crane shots to build up a multifarious panorama of Bombay, London and Gibreel's dream city of Jahilia. This is particularly effective when Gibreel takes over the narrative and the story is focalised through his camera eye, tying the reader to his particular way of seeing the world. These instances are seamlessly integrated into the narrative and highlight how contemporary readers, through their own habits of film and television viewing, no longer regard a self-consciously filmic narrative as alien. It reflects how film techniques have become naturalised in the perception of our surroundings. The narrative also absorbs the melodramatic staging and dialogue of Indian popular cinema, played out in the scenes between Rekha Merchant and Gibreel (see Rushdie 1998, 26–32).

Rushdie pays particular attention to the role Indian popular cinema plays in the migrant imaginary. Indeed, scholars of Indian popular cinema have increasingly looked at its role in shaping a South Asian diasporic identity, which Marie Gillespie has explored in her fascinating study of television and video viewing habits of South Asian families in west London (Gillespie 1995). The important function that this cinema plays for its diasporic community lies at the heart of the novel's arguments on home, belonging, migration and hybridity. Rushdie expresses the importance of cinema for South Asian

migrants in renegotiating their relationship with the homeland by engaging with classic films from the canon of Indian popular cinema. For example, on his train journey down to London, Gibreel encounters John Maslama, a Guyanese Asian who emigrated to Britain and now owns several record shops as well as the infamous nightclub, the Hot Wax Club. A longstanding fan of Gibreel's movies, he admires him for portraying 'a rainbow coalition of the celestial; a walking United Nations of the gods' (Rushdie 1998, 192). John Maslama has developed in his mind a concrete representative image of Gibreel by conflating the way he circulates as a global celebrity with the roles he chooses to play in movies. From that, Maslama has taken inspiration to fashion a new life, in which Gibreel is the anchor. Gibreel is shocked as he realises that Maslama's life is nothing more than a fantasy, a fantasy perpetuated in millions of different guises by his legions of fans: 'fictions were walking around wherever he went [ . . . ] fictions walking around as real human beings' (Rushdie 1998, 192).

Here Rushdie raises important questions about the consumption of Indian popular cinema in a diasporic context and how cinema functions as a memory trigger, similar to a visualised Proustian version of the madeleine, which instantly creates a direct link with the past and home. He explores this further in a different context in the domestic setting of the Shaandaar Café, owned by Muhammad Sufiyan and his wife Hind. Before migrating to England, Muhammad had been a successful schoolteacher in Bangladesh, but his involvement with the Communist Party forced him to flee his homeland. In admiration of her husband's pluralistic mind, Hind resorts to match his ethos in her travails in the kitchen, mapping the subcontinent through her culinary eclecticism. Her expertise as an accomplished cook is the greatest asset on their migration to England where her cooking initiates a role reversal between husband and wife as she becomes the main breadwinner.

Through her cookery, Hind is the chief architect of the Shaandaar Café's success, creating a space where people from far and wide come to sample her food to remind them of home, long lost and only a distant memory. Yet her family's migration to the Vilayet has fundamentally upset her value system. She now finds herself in a hostile environment of regular racist attacks, smashed windows in the night and constant verbal abuse. She also has to confront her own community—daughters killed because of dowries and her own children assimilating into a new environment and rejecting their subcontinental origins, refusing to speak their mother tongue. As a means of countering her sense of alienation and disappointment, she indulges in a regular diet of Hindi and Bengali cinema and its gossip magazines, which allow her to 'stay in touch with events in the "real world", such as the bizarre disappearance of the incomparable Gibreel Farishta and the subsequent tragic announcement of his death in an airline accident' (Rushdie 1998, 250–251). For Hind, Bengali and Hindi movies provide a direct link to home, projected through celluloid as a dream world, an escape from the reality of living in a

hostile and alien environment. Instead, cinema provides access to a familiar world and nostalgia for a long-lost past.

## Migration and National Identity—*Shree 420* and *The Satanic Verses*

From the outset, Rushdie's narrator negotiates issues of identity. Salahuddin's and Gibreel's fall to earth after their Air India flight is blown up in mid-air by suicide bombers over the English Channel can be read as a clear break with the past, throwing up the potential for renewal. This cataclysmic event forces his migrant-protagonists to confront 'the forgotten meaning of hollow, booming words, *land, belonging, home*' (Rushdie 1998, 4, original italics). Visually and cinematically imagined, the opening scene is underscored with the Hindi movie song 'Mera Joota Hai Japani' from the 1955 Raj Kapoor film *Shree 420*, which Gibreel Farishta sings as he and Salahuddin tumble down to earth:

> 'O my shoes are Japanese,' Gibreel sang, translating the old song into English in semi-conscious deference to the uprushing host-nation, 'These trousers English, if you please. On my head red Russian hat; my heart's Indian for all that.' (Rushdie 1998, 5)

Gibreel mimics Raj, the lead character in the film, and asserts through the song a consciousness of his own Indian identity, despite wearing clothing produced elsewhere in the world. He becomes a mirror image of the film hero, Raj, and Rushdie develops an intertextual relationship between *Shree 420* and *The Satanic Verses* to link it directly with the novel's central theme, the postcolonial divided between two identities—migrant and national (see Spivak 1990, 43). It gestures towards Rushdie's notion that a hybrid identity is made up of 'whatever clothes seem to fit'. The film refracts for the novel the complex negotiations of a national identity post-Partition and post-independence which, in the Nehru era, signed itself increasingly beyond regional and national affiliations as international (see Sahgal 2010).

Notably, Gibreel sings the theme song, not Salahuddin, though the latter's experience is closer to that of Raj, finding a way to renegotiate his identity and build a bridge between his adopted British identity and Indian national identity. Salahuddin needs to come to terms with his Indian identity while redefining his affiliations to Britain and his own definition of Britishness. In order to achieve this, he needs the help of Gibreel, Zeeny, Pamela, Jumpy Joshi and, finally, his father. In these confrontations Salahuddin shows a receptiveness to experience as he successfully negotiates the field of possibilities that allows the 'mongrelisation' of his self. In the film, the song is sung by a tramp (reminiscent of Charlie Chaplin) en route to Bombay. He uses the assortment of ragged clothes that he wears as a

conduit to profess the Indianness he feels within, despite being clothed with shoes from Japan, trousers from England and a red hat from Russia. Salahuddin is hostile to Gibreel belting out this song and counters it with a rendition of 'Rule Britannia'. Thus in mid-air there is a collision between Gibreel's assured sense of Indianness and Salahuddin's insecure Britishness, defined against a firm rejection of his own Indian identity. Throughout the novel, Salahuddin's dismissal of Indianness, which for Gibreel is defined through the popular cultural texts of Hindi cinema, is constantly challenged, as he finds himself in the inhospitable environment of 1980s racist Thatcherite Britain. The questioning of identity through popular culture is further emphasised later when, during his descent into madness, Gibreel proposes list-making (favourite books, movies, female film stars, etc.). Salahuddin offers the gems of world cinema: *Potemkin, Kane, Otto e Mezzo, The Seven Samurai, Alphaville, El Angel Exterminador.* While Gibreel, accusing Chamcha of being brainwashed, lists his top ten movies as '*Mother India, Mr. India, Shree Charsawbees*: no Ray, no Mrinal Sen, no Aravindan or Ghatak' (Rushdie 1998, 439–440) and states '"Your head's so full of junk, [ . . . ] you forget everything worth knowing"' (Rushdie 1998, 440). Both lists are exclusive and Rushdie links a hotchpotch of world and Indian popular cinema, deliberately excluding Indian art house cinema from the list (Ray, Sen, Aravindan, Ghatak). They reveal that Salahuddin can put into one list the gems of various national cinemas, bridging different worlds through film, despite the noticeable absence of any attempt to connect with India. Gibreel's list, however, is exclusively drawn from commercial Indian cinema. If these lists are taken as belonging to or representing two different worlds, it is almost ironic that, in the end, Salahuddin can reconcile both worlds, the art house cinema world which he so admires with that of Indian popular cinema. The list also reveals the many cinematic influences from world cinema that resonate in the narrative.

*Shree 420* is a film about journeying and a quest for identity and finding a place in an India that is transforming after the end of colonialism. Similarly, Salahuddin and Gibreel experience a journey to selfhood in the imperial metropolis. These complex identity negotiations closely link the novel to *Shree 420*.

The main character of *Shree 420*, Raj, sells his honesty and forsakes his integrity when he cannot find work in Bombay. He enters a seedy jet-set world, decadent and corrupt, where the fraudulent businessman and the corrupt politician, conning people out of their savings, are ultimately identified as the enemy of the nation. Pitched against this is the optimistic Nehruvian vision of the nation. Salahuddin's own journeying mirrors that of Raj, but pushes the boundaries further, as it not only asks what it is to be Indian—and a good Indian at that—but also what it means to be English/British in the context of the post-imperial nation. Therefore, the novel unmasks the identity crisis of postcolonial Britain, where one's own sense

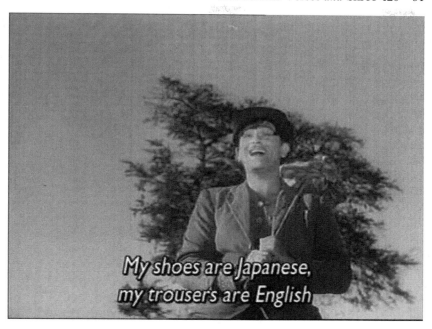

Figure 4.1  Raj (Raj Kapoor) on his journey from the countryside to Bombay, singing 'Mera Joota Hai Japani'.

of self can only be affirmed by othering and attacking the migrant community which seems to threaten received ideas of Britishness/Englishness. Salahuddin's journey is one of rediscovering and embracing his Indian roots, which he symbolically chopped off with the tree his father planted for him at birth in India. Yet he ultimately has to acknowledge that you can never completely deracinate yourself. Salahuddin needs to come to terms with, relearn and ultimately accept that his 'heart is Indian for all that'. This painful process leads to a complete reinvention, a rebirth of himself, which can only be completed through the rejection and 'death' of his former self.

By using the film as an intertext, Rushdie gestures towards the complicated body politics of the novel encapsulated in the song which opens the narrative. As Judith Butler describes it,

> The body is not a static phenomenon, but a mode of intentionality, a directional force and mode of desire. As a condition of access to the world, the body is a being comported beyond itself, sustaining a necessary reference to the world and, thus, never a self-identical natural entity. The body is lived and experienced as the context and medium for all human strivings. (1986, 38)

The song reflects this and therefore seems a fitting anthem for Gibreel to sing, an apt descriptor of Salahuddin's lived experience and, as mentioned in Chapter 2, appropriate to Saleem's journey. Rushdie only translates the refrain, but the entire song resonates with the protagonists' journeys, in the sense that it asks fundamental questions about rootedness and the responsibility of individuals for their own destiny. The song is an ode to migrancy and upward mobility but at its centre lies the acknowledgement of the hero's Indianness. It accompanies the hero's vagabond journey from rural India to the city and depicts his migration from the periphery to the metropolitan centre, also encapsulating the journey he embarks on, becoming a fraudulent businessman and forsaking his honesty and decency, which he dramatically reclaims at the end, escaping out of the net of profiteers, blackmarketeers and fraudsters, who are identified as the enemies of the young independent nation and its people.

In his essay 'Being God's Postman is No Fun, Yaar', Srinivas Aravamudan shows how the intertextuality runs further as he unravels the layers of meaning associated with connotations of the number 420 and its resonance in the novel. According to Aravamudan, the symbolism of '420' in the Indian imagination does not stem from the movie itself, but originates in the judicial apparatus installed by the British in an attempt to facilitate the governance of India, which led to the introduction of the Indian Penal Code in 1860 (1994, 191). In judicial terms, '420' is understood as a shortened reference to the section of the Code which stipulates:

> Whoever cheats and thereby dishonestly induces the person deceived to deliver any property to any person, or to make, alter or destroy the whole or any part of a valuable security, or anything which is signed or scaled [sic], and which is capable of being converted into a valuable security, shall be punished with imprisonment.[5]

Aravamudan highlights the importance of the number 420 in understanding the novel's South Asian sensibilities and deems it more important than several other untranslated and often untranslatable colloquialisms, allusions and Rushdie's choice of Hindi and Urdu words (1994, 191). Therefore Gibreel singing the song does not only transport into the novel the film and its sensibilities, but also the layered meaning of fraud associated with the number 420 as it is enshrined in the Indian Penal Code.

Looking closely at the song's refrain, Aravamudan observes that an ideologically sensitive reader would be struck by the late capitalist dichotomy the song conveys, where the nationalism of India is pitched against an emerging global market (1994, 190). While an analysis in these terms might be interesting, it is also an in-joke Rushdie has with his subcontinental readers and those familiar with Indian popular cinema, for whom the connection to the movie is immediately obvious. On the surface, Rushdie uses the

song and the film as a way of pitching the protagonist-actors' two identities against each other—Farishta chooses to sing a Hindi movie song during his unwanted sky-dive, countered by Chamcha's 'Rule Britannia'. Underpinning their spontaneous mid-air sing-song is the hold of the number 420; after all the Air India flight number is AI-420 too. Aravamudan further explains that the abbreviation 420, often cited in Indian newspapers, connotes small-scale fraud and confidence tricks, while in the popular imaginary the scope of 420 also extends to politicians and businessmen (1994, 191). But it also raises the question if Gibreel himself is nothing but a con artist. In *The Satanic Verses*, then, 420-ness features in many guises, exemplified, for instance, by the fraudulent businessman, Pakistani playboy Billy Battuta, with his sex kitten Mimi Mamulian. Rushdie connects the cultural baggage of the number 420 and its importance in the popular imaginary with that of the 1950s Hindi movie *Shree 420*, which roughly translates as 'The Gentleman Cheat'. It also highlights how these references travel beyond India and the wider significance they retain for the diaspora in the notion of Indianness they contain and describe, which echoes Salahuddin's statement: 'the earth is full of Indians, you know that, we get everywhere, we become tinkers in Australia and our heads end up in Idi Amin's fridge. Columbus was right, maybe; the world's made up of Indies, East, West, North' (Rushdie 1998, 54).

## ImpersoNation—the Star Cult of Indian Movie Heroes

*The Satanic Verses* is about journeying and migration and the effects it has on identity formations. Crucially, the main protagonists are both actors, impersonators and, to an extent, imposters. As Gibreel dreams himself into the Archangel of the Revelation, he fraudulently pretends to be someone he is not and descends further and further into madness. As Aravamudan has argued so persuasively, the bombastic re-enactment of religious mythology is 'an obvious "420-ing" of a credulous and illiterate public who worship the film star as divine incarnation' (1994, 192). Aravamudan brushes over the complex construction of the film star as avatar, elevated through his on-screen performance and his off-screen persona, largely constructed through rumour and hearsay in gossip columns in newspapers and magazines. This star image, in its scope unique to the Indian subcontinent, leads Gibreel to complete self-delusion and, ultimately, to his own downfall. The star cult that Rushdie constructs around Gibreel functions as an effective device with which his narrative enters into the dream sequences of the novel, where he imagines himself to be the angel of the revelation. However, Gibreel's own self-deception, which leads to his suicidal demise, can also be read as an open critique of the subcontinental star system, which has much wider ramifications. For example, for some stars this has translated into a political career: Nandamuri Taraka Rama Rao (also known as NTR) in Andhra Pradesh or M. G. Ramachandran in Tamil Nadu, as well as Sunil Dutt, who

represented the Congress Party in the Lokh Sabha.⁶ Amitabh Bachchan, on whom Gibreel is modelled to a certain degree, also served as an MP from 1984 to 1987, although his foray into politics was not successful, tainted by Rajiv Gandhi's implication in the Bofors scandal. Farishta is a composite of many of these figures, an amalgamation of NTR, Raj Kapoor and Bachchan, who shot to fame in the 1970s in the 'Angry Young Man' films such as *Deewar* (1975) and *Sholay* (1975). Various incidents in the novel clearly allude to Bachchan. For instance, Gibreel's accident on set that brings India to a standstill mirrors what happened when Bachchan injured himself on the set of *Coolie* (1983):

> His condition was the lead item on every radio bulletin, it was the subject of hourly news-flashes on the national television network, and the crowd that gathered in Warden Road was so large that the police had to disperse it with lathi-charges and tear-gas [ . . . ] The Prime Minister cancelled her appointments and flew to visit him. Her son the airline pilot sat in Farishta's bedroom, holding the actor's hand. (Rushdie 1998, 28–29)

Indeed, here Rushdie fictionalises accounts of Bachchan which appeared in the Indian press at the time, such as in the weekly magazine *India Today*:

> Bachchan, the near indestructible superstar who had battled seemingly insurmountable odds in thousands of celluloid frames, was fighting the most epic and riveting battle of all—for his life. [ . . . ] Childhood friend Rajiv Gandhi broke off his trip to the United States [ . . . ] [A]mong Prime Minister Indira Gandhi's first appointments after her return was a flying visit to see the stricken star. (Bob, Singh and Abraham 1982, 32)

Furthermore, Gibreel's ill-fated affair with Rekha Merchant, who is his lover in Bombay, also gestures towards real-life parallels with Bachchan—her name references 1970s Hindi film superstar Rekha, with whom Bachchan is rumoured to have had an affair.

Rushdie develops the links between seemingly disparate narrative strands, creating Gibreel as a composite figure of several public personae while overtly making use of the star cult of Indian popular cinema and the conventions of its production. He draws on elements of recognisable figures from Indian public life, which immediately resonates with his subcontinental readership and plays mischievously with the public perception of the movie star as halfway between the human and the divine—the very trigger for Gibreel's self-delusion. Rushdie draws on the constructions of these actors' public images, which can be read as the portrayal of a composite national personality as mass culture (Chakravarty 1993, 134). Actors harness the symbolic construction of their star persona and the characters they portray on celluloid, a point

I will discuss further in the next chapter in relation to the actress Nargis and the film *Mother India*.

Vijay Mishra's observations on the unique nature of the subcontinental star cult help to further open up the multi-layered complexities of Gibreel in *The Satanic Verses*. He argues that Bombay cinema puts forward a certain ideology where particular emphasis is placed on the received idea of dharma. According to Mishra, this is important in Hindi cinema's melodramatic staging where high metaphysics, the domain of the absolute, are staged as a revisionist ideological system, reinforcing the essentialisms of the Hindu world order through its own authorised identities, such as the filmic hero. Hence, this has allowed the star to become a political hero as well, as it 'has even elided the differences between cinema and politics' (Mishra 2002, 49). Ultimately, Mishra argues, 'the star personality traduces and takes over real history' (ibid). Rushdie translates this through Gibreel Farishta, who plays a central role in the commodification of ancient religion and myth, as interpreted and commercialised by television and cinema. Here, the Bombay movie actor, via a density of allusions, becomes a cultural transmitter. In this respect, Gibreel emanates and captures countless bits and fragments of a collective national life ranging from political intrigue and lurid journalism to gossip; Gibreel transforms into 'as mercurial a narrative surface as the cinematic consciousness he embodies' (Chakravarty 1993, 3). His audiences can project onto him and live several identities through him, ranging from romantic hero to mythological figure, Muslim to Hindu. Ultimately he cannot reconcile this multiplicity, which leads to his schizophrenia and destruction. Thus Hindi cinema, its industry and the way it is consumed, has a very specific function in the construction of the multifaceted character of Gibreel Farishta and how he drives the narrative forward. It then follows that through the character of Gibreel we can map out a space for the discussion of the novel within the framework of cinema.

As I have shown in the earlier discussion of *Midnight's Children* and *Shame*, Rushdie is acutely aware of the role of Indian popular cinema during the nation-building process of the late 1940s and 1950s. During that decade, India sought to break away from its colonial past to invent a postcolonial identity, its myth of nation outlined, for example, in the Nehruvian vision of the nation as socialist and secular, where people of all backgrounds co-exist harmoniously and prosper. This aspiration, which was promoted vigorously in 1950s and early 1960s Indian popular cinema, often takes centre stage in Rushdie's writing. However, Rushdie deploys this in a deliberately ironic way to critique the failure of politicians to realise this vision, as it does not reflect India's postcolonial post-independence reality. Hence he questions not only the reality of the All-India idea, but also constructions of a national identity which has increasingly signed itself as specifically Hindu. In *The Satanic Verses* Rushdie moves away from debunking India and Pakistan's 'myths of nation' as his narratorial emphasis shifts away from the subcontinent to the

diaspora in an exploration of complex identity crises brought on by the process of migration. Rushdie forcefully translates these concerns through the medium of Indian popular cinema into the protagonists' protracted searches for roots and belonging in a hostile environment, away from home, that become crucial struggles for survival.

## Film Songs, Dreams and the Role of Women

Rushdie uses the filmic song and dream sequence as a narrative device and integrates it into his narrative structuring. Given how steeped Gibreel is in the Indian commercial film world, it is no coincidence that this medium should impact on the way he expresses the dream world of Jahilia. Yet it also creeps into the contemporary world he inhabits. For instance, the narrator deliberately references Indian popular cinema in his retelling of the Rekha-Gibreel affair, which mirrors the actual gossip that surrounded the rumoured Rekha-Amitabh affair. He makes a particular connection to the film *Mughal-e-Azam* and the iconic moment when the film switches from black and white to Technicolor for the spectacular dance number in the emperor's mirror palace, where the film song plays an important role. Rekha and Gibreel use the film as a way to understand and explain their own relationship of secret love. The ghostly Rekha, who pursues Gibreel on her magic carpet, invokes the film by likening herself to Anarkali, whose love for Prince Salim is also forbidden:[7]

> All that night he walked the streets [ . . . ] while Rekha [ . . . ] serenaded him with the sweetest love songs [ . . . ] such as the defiant air sung by the dancer Anarkali in the presence of the Grand Mughal Akbar in the fifties classic *Mughal-e-Azam*, [ . . . ] 'Pyaar kiya to darna kya?'—[ . . . ] *why be afraid of love?* and Gibreel [ . . . ] felt the music attaching strings to his heart and leading him towards her, because what she asked was [ . . . ] such a little thing, after all. (Rushdie 1998, 334)

The film song here dramatises the question of love and rejection between the two and is comforting for Gibreel in his moments of doubt. However, Rekha's singing is interrupted as a different voice from his dreams intrudes.

Song and dance sequences are an integral part of Indian popular cinema. Film music displays a certain eclecticism and synthesis, not only in the picturisation of the song, but also in the composition itself. Hindi film music is arguably a meeting of East and West in its borrowing of traditional Indian musical elements, like sitars and tablas, Western instruments including violins and guitars and an increasing use of electronic instruments, such as synthesisers and electronic guitars. In this respect, this music can be seen as a site where, through an agglomeration of diverse cultural tradition—Eastern and Western, modern and traditional, urban and rural—we see most potently India's emerging and evolving regional, national and international identity

(Kabir 2001, 184). This is particularly evident for example in the work of composer A. R. Rahman (whose music was profiled in the Andrew Lloyd Webber-produced West End and Broadway musical *Bombay Dreams*), the composer trio Shankar-Ehsaan-Loy (credits include *Mission Kashmir* [2000], *Dil Chahta Hai* [2001] and *Luck by Chance* [2009]) and Anu Malik.

Songs fulfil multiple functions in Indian popular cinema and have a separate resonance for audiences beyond the aural visual experience of film viewing. Filmmakers use songs to define the meaning of love, describe many shades of emotion, to eulogise the beauty of the beloved or to convey the pain of separation. They provide a way of conversing and coercing through poetry as well as glorifying the splendour of nature (Kabir 2001, 179). Yet Indian popular cinema does not only express this through music alone, but also through the way the song is visualised/picturised for the audience and enacted by actors through dance. Similar to the songs, South Asian and Western dance traditions have increasingly influenced choreography in Indian popular cinema and look like hybrid fusions of the two (Kabir 2001, 188; David 2010). Songs in films happen during particular stock situations and established scenes such as dream sequences. Directors like Mani Ratnam and choreographer-director Farah Khan have been highly inventive in their song picturisations, for example in *Dil Se* (1998) or *Om Shanti Om* (2007). Through a particular staging they use the song to display the heightened inner emotions of characters. Rather than an emotional showstopper, the song becomes a way of driving forward the narrative through an affective aural/visual viewing experience underscored by music and poetic lyrics.

In *The Satanic Verses*, Rushdie expresses Gibreel's inner emotions through his dreams, which are a shaping agent for his increasingly destabilised sense of identity (1998, 92). The awareness of his dreaming self and the arrival of a dream version of Mohamed trigger Gibreel to ask: 'Question: What is the opposite of faith? Not disbelief. Too final, certain, closed. Itself a kind of belief. Doubt' (ibid). Gibreel Farishta suffers from a profound loss of faith in the wake of a movie star career where he has played too many gods. As a consequence, he keeps asking himself probing questions about the nature of absolute faith as he imagines the early history of a religion of submission that closely resembles Islam. This serious interrogation leads to his very personal and internalised crisis. Movie star that he is, even in his dreams he cannot escape the filmic idiom:

> Gibreel: the dreamer, whose point of view is sometimes that of the camera and at other moments, spectator. When he's a camera the pee oh vee is always on the move, he hates static shots, so he's floating up on a high crane looking down at the foreshortened figures of the actors, or he's swooping down to stand invisibly between them, turning slowly on his heel to achieve a three-hundred-and-sixty-degree pan, or maybe he'll try a dolly shot, [ . . . ] or hand-held with the help of a steadicam he'll probe

the secrets of the Grandee's bedchamber. But mostly he sits on Mount Cone like a paying customer in the dress circle, and Jahilia is his silver screen. He watches and weighs up the action like any movie fan, enjoys the fights infidelities moral crises, but there aren't enough girls for a real hit, man, and where are the goddamn songs? (Rushdie 1998, 108)

However, in these dreams Gibreel soon needs to leave his place on Mount Cone, his dress circle, as he is not only spectator, but also a central player, the star in this movie dream, forcing him to take on too many roles yet again.

The manifestation of his doubt in the dream exposes Gibreel's anxieties: 'the fear of the self his dream creates' (Rushdie 1998, 109). Gibreel feels ill-prepared to take on the role of the angel of the revelation: *'I'm just some idiot actor having a bhaenchud nightmare, what the fuck do I know, yaar, what to tell you, help. Help'* (ibid, original italics). In this confrontation Gibreel has to face up to the fundamental question of his own identity and his relation to god and religion. He feels paralysed in the presence of Mahound, but then the words flow, much to his surprise, though he does not feel he is in control, leaving him to conclude, 'Being God's postman is no fun, yaar. [ . . . ] God knows whose postman I have been' (Rushdie 1998, 112). The role of archangel that Gibreel enacts in his dreams has a destabilising effect on his grip on reality, which is linked to the forced revelation to the prophet on the role of the female pagan idols, the episode of the satanic verses. The crisis in his dreams is related to the role of women in his life and his dreamed revelation of a religion of submission. Through his relationship with Alleluia Cone, Gibreel regains a certain groundedness and rootedness in reality that has been upset by his loss of faith. Yet here Rushdie interlinks more broadly the female characters and the effects they have on the male protagonists. For example, Salahuddin needs Pamela Lovelace to affirm his Englishness—she is his Britannia; when their relationship breaks down Zeeny Vakil helps him reclaim and regain his Indianness on his return to Bombay—she becomes his Mother India.[8] In the Shaandaar Café, Hind's cooking encapsulates the entire subcontinent for her husband, family and the migrant community in Brickhall who congregate regularly in the café to refresh their memory of home through food. Thus the importance of woman as safe haven and guardian in whom the values of the nation are enshrined takes on wider meaning.

In the 'Jahilia' section, Al-Lat and Hind become the ultimate temptresses, standing as an opposite, independent organisation of morality and, therefore, a threat to the new religion which needs to be crushed. The struggle between Allah and Al-Lat that is fought out in Mahound's head sparks the satanic verses episode. Sara Suleri in *The Rhetoric of English India* suggests that this can be contextualised within 'the cinematic crossings between delusion and desire that the theologicals represent to the Indian subcontinent' (2005, 201). Writing a novel that draws from the mythological is audacious insofar as depictions of Allah and his prophets are prohibited in Islam. Furthermore, the

book is a larger exploration of religion and mythology in relation to nationalism and identity, which Rushdie already thematises in *Midnight's Children*, for example through the loss of faith of Aadam Aziz and the Sabarmati case. By invoking the mythological in the dream sequences and the 1950s social film, Rushdie deals with different aspects of Indian popular cinema. As Rachel Dwyer notes: 'The idea of the nation has not always been central in Indian cinema, as has often been suggested by the examination of certain key films, but has been found in specific films at given times, notably the 1950s' (2006, 2). Indeed Rushdie refers most overtly to 1950s cinema through his choice of filmic intertext, *Shree 420*. Yet, by drawing attention to the mythological film in the dream sequences, Rushdie further highlights the difficult question of secularism and religion which he has already debated in *Midnight's Children*. The use of cinema in such a rigorous questioning seems enabling as it highlights how these debates are approached through a medium that, as Dwyer notes, has been regarded as 'India's great experiment to fashion an Indian modernity' (2006, 4).

Dwyer defines the mythological 'as one which depicts tales of gods and goddesses, heroes and heroines mostly from the large repository of Hindu myths which are largely found in the Sanskrit Puranas, and the Sanskrit epics, the *Mahabharata* and the *Ramayana*' (2006, 15). Rushdie draws from this conceptualisation of Gibreel Farishta as the archangel who becomes his actual manifestation in the dream sequences. Yet in Gibreel, Rushdie also includes the figure of 'The Angry Young Man' as personified by the young Amitabh Bachchan in the early 1970s in films such as *Deewar* and *Sholay*. This figure became a popular avatar in Indian popular cinema, especially during the years of the Emergency. The Angry Young Man describes a man wronged by society who fights to re-establish a moral code. Arguably Gibreel is an inversion of this figure, as he fails and commits suicide. This crisis and failure manifests itself in the dream sequences, which function as 'an elaborate and lengthy piece of surrealism to denote the tortured state of mind of the hero' (Chakravarty 1993, 139). They include Mahound's own dilemmas, be they moral, intellectual or practical, which are brought out by his wives Khadijah and Ayesha and are implicitly mirrored by the whores in 'The Curtain' and their impersonation of the prophet's wives, and in the 'Ayesha' section by Ayesha and Mirza Saeed's wife Mishal,[9] who represent unshakeable faith, as opposed to Mirza Saeed's secular modernity.

The role of women in the 'Ayesha' section is particularly striking. Sara Suleri links the questions of faith that run through the novel with the role of women in the dream sequences and shows how women are instrumental in throwing light on the novel's obsessive question *'What kind of idea is he? What kind am I?'* that is again reiterated in 'The Parting of the Arabian Sea' section (Rushdie 1998, 500, original italics). Suleri sees the 'Ayesha' section as a modern retelling of the satanic verses episode in a contemporary cultural context. The inherent blasphemy in these parts is, according to Suleri,

100  *Fiction, Film, and Indian Popular Cinema*

'an enabling conceit, allowing the narrative to assume the highly ambitious task of rewriting the fiction of Muslim nationhood in India, and in so doing, attempting to locate an idiom for the feminization of Islam' (2005, 198). In this respect, the 'Ayesha' section needs to be read as an attempt at gendering religion, where a decentring of the grand narrative of Islam in Gibreel's dream through the story of Mahound is, as Suleri suggests, subsequently reshaped in the body of a woman (2005, 202).

The Ayesha episode is loosely based on the Hawkes Bay case of February 1983 and focuses on the powers of absolute faith.[10] Like the 'Jahilia' sections, Rushdie dramatises the struggle between faith and doubt, enshrined in the novel in the oft-used opening of Arabic folktales: *'Kan ma kan/ Fi qadim azzaman* . . . It was so, it was not' (Rushdie 1998, 143).[11] The ambiguous conclusion of that narrative thread in 'The Parting of the Arabian Sea' section also provides a narrative bridge for the theme of forgiveness that prevails at the end of the novel. Through Ayesha, Rushdie ruptures and re-examines the closure and rigidity that concluded the 'Jahilia' section.

The female characters, then, play a significant role in the way Rushdie structures his argument and shapes his narrative, as they destroy grand narratives of history and religion. Yet women also play an important role in how human beings become whole again, through the love of god or through the love of their fellow men and women (Rushdie 1992a, 395). As women shape the narrative, the mapping of the female body via a male voyeuristic gaze, as regularly featured in Indian popular cinema, serves a distinctive and specific function, explaining where Rushdie directs his novelistic camera lens (Rushdie 1998, 216–218). The direction of this gaze is often invested with a social significance, something that is mirrored by the proliferation and doubling of names. Martine Dutheil de la Rochère's observation on the treatment of the 'Ayesha' story is, therefore, all the more significant as it showcases the multiple layers of the novel: The section is drawn from a real event, narrated as a dream that is 'embedded' in fiction and then recycled as Gibreel's comeback movie (Dutheil de la Rochère 1999, 148). As the narrator notes,

> his first film, *The Parting of the Arabian Sea*, had bombed badly; the special effects looked home-made, the girl in the central Ayesha role, a certain Pimple Billimoria, had been woefully inadequate, and Gibreel's own portrayal of the archangel had struck many critics as narcissistic and megalomaniac. (Rushdie 1998, 513)

The badly made film based on Gibreel's dream is emblematic of the reverse process of Rushdie's own narrative method in *The Satanic Verses*, where he recycles and adapts a 'theological/mythological' movie, cross-fertilises it with 'real' events and narrates it as fiction.

As my discussion has shown, film permeates the novel at the level of narrative argument, plotlines, characters as well as architecture. Crucial to its

nine-part structure are the dream sequences—Mahound (II), Ayesha (IV), Return to Jahilia (VI) and the Parting of the Arabian Seas (VI)—which punctuate the sections set in London and Bombay. Rushdie specifically deploys a narrative version of dream sequences to investigate issues of morality, religious doubt and social injustice, breaking taboos as the opinions of many are allowed to collide in the arena of Gibreel's imagination. In Indian popular films, song and dance sections puncture the action and these, too, often take place in the hero's or heroine's imagination. In condensed form, these songs as dreams express fears and anxieties on themes such as love, religion, motherhood, crime and punishment.[12] Mani Ratnam's film *Dil Se* is a good example; the hero, an All-India Radio reporter, falls in love with a suicide bomber and the song and dance sequences translate his fantasy of their togetherness onto the screen.

Song picturisation in Indian popular cinema provides a way of expressing the erotic that would otherwise be prone to censorship, as discussed already in the previous chapter in relation to *Midnight's Children* and the episode of the indirect kiss in the Pioneer Café. The dream sequences have a similar function in *The Satanic Verses*, and are Rushdie's most explicit indicator of how they echo song picturisation in Indian popular cinema (see Rushdie 1998, 497–498).

In his groundbreaking *The Painted Face: Studies in Indian Popular Cinema*, Chidananda Das Gupta elaborates on the unique features of the filmic song. He sees song picturisation as one of the ways this cinema attempts to overcome realism and naturalism and creates a mythic space for discourse which, Das Gupta argues, allows the filmmaker to turn fact into fiction: 'the present tense

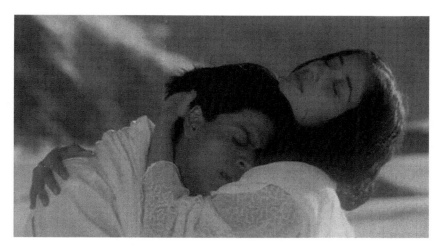

*Figure 4.2*   Actors Shah Rukh Khan and Manisha Koirala performing the song 'Satrangi Re' from *Dil Se*.

of the camera eye into the past and the future' (1991, 59). The songs, then, can be seen as the transcendental element in the language of Indian popular cinema, as it 'explains hidden meanings; comments, like a chorus, on the worth or consequences of an action, beside providing aural enchantment to the otherwise music-less urban world of its rural grassroots' (Das Gupta 1991, 60). In many ways, Gibreel's dreams echo the function of the film song, considering how Rushdie sets up Gibreel's dreamscape as a mythic space to question absolutes—especially the claim for absolute truth that disavows any other point of view relating to issues of purity and morality in the context of religion, which are most explicitly discussed in the 'Return to Jahilia' section.

The dream sequences provide an 'alienation effect', yet the concerns of writing are invested with new immediacy through the scribe Salman the Persian, Rushdie's namesake, and the poet Baal, both offering illuminating comments on the nature of the act of writing and literature. So while the authorial voice distances itself from the written word through the dreams, the character of the poet directly imparts these preoccupations to the reader. These sequences are supposed to create distance, yet they are also designed to provide a space where the unthinkable might be debated in a space of licentious enquiry. In the event, though, they did not have the desired effect as these sections sparked the controversy that developed into the Rushdie/ *The Satanic Verses* affair.

In his essay 'In God We Trust', Rushdie has outlined the significance of dreams and dreaming, deeming the process a fundamental part of what makes us human (1992a, 376–392). Through self-consciousness, we have the ability to dream versions of ourselves, allowing us to reinvent ourselves. Hence, mankind's response to the world is '*imaginative*: that is, picture-making. We live in our pictures, our ideas' (Rushdie 1992a, 377–378). Rushdie likens this capability to the Hindu idea of *maya*. In Hinduism and vedic philosophy, *maya* refers to the illusion of a purely mental and physical reality where the true unitary self has become veiled. *Maya* must be seen through in order to glimpse transcendental truth. Hence, Rushdie argues, this veil of illusion prevents us from seeing things as they truly are, so that we mistake the veil, *maya*, for reality, leading him to conclude that dreaming, as much as being man's gift, 'may also be his tragic flaw' (1992a, 378). In many ways, he explores this notion through Gibreel's journey and his imagination. In its exploration of religion, Rushdie argues that, while political dreams—usually associated with dreams of improvement, betterment and progress—place the human spirit in a position of power, the great universal religions ask mankind to accept inferiority to 'a non-corporal, omnipresent, omnipotent supreme being' (ibid). Hence, religion places human beings beneath history. Gibreel wrestles with this, being halfway between the human and the divine, and his loss of faith is the way into this struggle. The dream sequences make this battle concrete through a cinematic imaginary, in the filmic picturisation of dreams and the visualisation of women.

The use of the filmic song as it is translated into prose is interesting for another reason. *The Satanic Verses*, more overtly than any other Rushdie novel, is permeated by cinema, structurally as much as where plotlines and characters are concerned. It is the first novel to translate the filmic song into the novel text and can be seen as a foreshadowing of the move away from the cinemascope way of storytelling that started in *Midnight's Children* to a more polyphonic method exemplified in the rock and roll epic *The Ground Beneath Her Feet*.

## Hybridity, Cultural Identity and Diaspora

In his essay 'In Good Faith' Rushdie defends *The Satanic Verses* as 'a migrant's-eye view of the world' written from the very experience of uprooting, disjunction and metamorphosis with which he equates the migrant's condition. He argues:

> *The Satanic Verses* celebrates hybridity, impurity, intermingling, the transformation that comes of new and unexpected combinations of human beings, cultures, ideas, politics, movies, songs [ . . . ] *The Satanic Verses* is for change-by-fusion, change-by-conjoining. It is a love-song to our mongrel selves. (1992a, 394)

However, judging by the harsh reaction the novel provoked, many questioned Rushdie's view that this form of intermingling, dabbling in two cultures, is possible. Nevertheless, even though sections of the community Rushdie addressed were alienated by his explorations of the theme, its characters act out and explore the effects and consequences that this possibility of interconnection opens up. The two protagonists are each other's nemesis and represent extremes, one transforming into the archangel Gabriel, the other into Satan. They act out their battle for centrality against the backdrop of the racial tensions of 1980s London. Their confrontation links up with their identity negotiations, exposing Britain's attitudes to immigration, exile and race. Although Gibreel and Salahuddin are opposites, they need each other to complete their journey of self-discovery to reconcile what Rushdie describes as 'two painfully divided selves' (1992a, 397). Despite Gibreel playing a multiplicity of gods in his movie career, his attempt at negotiating this diversity in his own life fails. Gibreel needs to maintain continuity, 'joined to and arising from his past' (Rushdie 1998, 427). As Gibreel's dreams leak into his waking self, it leads to his downfall in a story of betrayal, where the boundaries between the real and the dream world become indistinguishable. The concept of time and place, reality and imaginary, collapse, and distinctions between them become impossible. Gibreel in that respect is a parallel figure to Saleem Sinai in *Midnight's Children*. While Gibreel operates in a largely diasporic context, Saleem stresses his continuity with the Indian

nation in his attempt to absorb its totality into his being. He also fails, which leads to his disintegration.

Pitted against this is Saladin-Salahuddin, 'a creature of *selected* discontinuities, a *willing* re-invention; his *preferred* revolt against history being what makes him' (Rushdie 1998, 427, original italics). Yet the acceptance of these discontinuities is not a given, but part of a process of painful learning which begins at the outset with his fall from the plane. Perhaps the acknowledgement of discontinuity needs to be read as the acceptance of a metaphorical death of a previous self, the prerequisite for transformation and being born again, which prepares the way for Salahuddin's redemption. This process of self-realisation and acceptance leads him to reconcile himself with his Indian identity. Salahuddin's identity is divided into his secular and societal self, torn between his Indian past and his new life in Britain, the clash between Bombay and London, while Gibreel's division is spiritual. As Rushdie explains, he is 'strung out between his immense need to believe and his new inability to do so' (1992a, 397). Salahuddin succeeds and survives as he returns to his roots through the process of 'facing up to [ . . . ] the great verities of love and death' to regain a new sense of self (Rushdie 1992a, 398). For Gibreel, this possibility is foreclosed.

Gibreel's quest fails as he cannot cope with the discontinuities in his life. The inevitable renegotiation of identity in the face of migration, the diaspora experience, is here defined through recognising a necessary heterogeneity and diversity with which Gibreel cannot cope. As Stuart Hall famously described it, this notion of identity 'lives with and through, not despite, difference; by *hybridity*' (1993, 402). This gestures towards the transformative quality of identity negotiations at home and abroad, and links to Rushdie's conceptualisation of continual reinvention already prevalent in *Midnight's Children*. In *The Satanic Verses* it finds its expression through Zeeny Vakil's approach to art as an aesthetic concretisation of such regeneration, questioning the defining myth of authenticity, 'which she sought to replace by an ethic of historic eclecticism, for was not the entire national culture based on the principle of borrowing whatever clothes seemed to fit, Aryan, Mughal, British take-the-best-and-leave-the-rest?' (Rushdie 1998, 52)

Rushdie's notion of mongrelisation echoes what Stuart Hall describes as the aesthetics of the 'cross-overs', of 'cut-and-mix' (1993, 402). This is perhaps best exemplified by the sense of belonging and alienation experienced by second-generation migrants and aestheticised in music and film, such as the 'cross-over' movies of Gurinder Chadha, *Bhaji on the Beach* and *Bend It Like Beckham*, or Stephen Frears's and Hanif Kureishi's *My Beautiful Laundrette* (1985). In the novel, Mishal Sufiyan and her sister feel completely alienated from Bangladesh, the place their parents still see as home and desperately try to keep alive in the Shaandaar Café. Both daughters see themselves as English/British. For their mother Hind, observing the change in her daughters is a painful process (Rushdie 1998, 250). The two realities of Britain and

concepts of Britishness, one idolised by Salahuddin and the other as lived by Anahita and Mishal, clash in the Shaandaar Café:

> 'What about us?' Anahita wanted to know. [ . . . ] And Mishal confided: 'Bangladesh in't nothing to me. Just some place Dad and Mum keep banging on about.' [ . . . ]
> But they weren't British, he wanted to tell them: not *really*, not in any way he could recognize. And yet his old certainties were slipping away by the moment. (Rushdie 1998, 259)

The process of identity formation as it clashes between the second generation and the first in an alien space is linked here to what Chakravarty refers to as 'the problematic scenario of originary desire' (1993, 3). This certainly holds true for Hind and could be extended to Gibreel, while Salahuddin has renegotiated his identity by marrying the English Pamela Lovelace, but also shows the city as a space of 'incompatible realities', in Otto Cone's words (Rushdie 1998, 314).

In *The Satanic Verses* the metropolis takes centre stage in many incarnations—Bombay-London-Jahilia—and the characters transform and invent the city as an imaginary, disjunctive space. In this respect, the urban in its literary-visual representation also echoes its uses as a filmic backdrop in Indian popular cinema within and against which identity formations play out. As Rukmini Bhaya Nair and Rimli Bhattacharya put it in 'Salman Rushdie: The Migrant in the Metropolis', the city is the greatest tangible symbol of human inventiveness, which makes it therefore the 'natural' setting for this process of identity formation (1990, 18). Yet this idea is not without problem since it does not account for migratory processes that do not end in the metropolitan centre but on its periphery, an issue which Rushdie touches on in the Rosa Diamond episode.[13] Clearly though, Rushdie argues that the best place for a renegotiation of identity is the multifaceted, palimpsestual metropolitan space where many realities co-exist side by side and, on occasion, intersect, overlap or clash. Rushdie uses the artificiality, the constructed, constructive and destructive nature of the cityscape as the backdrop against which identity politics play out, because the city is a malleable space allowing for non-stop transformation. Thus, 'A City Visible but Unseen' with the other London sections make up the most substantial part of the novel, highlighting the centrality of the theme of migrancy. Migratory processes imply movement from the periphery to the centre. In *Midnight's Children* and *The Moor's Last Sigh* Rushdie sets up Bombay as the metropolitan centre at a national level, one which has always drawn rural populations from all over India, foregrounding it as a syncretic multi-ethnic, multi-religious city, home to a large migrant community. Bombay features as the 'most cosmopolitan, most hybrid, most hotchpotch of Indian cities' (Rushdie 1992a, 404). In *The Satanic Verses*, Rushdie destabilises the centrality of Bombay by drawing parallels and contrasts

with London, which becomes the capital of 'Vilayet' in the novel's global context. Here, Bombay is the metropolis on the periphery, with London—the former capital of Empire, a city of migration and, in particular in the post-imperial context, a conflictual urban landscape and contact zone—taking centre stage. Implicitly, Rushdie shows how the centrality of the metropolis at a national and international level is in flux as the processes of globalisation impact on patterns of migration.

In 'DissemiNation: Time, Narrative and the Margins of the Modern Nation', Homi Bhabha shows in interesting ways how *The Satanic Verses* subverts the colonial space to play out in the imaginative geography of the metropolis 'the repetition or return of the postcolonial migrant to alienate the holism of history' (1994, 168). He observes that, as a consequence, the postcolonial space is no longer supplementary to the metropolitan centre, but 'stands in a subaltern, adjunct relation that doesn't aggrandize the *presence* of the West but redraws its frontiers in the menacing, agonistic boundary of cultural difference that never quite adds up, always less than one nation and double' (ibid). Indeed, *The Satanic Verses* shifts fluidly between various metropolitan centres of Bombay, London and the imaginary dream-space of Jahilia. In these realms, Rushdie creatively negotiates the migrant condition and the process of deracination in opposition to rootedness. Yet the reader encounters a nightmarish image of London rather than the 'reality' of a 'respectable' London as it is imagined and projected by Salahuddin. He flies out of his window at night 'to discover that there, below him, was—not Bombay—but Proper London itself, Bigben Nelsonscolumn Lordstavern Bloodytower Queen. [ . . . ] [D]own towards the city, Saintpauls, Puddinglane, Threadneedlestreet, zeroing in on London like a bomb' (Rushdie 1998, 38–39). Salahuddin maps the capital of the 'Foreign Land' as he zooms over it in his dreams. For Gibreel too the city represents an idealised reality: 'Proper London, capital of Vilayet' (Rushdie 1998, 4).

The novel's opening sets up a positive image of London that, as the action progresses, becomes increasingly unstable, and is linked to the destabilising of the protagonists' identities. This is perhaps best exemplified by the magic carpet chase through the city in the 'Ellowen Deeowen' section, reminiscent of a filmic car chase, a mapping of the city through a linguistic A to Z of London. It illustrates not only a sense of space, but Gibreel's transforming vision of the city reflective of his increasingly unstable mind as he flees the spectre of his spurned lover Rekha Merchant, who haunts him by following him everywhere on her magic carpet. This chase scene finds its doubling in the 'Ayesha' section. Gibreel dreams that he is flying back the Imam, a barely disguised fictional version of Ayatollah Khomeini, exiled in London and longing for his homeland, Desh (Rushdie 1998, 206). As the dream progresses, Gibreel takes on the point of view of the camera eye/I as they 'zoom through the night' flying back to Desh, and an immense cinematically visualised landscape emerges (Rushdie 1998, 208–215).

As Nicholas D. Rombes has suggested, this landscape is an image 'presented on a plane in which the foreground and background tend to gravitate towards each other, reducing three-dimensional images to two-dimensional ones' (1993, 49). This is crucial in producing the desired '2D' effect associated with cinema in its aerial shots, flattening out the landscape. Rombes shows that Rushdie uses aerial shots preferentially at the expense of 'intimate proximity' (ibid). This explains the use of metaphors of flatness and depthlessness as a way of highlighting the limited capability of the camera's understanding. For Rombes, this dichotomy explores 'the potential dangers of "one way of seeing" suggested by the camera perspective as well as [ . . . ] raise[s] questions about how all of the ways in which to manipulate the camera render it a possible tool for exploitation' (1993, 52–53). However, Rushdie counters this picturisation with that of London. Initially set up as the ideal Vilayet of the migrants' dreams, Rushdie exposes the city as a hostile and inhospitable environment. In the end, London is revealed as a depthless wasteland. In the central section of the novel 'A City Visible but Unseen', London is not the promised land at all, as Hind and her husband realise: 'they had come into a demon city in which anything could happen' (Rushdie 1998, 250).

References to phantom imps, ghosts and demons further highlight the *unheimlich*, in the sense of the 'unhomely' of the new host country. As Salahuddin transmutes into the devil, complete with goatee beard, hooves and horns, London, too, exposes its increasingly malevolent side: 'Yes: this was Hell, all right. The city of London, transformed into Jahannum, Gehenna, Muspellheim' (Rushdie 1998, 254). The city's 'unhomeliness' is further highlighted by evocative descriptions: 'The sun rose, unwrapping the misty city like a gift' (Rushdie 1998, 254), or the city thickening 'around them like a forest; the buildings twined together and grew as matted as her hair' (Rushdie 1998, 255). These intensely visual descriptions set the sinister mood of the section and are evidently cinematically invested. Yet they also recall the evocative descriptions of this cityscape by Charles Dickens. Rushdie's description of London, then, provides a narrative backdrop and locality where he exposes the overt racial tensions on the city's fringes. The locked-up anger explodes nightly in the Hot Wax Club by providing a counternarrative to received notions about the immigrant community (Rushdie 1998, 291–293). Here, too, the city is exposed as a complex, labyrinthine nexus. Otto Cone sums this up best in his idea of the modern city as 'the locus classicus of incompatible realities. Lives that have no business mingling with one another sit side by side upon the omnibus. [ . . . ] But if they meet! It's uranium and plutonium' (Rushdie 1998, 314). Cone's prophetic assumption finds its concrete expression in the transformation of London into a space which, similar to the novel's main protagonist, has lost a sense of itself, 'and wallowed, accordingly, in the impotence of its selfish, angry present of masks and parodies, stifled and twisted by the insupportable, unrejected burden of its past, staring into the bleakness of its impoverished future' (Rushdie 1998, 320). Rushdie

describes the city's own divided self, struggling with coming to terms with its imperial past, its postcolonial present and subordinate future, which links to the manner in which 1980s London refused to confront its multi-layered, chequered history. As the stuttering movie producer Whiskey Sisodia remarks, 'the trouble with the Engenglish is that their hiss hiss history happened overseas, so they dodo don't know what it means' (Rushdie 1998, 343).

Gibreel, then, is on a mission to reclaim the city and redeem it by exploring London from A to Z. What follows is a detailed mapping of the city where the breakdown of dream and reality becomes ever more disturbing as Gibreel's mind deteriorates (Rushdie 1998, 327). His comeback, carefully orchestrated by Whiskey Sisodia, ends in disaster, as Gibreel levitates out of the auditorium and looks down on London. In a moment of celestial delusion and in an attempt to turn London into Bombay, he then decides to tropicalise the city: 'Gibreel Farishta floating on his cloud formed the opinion that the moral fuzziness of the English was meteorologically induced' (Rushdie 1998, 353–354). Gibreel interlinks Sisodia's pronouncements on history and Otto Cone's deliberations on the city with his own observations on the weather. For Gibreel, it emblematises the widening gap between reality and illusion that threatens to swallow Gibreel, Salahuddin and London whole. His attempts at tropicalisation, then, are his ambivalent expression of his own cultural difference. Through the metaphor of the English weather Gibreel evokes an ambivalence, which Homi Bhabha describes pertinently as 'the most changeable and immanent signs of national difference' (1994, 169). Not only does this section conjure up stereotypical images of England—wind-battered shorelines and rainy, grey days—but, Bhabha suggests, it pitches it against a 'daemonic double': 'the heat and dust of India; the dark emptiness of Africa; the tropical chaos that was deemed despotic and ungovernable and therefore worthy of the civilizing mission' (ibid). Bhabha sees these imaginative geographies in flux as they assemble in the city, since the migrants, the minorities and the diasporic come to the city and change the history of the nation. This transformation of perceptions of history and the need to reassess national histories in the wake of migration accounts for the shifting perceptions of London and Bombay. Furthermore, Rushdie interlinks it with a social commentary on Indian politics in the final section of the novel, as well as the romanticised image of London as it exists in the Shepperton Studios and its juxtaposition with the mutant version outside.

The movie studio representation of London that features in 'The Angel Azraeel' section is a two-dimensional re-creation of a Dickensian London, reminiscent of any BBC costume drama. This stereotypical representation of London subverts the imaginary cityscape as it has featured so far, exposing the hostile exterior environment as nothing more than a dreamscape, a backdrop against which both Salahuddin's and Gibreel's journey of death and rebirth is unfolding. Thus the idealised version inside the studio must be read as a direct juxtaposition to the tropicalised 'real' version, where the rising temperature

mirrors the rising tempers and tensions that culminate in the race riots in London in the early 1980s. Gibreel descends further and further into paranoid schizophrenia, realities become increasingly blurred and the perceptions of London, filtered through Gibreel's observing eye, become ever more distorted: 'This is no Proper London: not this improper city. Airstrip One, Mahagonny, Alphaville. [ . . . ] Babylondon' (Rushdie 1998, 459).

As Salahuddin transforms from human into devil and back into human, Gibreel deludes himself into thinking he is the incarnation of the Angel of the Revelation, the exterminating angel, Azraeel. He presides over the city's descent into chaos, as the Shaandaar Café goes up in flames, killing Mishal Sufiyan's parents. Saved by Gibreel, Salahuddin escapes the flames, which opens up the possibility for Salahuddin to reinvent his life, renegotiate his own sense of selfhood in the wake of tragedy as a new beginning—which is likened to his rebirth so pertinently summed up in the opening of the novel: 'To be born again, [ . . . ] first you have to die' (Rushdie 1998, 3). This process underscores further the manner in which the cityscape is closely interlinked with the journey of both protagonists and the important role it plays for both characters' capability to renegotiate and reinvent their lives in the wake of crisis. The migrant characters are all desperate to hold on to an idea of home, lamenting their displacement, keeping the flame of home alive through the consumption of popular culture, such as Indian popular cinema.

*The Satanic Verses* is the novel where Rushdie deals most explicitly with the celebratory possibility of rebirth, though he presents this as a painful process not open to everyone. The novel addresses a profound sense of an irreversible and absolute loss of home, where the migrant finds himself trapped in a hostile environment, increasingly impossible to be remade as home. Within these considerations, Indian popular cinema fulfils a paradoxical double function; it serves as a way of forgetting the present reality and, through the aural/visual consumption of images, serves as a trigger to remember what has been lost and is irretrievable—the past sense of home and belonging. In this respect, all the characters have to negotiate ways of refashioning and reinventing their lives in the largely hostile environment of Thatcherite London in the 1980s, where the legacy of Enoch Powell's racist rhetoric is repeated, albeit in coded form, by Margaret Thatcher's government.[14]

*The Satanic Verses* is perhaps Rushdie's richest novel in his deployment of filmic techniques and cinema as intertext, and highlights how the medium is instrumental to his style of visual panoramic storytelling. In *The Moor's Last Sigh*, he continues to adapt this technique in a novel that is rich in allusions to two movies, *Mother India* and *Mr. India*, to narrate an epic of the Indian nation from its most marginal religious communities.

# 5 *The Moor's Last Sigh*
## Rewriting *Mother India*

In *The Moor's Last Sigh*, Rushdie refocuses his attention on the Indian subcontinent to investigate the rise of Hindu nationalism and the dangers and destructive forces of religious fundamentalism and corruption. This chapter pays particular attention to the way Rushdie revisits Bombay and perceives the changes that have transformed the city in the lead-up to the 1992/93 riots and bomb blasts.

Rushdie returns in this novel to the city of Bombay and its film industry, highlighted by two cinematic intertexts, *Mother India* (1957) and *Mr. India* (1987), which are instrumental for his assessment of post-Ayodhya Bombay, now transformed into communalist Mumbai. His first-person narrator, Moraes, uses the films to construct alternative visions of India. The trope of 'Mother India' which this chapter explores through filmic and novelistic representations is closely linked to the portrayal of his mother, the artist/painter Aurora Zogoiby, who articulates her own conceptualisation of a secular India in art. She ultimately embodies an alternative urban version of 'Mother India', in opposition to his father Abraham, who mutates into a *Godfather*-like villain. He becomes the archetype of a corrupt and corrupting businessman, responsible for the destruction of India's postcolonial promise of a free, secular and democratic society. Many commentators and intellectuals, including Rushdie, saw the events of December 1992 and March 1993 as the death of cosmopolitan Bombay, and the novel paints a bleak picture of what happened to the euphoric vision of the nation on the eve of independence.

In many ways *The Moor's Last Sigh* is a big-city novel, centring on Bombay and Cochin, with the da Gama-Zogoiby family saga at its heart. Here Rushdie re-evaluates India's myth of the nation, and in this respect the novel can be read as a companion volume, if not a sequel, to *Midnight's Children*. In the wake of increasing communal tensions, the ascent of the right-wing Hindu nationalist party Shiv Sena in Bombay and Maharashtra and the destruction of the Babri *Masjid* in Ayodhya, which triggered the riots and blasts, Rushdie decided to write a family saga that is pluralistic and eclectic in cultural and religious terms. The rise to power of the Shiv Sena in Bombay

is central to the novel's politics and important for a wider understanding of its arguments.[1]

According to Kalpana Sharma, the reasons for the communal violence in December 1992 and January 1993 can be attributed to a series of social, political and economic developments over three decades at least: 'the communalization of Bombay politics had been taking place throughout the 1980s, and particularly after the emergence of the Shiv Sena as a force in electoral politics' (1996, 269). Sharma further points out that the riots should not be separated from the bombings in March 1993 when a series of powerful explosions ripped through Bombay's financial district, targeting among other buildings the Bombay Stock Exchange and the Air India building. In the aftermath of the atrocities, Sharma claims, 'it became increasingly evident that Bombay has become a divided city not only between Hindus and Muslims, but also between those who are gaining from the changed economic environment in the city and those who are being left out' (1996, 286). It is against this backdrop that Rushdie's narrative unfolds (see also Zaidi 2002).

The novel links the Jewish/Catholic/Hindu/Muslim legacy of the Indian subcontinent, East and West, Indian and European history to spin out India's postcolonial history through its most marginal communities, and to show that they have an investment in India's history which should determine their role in its future. In so doing, *The Moor's Last Sigh* highlights the impact of exclusionist Hindu nationalist politics by challenging the concept of *Hindutva*.[2] The novel, then, becomes a forceful indictment of a political elite which has destroyed this pluralist ethos and replaced it with an exclusionist vision of the Indian nation. As Rushdie explains in a 1996 interview with Alvaro Vargas Llosa:

> If there is this idea that only Hindu India is India, let me do the opposite of that and try to find the smallest minority group. [ . . . ] I tried to show that, far from being a marginal or inauthentic experience, you could put this in the center and grow the whole of the country out of it. (Rushdie and Llosa 2001, 211)

The result is a multi-layered novel that challenges the reader to unpick the various narrative threads and re-examine the historical palimpsest that makes up India as a nation.[3] Rushdie confronts the idea of a monolithic country by turning a Catholic Cochin artist into the iconic figure of Mother India, the emblem of the nation, and the different connotations it encapsulates in numerous and competing configurations. In this respect, the novel outlines a clear argument about issues of representation with the multiple possible interpretations of the trope of 'Mother India'. Rushdie returns to India's most 'hotchpotch' metropolis, where his narrator Moraes observes first hand the effects of a new kind of religious nationalism in an age when concepts of the nation are increasingly dissociated from their secular roots. In this context,

he sets up Aurora and her art as a counternarrative that decentres a singular frame of vision.

*The Moor's Last Sigh* narrates the epic family history of the Zogoiby-da Gama clan through the eyes of Moraes Zogoiby, now imprisoned in his mother's spurned lover's Little Alhambra in southern Spain. The narrative of family rifts and premature deaths, thwarted loves, mad passions, the power of money combined with morally dubious seductions and mysteries of art is reminiscent of the family sagas that have become more and more popular in Indian popular cinema (Rushdie 1996b, 14). By interlinking the story of the nation with that of a family, Rushdie allows personal history to collide with national history where the role of Mother India is contested by the artist Aurora Zogoiby, fashioning herself into an urban version of that figure. She enters into direct competition with Indira Gandhi and Nargis, the Bombay film superstar who became an icon through her portrayal of Mother India in the 1957 film of the same title. Their contest for that role, and the ways in which they invest it with different meaning, is one of the core preoccupations of the novel. Mother India, one of the defining myths of post-independence India and closely linked to the independence struggle and India's birth as a nation, becomes the representative prism through which the novel develops the discourse on Indian nationhood and its postcolonial mutations. In this respect, the competing representations of Mother India are of vital significance in an age when ideological conceptions about nation become more and more religiously invested and entrenched. The varying interpretations of the trope of 'Mother India', then, serve as crucial markers that allow Nargis, Indira Gandhi and Aurora Zogoiby to enter the public domain.

## Inventing and Reinventing Mother India

Indian popular cinema played a crucial part in the post-independence era when the state still sought to establish itself as a new source of authority. India's diversity in language, religion, caste and cultures could threaten the Indian Union as a nation state, and this necessitated the creation of new myths. The film *Mother India* can therefore be read as a useful popular cultural production that through its structures of feeling generates for the young nation a new sense of unity by creating a sense of allegiance and belonging on the part of its audience. 'Mother India' as a cultural signifier resonates particularly in the context of nationhood. It is interwoven with the history of India's move towards independence. As the nationalist movement gathered pace, it went hand in hand with a cultural revival as an interest in the history and culture of the different regions of India increased in the early years of the nineteenth century. This allowed nationalists of the late nineteenth century to refer to this material as a source of pride in the ancient achievements of the motherland and its people. The Bengal Renaissance is perhaps the best-known example. A key figure of

that movement, Bankim Chandra Chattopadhyay (1838–1894) was one of the first to introduce the theme of the great mother into Indian nationalist discourse through a poem featured in his novel *Anandamath* (1882), 'Bande Mataram', where one of the characters appeals to the Goddess Durga as both a deity (land as mother) and mother as land (see Chatterji 2006, 48–50).[4] The idea of Mother India was an important tool for nationalism and the freedom movement, which is also reflected in greetings and battle cries of anti-imperial activists, such as *Bharat-mata ki jai* [May Mother India be victorious] and *vande mataram* [Hail Mother] (Chatterjee 2002, 49). In the post-independence era, Indian popular cinema engaged with the creation of a new myth of nation that presented India, on the one hand, as a timeless mythic entity and, on the other, as a modern secular state under the rule of law (see Chakravarty 1993, 132). Thus the various images that denote the motherland—*matri bhumi, vande mataram, bharat mata*—all needed to be woven into the fabric of the new nation.

Sumita S. Chakravarty succinctly shows how *Mother India* presents the powerful nation through its depiction of the land as mother and the mother as land as it is enshrined in a discourse of nationhood (1993, 149). She convincingly relates the film's timelessness to the way it engages with the Indian experience of suffering and narrates it as myth, with the everyday struggle of the peasant being portrayed as heroic, which allows the audience to reaffirm long-held cultural assumptions: 'These pertain to the conduct of woman, to her mythic strength and endurance, to her ability to provide stability and continuity in Indian social life' (1993, 150). *Mother India* celebrates the peasant woman Radha in her role as mother and mythologises it. By connecting the idea of India as a mother with rootedness and place, the film aligns itself with similar evocations made by Indian nationalists during the struggle for independence. At that time, the vast majority of India's population lived in a rural environment, and they identified with these representations of the peasant and the relationship with earth/land in the film's evocation of the motherland (Chakravarty 1993, 151–152). As Chakravarty shows, this strategy makes it possible to dissociate the peasant woman Radha from the destructive and vengeful woman as well as the threat of the prostituting woman, as her struggle and survival against the odds is presented as a story of service and devotion to the motherland (1993, 151).

The symbolism of the mother as divine derives from the cult worship of mother goddesses, especially in northern India. The film uses this complicated mythology about femininity in relation to motherness as its main source to create a new mythology, already denoted by the meaning of names in the film. Through references to gods, goddesses, representations of rituals and celebrations, the production team works a familiar iconography into the film through its representation of a rural, village-based community. Here, the mother is associated with a variety of Hindu goddesses: Dharti-mata or Mother Earth, associated with productivity and stability; Lakshmi, goddess

of wealth, beauty and prosperity; Radha, consort of Krishna and the personification of love; the Sita Savitri model of the devoted wife; and Kali, a figure of annihilation (see Chatterjee 2002, 28–29, 49–50; Dwyer 2000, 133). Her husband's name, Shyamu, is another name for Krishna and her sons Birju and Ramu, the bad and the good son, are associated with Krishna and Rama respectively. As Gayatri Chatterjee argues, the way the film appropriates epic and mythical sources in a cumulative process allows these elements to mutate and be subverted, leading to a dialogic as well as conflicting relationship between the contemporary and mythological material (2002, 30–31). In *The Moor's Last Sigh*, Rushdie uses the multi-layered meanings invested in 'Mother India' as they are proliferated in the film as symbolic of the secular post-independence Indian nation. He then goes on to investigate how the meaning of 'Mother India' changes with the rise and threat of religious fundamentalism and corruption.

In *The Moor's Last Sigh*, Rushdie chronicles the decline of secularism after independence. The Bombay riots and bombings demonstrate that the tolerant ethos of a state, which was harnessed in the anti-colonial struggle pre-independence, may not necessarily lead to religious tolerance in society. Moraes is particularly baffled by that. He shows very clearly the process by which Indian nationalism has been contaminated by exclusionist ethnocentric religious politics ever since the Emergency in 1975, and the 1992/93 demolition of the Babri *Masjid* and riots and blasts in Bombay that followed are here linked to it. Rushdie deals in this instance with a particular conceptualisation of 'secularism', unique to the Indian context. According to Ashis Nandy, 'secularism' contains two specific meanings. The first, which is also familiar to Western audiences, suggests that, by removing religion from political discourse, room for religious tolerance becomes possible—'the less politics is contaminated by religion [ . . . ] the more secular and tolerant a state will be' (2003, 34). In its second meaning, Nandy argues, secularism is not the opposite of the sacred, but of ethnocentrism, xenophobia and fanaticism. Thus, it is possible to be secular by being equally respectful or disrespectful to religion. Here, the emphasis is on respect, and it is this one which the anti-colonial elite stressed and provided the platform upon which a broad-based mobilisation against British colonial rule could be achieved (Nandy 2003, 35). *The Moor's Last Sigh* engages with these debates around religion, secularism and its relationship to a political and cultural public sphere. By using the trope of 'Mother India', Rushdie splits the public sphere into urban and rural, secular and non-secular representations, codings and debates.

Moraes is quick to underline that 'Motherness [ . . . ] is a big idea in India' (Rushdie 1996b, 137). He uses this as his springboard to start linking the different mother figures featured to the mythic construction of Mother India. Born ten years after independence and in the same year the film was released, Moraes emphasises his own connection to the movie.

The Moor's Last Sigh    115

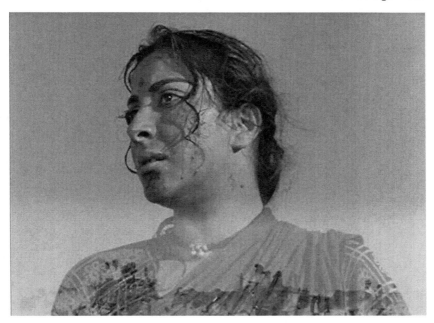

*Figure 5.1*  Radha (Nargis) imploring the villagers in *Mother India* not to leave the land.

> The year I was born, Mehboob Productions' all-conquering movie *Mother India*—three years in the making, three hundred shooting days, in the top three all-time mega-grossing Bollywood flicks—hit the nation's screens. Nobody who saw it ever forgot that glutinous saga of peasant heroism, that super-slushy ode to the uncrushability of village India made by the most cynical urbanites in the world. And as for its leading lady—O Nargis with your shovel over your shoulder and your strand of black hair tumbling forward over your brow!—she became, until Indira Mata supplanted her, the living mother-goddess of us all. (Rushdie 1996b, 137)

Moraes highlights the film here as one of the defining texts of Hindi cinema, with Nargis as the embodiment of the role. Furthermore, he emphasises the idea of 'Motherness', as it is defined and exploited in nationalist rhetoric, to trigger for the reader comparisons to the various mother figures in the novel.[5] Rushdie overtly develops these connections providing a template to unpack a novel dense with historical and popular cultural allusions. In this respect, the 'Mother India' motif is not only significant as a plot device that sets up and parallels the Oedipal relationship between mother and son, but also points to the novel's wider preoccupations with art, politics and representation (Rushdie 1996b, 138–139).

Throughout the novel, Moraes challenges the notion of 'Mother India', rewriting the trope and setting up his mother as an alternative urban version to Nargis's interpretation in Mehboob Khan's film. This image of the benevolent, stoic, nurturing and caring Mother India, the land as mother and the mother as land, is given a new dimension in the film by stressing the connection to India's progress ten years after independence. In this period of change sweeping the country, Radha/Nargis as mother symbolises continuity during upheaval. Rushdie's provocative, metropolitan version of an aggressive, treacherous, foul-mouthed, ruthless, exploitative, calculative and cruel mother counters and subverts this stoical image. Aurora as Mother India is a complex, multi-layered figure. On the one hand, she strives to break the patriarchally constructed image of Mother India and, on the other, she adheres to a conservative moral code and is, contradictorily, both divorced from as well as linked to the traditional mythical image. Rushdie pursues several strategies in the creation of Aurora. He sets her up as an iconic figure embodying an eclectic, multi-ethnic, multi-religious tolerant secular India that he associates with the 1950s and 1960s, while also using Aurora to subvert the image of India as the mother goddess.

Importantly, Nargis's role in the film later became conflated with her celebrity persona and helped her to reinvent herself in the public imagination. Similarly to Gibreel in *The Satanic Verses*, her star image is uniquely constructed by viewing audiences and the media. In 'Three Indian Film Stars', Behroze Gandhy and Rosie Thomas have looked closely at this phenomenon by analysing the creation of the subcontinental star cult and how film and gossip become intersecting discursive sites on questions of morality in the context of preconceived ideas of tradition and modernity in India (1991, 108). In many ways, Nargis can be read as the embodiment of this tension through the roles she chose to inhabit, be it skilled, educated, working woman, innocent village girl, vampish society lady or the irrepressible peasant mother who fights against oppression and injustice. These figurations transposed themselves onto the public image of Nargis. Gandhy and Thomas are concerned with the persona of Nargis as publicly constructed rumour through gossip magazines (1991, 119). Nargis's role in *Mother India* came soon after her split from the actor Raj Kapoor. Their on-screen pairing and widely reported off-screen affair turned them into the most recognisable couple of the 1950s Hindi film industry, epitomising a 'modern' freedom and lack of inhibition, despite the fact that Kapoor was married with children. When the affair ended, the public regarded Nargis as a ruined woman who deserved her lot as well as a figure of sympathy. *Mother India* became the film with which she reinvented herself in the public imagination. It salvaged her honour as she was 'rescued' by Sunil Dutt, the actor who played her son, through marriage. Subsequently she settled down to family life, leaving the film industry. The association with *Mother India*, Nargis's devotion to her son and husband and her commitment to

community charities allowed her to redeem herself in the eyes of the public. More significantly, she forged a close connection with Indira Gandhi and in 1980 was rewarded with a seat in the Rajya Sabha, the Upper House of Indian Parliament. By that time, the public revered her as a national symbol of dignified glamour and respectability, the other First Lady of India—Indira Gandhi's *alter ego*.[6] Before *Mother India*, Nargis presented herself as the modern woman—a secular Muslim and a working woman, who chose her own lovers. After her marriage, she became a bourgeois housewife and mother, turning her back on the seedy film world. Reinvented through the film as Mother India, she re-entered public life as a politician (see Dwyer 2000, 136). Rushdie's novelistic construction of Aurora, Nargis and Indira Gandhi as general rumour leads us as readers to consider how they are 'consumed' by the public. This 'reading' is generated by a fictional audience within the novel, which mirrors the actual audience's reactions to and influences on their constructed personae and determines these figures' space and impact in public life.

Rushdie draws obvious parallels between Indira Gandhi, Nargis and Aurora, deliberately blurring fact and fiction through gossip. Rushdie draws on set conceptions of Indian womanhood in a framework of publicly constructed figures through rumours and gossip—for example Aurora's fictional affair with Nehru or her clash with Nargis on the basis of which the public makes its judgements of her. The public's relationship with the constructed image of Aurora means she falls continually in and out of favour with her audience. Aurora brings this to a head at one of her soirées when, in a conversation with Nargis, she conflates real-life events with the narrative of the film:

> 'The first time I saw the picture', she confided to the famous movie star [ . . . ] 'I took one look at your Bad Son, Birju, and I thought, O boy, what a handsome guy [ . . . ] And now look—you have gone and marry-o'ed him! What sexy lives you movie people leadofy: to marry your own son, I swear, wowie.' [ . . . ] Nargis stood speechless, open-mouthed. (Rushdie 1996b, 137)

Rushdie mischievously plays with *filmi* gossip of the time. *Mother India*'s director and producer, Mehboob Khan, had legitimate concerns that the success of the film could be harmed significantly if Nargis's romantic attachment to Sunil Dutt entered the public domain. By conflating the plot of the film and Nargis and Sunil Dutt's romantic attachment, Rushdie introduces the Oedipal implications of the film plot compounded by the film stars' romance to flag up the analogies with his own cast of characters, especially the intense relationship between Aurora and Moraes. By alluding to the gossip surrounding the production of *Mother India* and its relation to the film's plot, he destabilises the film's position and its conceptualisation of Nargis as 'Mother India' and questions here the nature of motherness.

Rushdie draws on the idea of the actor's star persona as a parallel text, conditioned by the roles they enact and the way this affects the public image created by the media. Vijay Mishra has succinctly outlined this process in his analysis of Bombay film superstar Amitabh Bachchan in *Bollywood Cinema: Temples of Desire*. Mishra argues that stardom leads to distinctive dynamics of spectatorial desire (2002, 155). This in turn triggers particular processes of identification and responses on the part of the viewer. Aurora deliberately provokes Nargis and Sunil by reading their on-screen performance as mother and son and their off-screen romance as a conflation of fact and fiction, and her reading of the off-screen romance determines her reading of the on-screen mother-son relationship.

## Constructing Aurora as Mother India

Moraes constructs a cumulative, panoramic image of Aurora by making recourse to gossip and hearsay, tempered by facts through his insider knowledge of his family history. He develops this strategy at the outset of the novel, as he suggests she is the ghost or avatar of her deceased mother Isabella, who functions as an early defender of secularism. Yet, while he presents us with this all-important notion of his mother, Moraes undercuts this presentation by revealing the many family scandals, immediately pulling down these figures whenever they threaten to transcend fully into myth. Though Moraes constantly hints at the unreliability of his family stories, presenting them as half-truths, they are always made sufficiently plausible to be believable. Thus, these characters float somewhere between the human and myth, and the narrator deliberately manipulates his audience with the revelation of these half-truths. Yet the veracity of these family stories also cast doubts as Moraes can only relay the events that occurred on Cabral Island in Cochin through second-hand accounts from his mother and father. Hence his narration is self-consciously unreliable and directly bears on his family history and the multiple truths that can be found in the accounts, privileging more often than not the made-up tale of perceived factuality (Rushdie 1996b, 85–86).

*The Moor's Last Sigh* is a story about a dynasty, told by the only surviving member of the spice trader and business clan of the da Gama-Zogoiby family of Cochin (Rushdie 1996b, 5).[7] Moraes tells the story of his rise and fall from grace and that of his notoriously feisty and famous artist mother who dazzles with her extraordinary beauty (Rushdie 1996b, 5). Rushdie based Aurora on the Hungarian-Indian painter Amrita Sher-Gil. She was, according to Rushdie, the artist at the centre of modern Indian painting, whom he used to imagine Aurora's personality (Rushdie 2007, 12). Amrita was 'a woman much influenced by Gandhian ideas, who dedicated herself to painting the "true" life of India, the life of the villages' (ibid). He imagines Aurora as her opposite in her urbanity and sophistication but, after finishing the novel and then researching Amrita Sher-Gil further, Rushdie discovered that there

were more parallels between the fictional character and the real-life artist than he expected. Amrita Sher-Gil's bohemian lifestyle, her outspokenness and strong will make Aurora seem more like an imaginary sister to the artist rather than her antithesis.[8]

Central to the imagination of Aurora as a public figure, and one that can be read as an embodiment of a secular India, is the connection between the idea of Indian nationhood and Indian womanhood. This played out in the early sections of the novel between Aurora's parents Camoens and Isabella (Rushdie 1996b, 51).[9] Belle functions in these early sections not only as a prophetic Cassandra, but also as the defender of a secularist vision of the nation, which she upholds in opposition to her mother- and sister-in-law. She passes on her commitment to a secular version of the nation to Aurora. After Belle's untimely death Aurora, as her mother's phantom, throws away her uncle Aires's collection of Ganeshas and her grandmother Epifania's elephant teeth. In this respect, the legacy of the secular-orientated Isabella da Gama lives on in Aurora and, as a direct consequence, Aurora visualises her mother's ideals in art as she secretly transforms the walls of the room where she is locked away as a punishment into a depiction of India, real and imaginary, through the overpowering all-encapsulating image of Mother India (Rushdie 1996b, 59–61). Aurora combines here a mythological conception of Mother with 'real-life' characters from her family. She attaches to her artistic visions of Mother India those of her hated grandmother as monstrous and murderous and that of her beloved dead mother Isabella. She links, like Mehboob, the multiplicity of mythological conceptualisations of Mother India with living examples that seem to embody and represent these concepts. Aurora's painting depicts a Kali-like destructive Mother India, rather than a life-giving nurturing mother. The destructive potential of motherhood becomes for Moraes an overarching leitmotif, as Aurora is embroiled in the downfall of all her children.

Though Rushdie invites a metaphorical reading of Aurora, the mythic stature invested in the novel's female characters is undercut and deconstructed through their own actions. Amidst the patriarchal male-dominated discourse and conception of nation, Aurora encapsulates the various images of Mother India and acts these out either in her paintings or real life, taking on the role of prophetic Cassandra and annihilating mother. Ultimately, this sets her up as an urban version of Mother India, in direct competition with the trope in the film and its conflation with the star persona of Nargis, and with the political figure Indira Gandhi.[10] Moraes also explores this connection in his own intensive mother-son relationship that dominates the novel and the film and extends to Indira Gandhi's relationship with her son Sanjay. As Bishnupriya Ghosh has pertinently pointed out, the witticism that 'the entire country has a mother-son problem' has more serious repercussions, suggesting that the mother-son symbiosis depicts the central political imaginary of the Indian nation, which is reiterated and differently articulated by cinema and popular

culture (1999, 139). Moraes uses gossip as a way of explaining his conception of his family as dynasty, pointing to several chronological verities, especially the one missing night in the house cook Ezekiel's copybook, arousing his suspicions and establishing firmly a link between the Nehru-Gandhi family and the da Gama-Zogoibys. Aurora's refusal of the country's greatest honour and the subsequent newspaper outrage brings up all the old family scandals, highlighting the destructive nature of gossip as it forces Aurora to retreat from public life. That link is further accentuated when, in the early days of the Emergency, Moraes mentions the unhealthy relationship between Indira Gandhi and her son Sanjay, which his ayah counters with her own account of how his overintense relationship with his mother and sister leaves him in no position to judge (Rushdie 1996b, 197).

The close relationship between Moraes and Aurora has significant implications for their representation in the narrative. Mother and son form an eclectic secular unit that gradually fractures and separates as much as the country does. Aurora transforms her son into the prime subject of her paintings, the Moor series, functioning as a mirror through which the rise of communalism and the decline of pluralistic Bombay can be narrated. Moraes, on the other hand, turns to Indian popular cinema, revealing himself as a Bombay movie fan, explicitly and implicitly connecting films such as *Mother India* or *Mr. India* to his story. Visualising his life through the filmic idiom, Bombay is for him that 'super-epic-motion picture of a city' (Rushdie 1996b, 129). The authorial reciprocal gaze of mother and son allows Moraes to paint his own portrait of his mother, albeit in words, and infused with the movie language of his city:

> This is what I saw: a tall woman in a paint-spattered, mid-calf-length homespun kurta worn over dark blue sailcloth slacks, barefoot, her white hair piled up on her head with brushes sticking out of it, giving her an eccentric Madame Butterfly look, Butterfly as Katharine Hepburn or— yes!—Nargis in some zany Indian cover version, *Titli Begum*, might have played her. (Rushdie 1996b, 219)

## Bombay Central Revisited

Moraes's construction of Aurora climaxes in 'Malabar Masala', where he elevates her to 'the incarnation of the smartyboots metropolis' (Rushdie 1996b, 139). The section opens with Aurora dancing her Ganpati dance in defiance of the gods, a routine she performs for forty-two years. Moraes presents Aurora as the embodiment of Bombay's and India's eclecticism and secularism and a metaphor for modern, urban India, a counterpoint to Nargis's version of the rural Mother India (Rushdie 1996b, 203–204).

In this respect, Bombay's centrality, like Aurora's, looms large as a backdrop of mythic proportions against which the events of this cinematically

The Moor's Last Sigh    121

realised narrative unfold. Bombay features here as the quintessential setting to Indian modernity and progress, on the one hand and, on the other, reveals a dark underside. Here, Rushdie's portrayal of Bombay echoes his depiction of London in *The Satanic Verses*; it also foreshadows that of New York in *Fury* and offers a deliberate link to *Midnight's Children*. Some reviewers have argued that *Midnight's Children* and *The Moor's Last Sigh* work like bookends; others see the book as a mere sequel to *Midnight's Children*.[11] They seem to be missing the point. The novel presents the reader with a very different Bombay. Rushdie does not write another version of Bombay puzzled together out of childhood memory, but an adult, grown-up version of the city. The Bombay of *The Moor's Last Sigh* is a palimpsest painted over that of *Midnight's Children*.

The argument *The Moor's Last Sigh* is making about the death of India's eclecticism and the threat to its survival through unity in diversity is coded and steeped in these Indian popular cultural references.[12] As Rushdie has put it, *The Moor's Last Sigh* in fact fills the thirty-first pickle jar that Saleem left empty at the end of *Midnight's Children* for tales yet to be told (Rushdie 1995a, 462). It extends the time frame significantly to tell the story of the more pragmatic generation Rushdie thought was taking over at the beginning of the 1980s. In this respect Moraes as chronicler is linked to Saleem, both of whom tell their stories under similar pressures, like modern-day Scheherazades, as their time is running out. Their journey to, through and out of Bombay is, however, markedly different. Moraes is of Catholic-Jewish ancestry, Saleem's is Hindu-Muslim. Saleem's family hails from Kashmir and their journey takes them via Amritsar, Agra and Delhi to Bombay, whereas Moraes's family hails from what was then the princely state of Cochin, now part of the southern Indian state of Kerala. Yet both engage with the rise of Hindu fundamentalism, the growth of exploitative capitalism, gang warfare, drug trafficking, organised crime and a growing underworld with links to the political elite of the country, which both perceive to be the most serious threat to the Nehruvian vision of the nation.[13] Both characters view the growing radicalisation of India's religious groups, which Rushdie identifies as the biggest risk to the original secular concept of nation, as especially worrying. Like *The Satanic Verses*, *The Moor's Last Sigh* argues compellingly against the destructive force of a singular vision which he associates with fundamentalism, the problem of seeing the world in absolutist terms and the dangers of unchecked corrupt and corrupting capitalist exploitation. This serves as the impetus for Rushdie to revisit some of the narrative threads left open at the end of *Midnight's Children*. Rushdie makes this explicit by linking the narrative worlds of previous novels through the appearance of several intertextual characters. In particular, the arrival of Adam Braganza, Saleem's son, and his unflattering portrayal makes Rushdie's disenchantment with this younger generation—midnight's grandchildren—clear.

Various narrative strategies are at work in *The Moor's Last Sigh*. In setting up Moorish Spain and Granada and its decline as the historic parallel to pluralistic Bombay, Rushdie creates a framing narrative that gives the novel its title.[14] The novel's link to Spanish history also establishes a direct connection to Rushdie's short story 'Christopher Columbus and Queen Isabella of Spain Consummate Their Relationship (*Santa Fé*, AD 1492)', the last story in the 'West' section in his collection *East, West*. In the story, the conquest of Granada and Boabdil's surrender of the Alhambra, witnessed by Columbus, is juxtaposed with Columbus's growing desperation to secure funding from the Spanish Queen for his explorations (Rushdie 1994, 114). Ironically, the expulsion of one ruler is linked to the conquest of the Americas and gains even more pertinence, because Columbus thought he would discover a direct sea route to India.[15] This further underlines the complex palimpsestual historical layering Rushdie weaves into the fabric of his novel, connecting two very distinct histories of colonisation. Abraham Zogoiby's family is linked to Moorish Spain and Aurora's is linked to the Portuguese history of colonisation in India. The references to the Portuguese colonial heritage along the Malabar Coast (Goa and Cochin) is an implicit reminder of Bombay's own Portuguese links, which lie buried beneath decades of British colonial rule. Bombay was gifted to Britain as part of the dowry of Catherine of Braganza when she married Charles II in 1661.[16]

This complex layering, then, leads Moraes to present the *reconquista* of the Iberian Peninsula by Ferdinand and Isabella, leading to Boabdil El-Zogoiby's ('the unfortunate') last sigh and the ultimate death of multi-religious Moorish Spain, as a parallel to the rise of Gup Mainduck, a barely disguised caricature of Shiv Sena's leader Bal Thackeray,[17] which ushers in the death of tolerant multi-ethnic, multi-religious Bombay, replacing it with communal Mumbai. Raman Fielding causes the controversy around Aurora's painting *The Kissing of Abbas Ali Baig*, depicting an incident during the third Test Match between India and Australia, which Aurora fictionalised, turning the kiss into an 'explicit hyperbole' (Rushdie 1996b, 228–235). Aurora mixes the fascination with cricket with the depiction of a kiss between a Hindu girl and Muslim cricket player in a melodramatic Bombay *filmi* style. Moraes plays on the repressed eroticism of 1950s/60s Indian popular cinema, where much is left to the imagination through implicit suggestion as any public displays of affection are considered obscene and would not pass the censor's cut. The provocation for Mainduck, however, is not the kiss itself, but the issue of a Muslim and a Hindu kissing on the cricket field. Around this fictional incident, Rushdie highlights how cricket becomes a site of contestation over race, culture, gender and moral authority.[18] The 2001 Oscar-nominated film *Lagaan* would also use cricket as a vehicle for similar explorations in the context of the British Raj in India. Both texts comment on cricket as part of the defining experience of what it means to be Indian or Pakistani, which is all the more striking considering that it is a sport which is, according to

Grant Farred, 'stubbornly inaccessible, impenetrable to those who did not participate in the experience of British colonialism' (2004, 93).

Cricket functions as a cultural practice and a national obsession, which reflects the genealogy of a national essence. Therefore cricket occupies an equally significant role in the imaginary realm as the cinematic representations of Indian popular cinema, as *Lagaan* exemplifies. Like cinema then, cricket is a fundamental part of the Indian national consciousness, functioning as a defining sport, reinvented by Mainduck as a fundamentally Hindu game always threatened by 'the country's other, treacherous communities' (Rushdie 1996b, 231). Rushdie explains Raman Fielding's political philosophy through cricket and places this sport of Empire in its communalist context, commenting on its importance for postcolonial India, as well as using the sport to illustrate how regional and religious nationalism are fused in the explosive new group of the 'Mumbai's Axis' (Rushdie 1996b, 228–231).[19] The introduction of Raman Fielding marks a turning point, accentuated by the emerging radicalisation of various religious groups. It culminates with another historically defining moment, Indira Gandhi's Emergency rule, and Moraes laments: 'Before the Emergency we were Indians. After it we were Christian Jews' (Rushdie 1996b, 235).

The expulsion of the Moors from the Iberian Peninsula, then, becomes a screen through which Rushdie elaborates on the complex changes in India's political climate post-independence. He thereby underscores that rising religious fundamentalism is the biggest threat to India's plurality and hybridity, the fears of the 'Battering Ram', which Aurora's father expresses on his return from a Gandhi rally in novelist R. K. Narayan's fictional town of Malgudi (Rushdie 1996b, 55–56). Commenting on the 1993 Bombay bombings, his narrator remarks on Bombay's centrality and sees obvious analogies with the fall of Granada; the destruction of Bombay and its secular ethos leaves him with a sense of desperation and leads him to conclude that we 'now can only weep, at the last, for what we were too enfeebled, too corrupt, too little, too contemptible to defend' (Rushdie 1996b, 372–373). The section reiterates Rushdie's belief expressed in his essay 'In Good Faith' that 'secularism, for India, is not simply a point of view; it is a question of survival' (Rushdie 1992a, 404). Indeed, this has been exemplified by the horrific communal violence at Partition and, subsequently, in instances such as the atrocities against Sikhs after the assassination of Indira Gandhi or the Gujarat riots in 2002. In this respect, the novel is a lament for the loss of the Nehruvian political ideal, embodied by Aurora and Bombay. Aurora captures that eclecticism and documents its decline in visual art by fictionalising it in the analogous landscape of Mooristan, Palimpstine, a fusion of India and Moorish Spain (Rushdie 1996b, 226).

*The Moor's Last Sigh* demonstrates a significant shift away from *Midnight's Children*, as the secular nationalism associated with the struggle for independence and the notions of tolerance Nehru stood for have been hijacked

and have mutated into an exclusionist, religious, nativist nationalism. To directly challenge this vision, Rushdie writes an Indian family epic from the most marginal groups in Indian society, builds his narrative around them, grafts the history of the entire nation onto it and refracts it visually through Aurora's paintings with the historical parallel of Moorish Spain (Rushdie 1996b, 227).

Furthermore, Rushdie extends the connection of Moorish Spain to Mughal India as another important historical parallel. This is reinforced through filmic points of reference which take on an even greater role in *Shalimar the Clown* and *The Enchantress of Florence*. Rushdie suggests that India's Muslim heritage needs to be viewed as part of a larger picture of India's cultural and religious legacy. While he does not provide a clear-cut answer to the challenges India faces in dealing with religious fundamentalism, he presents Moorish Spain as a utopian parallel and an ideal. As Cantor suggests, for Rushdie, 'Moorish Spain offers an historical alternative to this sad spectacle of religious violence' (1997, 325). Rushdie uses the palimpsest methodologically and sets up Moorish Spain in the first half of the novel as a utopian landscape. However, in Aurora's series of Moor paintings, Al-Andalus transforms into a parallel to the conception of Nehru's India, where the rise of Hindu fundamentalism and its destructive potential is likened to the Spanish *reconquista* of the Iberian Peninsula. Perhaps Rushdie pushes this analogy too far. Moorish Spain was far from democratic and, although it allowed for religious tolerance, it was only acceptable for as long as Muslim primacy was not challenged. Yet it was an age when Muslims, Christians and Jews made advances in science and philosophy through dialogue.

## Creating a Many-Headed, Many-Brushed Overartist: Issues of Representation

Through Aurora, Rushdie creates a new hybrid form of representing postcolonial India, which echoes Zeeny Vakil's notion of art in *The Satanic Verses*. He argues that, in a multifaceted country like India, a pure national culture cannot exist and will always remain an illusion. Zeeny's approach to art foreshadows Aurora. Consider, for instance, Zeeny and Salahuddin browsing through the Chamchawala art collection and the Mughal-era *Hamza-nama* cloths, which she sees as a vivid illustration of India's interrelated artistic traditions where 'individual identity was submerged to create a many-headed, many-brushed Overartist who, literally, *was* Indian painting' (Rushdie 1998, 69–70). Zeeny's observations sum up Aurora's artistic project and link both novels. She makes a crucial cameo appearance in *The Moor's Last Sigh* as the curator of the Zogoiby bequest and replaces Aurora as the Mother India figure after her untimely death, along with Nadia Wadia.[20] In many ways, Aurora is the embodiment of the 'many-headed, many-brushed Overartist' Zeeny describes to Salahuddin. Through palimpsestual painting Aurora has

found a method to synthesise an idea of eclectic India into art. But pluralistic forms of artistic expression, to which the form of Indian popular cinema also belongs, thread their way further through the Rushdie canon. In *Shame*, Rani Harappa and her embroidery mirror the panoramic all-encapsulating art that Rushdie associates with Aurora. In *Midnight's Children*, Saleem talks about an artist who killed himself, because he could not get the whole of Indian reality into his pictures.

Rushdie suggests that movie-making is a fusion of writing and picture-making. In this respect, Indian popular cinema functions as a hybrid text between visual art and Rushdie's fiction, raising the notion of the cinematic and novelistic 'auteur'. Rushdie's narrative choices are firmly linked with the hybrid masala formula of Indian popular cinema, blending action, comedy, love triangles, tragedy and melodrama into layered, yet connected streams of stories. Rushdie's ideal of several cultures merging into a larger unit is mirrored in this method of fusing various art forms to create a panoramic picture that no canvas could hold, but which the elasticity of the novel form can accommodate. On this canvas/screen in novel form, Bombay becomes a multi-layered, meticulously observed, naturalistic backdrop against which his cast of surreal characters act out their tragedy, where Rushdie modulates different representational modes and apparatuses to express this multiplicity (Rushdie 1996b, 173).

To complement this modulation of styles, Rushdie develops an argument between commercial and realist cinema and their varied representations of modern India. He implicitly refers to Satyajit Ray, fictionalised in the novel as Sukumar Sen, whom he sets up as Aurora's only artistic equal, despite working in a different medium. While Ray's cinematic productions have brought Indian realist cinema world fame and admiration, these films have only had limited success inside India, where commercial Hindi language films produced in Bombay always draw exponentially larger audiences.[21]

Rushdie has had a longstanding interest in Satyajit Ray, one of India's greatest filmmakers. In an essay entitled, 'Homage to Satyajit Ray', Rushdie asserts that Ray invariably preferred the intimate story to the grand epic and he describes him as 'the poet *par excellence* of the human-scale, life-sized comedy and tragedy of ordinary men and women, journeying, as we all journey, down little, but unforgettable roads' (1990, 9). Ray represents auteur cinema in the subcontinental context, influenced by the French *nouvelle vague*, but Rushdie is intrigued by his strong interest in fantasy, for which Ray is little known in the West. Ray has a huge following in Bengal for his children's films like *Goopy Gyne Bagha Byne* [*The Adventures of Goopy and Bagha*] which, according to Rushdie, have a similar popular following in Bengal as *The Wizard of Oz* has in the United States. However, while the variety of fantasy films for children rapidly entered into the popular imagination and became part of popular culture in Bengal and, to a lesser degree, elsewhere in India, they never received the same acclaim outside India as his realist films did.

Andrew Robinson in his book *Satyajit Ray: The Inner Eye*, from which Rushdie quotes, states that *Goopy and Bagha* 'released the vein of pent-up fantasy in Satyajit Ray, that is given free rein in his grandfather's and father's work' (Robinson quoted in Rushdie 1990, 9).[22] By linking Sen with Aurora as her only equal, Rushdie connects two very specific sensibilities of artistic production, realism and fantasy, which intersect powerfully in the descriptions of Aurora's art.

These representational considerations are important for the depiction of Bombay, which features in the novel as 'the ocean of stories' (Rushdie 1996b, 350). Here, the intertextual or more aptly 'intra-textual' relationship between *Midnight's Children* and *The Moor's Last Sigh* becomes crucial, as it opens up many of the political and aesthetic arguments the novel makes about the hybrid nature of culture and cultural production. *The Moor's Last Sigh* maintains throughout a panoramic cinemascope portrayal of events and the city.

Rushdie introduces into *The Moor's Last Sigh* several characters from *Midnight's Children*, establishing a firm link between both texts. Readers are reacquainted with the private detective Dom Minto, now over one hundred years old. Aurora enlists him to spy on Uma, Moraes's deranged schizophrenic girlfriend. Cyrus Dubash, one of Saleem's childhood friends, before he is coerced by his mother to become Lord Kusro Kusrovani Bhagwan, makes a brief appearance when Aurora turns to him as a last resort to consult about Moraes's accelerated growth and ageing. The largest cameo role is given to Adam Braganza, Saleem's son. Undoubtedly, the various allusions to characters, events and the Braganza pickle brand (Rushdie 1996b, 199) from *Midnight's Children* foreshadow his arrival, and his appearance allows for some level of closure to the open narrative thread of *Midnight's Children* (see Moss 1998, 125). Rushdie persuasively argues that what has happened in India in the post-Indira Gandhi era is much darker and more dangerous than envisioned in the closing chapter of *Midnight's Children*. In the fourteen years between the publication of both novels India experienced huge upheaval and change. It witnessed the assassination of Indira Gandhi, that of her son Rajiv, growing communal tensions and riots between Hindus, Sikhs and Muslims. Separatist movements and insurgencies in Punjab, Assam and other states grew; tensions in Kashmir and with Pakistan were ongoing, and the Babri *Masjid* in Ayodhya was destroyed, leading to the riots and bombings in Bombay. Simultaneously, India moved away from socialist and protectionist economics towards an exploitative capitalist system, where parts of the economy are controlled by the Bombay underworld.[23] Here, these worlds collide, unleashing all-consuming violence and destruction.

### From Mother India to Father India

The conceptualisation of mother and nation in *The Moor's Last Sigh* focuses the reader's attention on the theme of family as dynasty. The many references

to Indira Gandhi and her family history deliberately parallel the fortunes and misfortunes of the Zogoiby clan. Furthermore, the narrator deconstructs the quintessential image of the mother goddess embodying the entire nation by challengingly building up an image of Aurora as an alternative urban and secular version. Throughout the sections 'Malabar Masala' and 'Bombay Central', motherhood, embodied by Aurora and translated into her art, no longer contests received notions enshrined in *Mother India*, but is increasingly diversified and threatened by alternative concepts, as represented by characters such as Uma, Moraes, her own daughters, Raman Fielding and, through his shady dealings, Abraham.

The Emergency, the period 'when the plague-spores of communal fanaticism were still spreading and the disease had not yet erupted in the metropolis', marks the emergence of Moraes's sister Ina as a supermodel and role model for young Indian women (Rushdie 1996b, 208). Blessed with her mother's good looks, she uses her body, posing for her mother's circle of artists, and achieves fame as a catwalk model and magazine cover girl. She also threatens the pre-eminent position of Aurora as Mother India. Her allure manifests itself in her silence and aloofness. These acts of dissent are aimed at her mother and she finally succeeds in fully antagonising her by sleeping with Vasco Miranda in the same location in Delhi where Moraes was allegedly conceived on the missing night in Ezekiel's cookbook diary.

Philomena starts to work as a human rights lawyer and political activist, fighting against the tyranny of the state. Minnie rebels by exchanging her mother for the Mother of God and devoting her life to Jesus of Nazareth after seeing Audrey Hepburn in the film *The Nun's Story* (1959), enraging the committed secularist Aurora. Minnie subsequently has visions which make Aurora fear for her daughter's balance of mind, but these visions also illustrate the shifting emphasis from secularism to sectarianism. The lives of the individual family members are precariously placed, 'crossing the frontiers between metaphors of art and the observable facts of everyday life' (Rushdie 1996b, 239). They further accentuate the novel's preoccupation with representation. Aurora's only answer to the brutalities of the time is to counter them in her art, trapped between the collapsing ideals of a democratic, free, secular, socialist India and her disintegrating family.

During the Emergency, schizophrenic Uma arrives and competes with Aurora for the affection of her family and, most brutally, for the love of Moraes as well as for the position as national artist. Uma is best understood as the negative side of multiplicity, which proves so destructive that any verities are challenged, decentred and put into flux. Her lack of a central focus, a mark of Uma's plurality with her multiple selves, mirrors the post-Emergency political climate. Rushdie suggests that, once Indian politics lost the founding principle of secular politics, for which he holds Indira Gandhi responsible, the split personalities of the nation start to emerge. The arrival of Uma changes the tone of the novel. That Aurora enlists the private detective Dom

Minto to spy on her son is an initial indicator, but this shift in genre towards the detective novel and thriller is more acutely realised in the search for the truth about Aurora's death and the possibility that she may have been murdered. In this disintegrating family world and a city increasingly under siege, Moraes finds himself adrift, no longer sure about the verities of his life.

The novel suggests that, with the rise of religious politics, there is no room for the secular eclectic version of Mother India that Aurora represents which is now recoded using the Hindu mythological baggage that Uma, 'young, beautiful, and driven by her strong religious faith', exploits in her art. Moraes alludes to how Indira Gandhi manipulated that same image in her election campaigns (Rushdie 1996b, 262). Uma, however, no longer has a clear sense of her self, suggesting that the definition of Indian identity outlined along the secular, democratic and socialist ideals of Nehru's India, has been destabilised by the rise of sectarianism.

After his expulsion from home and the failed suicide pact with Uma that subsequently lands him in jail, Moraes is released through the intervention of Mainduck and enlisted to work for him. Moraes exposes how successful Fielding has been at spreading his ideology in an aim to destroy the palimpsest that is India (Rushdie 1996b, 299). Aurora's retreat and her 'Moor in Exile' sequence respond to the political conception of *Hindutva* and its goal of 'saffronisation', for example, through the rewriting of history and the contestation of the plurality of India as a nation (Rushdie 1996b, 301). In these paintings, she transforms the Moor into a semi-allegorical figure of decay, mirroring Moraes's own situation post-expulsion.

In 1987, the fortieth anniversary of independence, Aurora tumbles to her death while dancing her annual dance against the gods. Although she has retreated from public life, after her death, her art is re-evaluated and acclaimed by the public who had spurned her, mirroring the enthusiastic celebrations of the fortieth anniversary of India's independence. In the ideologically entrenched times in the wake of the assassination of Indira Gandhi, the 1987 independence celebrations were only a short-lived moment of national togetherness. The eclectic accumulated image of Mother India takes on a different connotation, now completely subsumed into *Hindutva* ideology. Mother India transformed into *Bharat Mata* is no longer the iconic figure of Mehboob Khan's film. The character who represents that eclecticism, Aurora, squeezed between the capitalist corruptive businessman Abraham and the ultra religious-nationalist Gup Mainduck, is assassinated, tumbling into the Arabian Sea (Rushdie 1996b, 136). In many respects, Moraes's narrative is his attempt to find space alongside the overpowering presence of his mother. Yet he has to recognise that there is something about his mother that will remain forever enigmatic, outside his own system of meaning.

After Aurora's death, the narrative shifts towards Abraham and the struggle between two layers of power—sectarian politics and exploitative capitalism, between which Bombay and India are trapped. Abraham Zogoiby's

hostile takeover bid of the House of Cashondeliveri, which he assimilates into his business empire, changes him into the grandee of the Bombay business world, epitomising a new breed of entrepreneur. He has transformed himself from lowly clerk in the C-50 spice enterprise of Camoens da Gama in the seventies; and now, over seventy himself, he continues the process of reinvention (Rushdie 1996b, 241). The Emergency, then, is not only the watershed that opens the Pandora's box of increasing communal tension and violence, but also the point when Abraham mutates into a *Godfather*-like figure.

As Moraes realises that his father was the biggest gangster of them all, he searches for a fictional figure who encapsulates what his father has become in cinematic analogies. He struggles to find a film version that helps him to confront adequately their relationship, underscoring the imbalanced focus on mother-son relationships in Indian popular cinema. As he points out, 'nobody ever made a movie called *Father India*' (Rushdie 1996b, 168).

However, though he rejects the film as a 'trashy extravaganza', he finds a representative character in the villain of the 1987 film, *Mr. India*, Mogambo: 'There he sits, like a dragon in his cave, like a thousand-fingered puppet-master, like the heart of the heart of darkness, commander of uzied legions, fingertip-controller of pillars of diabolic fire [ . . . ] the dada of all dadas: *Mogambo*' (Rushdie 1996b, 168). Moraes shows how the character of Mogambo is constructed out of a motley of Hollywood movie villains, the name 'borrowed' from the title of an old Ava Gardner film.[24] Abraham, likened to Mogambo, is represented as an all-consuming, overarching villain.

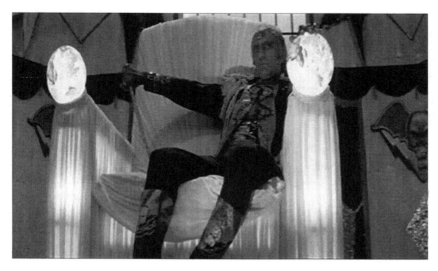

*Figure 5.2* Mogambo (Amrish Puri) in his villain's den.

The Mogambo level of fraud is set up as an adjective that denotes the extent of Abraham's scheming (Rushdie 1996b, 251). But Moraes makes an even more important connection to the life-and-death oppositions of many movie fathers and sons, from *Blade Runner* (1982) to the final showdown between Luke Skywalker and Darth Vader in *Star Wars* (1977). Caught in his own family drama, 'I see a lurid mirror-image of what was never, will never be a movie: the story of Abraham Zogoiby and myself' (Rushdie 1996b, 169). Although popular cultural referents open up a wider comparison and contrast between Abraham and Moraes, he never develops this into as powerful an allegorical leitmotif as the mother-son relationship.

Moraes believes his story to be a 'tragedy enacted by clowns' (Rushdie 1996b, 428). Being outcast from the family circle and then reconciled with the father after Aurora's death reverses Moraes's descent into the underbelly of the city and bears the hallmarks of the hero's journey in Bombay masala action movies. Moraes is torn between Mainduck and Abraham and the inevitable showdown between the two. In this respect and in the absence of Aurora, Abraham instrumentalises the rapprochement of son and father for his own ends.[25] Moraes continues to describe his family's story through filmic texts by drawing ongoing analogies to *Mother India* and *Mr. India*. While Aurora transforms into the 'image of an aggressive, treacherous, annihilating mother' who 'haunts the fantasy life of Indian males', Moraes concedes an affinity with the undutiful tearaway son, Birju (Rushdie 1996b, 139). Moraes, who writes his story retrospectively, foreshadows his own fall from grace, his descent into the shadowy world of crime and gangsterism, and prompts the reader to pay more attention to Abraham who, although sidelined in the story, is not as impotent as we are led to believe. In turn, Moraes is trapped and powerless among the colliding personalities of Abraham, Aurora, Uma, Vasco Miranda and Mainduck, increasingly their victim rather than the story's hero.

The overemphasis on mother-son relationships neglects the father figure, the real source of power in the novel, whether patriarchal, political or financial. As Ghosh persuasively argues, 'in an increasingly paternalistic India of fundamentalist resurgences and urban mafia, the hidden godfather looms to destroy the political sutures on the imaginary that held the Indian nation together' (1999, 139). By highlighting issues of imagination, narration and representation, and the social responsibilities of the artist and the historian, Rushdie 'creates a novel about a national culture—its ramparts, possibilities, failures and evolution—rather than a nation' (ibid). Hence, the odd father-son relationship that is cynically repaired when Aurora dies provides a further important link between the film *Mother India* and the novel. While initially present, fathers become absent in the course of the narrative of *Mother India*, which is emulated in *The Moor's Last Sigh*. Abraham takes care of the business interests and, for the greater part of the novel, remains on the margin, an invisible presence, despite his actions having great bearing on the entire

family. The anonymity his invisibility gives him allows him to build up his exploitative business empire and the analogy with Mogambo becomes even more fitting. *Mr. India* is about the retrieval of a formula that makes people invisible as part of Mogambo's plan for world domination, which is also a poignant reminder of the forces of exploitative capitalism, connected to the criminal underworld, that are seen as undermining independent India's free, socialist, democratic and secular ethos.

The reunion between father and son in the absence of the mother becomes not only a counternarrative to the Oedipal theme, but shifts the narrative away from the central position of women, raising serious questions that Jyotika Virdi asks with regards to the representation of the family in Indian popular cinema:[26]

> How does one reconcile the mother figure's centrality and the father's exclusion in a stringently patriarchal society? [ . . . ] What is at stake in a masculine delineation that draws battle lines within the family triangle, thus making winning the mother the ground for the boy's successful passage to manhood? (2003, 90)

Part of the answer lies with the acknowledgement of the primacy of honour as it is defined in patriarchal-sexual terms and Virdi focuses on the metanarrative of changing family politics where India's feudal-patriarchal culture is replaced by capitalist patriarchy (2003, 114). The novel mirrors this in Abraham's diversification of the original spice business, with its farms and fields, into other markets once the family moves to Bombay. Perhaps here lies the reason for Abraham adopting Adam Braganza, since Moraes is unfit to become the new figure of patriarchal authority. Ultimately, Abraham's entire project fails, as Adam too turns out to be wholly inadequate.

There remain some serious unresolved questions within the generational power transfer. These seem, however, less incongruous if regarded within the parameters of Moraes's quest for redemption—he leaves for Spain in an attempt to reconcile himself with his mother by finding her murderer. Abraham sends him on that journey to encounter and confront mad Vasco Miranda, who has made it his mission to destroy the entire artistic Aurora Zogoiby legacy. The final showdown is reminiscent of those in any action movie. Vasco dies of a drug overdose on the restored portrait of Aurora, before he can kill Moraes. Moraes muses: 'It's a Bombay remake of a cowboy movie [ . . . ] A showdown at high noon, except that only one of us is armed' (Rushdie 1996b, 431).

Love that goes beyond defeat best describes Rushdie's feeling for the decline of Bombay and, with it, an ideal of India with its three pillars of secularism, socialism and democracy, for which Nehru stood. At the end, Moraes sits on top of the hill which has given the novel its title, looking down into the valley where the proud fortress stands, the Alhambra, Europe's red fort,

which in *The Moor's Last Sigh* becomes sister to Delhi's and Agra's, '*that monument to a lost possibility, that nevertheless has gone on standing, long after its conquerors have fallen; like a testament to lost but sweetest love, to the love that endures beyond defeat, beyond annihilation, beyond despair*' (Rushdie 1996b, 433, original italics). The Moor's final lament, his last sigh should, therefore, not be read exclusively as his final surrender. Rushdie elevates the Alhambra to a monument of lost possibility and sets it up as a parallel to the metaphoric children of midnight, who function in the earlier novel as a symbol for hope betrayed and possibility denied. Through *Mother India*, Indian popular cinema provided the newly independent nation with a secular inclusive way of imagining woman in the role of mother as nation. The film reflects this by taking up the Nehruvian vision of the nation. In *The Moor's Last Sigh*, Rushdie constructs a similar vision arguing for tolerance and preserving India's 'unity in diversity' as embodied by the urban version of Mother India, Aurora Zogoiby. The novel's intertextual relation to one of the defining texts of post-independence secular mythology, in the form of the film version of *Mother India*, and the palimpsestual relationship to India's smallest minorities enable Rushdie to write a comic epic that encapsulates the all-inclusive Nehruvian vision of the nation. Rushdie makes a defiant stand by celebrating the idea of India's multiplicity, which is increasingly under threat, but which he deems crucial for the country's survival. In *The Ground Beneath Her Feet*, Rushdie returns to Bombay once again, but here his voice alters and it stands as his final goodbye to a city which has for so long formed part of his creative imagination.

# 6 *The Ground Beneath Her Feet* and *Fury*

Bollywood, Superstardom and Celebrity in the Age of Globalisation

This chapter explores how Rushdie engages with questions of stardom and celebrity in an age of globalisation. *The Ground Beneath Her Feet* and *Fury* mark a geographic and thematic shift in Rushdie's work as his focus shifts away from the subcontinent. *The Ground Beneath Her Feet* moves from India and Bombay to England—London and Lincolnshire, where the novel is suspended in transit—before moving to America—Mexico, the USA and New York. By contrast, the action of *Fury* predominantly takes place in New York, except for a short episode in London and in the South Pacific on the island of Lilliput-Blefusco, a fictional version of Fiji. As this discussion will highlight, both novels feature the hallmarks of cinemascope storytelling and offer further insights into the evolution of Rushdie's style. Filmic storytelling is less foregrounded in these novels, but they develop interesting connections with more recent Indian popular films, which, characterised as 'Bollywood', thematise the diasporic experience.

*The Ground Beneath Her Feet* also features a first-person narrator—the Parsee photographer Rai Merchant. Rai's distinctive profession bears on the way he tells the story of the rock music superstars Vina Apsara and Ormus Cama and the way he visualises it for the reader. My main focal point shall therefore be the way in which picture-making as a form of art is translated and debated in the novel, underlining implications for photo-journalism in its process of representing, imaging and imagining the world. Rai, as the narrator of the story, makes interesting choices about where and when to digress, repeat, summarise and digress again, creating a spiralling, cyclical narrative which straddles several genres and bears the hallmarks of the composite techniques of Indian popular cinema.

In *The Ground Beneath Her Feet*, Rushdie constructs a postmodern reworking of Greek and Hindu mythology in the modern age of globalisation and transglobal migration. He explores this in part through William Methwold's interests in the subject and wider correspondences.[1] Rushdie goes on to link the story to the Orpheus myth and rework it through the trope of discontinuous personalities which he explored previously in *The Satanic Verses*. Rushdie also revisits narrative threads from *Midnight's Children*, filling in the

background story of movie producer Homi Catrack and William Methwold, the British colonialist who is Saleem Sinai's biological father. The novel is fixated on parallel worlds, a version of reality always beneath another layer of reality. In many ways the novel establishes important links with Rushdie's previous story worlds, concretised through numerous cameo appearances of characters like Whiskey Sisodia, Pimple Billimoria and Aurora Zogoiby. By consolidating his different versions of Bombay he highlights the city as 'a metropolis of many narratives that converged briefly and then separated for ever, discovering their different dooms in that crowd of stories' (Rushdie 2000, 52). The chapter thus focuses in particular on how Rushdie constructs and reformulates this fictional Bombay architecturally and as a community through his intertextual cast of fictional characters. In this light, the Bombay novels *Midnight's Children*, *The Satanic Verses*, *The Moor's Last Sigh* and *The Ground Beneath Her Feet* will be read as interconnected streams, responding and complementing each other, revealing the many different aspects and layers of the city. Indian popular cinema's engagement with the transformation of the city also echoes this (Mazumdar 2007). In its transformation to megalopolis, Bombay has overwritten itself with new histories, reflected, for example, in its 1995 name change from Bombay to Mumbai, disavowing its colonial origins as well as relinking it to Maharashtrian roots.[2]

Rushdie's protagonists need to take account of these fundamental shifts and changes and its impact on their identity. Here, Rushdie dramatises disorientation, which his protagonists experience through a process of alienation that leads to migration and the loss of an idea of home triggered by their move from Bombay via London to New York.

## Negotiating Shifting Identities: Reimagining Bombay

After its initial opening in Mexico, the novel moves back to Rushdie's familiar setting of pre-independence Bombay in the declining days of the British Raj. Rai narrates the trials and tribulations of the Cama clan, close friends of his own family, the Merchants. Out of this close association grows the Rai-Vina-Ormus love triangle. The novel offers another nostalgic look at the city and its golden age of the 1950s and early 1960s. Rushdie's narrative also draws again from familiar tropes of Hindi film melodrama in his staging of the family, which are such an integral part of *Midnight's Children* and *The Moor's Last Sigh*.

In his essay 'Imaginary Homelands', Rushdie likens the process of remembering to the land reclamation projects of Ahmed Sinai and Dr Narliker in *Midnight's Children*. In *The Ground Beneath Her Feet*, architecture subsumes this metaphor, and Rai's act of writing could be seen as his own attempt at architecture. Rushdie's use of Bombay as a backdrop in *The Ground Beneath Her Feet* differs from previous novels. Here, he provides a detailed exploration of the construction of Bombay through Rai's parents'

occupation as architects, designing much of the city's Art Deco buildings, and their essence is interwoven with the physical texture of the city. On the one hand, this cosmopolitanism is encapsulated by modern architecture, always looking to the new; on the other, it is reflected in the language that Rai and Vina speak among themselves: '*Hug-me*. Hindi Urdu Gujarati Marathi English' (Rushdie 2000, 7). Rai's parents, Ameer and V. V. Merchant, are involved in the modernisation of the city, building cinemas, department stores and apartment blocks. Through them, Rushdie captures the city's transformation from Victorian to modern, which functions as an important precursor to the issues of globalisation that the novel tackles. Rushdie explains:

> The thing to say about Bombay of the 1950s and the 1960s is that it was a very different place than the city that now exists. [ . . . ] It does seem to have been Bombay's great moment. [ . . . ] Like any great city, it acted as a magnet [ . . . ] It had a greater diversity of Indians than any other Indian cities. And it was the commercial center, so it attracted a large population of non-Indians. (Rushdie and Kadzis 2000, 217)

Bombay during the 1940s and early 1950s displayed a broad commitment to progress which often went hand in hand with a *laissez-faire* attitude to conservation, as the authorities were more concerned with an eye to the future.

This transformative energy is not a recent phenomenon, but can be observed at several junctures in the city's history. For example, from the mid- to late nineteenth century, the city reinvented itself as neo-Gothic Victorian and then Edwardian in the early 1900s, in particular along Cuffe Parade (completed in 1905). The transformative design and architecture of Art Deco aided Bombay in becoming a modern city in the 1930s. As Sharada Dwivedi and Rahul Mehrotra record, Art Deco 'symbolised the shift in expression to represent contemporary aspirations' (2001, 253). The constant need to reinvent itself, often linked to commercial and spatial pressures, as well as aspirational considerations of the modern and new, reveal Bombay as a city on the frontiers, at the interstice of modernity and between East and West. Rai celebrates the Art Deco style of Bombay with pride because his parents' construction firm Merchant and Merchant pioneered it in Bombay. For Rai, Art Deco is quintessential to Bombay, highlighted by his misconceptions about the word 'Deco': 'a local invention, its name derived, in all probability, from the imperative of the verb "to see." *Art dekho*. Lo and behold art' (Rushdie 2000, 78). His discovery of the Art Deco buildings in Manhattan, which are on a much grander scale than Bombay's, make America more enthralling and his migration more bearable. For Rai, Art Deco Manhattan represents 'our little Bombay writ large' (ibid).

The multi-layered architectural construction of Bombay functions as an interesting analogy for the complex identity constructions of the main

protagonists. Bombay's own 'in-between' position, rooted in the East with its gaze directed towards the West looking beyond the Arabian Sea, leads to the city's population constantly reinventing Bombay, negotiating the shifting ground beneath its own feet in the name of 'progress'.

For all three main protagonists, the initial place where they have to confront the issue of selfhood is Bombay, paralleled with the city's need to come to terms with its colonial past—emblematic in its architecture shaped so much by Western influences—and find its place in postcolonial India. Rai's parents illustrate two diverging approaches to define that position. Ameer Merchant has her gaze firmly directed to the future, dreaming of skyscrapers and the transformation of the city for future generations, while V. V. Merchant's gaze is directed to the past, unearthing the city's legends. Ameer favours the creation of new myths of progress to define a new postcolonial identity. V. V. Merchant's approach is archaeological, in his attempt to unearth Bombay's pre-colonial history to find the roots of identity there, revealing this different Bombay to his son Rai in stories and myths, taking on the role of chronicler, excavator and local historian (Rushdie 2000, 62).

Rai states that it is perhaps his parents' love for the city that makes him want to escape and dream of America, his father and mother in many ways having given birth to the city's most iconic buildings (Rushdie 2000, 76). For Rai, the 1970s expansion of the city through land reclamation projects at Nariman Point and at Cuffe Parade marks the destruction of the old city and the end of its golden era. The parallel dissolution of his family and his home become a metaphor for the destruction of old Bombay and its optimistic post-independence ethos, which ultimately sets Rai adrift as the family's close-knit friendship circle of middle-class Bombayites disperses: after the murder of her husband, Lady Spenta Cama moves to England together with Virus and Ormus to become Lady Methwold; Rai's mother dies of a brain tumour and his father commits suicide. Rai finds it difficult to cope with this upheaval and uses photography as a way of comprehending the loss of his family and Bombay (Rushdie 2000, 210–211). Rai ultimately leaves India because he experiences first hand the destructive potential of widespread corruption of the political elite, which is associated here with the rise to power of Indira Gandhi and her son Sanjay, groomed to be her heir, and exemplified by Piloo and Golmatol Doodhwala (Rushdie 2000, 203).[3] For him, the corrupting economic power of Bombay and the corrupting political power of Delhi form an alliance, an alignment that ultimately alienates Rai completely from India:

> And so farewell my country [ . . . ] Oh, why must everything I say end up sounding like a *filmi gana*, a goddamn cheap Bollywood song? [ . . . ] I may not comprehend what you are becoming, what perhaps you already are, but I am old enough to say that this new self of yours is an entity I no longer want, or need, to understand.

India, fount of my imagination, source of my savagery, breaker of my heart.

Goodbye. (Rushdie 2000, 248-249)

In this emotional declamatory outburst, which he self-consciously associates with the heightened emotions expressed in Hindi film songs, Rai waves a final melodramatic goodbye to India and Bombay, dissociating himself from a transformed and continuously transforming city he no longer recognises. Yet his imaginative link to the city is never completely ruptured. Throughout the novel, Bombay returns in a different guise shrouded in nostalgia as Manhattan becomes, not a substitute for Bombay, but Bombay on a grander scale (Rushdie 2000, 355). Despite Art Deco triggering these nostalgic connections between both cities, Rai and Ormus's transition is stark because it is permanent, and they have to reinvent a home away from home where Rai cannot stop himself from thinking about Bombay and India (Rushdie 2000, 416). Rai is in search of another India, an India that he can claim elsewhere, though he seems to find a semblance of its 1950s/60s ethos in New York. Rai's negotiation of New York also dramatises and questions the nostalgia with which he approaches the United States, reflected in the deployment of popular culture in the novel. This is marked most pertinently in his drawing of analogies between India and US popular cultural texts and stars, equating Dara Singh with Hulk Hogan, listening to Tony Bennett instead of Tony Brent, preferring the transition into Technicolor of *The Wizard of Oz* to similar attempts in Indian popular cinema and finding new associations in the Hollywood star system—Gene Kelly, Ginger Rogers and Fred Astaire rather than Indian cinema's Vijayantimala and Madhuri Dixit. Yet he concedes, 'I still smell, each night, the sweet jasmine-scented ozone of the Arabian Sea, I still recall my parents' love of their *art dekho* city and of each other' (Rushdie 2000, 417).

As Caroline Rooney observes, in '*The Ground Beneath Her Feet* American popular culture does seem to be very much invested with an immense nostalgia for a past that is not that of the immigrant protagonists even as it might represent a former affect of non-belonging' (2000, 63). Thus, 'certain American images, and more broadly Western images, have the status of memories, memories always already interiorised and lacking external referents' (Rooney 2000, 63-64). These referents are internalised by Rai as he continuously overwrites them, for example, New York being a palimpsestual layer over a version of Bombay, but they also link with his deployment of pop/rock music. The novel rests on the conceit that this quintessential American export is hijacked by Ormus and, as such, becomes an Indian invention, as Ormus's dead twin Gayomart whispers—from the other world—the tunes of what are to become iconic songs of the 60s to his brother. In this respect, Ormus's sound evolves from a Western style of rock music, which his band VTO make their own. Rollason's criticism that Vina and Ormus do not send Western listeners back to Indian music therefore seems ill-founded as, for

Vina and Ormus, rock music is Indian music in the first place (see Rollason 2003, 114). The point is that, while their musical trajectory brings them from Bombay via England to New York, for them, at least musically, they remain in the East, and herein lies the audacity of the narrator's claim. This is further complicated by the fact that Vina's origins are in the United States and so the migratory trajectories of the protagonists—Vina, Rai and Ormus—decentre and destabilise further any notion of a fixed point of origin, not only because of the world 'splitting' as a parallel historical universe opens up, but also as popular cultural referents firmly associated with 'America' crop up to generate a new 'mythic' history (see Rooney 2000, 64). As a photographer and through his method of storytelling, Rai is a good example of this, offering up these images for consumption. Since there is no point of fixity and everything is disorientated and comes adrift, his narrative must ultimately be written at an angle to reality as it negotiates the shifting ground of its migrant-protagonists' feet.

The novel deploys the metaphor of its title with regards to cross-global and cultural migration, and decentres in the process received grand narratives of history, time, politics, culture and religion. When in America, Vina, Ormus and Rai need to confront a very different cynical contemporary public, 'convinced there's a subtext beneath every text, [ . . . ] an otherworld running parallel to the world' (Rushdie 2000, 418). Rai exposes this paranoia of the modern world and shows how meaningless and futile the endless search for meaning is, especially when celebrities become the objects onto which this search is projected. Rushdie reveals the constructed nature of celebrity and stardom through the Vina-, Ormus- and VTO-mania, which resonates with the star system of Indian popular cinema, previously explored in Chapters 4 and 5.

The price Ormus and Vina pay for their global superstardom is that, in the public imagination, 'they had become little more than signs of the times, lacking true autonomy, to be decoded according to one's own inclination and need' (Rushdie 2000, 426). Vina and Rai, fetishised as popular cultural commodities, are directly connected to Rai's preoccupations as a celebrity and news feature photographer, which further emphasises for all three the complex negotiation of 'reality', 'identity' and reception through the consuming fans' complicity in creating celebrity: 'Our creations can go the distance with Creation; more than that, our imagining—our imagemaking—is an indispensable part of the great work of *making real*' (Rushdie 2000, 466). Within this process, Rai concludes that the role of the photographer as narrator gives him the potential of creating the meaning of an event, encapsulated in an image.[4]

## Rai's Narrative Strategy in *The Ground Beneath Her Feet*

*The Ground Beneath Her Feet* is a sprawling, cyclical and digressive narrative mirroring the excessiveness of *Midnight's Children*. The novel mixes pop and

rock music, pop cultural references, Greek and Hindu mythology, anchored around political references fictionalised in a non-linear parallel timeline. Rai confuses dates, as though time can be transcended. Yet, although this seems familiar when we remember Saleem's own issues with memory and remembering accurately, Rai changes events so much that his characters seem to exist in a parallel universe. Rai is as distinct a narrative voice as Saleem or Moraes, but Rai represents a new phase in Rushdie's own search for a language with which to express stories that have shifted in subject matter, locality and sensibility within the context of globalisation by reworking them from a different position. Through his transition to America, Rai accepts his discontinuity with his past and concludes 'that there is thrilling gain, in this metamorphic destiny, as well as aching loss' (Rushdie 2000, 441). The questions Rai constantly asks himself in relation to this observation are 'Do you know who you are?' and 'Do you know what you want?'.

Rai's voice is distinctly separate from his predecessors when considering the popular cultural idiom of photo-journalism, through which he tells his story. Rai knows how to exploit photography as much as Rushdie knows how to use visuals in his novels. For Rai, photography allows for the transferral of perceived actuality into the historical and plays a crucial role with regards to memory and remembering. However, he makes a clear-cut distinction between news photography, celebrity/fashion photography and the snap for the family album. Photographs function as emotional triggers for memories and remembering, though our own memories of a place or an event might differ from the 'actual' photograph.[5] Rai's story, like that of Saleem and Moraes, is written in retrospect and from memory. Cyclical in nature, he begins with Vina Apsara's disappearance, turns his attention backwards, before returning to her presumed death and then moving the narrative forward to its conclusion in the present. Rai rejects linear storytelling from the outset, jumping backwards and forwards in time and between different locations. In this respect, Rai's narrative seems very filmic. He allows one scene to play out, then fades out and zooms in or cuts to the next and his story reads disjointed and episodic, a jigsaw puzzle of shards of memory with all their potential falsifications. This is most strikingly realised in Rai's uses and abuses of historical events, which 'happen' at the wrong moment, sometimes in the wrong place. For instance, the assassination of Indira Gandhi occurs in 1980 rather than in 1984.

The question is if Rai is just another one of Rushdie's unreliable narrators or if he engages in a more serious questioning of reality. Rai aligns history in his version of the world to fit conveniently into the dramaturgy of his tale. This shifting, bending and kneading of history to serve his purpose is all the more striking considering Rai's role as news photographer, often seen as impartial documentarians of events at the interstice of history, capturing the present moment and preserving it in one image for posterity. Thus his role as narrator, biographer and photographer subverts truth and truthfulness,

realism and reality, history and historiography, fact and fiction. Rai has no qualms in rearranging the timeline and he feels no need to alert his reader. The distortions in the fabric of *The Ground Beneath Her Feet*—John F. Kennedy not being assassinated because Oswald's gun jammed; Watergate as a fictional novel; the storming of the Golden Temple in Amritsar taking place in 1975, not in 1984; or the entirely fictitious 1989 earthquake on the west Pacific coast of Mexico—remain unexplained. Rai creates a parallel, surreal world, which bears some semblance to the paranoid fictional creations of Thomas Pynchon, revealing his world as a constructed deconstruction of the real.[6] Rai asks: 'What could one trust? How to find moorings, foundations, fixed points in a broken altered time?' (Rushdie 2000, 184). Perhaps the answer is to narrate your story at precisely this angle to reality so that this position becomes obvious.

The reader has to accept that Rai's position as a migrant and voyager in his role as photographer is that of a man who renders the world through the visual image. By turning it into pictures, he finds a process to create his own reality. Rai constantly reminds his readers about the power of stories, but also about their nature, official or unofficial, fictitious or real: 'Impossible stories, stories with No Entry signs on them, change our lives, and our minds, as often as the authorized versions, the stories we are expected to trust' (Rushdie 2000, 199). From the beginning of the novel, the popular cultural idiom through which Rai routes his tale is no longer Indian popular cinema, but American popular culture—film, television and pop/rock music—which increasingly dominates globally. This becomes immediately apparent in Vina's nightmare. The sacrificial priests in her dreams have a resemblance to the actor Christopher Plummer, star of such films as *The Sound of Music* and *The Return of the Pink Panther*. He also starred as the Inca god-king Atahualpa in the 1969 film adaptation of Peter Shaffer's play *The Royal Hunt of the Sun*, from which the imagery of Vina's nightmare derives. Only Ormus really thinks in the Bollywood idiom when it comes to designing and plotting VTO's stadium tours: 'Ormus began to devise great spectacles, hyperbolic feats of showmanship that showed him to be a Bombay lad at heart, turning naturally to the mythic vulgarity of the Bollywood musical' (Rushdie 2000, 425). This is a stark shift, especially in the context of the position of enunciation of the narrator Rai at the beginning of the novel. He writes his tale retrospectively after the death of both Ormus and Vina, having settled into happy family life in New York with Mira, a former Vina impressionist, and her daughter, Tara. Despite sharing similar themes of potential migratory transformation of identity, the novel contrasts sharply with *The Satanic Verses*, as in *The Ground Beneath Her Feet* Rai narrates his tale post-transformation and his narrative is from memory, reliving this experience. Therefore Rai's story perhaps seems less immediate than that of Gibreel Farishta and Salahuddin Chamchawala in *The Satanic Verses*.

The function of Rai as photographer/narrator/chronicler/biographer is important for other reasons, as his shift from one locale to another raises questions about how we picturise the troubled areas of the world and what images we create of developing countries. Do these images serve to reinforce the dichotomy between East and West or do they help to bridge the gap? What is Rai's position? Initially, Rushdie sets the narrative on the subcontinent post-independence and then extends it into a narrative of migration, movement and uprooting, which Rai perceives throughout the novel as 'Disorientation—the loss of the East'. What the 'East' is in this context remains ambiguous: does Rai talk about his childhood India or does he talk about a Western 'orientalist' view of the 'East'?[7] This tension, which preoccupies Rai in the way he photographs the world, emerges through his narratorial voice, which is concerned with exploring the uncertainties of the different realities he experiences:

> Suppose you've got to go through the feeling of being lost, into the chaos and beyond; you've got to accept the loneliness, the wild panic of losing your moorings, the vertiginous terror of the horizon spinning round and round like the edge of a coin tossed in the air. (Rushdie 2000, 177)

For Rai, disorientation through dislocation forms part of the process of freeing oneself, the process of daring to step across the line. Rushdie first dramatises this particular aspect in *The Satanic Verses* and the above section bears resemblances to Gibreel's and Salahuddin's fall to earth. Strikingly, Rushdie feels the need to return to this theme ten years after the publication of the controversial novel in the wake of the lifting of the *fatwa*, revisiting these deep-rooted anxieties about 'the forgotten meaning of hollow, booming words, *land, belonging, home*' (Rushdie 1998, 4). *The Satanic Verses* stages the act of migration and what happens internally through the process of voluntary or involuntary deracination. As Rushdie's narratives move westwards, they increasingly move towards introspection on the part of his migrating characters, in an attempt to make sense of a world that is fast becoming more and more interconnected.

The notion of metamorphosis in the context of migration already explored in *The Satanic Verses* becomes an important recurring motif which Rushdie extends in *The Ground Beneath Her Feet*. From London the narrative moves quickly to the USA, and Britain becomes simply a membrane through which the protagonists need to pass. Metamorphoses, translation, migration, renegotiating the shifting ground beneath our feet, are powerful metaphors illustrating how to make sense of that fast-changing world. *The Ground Beneath Her Feet* begins with the disappearance of Vina Apsara on 14 February 1989 in an earthquake in Mexico, which is also the date on which Khomeini decreed the *fatwa* after *The Satanic Verses* was published. The inclusion of the date appears like a conscious decision of authorial self-dramatisation

and should not be lightly dismissed, considering how both novels deal with the nature of celebrity in a modern age and view it as an *Ersatz* mythology, which proves itself to be self-referential and vacuous. It is striking in this context how both novels deal similarly with migration, transformation, love, celebrity and superstardom.

The creation of myth and self-mythologisation have preoccupied Rushdie in his fiction ever since *Grimus*. *The Ground Beneath Her Feet* seems to be loosely connected to the earlier novel in its depiction of Native American culture, the Axona tribe in *Grimus* and Vina's fascination with Amerindian mythology in the later novel. In *Grimus*, Virgil Jones is Flapping Eagle's guide in his ascent of Calf Mountain to find Grimus, which as Catherine Cundy notes is analogous to Virgil guiding Dante through the Inferno, Hell and Purgatory in order to attain a vision of Paradise (1996, 16). Journeying and questing link the three texts, a process that forms an integral part of the myth-making of *The Ground Beneath Her Feet*, which allows Vina and Ormus and their relationship, symbolic of an ideal of love, to grow into myth. Like *Grimus*, the novel amalgamates different myths, often showing their correlation. The debates in which William Methwold and Sir Darius Xerxes Cama engage with regards to Greek and Hindu mythology serve to underpin this and are an invitation to question modern myth-making and the building of legends in our celebrity-crazed age. As Rai suggests: 'One way of understanding their story is to think of it as an account of the creation of two bespoke identities, tailored for the wearers by themselves' (Rushdie 2000, 95). Rushdie links the modern culture of celebrity and the ancient Greek pantheon as well as Hindu polytheism insofar as the gods can do what they like, good or bad (Rushdie and Gross 2001, 268). Rushdie sees them as examples of ourselves writ large, 'put up on a giant movie screen for us to watch and see ourselves mirrored in them' (ibid). In the examination of the hero of mythic proportions and connections with celebrity culture also lies the link with Indian popular cinema and its heroes, where the actors and their on-screen personae fuse into one in the star cult that the public creates around its movie stars, resulting in the actors being revered like gods.[8] Rushdie satirises this in *The Satanic Verses* through the self-delusional Gibreel Farishta, who cracks because he has played too many gods in mythological films.

Within the imagining of Vina and Ormus as celebrities and their media- and self-constructed mythic stature is a critique of the cult of celebrity, showing them as vessels into which people fill their aspirations and desires or hatred and loathing as they define themselves against such images. In his essay 'Crash: The Death of Princess Diana', first published in *The New Yorker* in 1997, Rushdie shows how acts of self-mythologisation and the building of legends depend on the photographic image; Princess Diana, one of the most photographed women in the world, is a case in point. Rushdie argues that we live in an 'Age of Fame, in which the intensity of our gaze upon celebrity

turns the famous into commodities, too—a transformation that has often proved powerful enough to destroy them' (Rushdie 1997a, 68). He likens the death of Diana in a car crash, fleeing from the lenses of the paparazzi, to an act of sublimated sexual assault. He implicates the camera here in the sense that it 'seeks to possess the Beauty', to capture her image on film. That image, however, is tied to economic gain, as there is an audience hungry to consume it (ibid). Likewise Rai is fully aware of the predatory nature of photography (Rushdie 2000, 213). For him, a 'photograph is a moral decision taken in an eighth of a second, or one sixteenth, or one-hundred-and-twenty-eighth' (Rushdie 2000, 13–14). He develops 'a knack for invisibility', and invisibility defines his place in his narrative—always present, but not always visible, enabling him 'to shimmy into their charmed space, into the midst of their rage or grief or transcendent arousal, to penetrate the defining instant of their being-in-the-world and get my fucking picture' (Rushdie 2000, 14). Such voyeurism and exploitation is directly linked to Rai's role as narrator and photographer. Is the writing of Vina and Ormus's story an act of writing his own autobiography or is it collusive with his voyeuristic/exploitative use of the camera to shoot images? In other words, is his act of openly revealing all the secrets of Vina and Ormus by writing this book also a form of betrayal, cashing in on the VTO phenomenon? Rai, the great voyeur, collusive in building the myth of Vina and Ormus, is arguably also guilty of selling out by telling his tale.

Rushdie dramatises the tension and dilemma of celebrity between being perceived as an object for consumption and being a subject in the developing celebrity cult around Ormus and Vina (Rushdie 2000, 309). This leads Vina to fashion herself into 'the exaggerated avatar of their own jumbled selves' (Rushdie 2000, 339). In the process, Vina and Ormus not only achieve iconic celebrity status as individuals, but their love also becomes a story of mythic proportions, with parallels to classical mythology constantly being drawn. Within these negotiations, Ormus's oaths and pacts with regards to abstinence provide the necessary creative impetus for their celebrity status to be matched by their powerful musical achievements which lead to their fame.

However, the obstacles their love has to overcome are not only circumstantial, but self-inflicted, for example, Ormus's oath to stay celibate throughout their engagement. Others are not, such as Ormus's coma after a car crash from which he is awakened by Vina, like Sleeping Beauty or Snow White, which Rai encourages the reader to interpret as an inversion of the Orpheus and Eurydice myth and parallel to the story in Hindu mythology of Rati and Kama.[9] Vina reclaims Ormus from the underworld and Ormus's awareness of that place makes him realise the fabric of the world is in the process of being unwoven from the other side. Reality is thus seen as multiple and in conflict, dramatised in Ormus's affliction, but also in Rai's narrative strategy, which also takes account of these multiple realities.

## Globalisation and *The Ground Beneath Her Feet*

Critics often associate globalisation with American political, cultural and economic domination and perceive it as different worlds in collision, such as East and West, developed and developing world. English as a globalised language and the *lingua franca* across the globe mediates between these worlds. Rushdie highlights the status of English as a language with global currency that is capacious and flexible in accommodating and expressing vastly different experiences. As is well known, in Rushdie's constant rearrangement of language, his playfulness creates a blend of different varieties of English, arguably decolonising and remaking it. Ever since *Midnight's Children*, Rushdie has used a version of English which is, as Rustom Bharucha has argued, 'a bastardized, hybridized, and more recently Hindi-film-cinematised English that is now almost two centuries old' (1994, 160). Rushdie creates a worldwide web of linguistic referents in a dense narrative, rich in allusion, and often challenging for his readers, depending on their access to these reference points.

Rushdie blurs the boundaries of cultural cross-fertilisation and, in this respect, the novel debates economic and cultural exchanges as they become ever more fluid. He highlights how within the process of economic globalisation everything is commodified: language, music, goods, services, history, people's lives. This commodification bears on history, historiography and the notions of myth the novel explores, debased as a form of *Ersatz*, a projection and an illusion. Ormus and Vina and their band VTO undergo such a process, ending up as empty vessels that their fans can invest with whatever meaning they want. This meaning is revealed to be constantly shifting, never fixed, on the one hand, by the self-constructed image Vina seeks to project through her shameless self-promotion, on the other, by the image the media is willing to construct of her, her relationship with Ormus and VTO.

Frederic Jameson remarks that 'the concept of globalisation reflects the sense of an immense enlargement of communication, as well as of the horizon of a world market, both of which seem far more tangible and immediate than in earlier stages of modernity' (Jameson and Miyoshi 1998, xi). By contrast, Roland Robertson defines globalisation as 'the twofold process of the particularization of the universal and the universalization of the particular' (1992, 177–178). Put together, these two early attempts at defining globalisation immediately point towards the variety of areas upon which globalisation impacts most profoundly: the political, the economic and the cultural. Jameson 'defines' globalisation 'as an untotalizable totality which intensifies binary relations between its parts—mostly nations, but also regions and groups, which, however, continue to articulate themselves on the model of "national identities" (rather than in terms of social classes, for example)' (Jameson and Miyoshi 1998, xii).[10] What follows from this, Jameson argues, is a state of tension and antagonism as the terms stand in binary opposition

to each other, such as the USA or the West claiming universality and another region claiming particularity. These tensions express themselves in what Jameson calls 'a range of collective Imaginaries' (ibid).

Rushdie addresses these 'Imaginaries' and seeks to decentre them by posing similar questions with regards to the evaluation of globalisation: 'Is it a matter of transnational domination and uniformity or, on the other hand, the source of the liberation of local culture from hidebound state and national forms?' (ibid). Rushdie explores these notions on a variety of levels. Most intricately he addresses these concerns through the position of Rai, a migrant who has worked as a news photographer in the conflict zones of the world, as an artist and as a fashion/celebrity photographer. In 1987 Rai returns to Indochina to document the aftermath of American intervention there (Rushdie 2000, 419). Rai's theory is that the Vietnam War did not end at the time of American withdrawal, but instead left at the gates the Trojan horse of free trade and the potential of prosperity for all which, once the 'gift' was accepted, overran the place; Vietnam becomes 'just another consumer-serf of (and supplier of cheap labor to) Americana International' (Rushdie 2000, 441). Rai captures this process in a series of images that are ironic, ambiguous, full of tension and discontinuity. He takes them precisely at a moment when he is in the process of rethinking his place in the world as a new citizen of America, facing up to the fact that he himself is through his work a part of 'Americana International'.

The position of Rai raises the question if he arrives at a cosmopolitan, universalising, all-embracing position through his metamorphosis, his work as a globetrotting photographer, his migration? Or rather, must he recognise that ultimately, in order to give meaning to the renegotiation of the ground beneath his feet, he has to develop roots in a locality and in the nucleus of a small family? It seems as though Rushdie explains this away too easily. *Fury*, too, grapples with these questions, but the propositions there seem even more unsatisfactory than in *The Ground Beneath Her Feet*. Globalisation in the novel is tied to the vision of a disintegrating world, the exposure of an amnesiac culture of super-capitalism where everything is market-orientated. Within these confines it becomes ever more difficult for the protagonists to find answers to the pressing questions '*Do you know who you are? Do you know what you want?*' (Rushdie 2000, 447, original italics). But perhaps it is not possible to define any point of arrival. Migration, once Ormus, Vina and Rai have left Bombay forever, is a transformative experience that keeps them trapped in a perpetual transit zone (Rushdie 2000, 461). For Rai, within this metamorphosis lies revelation. However, what this revelation is, is never revealed but, rather, is lost in the multiple realities he encounters.

Rai exposes through his probing that through processes of globalisation the world is not homogenised according to the laws of Americana International but, on the contrary, is fragmenting. In this world, love and family are presented as the only certainties. However, this is undercut by the array of

dysfunctional families and destructive love affairs that he features. Ormus and Rai cling to the reality of their love for Vina, which for both is a fixed point in the process of metamorphosis. Their personal grief and obsessive search to recapture Vina contrasts sharply with the global outpouring of grief after Vina's death. The process of globalisation, personified in the figure of Vina, elevates her to the ranks of the quasi divine before she is debased as a commodity to be exploited for financial gain, to capitalise 'on the Vina Effect' (Rushdie 2000, 486).

Rushdie's fictional worlds have always proved to be multifaceted, where reality is decentred through parallel universes. Increasingly, though, these are in collision. In *The Ground Beneath Her Feet*, the fictional realities of Bombay that Rushdie created in *Midnight's Children* and *The Moor's Last Sigh* intermingle with the story world of *Grimus*, *Shame* and *The Satanic Verses*. The modern city as 'the locus classicus of incompatible realities' metamorphoses into multi-dimensional arenas—overworld and underworld, colonial and postcolonial, industrialised and developing, the 'real' and the 'other'. The lines between these different dimensions become blurred as the protagonists navigate and negotiate between these transitional spaces. The characters are continually suspended in limbo, which leads to infinite rearrangements of their identity. The only character who discovers some level of stability is Rai in his relationship with Mira and the little nuclear family that they form together with her daughter Tara. In ordinary human love, beneath his feet, Rai finds meaning, *terra firma*. Rai thus realises 'the fantasy of an imaginary family, a family without origins', where 'America becomes the site for a hope of *a family without origins*' (Rooney 2000, 65, original italics). The main protagonist of *Fury*, Malik Solanka rejects such hope.

## *Fury*

In *Fury*, Rushdie explores further the central theme of celebrity, with which he has become increasingly preoccupied. It is difficult not to read Malik Solanka as an acute form of authorial self-dramatisation, which is already latently present in *The Ground Beneath Her Feet*. Rushdie's and Solanka's biographies seem to be congruent in many ways. Solanka, like Rushdie, is born in Bombay in 1947 in a villa off Warden Road. Both received their university education at King's College Cambridge. Both have been married twice and in summer 2000 left their wives and young children to relocate to New York. Many of the largely hostile reviews have connected Rushdie's personal life between 1999 and 2001, which was widely reported in the tabloid press, with that of his fictional character. For example, Adam Mars-Jones in the *Observer* described the novel as 'just another uneasy midlife crisis in disguise' (2001, np), while John Sutherland reads Malik Solanka as 'a version of his author, but he is also everyman' (2001, np). Yet to consider the novel as Rushdie's diary or merely thinly veiled autobiography is reductive since it occludes the

issues the novel engages with—love, violence, divorce, New York, guys and dolls and America at the pinnacle of its economic might.

In *Fury*, Malik Solanka feels the urgency to escape from his past. Unlike Rai Merchant, he does not remake New York in his mind as an alternative Bombay. For him, his Bombay childhood as much as his recent life in England is taboo. Bombay becomes here 'the Forbidden City of the Arabian Sea' (Rushdie 2002a, 146). In *Fury*, the reader encounters a new type of the Rushdian migrant. Solanka has made the transition from Bombay to London and England, where he studies at Cambridge, becomes a professor and then crosses over into the commercial world of television with his puppet creation Little Brain, over which he loses creative control. After a heavy row with his wife, Solanka finds himself standing at her bedside where she and her son are sleeping with a carving knife in his hand. This shocking event is the catalyst for him to uproot himself again to move to New York, severing all ties with his family and his life in Britain to exchange it for 'America, in the highest hour of its hybrid omnivorous power. America, to which he had come to erase himself. To be free of attachment and so also of anger, fear and pain' (Rushdie 2002a, 44). He gets involved with young Mila Milo, daughter of an expatriate Serbian author, and Neela Mahendra, a third-generation diaspora Indian from the fictional South Pacific island of Lilliput-Blefuscu, a barely disguised version of Fiji.[11] Neela Mahendra's ancestors hail from another of Rushdie's fictional inventions from *The Satanic Verses*, the village of Titlipur (Rushdie 2002a, 156).

Solanka rejects the nuclear 'family without origins' which, for Rai, becomes the only way of finding meaning in the present, although we see him return to London and there is a hint at reconciliation with his family. Indeed, Solanka and his wife Eleanor, initially through the love of their son, 'take refuge in a fantasy of undamaged familial contentment' (Rushdie 2002a, 105). However, Solanka has to find new *terra firma* and meaning for his life elsewhere and believes he can do so with Neela. He is in search for someone to heal him from his fury and believes that Neela and the love they have for each other will be his cure. She is his antidote: 'For *furia* could be ecstasy, too, and Neela's love was the philosopher's stone that made possible the transmuting alchemy. Rage grew out of despair: but Neela was hope fulfilled' (Rushdie 2002a, 206).

The redemptive quality of love has always played an important role in Rushdie's fiction. Amina Sinai learning to fall in love with her husband in *Midnight's Children* and helping to unfreeze his assets, the relationship between Gibreel Farishta and Alleluia Cone and Salahuddin Chamchawala and Zeeny Vakil in *The Satanic Verses*, between Aurora Zogoiby and Abraham in *The Moor's Last Sigh*, between Rai and Mira and between Malik Solanka and Neela Mahendra are only some examples. In all these relationships Rushdie addresses the healing power of love and its potential to redeem us.

Rushdie's 1987 review of Naipaul's *The Enigma of Arrival*, reprinted in *Imaginary Homelands*, already outlines some of these preoccupations. Rushdie comments on the absence of the word 'love', which remains buried amidst the tragedy of its protagonists and remains an enigma, a riddle. For Rushdie, Naipaul's novel is about a life without love or a life 'where love has been buried so deep that it can't come out' (Rushdie 1992a, 151). However, can love as Rushdie conceptualises it provide the necessary resolution to Malik Solanka's problems in dealing with his fury, his angst, his past and his future?

All the women in Solanka's life—Mila, Eleanor and Neela—are avatars of *Furia*: 'Mila as Fury, the world-swallower, the self as pure transformative energy. [ . . . ] This is what he looked for in women: to be overpowered, outmatched. This Gangetic, Mississippian inexorability, whose dwindling, he sadly knew, was what had gone wrong in his marriage' (Rushdie 2002a, 178). At first, Malik Solanka sees these dynamics of fury spin out of control in his private life. Later, as a detached newly arrived observer in the United States, he hears the threatening question 'Is this all there is?' and sees the Furies hovering over himself, New York and America (Rushdie 2002a, 184).

## Displacement and Filmic Narration— Representing the South Asian Diaspora

The novel's final showdown on Lilliput-Blefuscu, reminiscent of Bollywood action movies, raises a number of important questions: What is the relationship between the diasporic migrant and their homeland? Where lies home for the diasporic Indian who originates from a place that is not India? Empire trade has spread the Indian community across the globe, especially after the abolition of slavery, when many Indians migrated to the Caribbean, East Africa and the South Pacific as indentured labourers. What rights do they have to 'home' and a homeland beyond the Indian subcontinent? Furthermore, the episode also raises questions about revolution, freedom fighters and terrorism, and foreshadows the preoccupations Rushdie takes up in *Shalimar the Clown*. Rushdie's interest in this issue is longstanding, harking back to a visit to Nicaragua in 1987 that he documented in *The Jaguar Smile: A Nicaraguan Journey*. Do we need to read the countercoup in Lilliput-Blefuscu merely as an expression of Solanka's inner turmoil as the coup merges with his invented narrative of *The Puppet Kings*? Clearly for Solanka, with *The Puppet Kings*, history is repeating itself in an amplified form. He lost creative control over his previous creation Little Brain and the countercoup on Lilliput-Blefuscu demonstrates that he has now also lost control over his other fictional world as it is appropriated by the counterinsurgency and used for its own ends.

Rushdie thematises the problems faced by second- and third-generation diaspora South Asians for whom the notion of home and homeland is no longer rooted in the subcontinent. The Bombay film industry has discovered

and is increasingly marketing its films to this audience, and these films dramatise location and dislocation in a problematic nexus for the filmic hero, a conflict that is often resolved with a return to the homeland. As Jigna Desai points out:

> If we are to have a nomadic diasporic politics of location and mobility that destabilizes and denationalizes national (and territorial) identity, it must be one that also is specifically anchored and attentive to complex and simultaneous multiple relations, in this case, of colonialism, slavery, indigeneity, capitalism, and heteronormativity. (2004, 100)

Malik Solanka's relocation to the USA embodies this nomadic politics of dislocation and mobility in his double-dislocation from India to America via the UK. He does not concern himself with a process of recuperation, but quite the opposite—forgetting, thus defining himself in opposition to his homeland. Solanka lives with his gaze towards neither his 'imaginary homeland', India, nor to his adopted homeland, England. On the contrary, Solanka wants to destroy precisely this backstory: 'our little storehouse of anecdote and what-happened-next, our private once-upon-a-time' (Rushdie 2002a, 51). Solanka wants to disappear into the anonymity of the big city and desperately grasps at the possibility of starting afresh: 'He had come to America as so many before him to receive the benison of being Ellis Islanded, of starting over. [ . . . ] No longer a historian but a man without histories let me be' (ibid).

By contrast, his new lover Neela has a different relationship with India. For her it remains the longed-for homeland, the country of originary desire that can provide fixity and a sense of belonging and rootedness, as she has been twice-dislocated in a different sense—her ancestors came to the island as indentured labourers and she migrated in turn to the USA. Solanka observes this desire to capture her ancestral homeland, reflected in the décor of her apartment:

> India was insisted upon everywhere [ . . . ], in the overemphasized manner of the diaspora: the *filmi* music, the candles and incense, the Krishna-and-milkmaids calendar, the dhurries on the floor, the Company School painting, the hookah coiled atop a bookcase like a stuffed green snake. Neela's Bombay alter ego, Solanka mused, pulling on his clothes, would probably have gone for a heavily Westernized, Californian-minimalist simplicity. (Rushdie 2002a, 208)

Yet, as Solanka's reflections emphasise, the décor reveals only her personalised version and idea of India. Here most obviously a connection with Indian popular cinema suggests itself. Vijay Mishra argues that the popular Hindi film in the diasporic context fulfils the function of bringing the homeland to the diaspora linguistically and culturally together, joining different

groups in an imagined moment of solidarity (2002, 237). Mishra sees Indian popular cinema 'as a crucial determinant in globalising and deterritorialising the link between the imagination and social life' (ibid). Where such a reading of Indian cinema becomes problematic is in its levelling of South Asia into a homogenised monoculture where an orientalised version of India becomes a stand-in (Desai 2004, 6). In this respect, Indian popular cinema informs a narrow ethnicity that finds its imaginative realism through a particular kind of cinema. According to Mishra, 'the consumption of Bombay cinema actively constructs an Indian diaspora of shared cultural idioms' (2002, 238). Hence one could argue that Indian commercial cinema functions in the diasporas as a tool to imagine communities. This self-contained, culturally specific phenomenon is reflected particularly in film music and its on-screen picturisation, which is often an interior monologue that expresses repressed desires, emotions and aspirations. In *Fury*, music is an emotional memory trigger and provides solace, which allows for escape from the harsh realities of everyday life in a host society that is often hostile towards its migrant communities. Here, music becomes a form of escape and respite for many South Asians who stand somewhere between 'East, West', caught betwixt the pressures of traditional values at home and the pressures the West puts on them.[12] For example, after the funeral of his murdered friend Jack Rhinehart, Neela puts on a Lata Mangeshkar song from the film soundtrack of *Samadhi* (1950):

> Neela took Malik back to Bedford Street, opened a bottle of red wine, drew the curtains, lit many scented candles, and disrespectfully selected a CD of Bollywood song classics from the fifties and early sixties [ . . . ] In all things pertaining to feeling, Neela Mahendra knew what worked. *Kabhi méri gali aaya karó*. The teasingly romantic song lilted across the darkened room. *Come up and see me some time.* [ . . . ] She drew him down on to a cushion-strewn rug and laid his head between her breasts, wordlessly reminding him of the continued existence of happiness, even in the midst of grief. (Rushdie 2002a, 204)

A useful way of comprehending the negotiations of identity in diasporic contexts through the medium of film, to bring together Chakravarty and Virdi's terms from their studies of Indian popular cinema, is through the tension between 'ImpersoNation' and 'Cinematic ImagiNation', which is also reflected in the song from *Shree 420* which I discussed in Chapter 3. The tension between the two is dramatised in the commercial exploitation of Malik Solanka's dolls. In both these metaphors we can locate, as Chakravarty argues, 'notions of changeability and metamorphosis, tension and contradiction, recognition and alienation, surface and depth: dualities that have long plagued the Indian psyche and constitute the self-questionings of Indian nationhood' (1993, 4). Indian popular cinema needs to address and debate

these issues. According to Chakravarty, the discussion of 'ImpersoNation' serves more than just 'reinforcing the truism that films impersonate life; characters impersonate real men and women; the film-viewing experience impersonates dreams' (ibid).

Fury is part of Rushdie's engagement with a world in collision and shows that life stories mirror each other. The close father-daughter relationship of Mila Milo and the suggestion of sexual abuse is very close to Malik Solanka's own story, for he suffered abuse at the hands of his stepfather on Methwold Estate in Bombay. The close bond they form in New York seems to be a variation on the theme. Furthermore, the older man–younger woman relationship is paralleled with the scandal of President Bill Clinton's incident of oral sex with White House intern Monica Lewinsky in the Oval Office (Rushdie 2002a, 137).

Rushdie's fiction has made the transition from the Bombay film of the 1950s and 1960s to the preoccupations of the films of the 1980s and 1990s which echo in *The Ground Beneath Her Feet* and *Fury*. Indeed, *Fury* seems to perpetuate many clichés of Bollywood films that thematise the diaspora. The idea that Neela Mahendra can afford Malik Solanka the solace and peace of mind he craves emulates the role the 'authentic Indian' plays in films such as *Kal Ho Naa Ho* (2003) in guiding a dislocated, fragmented family back to fulfilled life by reminding them of ingrained Indian values. It seems that Rushdie has moved away from the engaging Bombay film formula that Vasco Miranda, in his description of Aurora Zogoiby's art, defined as an 'Epico-Mythico-Tragico-Comico-Super-Sexy-High-Masala-Art' (Rushdie 1996b, 148–149) to Rai's frustrated rhetorical question, 'Oh why must everything I say end up sounding like a *filmi gana*, a goddamn cheap Bollywood song?' (Rushdie 2002a, 248–249). The novel cannot quite make up its mind what it wants to be—satire, social melodrama or thriller, comedy or tragedy, and the blend of the various genres is less accomplished than in previous novels.

Fury in different manifestations and embodiments is the driving force of the novel. Malik Solanka observes: 'Out of *furia* comes creation, inspiration, originality, passion, but also violence, pain, pure unafraid destruction, the giving and receiving of blows from which we never recover' (Rushdie 2002a, 30–31). Solanka describes here the spirit of the book and, while the underlying furious anger engages the reader and provides a filmic showdown which no Hollywood or Bollywood director could have imagined better with three spurned women congregating in Malik Solanka's bedroom, the novel's final chapters read like a huge anti-climax.

Fury is a transitory novel which is the codicil to *The Ground Beneath Her Feet*'s argument about celebrity. Thus, Malik Solanka's story is the counternarrative to Rai's. Formally, *Fury* is a less digressive narrative, goal-orientated, using elements of thriller and crime fiction, which Rushdie further develops effectively in *Shalimar the Clown*. While thematically weaker, *Fury* reads like a much more

disciplined novel in comparison to *The Ground Beneath Her Feet*. *Fury*'s main character belongs, through his origins in Bombay and Methwold Estate, to Rushdie's fictional landscape. While this link might seem flimsy, there are important thematic and structural connections between these novels.

Fury might occupy a marginal position in this landscape but, nevertheless, it is an important link between *The Ground Beneath Her Feet* and *Shalimar the Clown*, pointing towards the connection of identity politics and violence. Malik Solanka's fury coincides with his midlife crisis and leads him to uproot himself and start afresh in New York. Yet his fury is played out on a grander scale in Lilliput-Blefuscu and its countercoup. Solanka's personal rage is also reflected in the murders of rich society girls who have a *faiblesse* for kinky sadomasochistic sex, as well as in the anger of Solanka's wife and his two lovers. Where is the origin of this fury though? It can be partly located in the loathed role Malik Solanka has to play as celebrity intellectual. Here it becomes almost impossible to escape the parallels between Solanka's life and Rushdie's. Like *The Ground Beneath Her Feet*, it could be argued that the novel's primary concern is with celebrity and stardom. As Amitava Kumar has observed, the issue with the novel is that the narrative is too closely tied up with the persona of the protagonist who 'appears utterly complicit in what he wants to lampoon' (2001, 35). This already seems a jarring note in *The Ground Beneath Her Feet* but, because of the centrality of Solanka, it is amplified in *Fury* and becomes problematic as it has a detrimental impact on the social satire that the novel aims for, which often seems hollow and lacks credibility. The reference to the master satirist Voltaire and his work *Candide* only helps to further underline this (Rushdie 2002a, 22).

Solanka grapples with the compromises he has to make for worldly, global success, seeing how he and his inventions are commodified in the process. These deliberations show the profound unease of an intellectual with his persona as a celebrity author in a global arena. Indeed, Kumar sees Rushdie's novel as an emblem of the fiction Jack Rhinehart writes in the novel to keep his estranged wife in her comfortable lifestyle:

> He gave up visiting war zones and began to write, instead, lucrative profiles of the super-powerful, super-famous and super-rich for their weekly and monthly magazines of choice: chronicling their loves, their deals, their wild children, their personal tragedies, their tell-all maids, their murders, their surgeries, their good works, their evil secrets, their games, their feuds, their sexual practices, their meanness, their generosity, their groomers, their walkers, their cars. Then he gave up writing poetry and turned his hand, instead, to novels set in the same world, the unreal world that ruled the real one. (Rushdie 2002a, 56)

While this might be too dismissive of the novel, it is undeniable that the book does expose a central character who seems obsessively caught up in his own

life as celebrity, on the one hand, and, on the other, yearns for respite and escape from it. Yet a world of globalised popular culture does not afford this.

However, a mere reading of the novel as a thinly veiled memoir would obscure the way the novel engages with mass media and the commodification of popular cultural products. In 'Authorship as Crisis in Salman Rushdie's *Fury*' Sarah Brouillette argues that these are now made available as 'highly politicized forms of appropriation or interpretation that betray the controlling intentions of their authors' (2005, 140). Rushdie experienced this during the controversy about *The Satanic Verses* and the Ayatollah Khomeini's literal call for the death of the author. However, Rushdie has become a brand name and has created for himself an authorial persona, a role he enjoys playing. This has become increasingly apparent since his highly publicised relationship with Padma Lakshmi. Rushdie, as a star author who generates column inches in gossip magazines, is not a problem, but it impacts on the power of his critique of the celebrity circus both in *Fury* and *The Ground Beneath Her Feet*, which brings this discussion back to the notion of authorship and authority. Both texts seem to be concerned with the dissolution of the demarcation between public and private life. Why does Malik Solanka flee to New York? He needs to escape his notoriety and reclaim some form of anonymity. However, it seems like a case of 'old habits die hard'. When Solanka is confronted with the business proposition for *The Puppet Kings*, he agrees, fully aware that this new creation has the potential to become as successful, if not more, than his previous invention. What happens is that the FRM rebel group on Lilliput-Blefuscu appropriates his creation and Solanka has to realise there is no way of controlling his brain child, and that no icon, no text, is free from appropriation or transmission as a political message—which harks back to Vina Apsara and her idolisation after her death and the cult status of VTO (Brouillette 2005, 150).

Fury explicitly critiques the way in which texts, through their commercialisation, subsequently become available for political (mal)appropriation, making it impossible for any author to control the political meaning of their textual productions (Brouillette 2005, 154). Rushdie's reply to Peter Catapone's remark that the story of his life might read like 'a bad Salman Rushdie novel' is revealing in this context: 'There is that side to it, where if I'd thought of it as a plot I wouldn't use it. Because it's like an Indian movie. It's very overblown. [ . . . ] And it just seems inappropriate to say this is my story' (Rushdie and Catapone 2002). In the light of the semi-autobiographical starting point of *Fury*, this response seems ironic and, indeed, Rushdie has now written his memoir, *Joseph Anton*, focusing on the ten years he spent in hiding from 1989 onwards. In *Fury*, Rushdie pushes his questioning of the role of the author, authority and author celebrity to its limits and manoeuvres himself into an artistic and imaginative cul-de-sac. With his next novel, *Shalimar the Clown*, he attempts to breaks out of it by refocusing his attention on India. The novel's setting in Kashmir reinvigorates Rushdie's imagination as does the move away from an investigation of celebrity to the politics of terrorism and its life-changing effects on his cast of characters.

# 7 Rushdie's 'Mission Kashmir'
## *Mughal-e-Azam* and *Shalimar the Clown*

*Shalimar the Clown* engages with terror and violence and vividly demonstrates how Rushdie has rerouted and globalised his concerns over the course of his oeuvre. The narrative cuts across different time periods and territories, and challenges the legacies of Empire, nationhood and emergent new empires. Rushdie goes beyond an investigation of the postcolonial nation's 'national longing for form' and instead highlights the repressions and exclusions that a newly independent postcolonial state imposes on its periphery, drawing attention to how India in Kashmir acts as a colonial occupying power. Rushdie complicates this in the continuing struggle over Kashmir between India and Pakistan and a variety of jihadist groups. In the process, individuals are left destitute and displaced. *Shalimar the Clown* intertwines a complex double love triangle familiar from many Hindi films with an investigation into resistance narratives, discourses of nationhood and nationalism. Furthermore, the novel offers a psychological profile of the internal workings of a terrorist's mind. Rushdie debates a variety of important political issues, but at the core of the novel lies the individual's struggle towards selfhood and subject formation in the face of stark ruptures conditioned by historical events.

Shalimar's murder of the former American ambassador to India, Maximilian Ophuls,[1] is privately as well as politically motivated. The axis on which the novel turns is the question: when is the personal political and the political personal? The book deliberately blurs these boundaries and it seems there are no clear demarcations between the two any more. Thus the novel deals with different forms of violence and investigates their profound impact on individuals' lives. When confronted with the ruins of the environments they live in, the cast of characters has to question whether there is any possibility left to reshape their sense of self. Rushdie reveals how a conflict in one of the most remote territories, Kashmir, has consequences on the lives of people who live in different worlds and have vastly different experiences. In this respect, *Shalimar the Clown* needs to be considered a globalised novel on a much more intimate level than *The Ground Beneath Her Feet*.

After *The Ground Beneath Her Feet* and *Fury*, Rushdie reflected further on how to achieve clarity within his multi-dimensional plots: 'A story doesn't

have to be simple, it doesn't have to be one-dimensional but, especially if it's multidimensional, you need to find the clearest, most engaging way of telling it' (Rushdie and Livings 2005, 110). *Shalimar the Clown* is a plot-driven novel with intertwined personal/private and political/public narrative strands. This stylistic shift allows for a clearer treatment of the subjects to emerge. Geographically, the novel begins in Los Angeles, flashes back to Kashmir and Delhi, 1940s Strasbourg and France, London, back to Kashmir, the Philippines, to climax, full circle, in Los Angeles. As effortlessly as the novel moves over the globe, the novel collapses chronologies and bridges different timelines, as a range of narrative strands merge and add new layers of meaning to the narrative.

Structurally, *Shalimar the Clown* bears resonances to *The Moor's Last Sigh*, which also intertwines different historical narratives, time periods and locations ranging across Cochin, Bombay and Andalusia. *Shalimar the Clown* is less digressive and, especially in the latter half, borrows the straightforward model of the thriller. Rushdie creates an ensemble cast in this novel, rather than allowing one particular character to take centre stage, despite the suggestions of the title to the contrary. Rushdie's strategy points towards several aims. Firstly, it is a further exploration of the theme of 'worlds in collision' that have preoccupied him ever since *The Satanic Verses*. Secondly, it is an attempt to further develop the 'everything novel' while exposing the difficulty in writing about everywhere and the danger of ending up writing about 'nowhere' (Rushdie and Livings 2005, 110). Similarly to *The Moor's Last Sigh*, *Shalimar the Clown* features a central intertextual relationship with a defining film of Indian popular cinema, *Mughal-e-Azam* (1960). Through the movie, Rushdie creates a panoramic screen within the novel that is capacious enough to explore different experiences and realities. Belonging to the genre of the 'historical', Rushdie uses the film to highlight the fundamental influence of India's Mughal heritage, the legacy of cultural synthesis and the importance of the concept of *Kashmiriyat*, which stresses communal harmony and tolerance. Unlike Rushdie's previous novels, *Shalimar the Clown* is not defined entirely by an urban setting.

As *Shalimar the Clown* traverses the globe, Rushdie considers important geopolitical questions: American interventionism, separatist insurgencies, religious fundamentalism, terrorism, freedom struggles and the shifting role of a former colonised country like India, its emergence as a regional power, but also as a 'colonial' power of occupation. Rushdie links the Kashmir conflict and the dispute over the territory between India and Pakistan to the Franco-German conflict over Alsace-Lorraine that was finally resolved with Germany's defeat in 1945. He draws tentative parallels between separatist movements in different countries and different periods, questioning and exploding categories such as 'terrorist' and 'freedom fighter'. The novel argues that the Kashmir conflict is a religious, political and territorial issue and investigates the impact of military, political and religious violence as

idyllic Kashmir is physically destroyed. Rushdie connects the conflict to people who live in different territories, highlighting how these experiences bear on other people's stories:

> It used to be possible to write a novel about, say, London or Kashmir or Strasbourg or California, without any sense of connection. [ . . . ] Now I feel more and more that if you're telling a story of a murder in California, you end up having to tell the story of many other places and many other times in order to make sense of that event and that place. To try to show how those stories join. (Rushdie and Dougary 2005)

## Writing Kashmir from *Midnight's Children* to *Shalimar the Clown*

Most of the plot of *Shalimar the Clown* revolves around the mountainous valley of Kashmir. Rushdie, who is of Kashmiri ancestry, has used the valley as a setting before. It therefore requires a closer analysis of the previous ways it features in his writing from *Midnight's Children* to *Haroun and the Sea of Stories*. In *Shalimar the Clown*, Rushdie most explicitly deals with Kashmiri politics, the disputed status of the valley within the Indian Union and how, in this conflict, individuals are trampled underfoot as paradise is smashed to pieces. The valley has also been of longstanding importance for the Indian film industry. Initially featuring as the setting for romantic song sequences, it has increasingly featured as the backdrop for action thrillers, set amidst the conflict. The romantic song sequences have been displaced to Swiss alpine locations, as shooting has become more and more difficult.

The first two chapters of *Midnight's Children* narrate the return of Aadam Aziz from medical training in Heidelberg and his falling in love in fragments with Naseem Ghani. By using the filmic device of intercut scenes, Saleem narrates in a flashback to 1915 Kashmir the courtship of his grandfather and grandmother. The novel begins with Aadam Aziz's profound loss of faith during his stay in Europe. For Aziz, this triggers a conflict between modernity, represented by the anarchist/communist principles of his German friends Oskar, Ilse and Ingrid, and the traditional values of Kashmir (Rushdie 1995a, 10). Rushdie suggests that Kashmir in *Midnight's Children* is a mythic paradisiacal space, which Aziz threatens through his foreign education, having stepped into 'history'. The act of leaving the valley to attend university creates a split in Aadam Aziz's sense of self, which in another flashback he recalls occurring through his discussions with Ilse Lubin and Oskar. By returning to Kashmir, Aziz tries to reconcile his new self with a previous one (Rushdie 1995a, 11).

Dramatised in the relationship between the boatman Tai and Aziz and their subsequent conflict, Kashmir takes on different connotations. For Tai, Aziz is the embodiment of rationality and science, associated with a modernity

that Tai sees as a threat to the ancient cultural and historical legacy of Kashmir. In this respect, Kashmir is a place of origins, a place of beginnings that later transforms into a place of hope betrayed and possibilities denied, akin to the symbol of the Midnight's Children. In *Shalimar the Clown*, there are deep-rooted echoes of Rushdie's earlier treatment of Kashmir:

> In those days there was no army camp at the lakeside, no endless snakes of camouflaged trucks and jeeps clogged the narrow mountain roads [ . . . ]. In those days travellers were not shot as spies if they took photographs of bridges, and apart from the Englishmen's houseboats on the lake, the valley had hardly changed since the Mughal Empire. (Rushdie 1995a, 10–11)

Presented as a primordial paradise, Kashmir is in *Midnight's Children* a territory still unblemished by the wrangling of Pakistani and Indian politics.

Aadam Aziz's altered vision generates an argument about faith and reason, which causes his self to split. Parallel to this, Rushdie develops the conflict between tradition and modernity through Tai's inexplicable rage. Tai features as a primordial figure who represents unchangingness, underlined by his decision to stop washing as an act of defiance against the doctor who brings an alien knowledge to the valley and threatens to upset its volatile balance. For him, modernity, science and progress pose a serious risk that may lead to the potential destruction of the valley's equilibrium. *Shalimar the Clown* picks up this argument in a different guise by explicitly asking what the creation of India and Pakistan achieved in Kashmir.

Rushdie raises here already the important question of self-determination and secular communal harmony, which he associates with Kashmir, and these are developed in greater detail in *Shalimar the Clown*.[2] In her analysis of Part I of *Midnight's Children*, Ananya Jahanara Kabir engages astutely with the novel's representations of Partition, the trauma of the loss of Kashmir and its effects on the novel's protagonists. Similarly to *Shalimar the Clown*, *Midnight's Children* features Kashmir as a lost paradise to which a return seems impossible. Kabir suggests that the narrative is shaped by two losses, on the one hand, that of *Kashmiriyat* (the concept of 'Kashmiri-ness') and, on the other, what Kabir calls 'the mythic geography of South Asian Muslim high culture, specifically that invested in the imperial Mughal past' (2002, 252).[3] The sign denoting that loss within the Kashmiri context of the narrative is Aadam Aziz's pigskin bag, which outrages the boatman Tai as it symbolises the profane, the foreign, the alien and the invasion of progress that threatens to destabilise Kashmiri peace (Rushdie 1995a, 27).

In *Haroun and the Sea of Stories*, Rushdie's fictionalised Kashmir, the valley of K., is presented not only as paradise, but also a political battleground. The story makes a wholehearted argument for the human need of stories for our

own survival. The question on which the story hinges is 'What's the use of stories that aren't even true?' (Rushdie 1991, 22, original italics). The novel follows the adventures of Haroun and his father Rashid Khalifa, a storyteller, who on a tour paid for by a group of corrupt politicians in the valley of K. have to save the Ocean of the Stream of Stories from Khattam-Shud, the arch-enemy of all stories, language and speech. Rashid faces the problem of having lost his storytelling gift after his wife left him for another man and he accidentally cancelled his subscription of story water supply. After apprehending the story water disconnector, Haroun forces Iff the water genii to take him to Gup City in Kahani on the shores of the ocean.

The starting place for Haroun's adventure is a fictionalised Kashmir, which Rashid describes as follows: 'There are fields of gold and mountains of silver and in the middle of the valley is a beautiful Lake whose name, by the way, is Dull' (Rushdie 1991, 25). Rushdie uses Kashmir's awe-inspiring natural beauty as a backdrop, which he describes as 'a view spread out like a magic carpet, waiting for someone to come and take a ride' (Rushdie 1991, 34). Yet Rushdie suggests that the valley of K. in the country of Alifbay is not an entirely happy place, denoted by a vandalised welcome sign that now announces 'WELCOME TO KOSH-MAR'. Rashid explains: 'Let me think, Yes, that was it. "Kache-Mer" can be translated as "the place that hides a Sea". But Kosh-Mar is a ruder name. [ . . . ] In the old tongue,' Rashid admitted, 'it was the word for "nightmare"' (Rushdie 1991, 40). Rushdie sets up a dialectic tension between the natural beauty of the valley and the people's unhappiness because of the political situation, which is reflected in the insincere 'movie-star smile' of the politician Mr Buttoo who invites Rashid to his election rally. Rushdie reveals that, on the one hand, the valley of K. is a place of such beauty that it inspires stories, reflected also in the name of the barge on which Rashid and Haroun spend the night, The Arabian Nights Plus One, while, on the other, its people live a man-made nightmare caused by a corrupt political elite. After ridding Kahani of the evil Khattam-Shud and with his storytelling gift restored, Rashid turns the people at the rally against Buttoo and his unpopular local government through the power of his story. Buttoo flees, never to be seen again in the valley, which allows the people in the valley of K. the freedom to choose their leaders (Rushdie 1990, 207). The moral, then, of this fable is that 'stories that aren't even true' can inspire people to be active participants to stand up for their rights. This might seem idealistic, but works in the context of a children's novel and also resonates in some of Rushdie's other fiction and non-fiction.

Freedom of expression is intrinsically linked to the right to self-determination, which become important markers in the narrative argument of *Shalimar the Clown*. This is also reflected in Rushdie's non-fictional engagement with the Kashmir conflict. In a column which Rushdie wrote for the *New York Times* on the occasion of the stand-off between India and Pakistan in the Kargil area in 1999, Rushdie laments how both nations have disregarded

the wishes of Kashmiris, turning the valley into a militarised battle zone, a territory over which the two nations and, more dangerously, two nuclear regional powers, compete.[4] In *Shalimar the Clown*, Rushdie portrays a landscape physically destroyed by man:

> *Shalimar* was a kind of attempt to write a Kashmiri *Paradise Lost*. Only *Paradise Lost* is about the fall of man—paradise is still there [ . . . ] *Shalimar* is about the smashing of paradise. It's as if Adam went back with bombs and blew the place up. (Rushdie and Livings 2005, 112)

The Kashmir of *Shalimar the Clown* draws on aspects of the territory Rushdie has written about previously; however, it is more focused in detailing how Kashmir transformed into a battle zone after India and Pakistan became independent nation states. In the initial stages of the 'Boonyi' section, Kashmir appears to exist out of real time. The impact of politics is peripheral and does not influence day-to-day life in the village. It is only the analogy between Abdullah Sher Noman who is compared to a lion—like Sheikh Abdullah, 'The Lion of Kashmir'—that introduces Kashmiri politics into the narrative.[5]

At first, the novel concerns itself with the multiple meanings of names and the mythic space associated with Kashmir. The village name of Pachigam, it is suggested, is a version of Panchigam, birdville, an implicit allusion to the Sufi interpretation of Islam that used to be prevalent in Kashmir (Rushdie 2006b, 60).[6] At this stage, clashes on religious lines seem impossible. However, the conflict between Shirmal and Pachigam, which erupts when Pachigam expands its business from bhand pather clown-story performances into catering to offer an all-round entertainment package, foreshadows the violent religious conflicts that follow. This first flaring of violence is met with widespread shock: 'nobody had imagined that so outrageous a breach of the peace was possible, that Kashmiris would attack other Kashmiris driven by such crummy motivations as envy, malice and greed' (Rushdie 2006b, 62–63). The conflict between the two villages is economic, rather than ideological, as Pachigam has broken the Shirmali's monopoly of the banquet market—but the prophetess Nazarébaddoor sees the 1946 pot war as an ill omen, a prelude to more serious bloodshed to come (Rushdie 2006b, 63).

Both villages are brought back together when the maharaja requests the villagers to present their skills at the Grand Dassehra festival. This occasion leads Pyarelal Kaul, Boonyi's father, to remark on Mughal synthesis and the interconnectedness between Hindus and Muslims in the valley. He reflects, in the setting of the Mughal Shalimar Gardens, on this extraordinary occasion that a Muslim village has been requested by a Hindu maharaja to put on a play and provide food for his guests in celebration of the day on which Rama launched his quest to return Sita from the Demon King Ravan. Pyarelal pertinently concludes that here 'in Kashmir, our stories sit happily side by side on

the same double bill, we eat from the same dishes, we laugh at the same jokes' (Rushdie 2006b, 71). The emblem of this Kashmiri tolerance, of communal harmony which, along with the natural splendour of the valley, is likened to paradise, are the Shalimar Gardens—which are evoked as such on numerous further occasions (Rushdie 2006b, 75–80). The gardens, built by the Mughal Emperor Jehangir, represent an ideal synthesis and communal harmony that prevails in this fictional pre-Partition Kashmir. The narrator elaborates: 'Paradise too was a garden—Gulistan, Jannat, Eden—and here before him was its mirror on earth' (Rushdie 2006b, 78). In the Shalimar Gardens, Abdullah Noman drifts in and out of dreamlike musings about the genesis of Kashmiri tolerance and focuses on what, in his opinion, distinguishes the valley: it values 'what was shared far more than what divided' (Rushdie 2006b, 83). This primordial paradisiacal vision of Kashmir is shattered with the coming of independence for India and Pakistan. As Pachigam and Shirmal prepare for their performances, news of Pakistan's invasion of the valley spreads, dramatising the events of October 1947 when rebels gained control over Poonch and advanced quickly to Srinagar, leading the maharaja to flee Kashmir (Rushdie 2006b, 85). Rushdie juxtaposes the political and military arguments in a dialogue of different rumours that debate the status of the valley and the indecisiveness of the maharaja, creating panic among the villagers and implying that Nazarébaddoor's prophecy is starting to come true. She describes the new age that dawns metaphorically as a time of demons beginning, and Abdullah Noman as 'the bizarre sensation of living through a metaphor made real' (Rushdie 2006b, 88). The end of this section suggests the loss of paradise. The narrative then leaps fourteen years to 1962 with Kashmir now a militarised zone, brilliantly evoked in the army camp Elasticnagar, which grows so large that it becomes known as broken Elasticnagar.

The Indian government's line is encapsulated by Rushdie's fictional General Hammirdev Kachhwaha, who commands the army in Kashmir (Rushdie 2006b, 96). Known for his hard-line approach, he is later nicknamed the Hammer of Kashmir. Rushdie finds a powerful way of describing the illogical reasoning for the Indian military presence in Kashmir by linking it to a discourse of nationhood and nationalism. For Kachhwaha, Kashmiris' self-determination of their own political future is an absurd notion. Yet, through the absurdity of his own argument, he inadvertently reverses this. General Kachhwaha is quick to dismiss any challenge to the unity of India: 'Where did that kind of thinking get you? If Kashmir, why not also Assam for the Assamese, Nagaland for the Nagas? [ . . . ] Why not stand still and draw a circle round your feet and name that Selfistan?' (Rushdie 2006b, 101–102). But in all the regions he mentions, groups are fighting precisely for their right to determine their own political future (Stadtler 2009).

While the central state forms one part of the destructive force in Kashmir, Rushdie then introduces radical Islam into the novel as the second damaging component in the region through the arrival of the 'blood-and-thunder

preacher' Bulbul Fakh in Shirmal (Rushdie 2006b, 115). Nicknamed the iron mullah, the villagers of Shirmal associate him with the detritus of military hardware that contaminates the valley and, transformed into local myth, like a Transformer toy, adopts human form and a life of its own. Rushdie visualises the emergent religious radicalisation of Kashmiris through the influx of Islamic terrorists and preachers, in parallel with the increasing and evermore draconian Indian military stranglehold.

The iron mullah then arrives to preach resistance and revenge. Maulana Bulbulb Fakh, whose name roughly translates as 'nightingale with a bad odour', is honoured, feared and obeyed, and is the cause for communal strife, further exacerbating the relations between Shirmal and Pachigam. It culminates in the rape of the Hindu girl Zoon Misri by the Muslim Gegroo brothers Aurangzeb,[7] Alauddin and Abulkalam, as the mullah denounces Pachigam as 'the enemy within' because of its celebration of communal interaction and harmony (Rushdie 2006b, 119). The arrival of Bulbul Fakh in Shirmal coincides with the 1965 war between India and Pakistan in the Rann of Kutch, which makes Elasticnagar snap into 'Broken Elasticnagar', due to yet another increase in the military presence in Kashmir. The army general speaks of his disillusionment with Kashmiris and their renewed calls for self-determination, which for him suggested that the population is somehow wanting insofar as it shows itself 'ungrateful' to be 'defended' (Rushdie 2006b, 130).

Kachhwaha's disenchantment is countered by Abdullah and Firdaus Noman's serious doubts over Kashmir's continued union with India:

> Up to now they had tried to believe that their beloved Kashmiriness was best served by some kind of association with India, because India was where the churning happened, the commingling of this and that, Hindu and Muslim, many gods and one. But now the mood had changed. (Rushdie 2006b, 131)

The changed situation turns the love match of Boonyi and Shalimar into a false symbol, associated with a fast disappearing golden age, now irretrievably lost. This lament recalls Rushdie's belief, expressed in *Midnight's Children* and *The Moor's Last Sigh*, that India moved away from the secular ethos after Nehru's death in 1964 and that communal politics were allowed to play a much larger part in Indian life. Rushdie's analogies with the 'historical' film *Mughal-e-Azam*, an important intertext, need to be seen in this context. At the heart of the film lies the story of forbidden love between Prince Salim and the dancing girl Anarkali. Yet the film also takes up debates about justice and Mughal tolerance, indeed how the Muslim presence in India forms an integral part of the nation, important in a contemporary context. The film was released in 1960, only thirteen years after the country had witnessed the horrors of Partition.

Undoubtedly, Rushdie strategically evokes the film to suggest nostalgia for an irretrievably lost period and a glorious past of Hindu-Muslim understanding and tolerance as it is presented by the court of Akbar. He was a Muslim ruler who married a Hindu princess without forcing her to convert, allowing her to practise her religion.[8]

What then is the narrative importance of the allusion to Akbar through *Mughal-e-Azam*? In *The Argumentative Indian*, Amartya Sen ties Akbar's ethos of tolerance to a wider tradition of argument and reasoning in India, which he links back even further to emperor Ashoka. According to Sen, Akbar was not only an advocate of the primacy of tolerance, but institutionalised it by enshrining the religious neutrality of the state through a secular legal structure (2006a, 18). What is exceptional about Akbar is that, at a time when the Inquisition was still on the rampage in Europe, he had the foresight to recognise that cultural and religious diversity was integral to India and this recognition makes for a distinctive argument about the unity of India (2006a, 39).

Sen points towards two specific features of intercommunal discussions that took place at Akbar's court at the end of the sixteenth century:

> The first was the 'acceptance of plurality', embracing the regular presence of a multitude of beliefs and convictions. The second was the 'dialogic commitment' in the form of Akbar's visionary insistence on the need to have conversations and interchanges among holders of different beliefs and convictions. (ibid)

For Sen, Akbar's commitment to religious neutrality in state affairs is the foundation stone of the non-denominational, secular state (2006a, 287). In this respect, by invoking Akbar, Rushdie implicitly references the Mughal Emperor's convictions, the recognised plurality of India and the need for ongoing dialogue and discussion. This point of view features highly through the musing of Kashmiri Hindu Pandit, Pyarelel Kaul, but also Max Ophuls, and is presented as the only way of resolving the Kashmir conflict. In this respect, the discursive, argumentative tradition of Akbar's rule functions as a lost ideal, similar to the representation of Moorish Spain in *The Moor's Last Sigh*.

### Defeated Love—*Shalimar the Clown* and *Mughal-e-Azam*

While the novel's political themes impact on all the characters, the novel is first and foremost a story of betrayed love where humiliation and shame lead to all-consuming violence. Rushdie ties the love story of Boonyi and Shalimar to the notion of *Kashmiriyat* and its decline. When news of their lovemaking spreads and their secret is exposed, the village headman invokes *Kashmiriyat* to rationalise the possibility of a union between a Hindu girl and a Muslim boy:

*Rushdie's 'Mission Kashmir'* 163

*Kashmiriyat*, Kashmiriness, the belief that at the heart of Kashmiri culture there was a common bond that transcended all other differences. Most bhand villages were Muslim but Pachigam was a mixture, with families of pandit background, the Kauls and Misris [ . . . ] and even one family of dancing Jews. 'So we have not only Kashmiriness to protect but Pachigamness as well. We are all brothers and sisters here,' said Abdullah. 'There is no Hindu-Muslim issue.' (Rushdie 2006b, 110)

In this respect, their marriage and love match serve as an emblem and indeed a defence of the concept of *Kashmiriyat* itself.

The love story of Boonyi and Shalimar shares certain parallels with *Mughal-e-Azam*. This 1960s historical film narrates the story of forbidden love between Prince Salim and the dancing girl Anarkali. Boonyi re-enacts the famous dance number from the film as part of the troupe's bhand performances and serves as a reminder for the reader of the spectacular song picturisation in the film.

Although filmed in black and white, there are two instances where the movie bursts into colour, one of them the elaborate dance number in question.[9] The film plot of the legendary Anarkali-Prince Salim love story draws a further subtle parallel between Boonyi and Max. The film becomes a marker with which Rushdie bridges the novel's politics with his story of forbidden and betrayed love. Rushdie's references to *Mughal-e-Azam* are not accidental and the inclusion of the dance number is not a conceit merely to provide cinematic spectacle, but to allow him to implicitly articulate the importance of Kashmir for the Mughal Emperors Akbar and Jehangir. Furthermore, he

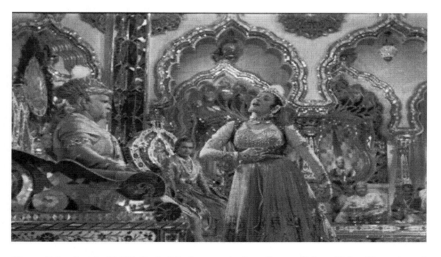

*Figure 7.1* Anarkali (Madhubala) dancing before Prince Salim (Dilip Kumar) and Akbar (Prithviraj Kapoor).

links the larger concept of Mughal Hindu-Muslim cultural synthesis with the idea of *Kashmiriyat*.

Rachel Dwyer's analysis of what she calls the 'Islamicate' film is instructive here. Such films refer to Islam in its social and cultural context, although they are not concerned with religion and religious depictions as such (Dwyer 2006, 96). In the early years of independence, films set in the Mughal era were made specifically in an attempt to show the 'Muslim period' as an integral part of Indian history to promote national unity (2006, 115). These films depicted 'a composite religious culture as an ideal to be emulated', and Dwyer further notes that the legend of Anarkali and Prince Salim, who later became the Emperor Jehangir, was incredibly popular (ibid). Rushdie references the song 'Pyar kiya to darna kya?' [What is there to fear? All I have done is to love/why be afraid of love?], the moment when Mughal-e-Azam transforms from black and white into colour.[10] The film's main focus is on the family history of the Mughal Emperor, Akbar, and his son Jehangir, not an accurate depiction of Mughal history. It is not even clear if Anarkali is an historical figure. However, '*Mughal-e-Azam* tells Mughal history in the context of the new nation' (Dwyer 2006, 116). In this respect, the film, like many historicals of the time, emulates the idea of history as discussed in Nehru's *The Discovery of India*.

Indeed, before Asif's 1960 film there have been previous cinema adaptations (1928, 1935, 1953) and two theatrical versions (Rajadyaksha and Willemen 2002, 251). This complex layering of historical, cinematic and theatrical antecedents has been tantalisingly revealed in Alain Désoulières's chapter 'Religious Culture and Folklore in the Urdu Historical Drama *Anarkali*, Revisited by Indian Cinema' (2007). The film has its origin in the historically themed Urdu play, *Anarkali*, written by Sayyad Imitiaz Ali Taj in 1922, who published a revised version in 1931. As Désoulières remarks, 'the genre of the historical drama' reveals the 'tension between historical realism and popular entertainment' (2007, 125). Yet the Anarkali story is by all accounts a legend, rather than rooted in historical fact, and Asif's 1960 version goes to great lengths to stress its legendary, rather than historical, roots. More interestingly, it reveals the Emperor Akbar, known widely for his tolerance, as an uncompromising ruler and hard-hearted father. It is not until Asif's version that a merciful Akbar emerges, with its revised ending which allows Anarkali to escape through a secret tunnel.

*Mughal-e-Azam* belongs to the genre of the historical film, which were made much more rarely, presumably because of the resources needed to create the lavish sets and costumes on screen. Between 1947 and 1967 an average of about three historical films were produced every year (Chakravarty 1993, 157). While the genre was in decline from the late 1960s onwards, it has had a revival in recent years with the success of films such as *Lagaan* (2001), *Mangal Pandey: The Rising* (2005) and *Jodhaa Akbar* (2008).

The inclusion of *Mughal-e-Azam* in *Shalimar the Clown* subliminally raises issues of history and historical representation and how they are transformed

in the narrative to become integral to the plot. By bringing together history and narration, historicals create their own mythology by moving away from realist representation through opulent sets, creating a sense of heightened drama and emotion that drive the narrative forward. Indian popular cinema's historical films are by nature a mixture of myth, legend and folktale and do not engage in a 'truthful' representation of the past. This aligns the representation of history in Indian popular cinema to an Indian tradition of historiography, where history is intertwined with myth and legend and reveals a process of cultural syncretism, reflected in terms like 'unity in diversity' and 'synthesis' that stem from a complex process of cultural adaptation and adjustment (Chakravarty 1993, 160). Similarly to the Muslim 'social' films, the 'historical' sought to appeal to a sense of national identity that went beyond the divisions of caste, regional and religious identity.[11] In this respect, the 'historical' can be read as an inflection of post-independence India (Chakravarty 1993, 163).

*Mughal-e-Azam*, released in 1960, resonates explicitly with the issue of Partition and the Muslim minority that still lived in India at the time. The filmmakers worked on the film from 1945 to 1960, and during this time they lived through the transition from colonial to postcolonial, the withdrawal of the British and Partition that brought with it the displacement of millions and bloodshed and violence on an unimaginable scale. The film emphasises synthesis through its selective representation of the past in its nostalgic display of Mughal grandeur. As Chakravarty argues, in *Mughal-e-Azam* 'the impulse toward synthesis becomes a means of exploring ideological and psychic disturbances pertaining to the group in question that then get resolved through emotional drama' (1993, 165). In this respect, the Hindu-Muslim relationship is sublimated in historical representation (see Dwyer 2006). The nationalist ideology of the new Indian nation and Nehruvian ideals of synthesis are expressed, however problematically, through the historical parallel of the Mughal period (see also Chakravarty 1993, 166). The film has to be understood in the context of the debate about the Muslim intervention in Indian history and in relation to the ideal of 'unity in diversity'. The portrayal of Hindu-Muslim syncretism relates to the creative and production context of the Indian popular film industry which relied on the collaborations of Hindu and Muslim writers, directors, actors, musicians—a concrete example of mutual cultural interaction. Saadat Hasan Manto, renowned Urdu short story writer, explores these connections and interactions in *Stars from Another Sky*. This collection of profiles of the leading personalities working in the Indian film industry of the 1940s recounts his work and intimate connections with many of them, and highlight personal relationships across the religious divide to create popular cultural entertainment.

*Mughal-e-Azam* uses the historical setting of Akbar's Mughal court in its retelling of the Anarkali legend.[12] Prince Salim, Akbar's son, falls in love with a dancing girl. As the title of the film [The Great Mughal] suggests,

Akbar is just as important to the film as the love story of Prince Salim and Anarkali, merging the legend of Anarkali with history. The Mughal period (1556–1707), and especially Akbar's rule (1556–1605), has been of particular interest for Bombay filmmakers, as his reputation as a just and tolerant ruler, his sponsorship of the arts and his respect for Hindu culture allowed for the suggestion of a common cultural bond between Hindus and Muslims (Chakravarty 1993, 168). Indeed, this is also attractive for Rushdie, who makes repeated allusions to this in novels such as *Midnight's Children* and *Shame*, exploring it more fully in *The Enchantress of Florence* where Akbar and his wife Jodha Bai feature as central characters.

The opening shot of the film features a rising map of India with a voiceover that explains the common citizenship and ancestry of India. The camera then shows the artistic and architectural legacy of the Mughal period in Akbar's palace in Fatehpur Sikri, near Agra, as a living monument to the cultural and artistic synthesis of Hindu and Muslim architectural styles. The film initially takes on these broader contextual issues before moving on to the love story of Salim and Anarkali who fall in love in defiance of Akbar. The melodramatically staged romance in direct confrontation with the patriarchal father figure is the film's driving motor, but the Technicolor, dramatically choreographed and picturised dance sequence in the mirror palace is the undisputed highlight of the film. Here, the film most explicitly finds its way into *Shalimar the Clown*. Anarkali, the enslaved dancing girl, plays on her allure, fully aware that she is being visually consumed by two men who determine her destiny—Akbar and Salim. Anarkali knows her powers of enchantment and, in this brief moment on the dance floor of the mirror palace, she holds these men in her grasp and is fully in control. In defiance of Akbar, who has forbidden the relationship, her dancing and singing become an emotional expression that she is still in love with Salim. Anarkali's dance is an act of defiance; Rushdie transforms it in *Shalimar the Clown* into Boonyi's leitmotif and recurring reference point with which she compares and contrasts her position in his story world. Boonyi is invited to perform the Anarkali dance sequence in front of Max Ophuls and subsequently becomes the American ambassador's lover, by choosing a life where through her actions she is forced to live outside respectable society. Her fate and position resonate with the seminal character of the courtesan in Indian popular cinema, though it is worth noting that Anarkali, despite being a slave girl whose role is to dance and sing for the ruler, is not a courtesan (Désoulière 2007, 131). In films like *Umrao Jaan* (1981), *Pakeezah* (1971) and *Devdas* (2002), the courtesan embodies an Islamicate culture shaped by Mughal India and its traditions, although she is a woman whose place is outside of respectable society displaying, as Dwyer argues, 'a socially unacceptable sexual but non-reproductive femininity' (2006, 122). This places her in a position on the margins, incompatible with the image of the 'modern' Indian woman, but an image of licentious sexuality, directly opposite and a threat to that of the Hindu wife and mother as it features in 1950s/60s Hindi cinema (ibid).

Although Boonyi is Hindu, not Muslim, her position relates to that of Indian popular cinema's portrayal of the courtesan. When Boonyi leaves Pachigam for New Delhi to dance for the American ambassador, she plays precisely that role as much as Max takes on the part of the heir to the Mughal throne (Rushdie 2006b, 191). It is never quite clear if Boonyi sees Max only as her ticket to escape or if she is attracted to him. His desire, however, turns to love, despite the fact that it compromises his position as a representative of the US government in South Asia. Boonyi's attempt at fleeing from the village of her birth fails spectacularly as the attraction between her and Max wanes and the relationship comes to an end. In the process, Boonyi betrays Shalimar, despite her continuing love for him. The intense affair between Max and Boonyi reveals the fragility of lovers' bonds and that love can be blinding and lead to deceit and self-delusion. She becomes the accomplished concubine because in her relationship with Max she *'will be the perfect counterfeit of a loving woman and you will receive from me a perfect forgery of love'* (Rushdie 2006b, 194, original italics). Yet Boonyi comes to realise that the old life in Kashmir with Shalimar, which she sought to escape because she felt as though it imprisoned her, was actually freedom and that she had been misled by her own calculations. The idea of freedom becomes for her a matter of perspective. By adopting the role of Anarkali, she comes to realise love is an illusion that does not necessarily endure, but is something that can be wanton, destructive and selfish:

> But Boonyi was no longer Anarkali, she had lost her beauty and could no longer dance, and the ambassador was nobody's son but the man of power himself. And Anarkali didn't get pregnant. Stories were stories and real life was real life, [ . . . ] impossible to cosmeticize in the greasepaint of a tale. (Rushdie 2006b, 204)

The Anarkali legend filtered through the movie serves as a useful way of paralleling the double love triangle of Shalimar-Boonyi-Max-Peggy. While the story is a recurring motif, it is also frustrated insofar as the narrator stresses repeatedly where the analogy ends. Thus, the Anarkali story in which Boonyi envelops herself is a screen behind which she hides from reality. Rushdie follows here a similar strategy to the one he deploys in *The Moor's Last Sigh* and its intertextual relationship with *Mother India*. In *Shalimar the Clown*, *Mughal-e-Azam* serves as an analogy of the representation of an idealised love and cultural synthesis, linking the character-driven plot elements with wider political considerations on Kashmir.

When Boonyi returns to the village, she finds that she had been declared dead by her father, her mother-in-law, her father-in-law and her husband (Rushdie 2006b, 223). Only Zoon Misri thinks of speaking to her as she also inhabits, after the rape she had to endure, the world of the living dead to which Boonyi is now also condemned. Boonyi is described as 'a stationary

corpse' and 'a snow-woman with the body of the deceased Boonyi inside' (Rushdie 2006b, 221). She returns to her village as a ghost and has to confront the cuckolded Shalimar who only bides his time to assassinate her. The betrayal of his love drives him to fulfil the oath he made on their first lovemaking: 'Don't you leave me now, or I'll never forgive you, and I'll have my revenge, I'll kill you and if you have any children by another man I'll kill the children also,' a remark she carelessly dismisses as post-coital romantic effusions on the part of her lover (Rushdie 2006b, 61). On her return, Boonyi immediately understands Shalimar's feelings and that he means to stand by the oath she so carelessly dismissed (Rushdie 2006b, 222). Boonyi has a sense of foreboding that she will die at the hands of her husband. Like Zoon, Boonyi now exists out of real time and, by that conceit, she becomes the replacement for the prophetess Nazarébaddoor and communicates telepathically with Shalimar. Boonyi shuts herself away in Nazarébaddoor's remote hut, once again evoking the analogy with Anarkali: 'Anarkali, too, had been immured for indulging a forbidden lust. And the trapdoor and the escape passage that set her free? That was just in the movies' (Rushdie 2006b, 227).

Betrayed love, then, becomes closely intertwined with the political themes of the novel insofar as the love story of Boonyi and Shalimar, a Muslim boy and a Hindu girl, is set up as an emblem of tolerance that prevails in the village of Pachigam and distinguishes itself from the neighbouring village of Shirmal (Rushdie 2006b, 61). The end of their friendly neighbourly relationship also ushers in the decline of the principle of *Kashmiriyat*. For Shalimar and Boonyi, the designations 'Hindu' and 'Muslim' were immaterial, merely descriptive terms which had become blurred at the edges (Rushdie 2006b, 57). When Boonyi returns to Kashmir after her affair, the Hindu-Muslim harmony has already been irreparably disturbed with the emerging radicalisation of the neighbouring village of Shirmal. In this respect, the death of Shalimar and Boonyi's love parallels the decline of tolerant Kashmir and unleashes Shalimar's vengefulness and violence. When Shalimar learns a rope trick so he can join the bhand pather troupe, his father initiates him into a separate trick that enables him to transform himself and metamorphose seamlessly (Rushdie 2006b, 56). His broken love triggers another transformation and he leaves to train as a terrorist to enable him to fulfil his seemingly innocent promise. Shalimar joins a jihadist camp in Pakistan, under the supervision of the iron mullah Bulbul Fakh, so that one day he will kill the American ambassador.

The loss of Shalimar and Boonyi's love and its link to the ideal of *Kashmiriyat* leads her Pandit father Pyarelal Kaul to a deep questioning of human nature:

> The love of Boonyi and Shalimar the clown had been defended by the whole of Pachigam, had been worth defending [ . . . ] Maybe *Kashmiriyat* was an illusion. [ . . . ] Maybe tyranny, forced conversions, temple-

smashing, iconoclasm, persecution and genocide were the norms and peaceful coexistence was an illusion. (Rushdie 2006b, 238–239)

In this respect, the loss of love is entwined with the loss of an ideal, which their love encapsulates, and it allows for a merging of the political and personal elements in the novel.

## One Man's Terrorist is Another Man's Freedom Fighter

The question of why Rushdie chose to tackle terror overtly in one of his novels may be attributed not only to the events of 11 September 2001, but also to his engagement with Kashmir and the different dimension brought into the India-Pakistan conflict with the rise of Hindu and Muslim fundamentalism and their influence on mainstream politics in both countries. In this respect, as Walter Laqueur argues, in Kashmir the nature of a territorial conflict acquired a religious dimension, which needs to be taken into account when writing about the region (2003, 178). The novel needs to be understood in the context of different theories of nationalism and the uniquely Indian conceptualisation of secularism, which differs from that in the West. The question of nationhood and separatism is important for the narrative argument in *The Moor's Last Sigh* and, more superficially, in *The Ground Beneath Her Feet* and *Fury*. While *The Moor's Last Sigh* engages with the 1992/93 riots and bomb blasts in Bombay and argues against a single, unitary idea of Indianness, *The Ground Beneath Her Feet* focuses briefly on Sikh separatism. Although the discovery of Yul Singh's financial aid and moral support in the fight for a Sikh homeland is a plot device that ushers in his fall, it introduces into the novel an implicit argument about the fractured nature of Indian identity and conceptualisations of nationhood and belonging in the subcontinent and diaspora. *Fury* similarly takes this up, albeit in the different context of Fiji. These are important precursors to Rushdie's engagement with separatist movements that have emerged and continue to surface in India and threaten the integrity of the Indian Union, with one of its most brutal expressions being in India's treatment of the peripheral state of Kashmir. Rushdie paints a complicated picture by paralleling this narrative strand with that of Max Ophuls in 1930s Strasbourg, the subsequent occupation of France by Nazi Germany in 1940 and his involvement in the French Resistance.

The link between Kashmir and Alsace-Lorraine might at first seem spurious. Yet Max, a bullish diplomat who has the political negotiating skill of a politician like Henry Kissinger and the charm and sexual energy of Bill Clinton, makes the analogy himself, thinking that his capacity to understand India and Kashmir stems from the fact that the region he comes from has similarly been defined and redefined over the centuries by the shift in frontiers because of the rivalry between France and Germany (Rushdie 2006b,

138). Rushdie compares the evacuation of Strasbourg in 1939 and the sudden perceived emptiness with the events in Srinagar in 1947 when the maharaja flees and no one turns up for the bhand pather performance and banquet. This leads Max to conclude: 'Each tragedy belongs to itself and at the same time to everyone else. What diminishes any of us diminishes us all' (ibid). Max sums up here the core of *Shalimar the Clown*'s narrative argument. The meaning of Max's assertion reveals itself gradually and is shaped through his own experience of the loss of home, his homeland and his parents to the terror of Nazi occupation. It forces him to question civilisation and the loss of humanity that leads him to resistance.

Described as a 'flying ace', 'giant of the Resistance', a 'man of movie-star good looks and polymathic accomplishments', Max, the Résistance fighter, is related to the reader through his own memoirs that set him up as a romanticised war hero (Rushdie 2006b, 161). In this respect, his actions are never really questioned. In the construction of Max as an overarching and often overbearing character, the foil to Shalimar, Rushdie highlights how, in this creation of a narrative of war heroism, Max's public persona is manufactured self-mythologisation. Indeed, Max, like Shalimar, has the capacity to reinvent his idea of self at different points in the plot. Max learns this skill of personal reinvention during his time in the Resistance (Rushdie 2006b, 162), as he explains: 'One took leave of one's name, one's past, one's future, one lifted oneself away from one's life and existed only in the continuum of the work, borne aloft by necessity and fatalism' (Rushdie 2006b, 166). In the context of Max's story, this sounds like an elaboration of the heroic undertaking of the Resistance yet, when set alongside the story of Shalimar, it becomes evident that he engages in his work as an assassin and terrorist in exactly the same way. Rushdie later draws a grim parallel with the brainwashed reconfigured selves in the terrorist training camps which Shalimar attends across the border from Kashmir.

Max further elaborates on the link between identity configurations and violence when he learns of the assassination of an old Resistance friend by an IRA bomb: 'Perhaps violence showed us what we meant, or, at least, perhaps it was simply what we did' (Rushdie 2006b, 173–174). Although the 'Max' section in Strasbourg has the qualities of an old film noir from the 1940s and some of the characters are rather two-dimensional and predictable, the effects of oppression and violence that Max sees prevailing in Nazi-occupied France have a profound and lasting impact on the narrative. These experiences are the catalyst for Max to become actively involved in the creation of a new world order after 1945. He is part of the negotiation of the Bretton Woods agreement, which redefined and shaped the post-war monetary and economic policies. His role as an American undercover negotiator after his disgraced exit from office following his affair with Boonyi further emphasises this desire to remain an actor on the diplomatic world stage.

The Kashmiri setting of the novel allows Rushdie to explore the question of the Indian Union and its conflicting definitions of nationhood from the margins, and raises the question of the fragmenting and fragmented nation. The increase of separatism and terrorism on the periphery of the Indian nation state draws attention to the problematic paradigm of a singular idea of nationalism, nationhood and nation and throws into question Benedict Anderson's theory of the nation as an 'imagined political community—and imagined as both inherently limited and sovereign' (1983, 15). As Sumita S. Chakravarty points out, it seems as though nationalism has entered a new stage, which follows on from the nineteenth century genesis of European nation states and the new wave of nation formation in the wake of decolonisation. This stage 'is highly uneven, with no clear moral or political centre, and with goals ranging from the ultra chauvinistic to the more traditional strivings for a designated nation-space' (Chakravarty 2000, 223). These nationalisms or sub-nationalisms do not neatly fit into categories. What emerges, however, is a sense of nationhood defined against these sub-nationalisms that have generated their individual secessionist movements, as the examples of Kashmir, Assam, Nagaland and Punjab show. This has become increasingly significant in representations of terrorism, the Kashmir conflict and India's Muslim minority in Indian popular cinema. While Indian popular cinema emphasises the 'All-India' idea, it has a tendency to eschew a singular vision of the Indian nation—indeed, this is why it proves such a pivotal influence on Rushdie's writing about India—and it achieves it through the particular representation of people living on the nation's margins. In this respect, specific regional and cultural representations, an assemblage of the nation in its fragments, often complicate definitions of Indian statehood. If narrative cinema can only depict the nation in its fragments, as Chakravarty argues, the collective nature of national identity can only be represented through the particular:

> Thus the 'nation' as an entity is always eclipsed in cinema and has to be reconstituted by viewers through its screen absence. It is the absence which marks the fullness of the nation. The fragment is therefore both the nation's source of fear and its object of desire, its threat and its promise. (2000, 226)

Indian popular cinema has developed a distinct apparatus of how to incorporate different aspects of India's diverse cultures as part of representations of the Indian nation since independence. Taking up the Nehruvian ideal of India as a composite, syncretically imagined community, it has striven to include those different cultural markers and highlight how they sign themselves as 'Indian' in multiple cultural, societal, religious and ethnic contexts. This proved a highly ideologically invested process, which 'always could be counted on to reveal an essential Indianness comprised of a core of fraternal or civilisational, and patriotic values' (Chakravarty 2000, 228). This is why

Indian popular cinema of the 1950s and 1960s represents so succinctly the Nehruvian vision of the nation, which was a particularly pressing issue in the context of the large number of Muslims who decided to remain in India after Partition. Within the Bombay-based Hindi-Urdu language film industry, in which people from a variety of religious and cultural backgrounds work, it almost became a ritualistic function of cinema to reinscribe India's Muslims into the new nation as an affirmation of their loyalty to the 'motherland'. This is complexly realised in the multi-layered coding I explored previously in relation to *Mother India* and *The Moor's Last Sigh*.

The role of the Muslim community in the Indian body politic has remained very important for India's popular filmmakers. For instance, in Vidhu Vinod Chopra's film *Mission Kashmir* (2000) Altaaf is orphaned at the age of eleven when his village is subjected to a military crackdown. He is adopted by an army officer who, he later discovers, is the person responsible for the death of his family in the operation. He flees and joins a militant Kashmiri group and is trained by its leader to become a terrorist. Altaaf is torn between the love for his childhood sweetheart and the hatred for his adopted father in a story of vengeance and betrayal. In the final showdown, Altaaf kills the militant leader and recognises him as the enemy within. The film was co-written by Vikram Chandra, who found fame with his novel *Sacred Games* and his short story collection *Love and Longing in Bombay*, and Suketu Mehta, author of *Maximum City*. Mehta goes into detail about the genesis of *Mission Kashmir* in *Maximum City* and notes the rise in films that explicitly deal with political issues and terror and 'scenes of bombings, terrorists, usually in league with Gandhi-cap-wearing politicians' (2004, 334). The film echoes many of the themes that Rushdie's later novel takes up, in particular its lament for the loss of *Kashmiriyat*. More recently, *Fanaa* (2006) and *Lamhaa* (2010) deal with similar issues.[13]

Mani Ratnam's three films *Roja* (1992), *Bombay* (1995) and *Dil Se* (1998), which can be taken as a trilogy investigating issues of identity and citizenship on the margins of the Indian state, are also important investigations of the fragmentary nature of Indian nationhood in the context of rising secessionist movements and terrorism.[14] The director, a filmmaker from the southern Indian state of Tamil Nadu which situates itself outside the mainstream of the Bombay-based Hindi film industry, offers a different exploration of the subject. The three films and its later counterpart, *Mission Kashmir*, stress that much terrorist violence is a direct consequence of excessive state violence at the hands of which the hero or heroine have suffered. This forms the opening premise for a complicated investigation about Indian nationhood and the Indian nation state which has become compromised by these acts of violence. As Chakravarty suggests, films like Mani Ratnam's trilogy see the concept of India as a nation as problematic and in need of reformulation, highlighted by the films' dramatisation of violence and the fraught connection between the nation and its territories on the periphery (2000, 232). Yet

neither Chopra nor Ratnam challenge the territorial integrity of the Indian nation. Rushdie, by contrast, does, and in this sense he pushes the argument further. Yet, Ratnam's terrorism trilogy is provocative in its dramatisation of the difficult relationship between Indian territories on the periphery and the centre. In this respect, the 'poly-vocal' and 'multi-accentual' character of Indian cinema that Chakravarty outlines finds its echo in Rushdie's argument about Kashmir (Chakravarty 2000, 233). However, where films and fiction differ is that the argument Rushdie presents is less about making a renewed case for India as a unitary nation state than about Kashmir, and how India, Pakistan and the insurgents have destroyed its principles and its people. While Chopra would have liked his film to have a similar message, he knew the Censor Board would never have passed it or he and his family may have become a target for assassination (Mehta 2004, 335).

For filmmakers and author, what was worth celebrating about Kashmir—its secularist, tolerant multi-faith ethos—is now irretrievably lost. In this respect, the novel's conclusion is even more damning and hopeless than that of *The Moor's Last Sigh*, which lamented the passing of the pluralist, secular ethos of Bombay and India. Rushdie, by living outside India, can make a much more provocative argument than filmmakers like Ratnam or Chopra through his novel's hard hitting critique of both terrorism and state-led counterterrorism. In so doing, the novel also questions how nations effectively dismantle their democratic constitutional structures in the name of 'security' and asks important questions about terrorism, its threats and governments' responses to it. Ever since the beginning of the insurgency in 1989, terrorist activity in the state of Jammu and Kashmir has dramatically increased, ranging between 1,243 to 5,793 instances in the early 1990s alone (Nandy 2003, 133). Yet it is difficult to attain reliable data on the subject.[15] Rushdie, however, is more concerned with the psychological impact of terrorism on his characters. In this respect, his approach to the broader political dimensions of terrorism remains sketchy.

Having previously set up an idyllic paradisiacal vision of Kashmir, Rushdie traces Shalimar's progression to a terrorist and assassin. As the action moves to 1989, the novel records the destruction of Kashmir and its tolerant ethos. As, on the one hand, jihadists move into the territory and women are forced into wearing the veil, on the other, the local population is terrorised by army crackdowns in which the last performance of the bhands of Pachigam, emblematic of *Kashmiriyat*, is a final, futile, act of defiance. Rushdie records the oppositional destructive forces operating in Kashmir with competing agendas: one group wants to achieve the old dream of 'Kashmir for the Kashmiris'; another sees Kashmir becoming part of Pakistan; and yet another aims 'to be part of Islamic terror international' (Rushdie 2006b, 291). Colonel Kachhwaha, now metamorphosed into the grotesque figure of 'The Hammer of Kashmir', can only respond with an endless series of crackdowns:

> The philosophy of crackdown was, *fuck the enemy in the crack.* [ ... ] Town by town, hamlet by hamlet, every part of the valley would be visited by his wrath, by men who had taken their gloves off, his warriors, his storm troopers, his fists. (Rushdie 2006b, 292, original italics)

The allusion to the storm troopers of *Star Wars* is not accidental. It draws an implicit analogy between the evil Empire of the film and its heavy-handed approach to any peripheral state with that of the Indian army in Kashmir, who engage in similar colonial-type repression there.[16] This matter-of-fact description of the Indian army's method to fight insurgents is painfully and powerfully contrasted with the crackdown to which Pachigam is subjected, where a large number of villagers are raped, killed and tortured. The narrator cannot bring himself to recount this fully, despite his three abortive attempts (Rushdie 2006b, 308–309). Indeed, through the suggestion of atrocities rather than fully revealing all the details, the section becomes one of the most moving and powerful. This is in large part due to the visual style of storytelling that is all-pervasive in the book, then held back at this juncture. While this filmic narrativisation is no longer self-consciously dramatised as, for instance, in *Midnight's Children*, it runs implicitly through the novel. Throughout the book, Rushdie creates great empathy for Pachigam and its inhabitants. Thus, when the village is subjected to this destructive crackdown, the pain and horror of the events shakes the reader as the narrator's power of description fails him:

> What happened that day in Pachigam need not be set down here in full detail, because brutality is brutality and excess is excess and that's all there is to it. There are things that must be looked at indirectly because they would blind you if you looked them in the face [ ... ] Pachigam was destroyed. Imagine it for yourself. (Rushdie, 2006, 309)

### From India to Kashmira

While Rushdie deals with broad political themes across different locations and historical timeframes, at the heart of the story lie his individual protagonists and they, not the events that happen to them, propel the narrative forwards. The section headings, which are all titled after the novel's main protagonists—India, Boonyi, Max, Shalimar the Clown, Kashmira—indicate this well. The narrative is framed by India/Kashmira's story and maps her difficult relationship with her father Max. She has to confront the loss of her father at the hands of an assassin who infiltrated his household as his chauffeur and valet, only to plot his murder on her birthday. The murder of the American ambassador appears to be politically motivated, given Max's involvement in many Secret Service plots of the Cold War world. The murder happens at the beginning of the novel, which then moves on to discuss and debate Shalimar's possible motivations for his crime. In this respect,

the novel is not so much a 'who-done-it', but a 'why-done-it'. As the plot of intrigue unravels, the narrative becomes, as has been argued above, one of defeated love. The framing story takes place in 1990s Los Angeles, like Bombay a city famous for its film industry. In the last section of the novel, the narrative comes full circle, picking up events from the initial framing. Confronted with the catastrophe of her father's murder, the whole story of India's origin emerges. To underline her predicament, Rushdie quotes two Hollywood films in particular, John Frankenheimer's *The Manchurian Candidate* (1962) and Alfred Hitchcock's *Vertigo* (1958).

India, a documentary filmmaker, is well-versed in filmic idioms and has an encyclopaedic knowledge of cinema. This helps her deal with the consequences of the intersecting relationships of Max, Boonyi and Shalimar, and to draw the conclusions for herself. In death, many of Max's secrets are exposed as he is revealed to have been the United States' counterterrorism chief, with much blood on his hands. In the light of these disclosures, India questions if justice had 'been done to Max' as notions of 'right' and 'wrong' start to lose their meaning (Rushdie 2006b, 335). The assassination of Max triggers in her a fundamental crisis of identity as her image of her father is overwritten by the secret life he led as the US government's secret envoy, jet-setting to the troubled regions of the world where he acted as kingmaker, arms dealer and sometimes terrorist. The image that emerges is almost monstrous:

> He [ . . . ] had been both a manipulator and a benefactor, both a philanthropist and a dictator, both creator and destroyer, buying or stealing the future from those who no longer deserved to possess it, selling the future to those who would be most useful in it. (Rushdie 2006b, 336)

Yet the crisis India faces through the loss of her father and the revelation of his secret activities for the US government shifts very quickly to the private personal level through the conceit that India hears Shalimar's voice in her head and starts to communicate with him, like her mother Boonyi before her, telepathically. Thus the mother who was banished from her life by the spurned Peggy Ophuls is now brought to life within her. For India, life as she knew it unravels, all certainties become vagaries and the real world becomes nightmarish (Rushdie 2006b, 342).

The suggestion of Hitchcock's *Vertigo* (1958) in relation to her reconfiguration of selfhood is revealing here. The film challenges precisely the certainties the central character has come to assume as factual. The story of Carlotta, whose ghost haunts Madeline, also seems to resonate with that of India in *Shalimar the Clown*. It is suggested that Carlotta, a nineteenth century socialite, was spurned by her husband and had her child taken away from her. The film is important for India as it requires the reader—like *Mughal-e-Azam* on a larger scale—to parallel the action in the novel with familiar reference points. The film also indicates a shift in mode as the love story becomes secondary

to solving the puzzle about who her mother was, in relation to why Shalimar committed his crime. In this respect, the film's climactic scene and the mode of the psychological thriller, which the novel adopts at the last movement, become important. This is further accentuated when the novel quotes *The Manchurian Candidate* in Shalimar's trial where his defence lawyer suggests Shalimar was just a brainwashed automaton, destined to kill.

India's adoptive mother, Peggy Ophuls, comes to see India in her delirious state to finally reveal the story of her true origin and name, which is not India, the one Peggy gave her, but Kashmira. Kashmira/India is the body, character and name upon whom all the narrative threads converge. She becomes the concrete embodiment of Rushdie's argument that '[e]verywhere was a mirror of everywhere else' (Rushdie 2006b, 355).

Peggy's revelations lead India to visit Kashmir to discover her birth mother's story in order to find a better understanding of herself—having to come to terms with the death of an old self and, through self-knowledge, a rebirth (Rushdie 2006b, 357). As her guide and lover, Yuvraj Singh explains:

> 'But maybe the truth is that [ . . . ] our human tragedy is that we are unable to comprehend our experience [ . . . ] Maybe too much time has passed for you and you will have to accept [ . . . ] that there are things about your experience you will never understand.' (Rushdie 2006b, 358)

Yuvraj takes Kashmira to Pachigam in order for her to understand some of her story. On their journey, she experiences first hand the reality of a brutalised and militarised Kashmir (Rushdie 2006b, 361). She also encounters Bombur Yambarzal and his wife Hasina, who narrate the story of Pachigam and the murder of Boonyi, revealing that the person who killed Kashmira's father also murdered her mother. Kashmira now recognises the impossibility of love as she is confronted with the broken love of her father and mother and the wrath of the spurned Shalimar, whom she feels the need to challenge.

Kashmira becomes set on avenging her dead father. She starts persecuting Shalimar by writing him daily letters reminding him of his crime, likening herself to a black Scheherazade (Rushdie 2006b, 374). Kashmira then deals Shalimar the final blow when she reveals at his trial his culpability, not only for her father's but also her mother's death, unravelling Shalimar's defence lawyer's argument that, through personality profiling and brainwashing, Shalimar had had his free will hijacked and was turned into a programmed killing machine that could be activated at will. Kashmira displays the steely determination of her mother and in her Shalimar has found his match, similarly capable of hate and equally determined to carry out her aims. In this respect, the boundaries between persecutor and persecuted become blurred. Shalimar, however, even though he is sentenced to death, remains a man on a mission, as he explains in a letter to Kashmira, '*Everything I am your mother*

*makes me* [ . . . ] *Every blow I suffer your father deals.* [ . . . ] *Your father deserves to die, and your mother is a whore*' (Rushdie 2006b, 392, original italics).

Shalimar performs the perfect tightrope walk, escapes from prison and tracks down Kashmira in the mansion on Mulholland Drive that looks similar to the monastery in *Vertigo*. The novel ends in a moment of suspense where the notion of hunter and hunted remains ambiguous. Shalimar enters her bedroom armed with a virginal blade to kill her while Kashmira, with night-vision goggles on and armed with bow and arrow, lies in wait ready to shoot, avenging her father and mother by killing Shalimar the Clown. This is perhaps Rushdie's most visually compelling ending, perfectly orchestrated like a Hollywood thriller and reminiscent of Jonathan Demme's *The Silence of the Lambs* (1991). Kashmira, having affirmed her sense of self, can successfully confront Shalimar, as she has completed the individual's struggle towards subject formation in the face of stark ruptures that are conditioned by historical events.

In *Shalimar the Clown*, Rushdie pushes visual storytelling within the confines of the novel to its limits. He draws on *Mughal-e-Azam* and the Anarkali story directly for the novel's central love story and, through the prism of the film, gestures towards Akbar and his vision of tolerance. Filmic narrativisation and visual storytelling are integral to the plotting of the novel. The destruction of Pachigam and the final sections of the novel that are reminiscent of Hitchcock are perhaps the best examples. Rushdie's striving for clarity in his narration allows him to create immediacy and urgency to clearly communicate his narrative argument through a matured, yet distinctive, style of visual filmic storytelling.

# Conclusion

As I have shown in my case studies of Rushdie's fiction, Indian popular cinema develops its own politics and these are in turn instrumentalised by authors in their deployment of filmic texts in their fiction. This can take different forms and is not exclusively tied to a deep questioning of Indian national identity. Contemporary South Asian literature in English has begun to draw on the visual culture of commercial Indian cinema and Bollywood. As my discussion suggests we need to find new critical and analytical tools to unlock these layers of meaning. What I am looking towards here is the development of a critical language that can accommodate the stylistic devices this cinema is using and the processes by which writers transform and fictionalise them into language.

*Midnight's Children* remains a key trailblazer for the arrival of the Indian novel in English onto the global literary stage. Although the hype occludes the excellent writing by previous generations of writers, 1981 remains a crucial benchmark and, for many writers following in Rushdie's wake, opened up new pathways of imagining India. Rushdie was one of the first authors to use the cinematic idiom derived from Indian popular film in fictional form, which has encouraged others to follow his lead. Notable examples are Shashi Tharoor's *Show Business* (1994), Vikram Chandra's *Sacred Games* (2006) and Tabish Khair's *Filming* (2008). Suketu Mehta's non-fiction memoir *Maximum City: Bombay Lost and Found* (2004), an account of his return to the city of his birth, describes the various realities of the place, such as the underworld of rival Hindu and Muslim gangs, the city's creaking political system, the difficulties of policing this labyrinth and the glamour world of the Bombay film industry. Mehta and Chandra collaborated on the film *Mission Kashmir* and, interestingly, similar elements feature in both writers' engagement with Bombay. In the fictional world of *Sacred Games* Chandra weaves an intricate tapestry from which an image of a metropolis emerges that is, on the one hand, brittle, full of anxiety for the future, and on the other, longing for the ideals and glamour of the past. *Sacred Games* narrates the story of policeman Sartaj Singh and his working partners Kartekar and Kamble alongside the tale of Hindu gang lord and underworld don, Ganesh Gaitonde. Two

narrative strands intersect when, after a tip-off, Singh apprehends Gaitonde in his hideout, a nuclear bunker, in a Bombay suburb, whereupon this story of intrigue, greed, corruption, sexual exploitation, violence and intimidation grows into a political thriller. Together with a government agency Singh investigates not only the death of the city's most prolific gangster in a shoo-tout, but also his connection to a plot to detonate a dirty bomb in the city. Chandra intersects the two narratives, of Singh—who has to investigate the mysterious suicide of the gangster and model agent Jojo Mascarenas—and Gaitonde, who tells his life story from beyond the grave to Singh. The novel's labyrinthine cityscape mirrors the narrative, and its well-timed and choreographed action and fight sequences, its modulation of melodrama, romance, suspense thriller and incredible attention to visual detail gesture towards the productions of Indian popular film. The novel is infused with film songs, characters discussing films and Ganesh Gaitonde writing, producing and financing a film as a star vehicle and career launchpad for one of his lovers. In this respect, the novel is not a conventional thriller, but deliberately quotes from and fictionalises Hindi cinema's action genre.

As we have seen, Rushdie's fiction pioneered the use of Indian popular cinema as an integral narrative device and reference point. The modes by which films such as *Shree 420*, *Mother India* and *Mughal-e-Azam* are woven into his novels reveal his attachment to what is considered the golden era of Indian popular cinema, the 1950s and the early 1960s, which he recalls vividly in his novels. The syncretic form of Indian popular cinema and the range of issues it covers provide Rushdie with a template he adapts to fit his own views of postcolonial India and Pakistan and transglobal migration to Britain and the United States. In this respect, the different genres and the omnibus form of Indian popular cinema are, as I have argued, integral to Rushdie's own artistic, aesthetic and philosophical project and not a mere reference point to lend authenticity to his narratives. Thus, as my analysis of Rushdie's major novels demonstrates, cinematic visual storytelling augments the issues and questions Rushdie's fiction raises. As Mishra has suggested:

> Bollywood, for Rushdie, is like an empty signifier into which is poured a number of things: diasporic idioms and cultural practices, the English language which, as the universal tongue of cyberculture, will gradually strip the genre of its historicity and Indian-specific foundations, and a growing cosmopolitanism. Bollywood then is integral to Rushdie's style, both as source of discourse and of genre. (2007, 26)

Thus the idiom of Indian popular cinema and its adaptation and subversion in Rushdie's fiction allows him to interrogate and articulate a particular aesthetic argument about India's multiplicity.

Most clearly, Rushdie's fiction is concerned with the crossing of frontiers, exemplified by the adaptation of this cinema's aesthetic conventions and its

ideology in his fiction and the geographical trajectory his story worlds cover, subsuming borders and shifting between several metropoles. Indian popular cinema's key texts have traversed a similar trajectory and show how physical and aesthetic boundaries are being reformulated in the process. The use of film as narrative strategy is instrumental in the context of such frontier crossings. In Rushdie's writing, the adaptation of filmic conventions for the novel push its aesthetic boundaries to the limit. In 'Notes on Writing and the Nation', Rushdie argues that 'Nationalism is that "revolt against history" which seeks to close what cannot any longer be closed. To fence in what should be frontierless. Good writing assumes a frontierless nation. Writers who serve frontiers have become border guards' (1997b, 22). This assumes an absolute freedom of expression on the part of the novelist, which Rushdie has vociferously defended ever since the controversy around *The Satanic Verses*. Furthermore, Rushdie addresses this issue in his critique of a particular nationalism that is religiously and culturally exclusive. For Rushdie, the production of cultural identity must contain the sum-total of difference and here the connection between his use of novelistic conventions and the idiom of Indian popular cinema becomes most obvious.

As Stuart Hall once put it in the context of the African-Caribbean diaspora, the experience of dislocation 'is defined, not by essence or purity, but by the recognition of a necessary heterogeneity and diversity; by a conception of "identity" which lives with and through, not despite, difference; by *hybridity*' (1993, 402). For Rushdie, this is not only related to the experience of migration, but is integral to a conception of Indian identity which recognises the hybridity of its own cultural identity:

> The selfhood of India is so capacious, so elastic, that it manages to accommodate one billion kinds of difference. It agrees with its billion selves to call all of them 'Indian'. This is a notion far more original than the old pluralist ideas of 'melting pot' or 'cultural mosaic'. It works because the individual sees his own nature writ large in the nature of the state. (Rushdie 2003, 179)

Through its method, Rushdie's fiction aims to aestheticise and encapsulate such multiplicity. His novels seek the opening of frontiers and the crossing of boundaries, and, as this book has shown, this process is intrinsically realised in Rushdie's deployment of cinematic conventions and their fusion with novelistic ones.

Rushdie's fictional world is largely shaped by the cosmopolitan environment in his glorification of the urban cityscapes of Bombay, London and New York. Even a novel like *Shalimar the Clown*, which is set for the most part in Kashmir, is framed by a narrative rooted in the urban space of that other great movie city, Los Angeles. Through cinematic strategies Rushdie represents the complexity, diversity and heterogeneous dynamics of the city in all

## Conclusion 181

its facets. Los Angeles in *Shalimar the Clown* and Bombay, London and New York in particular are marked out as representative of a distinctive urban experience for his cast of transglobal migrants. As I have argued in the preceding chapters, the manner in which this urban environment is expressed and experienced is shaped by cinema, a medium that like no other is bound up with the representation of metropolitan modernity (Shiel and Fitzmaurice 2001, 1–2). Rushdie exploits the city's relationship with cinema as its prime marker in his descriptions of Bombay, London and New York to complicate the conceptualisation of nationhood for newly independent postcolonial countries. Through the reconfiguration of that nationhood in the process of globalisation, the city becomes a privileged space of global exchange and guarantor of the free movement of goods, people and capital. Here emerges the close relationship between these different urban spaces as the trajectory is traversed by Rushdie's heroes and by cinema itself. Indian popular cinema and its globalised variant, Bollywood, have increasingly thematised the diaspora ever since the 1990s, with New York and London, as the locus of the non-resident Indian community, becoming particularly important in their picturisation.

The heightened public awareness of Bollywood and the South Asian diaspora suggests that Bollywood's aesthetic is invested with some kind of cultural capital that goes beyond the commercial and the local. Thus, what we mean by 'Bollywood' needs to be analysed in more complex terms—as, Rajinder Dudrah suggests, 'part and parcel of cultural and social processes and elaborated on, though not exclusively, through an engagement with actual social subjects' (2006, 29). As my discussion has shown, in Rushdie's novels these debates impact on his narratives and his engagement with questions about the role of cinema as a site of discourse for his protagonists. Indian popular films function in these instances as cultural texts and analogies in his fiction. In this respect, the correlations his characters make between their lives and the productions of Indian popular cinema become a prism through which their being in the world is refracted for the reader—be it Hind's avid consumption of Gibreel Farishta's films, John Maslama's adoration of the same star, Gibreel's own attachment to *Shree 420*, Moraes's and Aurora's reading of *Mother India* or Boonyi's equation of her life story with that of Anarkali in *Mughal-e-Azam*.

Rushdie's engagement with Indian popular cinema suggests interdynamic relationships between the local and the global, the national and the international, and the national and intra-national, where 'Bollywood', through multiple sites of productive economies, has the power to link broader networks of transnational societies and diasporic communities (Kaur and Sinha 2005, 23). Evidently, since the 1990s and the process of economic market liberalisation in India, the construction of a 'national fantasy' within Indian popular cinema has become unstable. Indian popular cinema and the global brand 'Bollywood' with which it has become recognised as a global commodity, is

a postcolonial, transnational and multicultural medium and it is deployed as such in Rushdie's fiction to articulate a particular logic of culture through which 'India' and its diaspora is being 'read' across the globe (see also Mishra 2007, 25–26). Within these debates about Indianness and authenticity lies a much more politicised one about home and the positioning of India as the authentic homeland. In this respect, Rushdie's reading of Indian popular cinema allows him to open up the arguments about the question of Indianness, both in India and in the diaspora, central to his characters' identity negotiations and their definitions of selfhood.

# Notes

### Notes to Chapter 1

1. In 1995, Bombay was renamed Mumbai at the behest of the Maharashtrian nationalist party, Shiv Sena. The name change has remained contentious with many still using Bombay as a way of highlighting the city's secularist multi-ethnic ethos associated with it.
2. See for instance the theatre productions *Bombay Dreams* (2002) and *Wah! Wah! Girls* (2012).
3. While Rushdie remains a controversial novelist in India, there is admiration for the way in which his novels manage to encapsulate the spirit of Bombay's golden age. In their collection *Bombay, Meri Jaan: Writings on Mumbai* Jerry Pinto and Naresh Fernandes call Rushdie '*the* storyteller of Bombay' (2003, 112).
4. In his foreword to his novel *Kanthapura*, Raja Rao describes the challenges to find a way of expressing the Indian reality of village life in a language that was not 'native' to India, but a colonial export: 'One has to convey in a language that is not one's own the spirit that is one's own. One has to convey the various shades and omissions of a certain thought-movement that looks maltreated in an alien language. [ . . . ] Our method of expression therefore has to be a dialectic which will some day prove to be as distinctive and colourful as the Irish or the American' (Rao 1989, i). Rushdie faces a similar predicament. Inspired by G. V. Desani's undertakings in *All About H. Hatterr*, which, in his article 'The Empire Writes Back with a Vengeance', Rushdie describes as 'the first great stroke of the decolonising pen' (1982a, 8), he also looked to India's oral storytelling tradition, the *Mahabharata* and the *Ramayana*, as well as the *Arabian Nights*.
5. Vilayet, literally meaning 'foreign land' in Hindi, is used as a name for England. In *The Satanic Verses*, the term sets England up as the promised land that falls short of expectations. Thus the story of the migrants in their fight against racist attacks becomes not the *Mahabharata* but *Mahavilayet*, the epic of the great foreign country (Rushdie 1998, 283).
6. For an incisive analysis of Rushdie in the contexts of postmodernism see Teverson 2007.
7. Vijay Mishra and Douglas Hodge have demonstrated this in their reading of *Midnight's Children*: 'For postmodernism, Rushdie's questioning of historical certainties is exemplary of its own project [ . . . ] Whereas a postmodern reading of *Midnight's Children* would emphasize play and deferral, a fully post-colonial

reading will locate the meaning of untranslated words and the special, culture-specific resonances of the text. It might even offer a radical reshaping or rethinking of what Habermas has called our "communicative rationality"' (1993, 282). For an interesting reading of *The Satanic Verses* as a text that is simultaneously postmodern and postcolonial see Aravamudan 1989, 3–20.

8. This is especially evident in ongoing debates around freedom of artistic expression in India, when Rushdie was prevented from attending the Jaipur literature festival in January 2012 and from speaking in Kolkata to promote the film of *Midnight's Children* in January 2013.

9. According to Rachel Dwyer in *All You Want is Money, All You Need is Love: Sex and Romance in Modern India*, the rise of the middle classes is closely intertwined with the growth and development of Bombay. According to Dwyer, 'the bourgeoisie was not a single community, but included a wide spectrum of castes and also of social class from the small shopkeeper to the rich merchant, who might aspire to the highest social status and could certainly dominate the commercial, and to some extent the political, life of the city' (2000, 65). The most significant change to the structure of the Bombay middle classes came with independence. The partition of British India in 1947 significantly altered the social fabric of the city, as many of the Muslim elite left Bombay while some 200,000 migrants arrived in the city (Dwyer 2000, 73). Dwyer describes the first decade of independence as 'by and large a middle-class rule and is looked back to as a golden age for the professional and intellectual middle classes, a time of high morality, ending with the defeat by China in 1962' (2000, 74).

10. This will be discussed in further detail in relation to the magical gifts of the Midnight's Children as a symbol of hope and possibility that is destroyed; Sufiya Zinobia's transformation into a violent beastly figure as the avatar of shame and shamelessness, indicting a corrupt political elite; and Salahuddin Chamchawala's transformation into the devil that mirrors the demonisation of the migrant community in Britain in the early 1980s.

11. This seems to articulate the argument between the commercial sector of filmmaking and the Calcutta Film Society in the 1950s, a debate that was shaped largely by Satyajit Ray, who was deeply critical of commercial cinema. See for instance his 1948 essay 'What is Wrong with Indian films' and his 1967 essay 'Those Songs' (Ray 1976).

## Notes to Chapter 2

1. Rushdie states that, while *Midnight's Children* and *One Hundred Years of Solitude* are in the same area of fiction, they are different in concept. Rushdie's point of departure is the urban vision of Bombay as an idea, as well as a place. Márquez's vision in *One Hundred Years of Solitude* by contrast is essentially about taking what seems normal and natural in a village and very strange and wonderful outside the village. Rushdie's point of departure is exactly opposite to that (see Rushdie and Kumar 2001, 34).

Magical Realism is a term invented by German photographer, art historian and art critic Franz Roh in 1925 in his book *Nach Expressionismus: Magischer Realismus [After Expressionism: Magic Realism]*. Magical Realism describes modern realist paintings with fantasy or dream-like subjects. In Central Europe,

Magical Realism was part of the reaction against avant-garde art, known as the return to order, that took place generally after the First World War. In 1955 the critic Angel Flores used Magical Realism to describe the writing of Jorge Luis Borges and Gabriel García Márquez, and it has since become a significant if disputed literary term. For a good overview see Zamora and Faris 1995.

2. According to Rushdie, this rather peculiar way of examining a patient is based on a true story: 'My grandfather once told me [ . . . ] he had been called as a doctor to the house of a woman who was in purdah and her normal lady doctor was not available for some reason and he had been asked to examine her through a hole in a sheet, which he told me as a comedy story—he said this is a completely bizarre thing to be asked to do if you're a doctor, to put a stethoscope through a hole in a sheet and feel somebody's heart' (Reynold and Noakes 2003, 14).

3. '[T]he nightmare of Indira Gandhi is fused with the equally nightmarish figure of Margaret Hamilton [the actress who played the witch]: a coming-together of the Wicked Witches of the East and West' (Rushdie 1992b, 33).

4. 'At the stroke of the midnight hour, when the world sleeps, India will awake to life and freedom. A moment comes but rarely in history, when we step out from the old to the new, when an age ends, and when the soul of a nation, long suppressed, finds utterance. [ . . . ] We have to build the noble mansion of free India where all her children may dwell' (Nehru 1997, 1–2).

5. In the short story 'A Free Radio' in *East, West* Rushdie also comments on the forced sterilisation programmes (Rushdie 1994, 17–32).

6. Rushdie notes: 'And originally I thought there'd be only one child—the idea of having the exchange of children came later. That was partly because I thought of a sort of dualism between the children—they represent wealth and poverty, reason and unreason, peace and war and so forth. [ . . . ] And also it's a nice Bombay talkie idea; I liked it because of its melodrama and its cheapness' (Rushdie and Pattanayak 1983, 21).

7. The song's importance for Rushdie's fictional characters will be discussed in further detail in Chapter 4 in relation to *The Satanic Verses*.

8. Some characters are named after gods, Shiva fathers a child with Parvati and, although he is not named Ganesh, he has elephantine ears, hinting at that God's elephant head. Thus the narrative plays with mythological elements in its own aim to become mythic and epic.

9. See Nehru 1997, 1–2. Nehru elaborates on his vision of a free India in Chapter 10, 'Ahmadnagar Fort Again', in *The Discovery of India*; see Nehru 2004, 532–632.

10. The notion of cultural synthesis and India as a palimpsest is significant to the narrative argument of Rushdie's *The Moor's Last Sigh* and will be discussed in further detail in Chapter 5.

11. In *Fury*, violence is also all-pervasive and associated with the bestial murders of young female socialites after some depraved sado-masochistic ritual.

12. This periodisation of Indian history dates back to James Mills's *History of India*, first published in 1818.

13. In *Midnight's Children*, women are presented as spectacles of Motherhood, which ties the novel most obviously to *The Moor's Last Sigh* (see also Natarajan 2003, 173).

14. The description of this incident is based on a similar attack on Rushdie's sister Sameen, to whom the novel is dedicated.

15. See Rushdie 1985.
16. In *Shame*, the reader encounters the family feud between two Pakistani political dynasties, the Hyders and the Harappas. In *The Moor's Last Sigh*, the reader is introduced to the life and death stories of the commercial dynasty of the Zogoibys, the wife an artist-celebrity, the father an underworld don.
17. For instance, during the Emergency, there were suggestions that the relationship between Indira and Sanjay was incestuous, the Oedipal ambiguities being wildly exaggerated, a theme Rushdie takes up in *The Moor's Last Sigh*. There were public confrontations between Jawaharlal Nehru and his son-in-law Feroze Gandhi, Indira Gandhi was ousted and disgraced post-Emergency and Sanjay, in what some called a moment of divine retribution, was killed in a plane crash. Furthermore there were confrontations between Indira Gandhi and her daughter-in-law Maneka, Sanjay's wife.
18. Rushdie has talked about the role of Bombay in the novel in various interviews: 'I think the kind of sensibility in the book is basically urban. Although half of the novel takes place in Bombay, the other half doesn't. But to my mind it all takes place in Bombay, because Bombay is the spirit of the book. Bombay is an idea as well as a place' (Rushdie and Kumar 2001, 34). In another interview Rushdie has commented on how writing about Bombay was the original motivation for writing *Midnight's Children*. 'Bombay in the fifties and sixties was a remarkable city [ . . . ] In a way my memory was frozen at the time that I left, so it was as though the city which no longer existed continued to exist inside my head' (Rushdie and Ross 1984, 111). Before proceeding to describe the microcosmic world of Methwold Estate, Saleem spends some time tracing the city's history and its mythic past, reclaiming an ur-Bombay when there were still seven islands, before the East India Company and the British Raj through land reclamation turned Bombay into one big peninsula connected to the subcontinent (see Rushdie 1995a, 92–99).
19. In a 1983 interview with *Literary Criterion* Rushdie states: 'There is a technique that Dickens used that I thought was very remarkable. He uses a kind of background or setting for his works which is completely naturalistic, down to the tiniest details. And on top of this completely naturalistic background he imposes totally surrealistic images—like the Circumlocution office, which is a civil service department designed to do nothing, or like many of the characters, who are much larger than life. [ . . . ] What I tried to do—though not quite in the Dickensian way—was to make sure that the background, the bedrock of the book, was right—that Bombay was like Bombay, the cities were like the cities, the different dates were recognisably correct so that the fantasy could be rooted in that kind of reality' (Rushdie and Pattanayak 1983, 20).
20. These events are already described very vividly in the novel, but are visualised even more strikingly, horrifically and poignantly in the screenplay and film adaptation.

## Notes to Chapter 3

1. In a 1982 interview Rushdie states: 'I am very interested in movies, and I think they probably have influenced the writing quite a lot. Bombay, as the book makes clear, is very much a movie city, apart from anything else, so you grow up there with the feeling of being in a film capital. And I did have relatives who

were involved in the movies, although not quite in the way the characters in the book are, so I've had movies in my blood from an early age.

And I think there's one thing particularly which the development of film since the New Wave has done for audiences and even for readers: it has made people much more sophisticated about accepting what might once have been thought to be very strange techniques. For instance, if you want to intercut two scenes in prose now, people know what you're doing and don't think of it as being confusing. The whole experience of montage technique, split screens, dissolves, and so on, has become a film language which translates quite easily into fiction and gives you an extra vocabulary that traditionally has not been part of the vocabulary of literature' (Rushdie and Ross 1984, 416).
2. See *The Guardian* 2000.
3. When the book was first published, a few directors were interested in turning *Midnight's Children* into a film, among them renowned Indian filmmaker Shyam Benegal (see Rushdie and Dube 2001, 10). Satyajit Ray, by contrast, thought the book was unfilmable, because the amount of simplification needed would mean the book would no longer be itself.
4. For further details, see also Rushdie's memoir, *Joseph Anton* (2012, 498, 524–527).
5. Saleem is a big movie fan and steeped in the popular culture of 1956 Bombay, using his magical powers to insert himself into the minds of movie stars, such as Vijayanatimala, to discover the truth about the gossip surrounding her; cricket players such as Polly Umrigar, to be in the thick of the action at Brabroune Stadium; as well as visiting the mind of playback singer Lata Mangeshkar, and Bobo the Clown (Rushdie 1995a, 174).
6. Rushdie had to delete the following sentence from subsequent editions of *Midnight's Children*, over which Indira Gandhi sued him: 'It has often been said that Mrs Gandhi's younger son Sanjay accused his mother of being responsible, through her neglect, for his father's death; and that this gave him an unbreakable hold over her, so that she became incapable of denying him anything' (Rushdie 1981, 406). See also Rushdie 2006a, xv–xvi.
7. This seems to echo also the ending of *A Passage to India*.

## Notes to Chapter 4

1. According to Rushdie, 'Jahilia' refers to the time in Islamic history before the revelation. 'Jahilia' means ignorance (See Rushdie 1992a, 398).
2. The difficult nature of this process was highlighted in 2007 with the conferring of a knighthood on Salman Rushdie, which provoked violent protests and heated comments in both Pakistan and Iran and reignited the controversy around Rushdie and the novel.
3. For a collection of articles and letters and a good introduction to the debates surrounding *The Satanic Verses* see Appignanesi and Maitland 1989.
4. For a detailed discussion of Rushdie's affiliation with Dickens and that of *The Satanic Verses* with texts like *David Copperfield* and *Our Mutual Friend* see Dutheil de la Rochère 1999, 63–79.
5. Chitaley, D. V. and S. Appu Rao. *The Code of Criminal Procedure* 1973, vol. 4, quoted in Aravamudan 1994, 191.

6. Rushdie expands on this in his interview with the London Consortium; see Rushdie and MacCabe 1996, 51–70.
7. Anarkali and the film *Mughal-e-Azam* are important intertexts in *Shalimar the Clown*, where Boonyi performs the film's central dance number and draws comparisons between her own situation and that of Anarkali.
8. Zenat Vakil returns in *The Moor's Last Sigh* as the curator of the Aurora Zogoiby bequest, the artist who fashions herself as an urban, sexy version of Mother India, and becomes the guardian of her artistic legacy.
9. A consistent doubling of names holds the various narrative threads of the novel together. For instance, in the 'Jahilia' sections Ayesha is the name of the prophet's favourite wife, while in the 'Ayesha' section Ayesha is a modern-day prophetess leading an entire village on a pilgrimage to Bombay and then through the Arabian Sea to Mecca.
10. In February 1983, thirty-eight Shia Muslims walked into the Arabian Sea expecting that the seas would part and they would be able to walk to Basra and then on to Karbala. According to Suleri, they were inspired by a young woman, Naseem Fatima, who claimed to be in direct visionary contact with the twelfth Imam. By the time the police reached Hawkes Bay, most of the pilgrims had drowned and police arrested the survivors on grounds that they tried to leave Pakistan without a visa. However, rich Shias, impressed by the devotion of the survivors, paid for their journey to and from Karbala, where they were greeted with gifts, thus fulfilling Naseem's promise that they would visit Karbala without worldly means (see Suleri 2005, 202). See also Akbar S. Ahmed 1986, 46–67.
11. Rushdie notes: 'The original incident on which the dream of the villagers who drown in the Arabian Sea is based is also part of what I "knew". The story awed me, because of what it told me about the huge power of faith. I wrote this part of the novel to see if I could understand, by getting inside their skins, people for whom devotion was as great as this' (Rushdie 1992a, 409–410).
12. See Rachel Dwyer's discussion of specific sets in Dwyer and Patel 2002, 78–81.
13. In sharp contrast to this is Naipaul's *The Enigma of Arrival*, where the issue of migrancy is negotiated in the rural location of the Wiltshire Downs. For an interesting discussion of this see Susheila Nasta's chapter 'If the "House" Falls Down: The Enigma of Writing Survival in V.S. Naipaul' (2002, 93–131) and Abdulrazak Gurnah's essay 'Displacement and Transformation in *The Enigma of Arrival* and *The Satanic Verses*' (in Lee 1995, 5–20).
14. Rushdie's early working title for *The Satanic Verses* was *Rivers of Blood: Or, the Adventures of Saladin Chamcha*, directly referencing Enoch Powell's infamous 1968 Birmingham speech (Rushdie Papers, Box 45, Folder 6).

## Notes to Chapter 5

1. The Shiv Sena was launched in 1966 and initially only had a very limited constituency with a simple programme. In the main it fought for the reservation of jobs and new economic opportunities for Maharashtrians, specifically protesting against the influx of workers from south India, which had increased dramatically since independence and which was deemed responsible for a shortage of employment opportunities. After the creation of the state of Maharashtra

in 1960, up to 1966, Bombay's economy underwent fundamental structural changes and the underside of state-sponsored private capitalist development started to emerge, an 'underworld' of extortion, smuggling, drug trafficking and contraband peddling. By the end of the 1960s, although the Sena publicly attacked the underworld, it had established strong ties, building up a following that gave the organisation its muscle and power and, in return, lent those in the underworld the benefit of its organisation.

For a detailed account of the Shiv Sena's genesis and politics, see Lele 1996, 185-212.

2. I use the term *Hindutva* not in its original sense, but in its more recent political meaning. *Hindutva* has become a term that describes a specific ideology of cultural nationalism that seeks to reorganise Indian society. Through, among others, the Bharatiya Janata Party, it is no longer used in religious terms, but has taken on more of a political meaning. It no longer stands for Hinduism, but for a distinctive worldview that, according to the BJP, seeks to reorganise cultural nationalism along the concept of one people, one culture, one nation. During the BJP's term in government, this became concrete, for example, as many history books were rewritten to align school syllabuses to this conceptualisation, one of the first things the Congress government reversed. The fascist implications of this line of thinking are also evident.

3. The Church of South India was founded in 1947, mixing Anglican and various Protestant churches and Rushdie mentions it in the interview to draw attention to the variety of Christian minorities in south India. The da Gamas are Roman Catholics, which makes explicit the family's connection to Vasco da Gama and the Portuguese legacy of colonialism along the west coast of India.

4. Sri Aurobindo has detailed the importance of 'Bande Mataram' for the Indian freedom struggle in a lecture in Amraoti, a summary of which appeared in the newspaper *Bande Mataram* on 29 January 1908. Aurobindo translated the song from Bengali into English in 1909 (Aurobindo 1973, 666-667).

5. In his 1996 interview with Michael Silverblatt, Rushdie describes the Mother India theme as 'the intellectual way into the book. The fact is that the idea of India as a mother, the idea of the mother goddess has always been the most central defining image of India' (Rushdie and Silverblatt 2001, 199).

6. See Gandhy and Thomas 1991, 107-131.

7. The novel features a detailed family tree at the beginning of the novel. *Shame* also has the same feature. It is notable that Rushdie chooses to provide his readers with this in his companion volume to *Midnight's Children*, but not in *Midnight's Children* itself, despite the novel's concerns with lineage and parentage.

8. For an interesting discussion of Amrita Sher-Gil and her art see Rushdie 2007, 12-13; and Sundaram and Dercon 2007.

9. Camoens is also the name of Portugal's national poet. After attacking a royal guard at court, Camoens was released from prison on condition that he enlist as a soldier and go to India (Goa) in 1553. Camoens is famous for his epic poem *Os Lusiadas* in which Vasco da Gama and his journeys of discovery along the African and Indian coasts are central.

10. There are deliberate parallels between the three, for instance the love letter Nehru writes to Aurora is actually taken from Nehru's letters to Indira. Aurora is linked to the Nehru family, alleged to be his lover and Moraes hints that he might be

their illegitimate love child (Rushdie 1996b, 175). This implies not only the Nehru dynasty as a parallel, but also draws analogies between their relationships. Thus, the intense mother-son relationship of Aurora and Moraes is an explicit connection to that between Sanjay and Indira Gandhi. These legends contribute to setting up the family as dynasty, underlining its importance in South Asia's political life.

11. Catherine Cundy (1996) and Laura Moss (1998) both comment on how the novel seems to be a self-parody of *Midnight's Children*, while Paul A. Cantor (1997) recognises that the novel goes beyond the political preoccupations of *Midnight's Children*.
12. For an interesting analysis of this see Ghosh 2004, 84–108.
13. For an interesting anecdotal account see Mehta 2004.
14. The title page of an early draft of the opening of the novel featured an epigraph from Louis Buñuel's autobiography, *My Last Breath*: 'As I drift towards my last sigh I often imagine a final joke [ . . . ] But will I have the strength to joke at that moment?' (Buñuel 1984, 256).
15. It is even more ironic that Columbus could never have accomplished his journey without the help of a converted Jew, Louis de Santanel, who interceded on Columbus's behalf after Isabella had rejected Columbus's plea. Another converted Jew, Louis Coronel, the Court's Minister of Finance, bankrolled the entire expedition. Columbus studied Arabic maps and navigated with astral aids and equatoria perfected by Arabic astronomers from Toledo. Thus, without Muslim and Jewish assistance, Spain could not have achieved its status as the pre-eminent colonial power of sixteenth century Europe.
16. The pickle factory, in which Saleem narrates his story, is also named after Catherine of Braganza. The ancestral home of the da Gama family in Cochin is on Cabral Island, named after the Portuguese sailor who was the first to set foot at Cochin.
17. In the novel, the parallels between Raman Fielding and Bal Thackeray are more than evident. Both carry the surname of noted English novelists, although Fielding is also one of the characters in Forster's *A Passage To India* as, notably, there is a Doctor Aziz in *Midnight's Children*. Before founding the Shiv Sena, Thackeray worked as a cartoonist for the *Free Press Journal*, an English language daily, but left in 1960 to set up his own Marathi weekly journal, *Marmik*, featuring cartoons, political comment and humour. Gup Mainduck roughly translates as 'ugly toad', reflecting Thackeray's unflattering facial features. Even before founding the Shiv Sena in 1966, Thackeray was politically active during the language riots that led to the partition of the former colonially defined Bombay province into the states of Maharashtra and Gujarat. Initially not pursuing a consistent political line, his journal severely criticised all practicing politicians and public figures that did not meet Thackeray's approval, which increased his popularity among the lower middle classes. During these years, his strong strain of Hindu nationalism emerged in his writing.
18. For an interesting exploration see Sen 2001, 237–249.
19. Rushdie develops this further in the intercommunal Pentangular Tournament, a cricket match between Bombay's British, Hindu, Muslim and Parsee teams and a new one made up of the rest, drawn from the Christian, Anglo-Indian and Jewish communities in *The Ground Beneath Her Feet* (Rushdie 2000, 27–30).

20. Rushdie's fictionalised Nadia Wadia wins the Miss World competition and becomes the official face of Abraham's company, while Mainduck unsuccessfully tries to woo her. Sammy 'Tin-man' Hazaré, Mainduck's most loyal henchman, is also obsessed with her. Rushdie attributes one of the actress Madhuri Dixit's most famous dance numbers from the film *Khalnayak* (1993) to her as Hazaré sings '*What is under my choli [ . . . ] What is under my blouse?*' using a cut-out colour photograph of her as a mask (Rushdie 1996b, 357). The real-life Nadia Wadia, or Fearless Nadia as she became known, was a famous stunt actress, born Mary Evans in Perth, Australia. She worked for Zacko's Russian Circus before touring India with Madame Astrova's ballet group. She joined Wadia Movietone as a chorus girl in the 1940s and then went on to star in a string of action movies, usually set in unspecified periods or Tarzan-esque landscapes as well as fantasy versions of Hollywood gangster movies. Most movies were directed by her husband Homi Wadia who launched her as 'India's Pearl White' (Rajadhyaksha and Willemen 2002, 155–156). Rushdie's choice of name is fitting. Nadia Wadia has to negotiate between the gangsterism of Abraham and Mainduck and, in the wake of catastrophe after the riots and explosions, she displays a fearless optimism for the future, despite the visible and invisible scars she bears. Arguably, in tandem with Zeeny Vakil, she becomes the Mother India substitute in the wake of the deaths of Aurora, Nargis and Indira Gandhi.

21. In an interview, Nargis, by this time a member of the Upper House of the Indian Parliament, asserted the following:
NARGIS: Why do you think films like *Pather Panchali* become popular abroad? . . . Because people there want to see India in an abject condition. That is the image that they have of our country and a film that confirms that image seems to them authentic.
INTERVIEWER: But why should a renowned director like Ray do such a thing?
NARGIS: To win awards. His films are not commercially successful. They only win awards. . . . What I want is that if Mr Ray projects Indian poverty abroad, he should also show 'Modern India'.
INTERVIEWER: What is 'Modern India'?
NARGIS: Dams . . .
(Quoted in Rushdie 1990, 9)

22. Rushdie pays homage to Ray by naming the two plentymore fish in *Haroun and the Sea of Stories* Goopy and Bagha. Meenakshi Mukherjee makes some further illuminating connections between the film and *Haroun* with regards to the use of fantasy and fable (Mukherjee 2000, 149–165).

23. Rushdie makes this point succinctly in 'India's Fiftieth Anniversary' (Rushdie 2003, 174–179).

24. *Mogambo* is the title of the 1953 John Ford movie starring Ava Gardner, Clark Gable and Grace Kelly (apparently Clark Gable and Grace Kelly started an affair on set that lasted for several months).

25. Forgiveness between fathers and sons plays a major part in the denouement of *The Satanic Verses* with father-son relationships becoming increasingly important in Rushdie's writing. This has often been connected to Rushdie's own uneasy relationship with his father, and the emphasis on these relationships in his

writing is striking. *Haroun and the Sea of Stories* as well as the short story 'The Courter' deal with father-son relationships. *Haroun* is perhaps Rushdie's only story with a true happy ending. The father-son relationship between Abraham and Moraes, however, remains dysfunctional and is ultimately beyond redemption as Abraham is unmasked as Aurora's murderer.
26. See also 'Heroes and Villains: Narrating the Nation', in Virdi 2003, 87–120.

## Notes to Chapter 6

1. For an interesting exploration, see Roger Y. Clark 2001, 198.
2. The renaming of Bombay into Mumbai is shifted in Rai's timeline to the 1970s.
3. Rushdie has modelled Piloo and Golmatol Doodhwala loosely on Laloo Prasad Yadav and his wife Rabri Devi. While in office as Bihar's Chief Minister, Yadav was implicated in the Fodder Scam, in which large amounts of public livestock subsidies were claimed for the maintenance of cows which did not actually exist. Piloo runs a similar scam with goats in *The Ground Beneath Her Feet*. Yadav was sent to prison but managed to secure the post of Chief Minister for his wife, and continued to run the state by proxy from prison (see Rushdie 2003, 203). Rai exposes Piloo's and Golmatol's scam by stealing the roll of film from another photographer who is hanged. Thus Rai builds his reputation on pictures that he did not take. This moral dilemma constantly haunts him (see Rushdie 2000, 231–249).
4. In Rai's career they are his images of Vina Apsara (Rushdie 2000, 466–468).
5. Rushdie makes this explicit in the opening paragraphs of his essay 'Imaginary Homelands' (Rushdie 1982b, 18).
6. There are references to Thomas Pynchon's novel *The Crying of Lot 49* in the showdown between Mull Standish and Yul Singh. Their confrontation takes place in an auction room in the novel's fictional town of San Narciso, California: 'First let me tell you why *you're* here, says Mull. Turns out you're interested in conspiracies, underground organizations, militias, the whole right-wing paranoid-America thing. Who knows why. You're here to bid for the memorabilia of some defunct immigrant cabal, used to go around writing DEATH on people's walls. Don't Ever Antagonize The Horn. They had a trumpet logo. Nice' (Rushdie 2000, 400–401). In *The Crying of Lot 49* the anagram at the centre of the mystery is WASTE (We Await Silent Tristero's Empire), the symbol of the secret underground organisation is the post horn.
7. Rai uses the terms East and West rather uncritically. The question is if Rai's view of the East is, through his work as a news photographer, 'Eurocentric', i.e., does he present the East as a site for Western discursive engagement, another systematic misrepresentation of it through an orientalising discourse; or does his questioning allow the narrative to move beyond such a narrow conceptualisation of the East? Alternatively, is the novel going beyond a concern with misrepresentation of the East? Indeed, through the audacious claim that rock and roll is an Eastern invention, it could be argued that the novel destabilises a form of Orientalism which Edward Said described as 'a style of thought based upon an ontological and epistemological distinction between "the Orient" and (most of the time) "the Occident"' (1995, 2).

8. Chapter 4 explores this in greater detail. For an interesting analysis of the star cult of Indian movie stars and their relationship with their audiences see Gandhy and Thomas 1991, 107–131.
9. Ormus's surname already gestures towards this myth as well as many other stories: 'Ameer Merchant would conflate Ormus Cama and Vasco da Gama—"Ormie da Cama your great explorer, discovering you like a new world full of spices"—and it was a short step from Gama to *Gana*, song, and between Cama and *Kama*, the god of love, the distance was even less' (Rushdie 2000, 125). While these remarks show the potential of endless interpretation of the meaning of names and naming, the Cama/Kama connection seems to be intriguing, not only as an inversion of Orpheus and Eurydice, but also as an especially important connection between myth and myth-making in the novel. Vina makes the link between Ormus's comatose state after the car accident, her awakening him and the Rati/Kama myth (Rushdie 2000, 324). Kama is the God of Love in Hindu mythology and, like Cupid, portrayed with a bow and arrow. He likes to surround himself with nymphs (*apsaras*). In consultation with his wife Rati he aided Parvati to gain the favour of Shiva by disturbing his meditation and shooting his arrow at Shiva. When Shiva realised what had happened, he immediately opened his third eye and reduced Kama to ashes. Eventually the marriage of Shiva and Parvati took place. Through the intervention of Parvati in response to Rati's pleas, Shiva restores Kama back to life, however only as a mental image, no longer just an image of physical lust, but true love (see Doniger O'Flaherty 1975, 154–159).
10. Miriam Pirbhai uses Jameson's definition as her starting point for an incisive discussion of the novel (see Pirbhai 2001, 54–66).
11. Rushdie has written on Fiji in a column for the *New York Times* which was subsequently reprinted under the title 'June 2000: Fiji' in *Step Across This Line* (Rushdie 2003, 341–343). The fictional name of the island also echoes Swift's *Gulliver's Travels*.
12. For an interesting discussion see Gillespie 1995.

## Notes to Chapter 7

1. The name alludes to the film director of German origin Max Ophuls. Rushdie however maintains: 'I wanted Max to have a name that is both French and German, because I wanted the history of Strasbourg to be in the name. [ . . . ] I just kept thinking of him like that, and in the end I forgot about the film director' (Rushdie and Livings 2005, 136). Maximilian Ophüls (the umlaut was dropped when he worked in France and the USA) was born in Saarbrücken, Germany in 1902. In the late 1920s he started work for the German film studio, UFA. He fled to France in 1933 and, after its invasion in 1940, he moved to the USA. He returned to Europe in 1950. Well known for opulent sets, strong female characters and interesting use of dolly shots, crane shots and tracking sweeps, his smooth camera movement is said to have influenced the young Stanley Kubrick.
2. It would not have been surprising to see Tai appear as an intertextual character. However, a different, more distant figure, a cousin of Naseem Aziz and relative of the landowner Ghani, briefly appears in the story, thus linking the

earlier version of Rushdie's fictional Kashmir to the one in *Shalimar the Clown*. Shalimar and his gang blackmail the local gentry to fund their fight against the Indian army, and they arrive at Ghani's house. In memory of Naseem, he dutifully pays up. Thus Saleem's extended family is linked to the story of Shalimar and, in this respect, it can be argued that the narrative of Kashmir in this novel is also the continuation of the story of Kashmir in *Midnight's Children*.

3. According to Mirdu Rai, the term *Kashmiriyat* is reflective of a peerless tradition of regional nationalism that elevates itself above petty religious rivalries. It is 'founded on the historical survival of what is perceived as a more salient legacy of cultural harmony. However, *Kashmiriyat* so defined was an idealized "remembering" of one of several shifting meanings of "being Kashmiri": it was not only summoned but also circulated in very specific political and historical moments' (2004, 224).

4. See Rushdie 2003, 305–307; 2002b.

5. Sheikh Abdullah, who was known as 'Sher-E-Kashmir'—the 'Lion of Kashmir'—was the leader of the Kashmir National Front and one of the most influential politicians of the region. He became the leader of the regional administration soon after the maharaja fled. Before independence he had agitated against rule of the Dogra dynasty and promoted Kashmiri self-determination. He continually held India to account over its broken promise of autonomy for the region, which led to his dismissal as prime minister of Kashmir in 1953 and an eleven-year jail term over charges of corruption and separatism (see Schofield 1996, 91–93).

6. This also seems to be an allusion to Attar's Sufi poem *The Conference of the Birds*.

7. Aurangzeb was the late Mughal Emperor who ruled from 1658 to 1707. He was the younger son of Shah Jahan (builder of the Taj Mahal) and killed his elder brother to secure the throne for himself. Known as the Mughal Emperor least tolerant towards Hindus, he was responsible for pogroms and temple desecrations. For one of the Gegroo brothers to be named after him seems therefore particularly striking (see Sen 2006b, 60–61).

8. Rushdie's 2008 novel *The Enchantress of Florence* is set in sixteenth century Mughal India and Renaissance Florence and explores this relationship further.

9. In 2005 a full-colour version of the film was released in Indian cinemas. Although this captured some of the attention to detail and exuberant set and costume designs, it is arguable that the original black-and-white film suddenly bursting into colour was part of its appeal.

10. This is also the film song Rekha Merchant sings to Gibreel in *The Satanic Verses*.

11. A more recent example would be *Lagaan*. By invoking the anti-colonial struggle against the colonial power, the film showed how all sections of the village community were brought together to beat the British at a game of cricket so that they would not have to pay the crippling land tax as their village faced starvation. The film sought to appeal to intercommunal harmony and suggested that India can only be strong when united in its diversity.

12. Sumita S. Chakravarty points towards two instances which confirm Anarkali's historical identity. An Indian dictionary of Indian history describes her as the secret love of Prince Salim for whom he built a marble tomb in 1615. Edward Balfour's *The Cyclopaedia of India* also mentions her tomb (Chakravarty 1993, 168).

13. The question of the relationship between the state and its Muslim minority has been tackled increasingly by Indian popular cinema, for example in films such as *Fiza* (2000). The issue of Pakistan also plays a role in this, and more recent films have underlined what connects rather than divides Indians and Pakistanis in films such as *Main Hoon Na* (2004) and *Veer-Zaara* (2004).
14. For an interesting discussion of *Roja* see also Nicholas B. Dirks's essay 'The Home and the Nation: Consuming Culture and Politics in *Roja*' (2001, 161–185). For an interesting discussion of *Bombay* see Ravi S. Vasudevan's essay '*Bombay* and Its Public' (2001, 186–211).
15. More recent data from Amnesty International suggests that since the start of the armed struggle in Kashmir in 1989 between 45,000 and 60,000 people have lost their lives (see Amnesty International 2006); the Indian government has acknowledged that some 47,000 people have lost their lives (*Reuters* 2008); more recent data from Associated Press estimates the number of victims at 68,000 (*Guardian* 2012).
16. Within the context of the novel, the storm troopers could also refer to the paramilitary organisation of the National Socialist Party (NSDAP), the SA (Sturmabteilung).

# Bibliography

## Manuscripts

Box 43, Folder 1. *The Antagonist*, typescript, 12 May 1975, 1–120. Salman Rushdie Papers. Manuscript, Archives and Rare Book Library, Emory University.

Box 43, Folder 2. *The Antagonist*, typescript, 12 May 1975, 121–240. Salman Rushdie Papers. Manuscript, Archives and Rare Book Library, Emory University.

Box 43, Folder 3. *The Antagonist*, typescript, 12 May 1975, 241–341. Salman Rushdie Papers. Manuscript, Archives and Rare Book Library, Emory University.

Box 44, Folder 13, *Madam Rama*, typescript, February 1976 [1 of 2]. Salman Rushdie Papers. Manuscript, Archives and Rare Book Library, Emory University.

Box 44, Folder 14, *Madam Rama*, typescript, February 1976 [2 of 2]. Salman Rushdie Papers. Manuscript, Archives and Rare Book Library, Emory University.

Box 45, Folder 6. *Rivers of Blood*, manuscript and typescript [with notes and fragments]. Salman Rushdie Papers. Manuscript, Archives and Rare Book Library, Emory University.

Box 48, Folder 7. *After Midnight: 40 Years of Partition*, typescript. Salman Rushdie Papers. Manuscript, Archives and Rare Book Library, Emory University.

Box 51, Folder 12. *The Ground Beneath Her Fee*t, typescript, 3$^{rd}$ version: rewritten by Salman Rushdie, March 2001. Salman Rushdie Papers. Manuscript, Archives and Rare Book Library, Emory University.

Box 56, Folder 8. *Midnight's Children*, "Episode One (of 5); Final Script," typescript, 27 November 1997. Salman Rushdie Papers. Manuscript, Archives and Rare Book Library, Emory University.

Box 56, Folder 9. *Midnight's Children*, "Episode Two (of 5); Final Script," typescript, 27 November 1997. Salman Rushdie Papers. Manuscript, Archives and Rare Book Library, Emory University.

Box 56, Folder 10. *Midnight's Children*, "Episode Three (of 5); Final Script," typescript, 27 November 1997. Salman Rushdie Papers. Manuscript, Archives and Rare Book Library, Emory University.

Box 56, Folder 11. *Midnight's Children*, "Episode Four (of 5); Final Script," typescript, 27 November 1997. Salman Rushdie Papers. Manuscript, Archives and Rare Book Library, Emory University.

Box 56, Folder 12. *Midnight's Children*, "Episode Five (of 5); Final Script," typescript, 27 November 1997. Salman Rushdie Papers. Manuscript, Archives and Rare Book Library, Emory University.

Box 58, Folder 12. *Mr. Kipling and the Bandar-Log*, "A Treatment for a Television Script," typescript [with notes and fragments]. Salman Rushdie Papers. Manuscript, Archives and Rare Book Library, Emory University.

Box 60, Folder 5. *Saleem's Story*, "Cast List," typescript, 5 December 1997. Salman Rushdie Papers. Manuscript, Archives and Rare Book Library, Emory University.

Box 60, Folder 9. *Shame*, "An Idea for a Film," typescript [3 versions and fragments]. Salman Rushdie Papers. Manuscript, Archives and Rare Book Library, Emory University.

Box 60, Folder 12. *The Silver Land*, typescript, 15 December 1984. Salman Rushdie Papers. Manuscript, Archives and Rare Book Library, Emory University.

Box 66, Folder 4. *Haroun and the Sea of Stories*, Illuminated Film Company film script based on the novel by Salman Rushdie, typescript. Salman Rushdie Papers. Manuscript, Archives and Rare Book Library, Emory University.

Box 66, Folder 8. Danny McCurry, *Midnight's Child*, film script proposal, typescript, 28 December 2002. Salman Rushdie Papers. Manuscript, Archives and Rare Book Library, Emory University.

Rushdie Digital Files, n.d. *The Courter*, film script. Manuscript, Archives and Rare Book Library, Emory University.

## Bibliography

Ahmad, Aijaz. [1992] 1994. *In Theory: Classes, Nations, Literatures*. London and New York: Verso.

Ahmed, Akbar S. 1986. *Pakistan Society: Islam, Ethnicity, and Leadership in South Asia*. Karachi: Oxford University Press.

Akhtar, Javed, and Nasreen Munni Kabir. 2003. *Talking Films: Conversations on Hindi Cinema with Javed Akhtar*. New Delhi: Oxford University Press.

Ali, Tariq. 1985. *The Nehrus and the Gandhis: An Indian Dynasty*. London: Pan Books with Chatto and Windus.

Amnesty International. 2006. "India: Targeted Killings of Members of Minority Groups Must Stop." Amnesty International Public Statement News Service No. 112. May 3. Accesed October 31, 2006. http://web.amnesty.org/library/print/ENGASA200132006.

Anderson, Benedict. 1983. *Imagined Communities: Reflections on the Origin and Spread of Nationalism*. London: Verso.

Appiah, Kwame Anthony. 1991. "Is the Post- in Postmodernism the Post- in Postcolonialism?" *Critical Inquiry* 17(2) (Winter): 336–357.

Appignanesi, Lisa, and Sara Maitland. 1989. *The Rushdie File*. London: Fourth Estate.

Aravamudan, Srinivas. 1989. "Salman Rushdie's *The Satanic Verses*." *Diacritics* 19(2) (Summer): 3–20.

———. 1994. "Being God's Postman is No Fun, Yaar." In *Reading Rushdie: Perspectives on the Fiction of Salman Rushdie*, edited by D. M. Fletcher, 187–208. Cross/Cultures 16. Amsterdam-Atlanta: Rodopi.

Attar, Farid Ud-Din. 1984. *The Conference of the Birds*. Trans. Afkham Darbandi and Dick Davis. London: Penguin.

Aurobindo, Sri. 1973. *Bande Mataram: Early Political Writings*. Pondicherry: Sri Aurobindo Ashram.

Balaswamy, P. 2003. "A Post-modern, Provocative, Metropolitan Mother India: Aurora Zogoiby of Rushdie's *The Moor's Last Sigh*." In *Salman Rushdie: New Critical Insights*, vol. 2, edited by Rajeshwar Mittapalli and Joel Kuortti, 52–64. New Delhi: Atlantic.

Ball, John Clement. 2000. "Acid in the Nation's Bloodstream: Satire, Violence, and the Indian Body Politics in Salman Rushdie's *The Moor's Last Sigh*." *International Fiction Review* 27: 37–47.

Benwell, Bethan, James Procter and Gemma Robinson, eds. 2012. *Postcolonial Audiences: Readers, Viewers and Reception*. New York: Routledge.
Bhabha, Homi. K. 1994. *The Location of Culture*. London and New York: Routledge.
Bharucha, Rustom. 1994. "Rushdie's Whale." In *Reading Rushdie: Perspectives on the Fiction of Salman Rushdie*, edited by D. M. Fletcher, 159–171. Cross/Cultures 16. Amsterdam-Atlanta: Rodopi.
Billington, Michael. 2002. "Review of *Midnight's Children*." *The Guardian*, January 30. Accessed February 21, 2013. http://www.guardian.co.uk/stage/2003/jan/30/theatre.artsfeatures3.
Bob, Dilip, Chander Uday Singh and Gita Abraham. 1982. "Amithabh Bachchan: A stricken star." *India Today*, August 31: 32–36.
Booker, M. Keith, ed. 1999. *Critical Essays on Salman Rushdie*. New York: G. K. Hall.
Bratton, Jacky, Jim Cook and Victoria Gledhill, eds. 1994. *Melodrama: Stage, Picture, Screen*. London: British Film Institute.
Breckenridge, Carol A., ed. 1995. *Consuming Modernity: Public Culture in a South Asian World*. Minneapolis: University of Minnesota Press.
Brooks, Peter. 1994. "Melodrama, Body, Revolution." In *Melodrama: Stage, Picture, Screen*, edited by Jacky Bratton, Jim Cook and Victoria Gledhill, 11–24. London: British Film Institute.
———. 1995. *The Melodramatic Imagination: Balzac, Henry James, Melodrama, and the Mode of Excess*. New Haven: Yale University Press.
Brouillette, Sarah. 2005. "Authorship as Crisis in Salman Rushdie's *Fury*." *Journal of Commonwealth Literature* 40(1): 137–156.
Buñuel, Louis. 1984. *My Last Breath*. London: Jonathan Cape.
Butler, Judith. 1986. "Sex and Gender in Simone de Beauvoir's *Second Sex*." *Yale French Studies* 72: 35–49.
Cantor, Paul A. 1997. "Tales of the Alhambra: Rushdie's Use of Spanish History in *The Moor's Last Sigh*." *Studies in the Novel* 29(4) (Fall): 323–341.
Chakravarty, Sumita S. 1993. *National Identity in Indian Popular Cinema, 1947–1987*. Austin: University of Texas Press.
———. 2000. "Fragmenting the Nation: Images of Terrorism in Indian Popular Cinema." In *Cinema and Nation*, edited by Mette Hjort and Scott Mackenzie, 222–237. London and New York: Routledge.
Chandra, Vikram. 1997. *Love and Longing in Bombay*. London: Faber and Faber.
———. 2006. *Sacred Games*. London: Faber and Faber.
Chatterjee, Gayatri. 2002. *Mother India*. BFI Film Classics. London: British Film Institute.
Chatterjee, Partha. [1990] 2001. "The Nationalist Resolution of the Women's Question." In *Postcolonial Discourses: An Anthology*, edited by Gregory Castle, 151–166. Oxford: Blackwell.
Chatterji, Bankim Chandra. 2006. *Anandamath*. Trans. Basanta Koomar Roy. New Delhi: Orient Paperbacks.
Chauhan, Pradyumna S., ed. 2001. *Salman Rushdie Interviews: A Sourcebook of His Ideas*. Westport: Greenwood Press.
Chordiya, Deepa P. 2007. "'Taking on the Tone of a Bombay Talkie': The Function of Bombay Cinema in Salman Rushdie's *Midnight's Children* ." *ARIEL* 38(4) (October): 97–121.
Clark, Roger Y. 2001. *Stranger Gods: Salman Rushdie's Other Worlds*. Montreal and Kingston: McGill-Queen's University Press.
Cundy, Catherine. 1996. *Salman Rushdie*. Manchester: Manchester University Press.
Das Gupta, Chidananda. 1991. *The Painted Face: Studies in India's Popular Cinema*. New Delhi: Roli Books.

David, Ann R. 2010. "Dancing the Diasporic Dream? Embodied Desires and the Changing Audiences for Bollywood Film Dance." *Participation: Journal of Audience and Reception Studies* 10(2) (November): 215-235. Accessed December 12, 2012. http://www.participation.org.

Desai, Jigna. 2004. *Beyond Bollywood: The Cultural Politics of South Asian Diasporic Film*. New York: Routledge.

Désoulières, Alain. 2007. "Religious Culture and Folklore in the Urdu Historical Drama *Anarkali*, Revisited by Indian Cinema." In *Indian Literature and Popular Cinema: Recasting Classics*, edited by Heidi R. M. Pauwels, 123-146. Abingdon: Routledge.

Dirks, Nicholas B. 2001. "The Home and the Nation: Consuming Culture and Politics in *Roja*." In *Pleasures and the Nation: The History, Politics and Consumption of Public Culture in India*, edited by Rachel Dwyer and Christopher Pinney, 161-185. New Delhi: Oxford University Press.

Doniger O'Flaherty, Wendy, ed. and trans. 1975. *Hindu Myths: A Sourcebook Translated from the Sanskrit*. Harmondsworth: Penguin.

Dudrah, Rajinder Kumar. 2006. *Bollywood: Sociology Goes to the Movies*. New Delhi, Thousand Oaks, and London: Sage Publications.

———. 2012. *Bollywood Travels: Culture Diaspora and Border Crossings in Popular Hindi Cinema*. Abingdon: Routledge.

Dudrah, Rajinder, and Jigna Desai, eds. 2008. *The Bollywood Reader*. Maidenhead: Open University Press.

Dutheil de la Rochère, Martine Hennard. 1999. *Origin and Originality in Rushdie's Fiction*. Bern: Peter Lang.

Dwivedi, Sharada, and Rahul Mehrotra. 2001. *Bombay: The Cities Within*. 2nd ed. Bombay: India Book House.

Dwyer, Rachel. 2000. *All You Want is Money, All You Need is Love: Sexuality and Romance in Modern India*. London and New York: Cassell.

———. 2005. *100 Bollywood Films*. BFI Screen Guides. London: British Film Institute.

———. 2006. *Filming the Gods: Religion and Indian Cinema*. London: Routledge.

Dwyer, Rachel, and Divia Patel. 2002. *Cinema India: The Visual Culture of Hindi Film*. London: Reaktion Books.

Dwyer, Rachel, and Christopher Pinney, eds. 2001. *Pleasure and the Nation: The History, Politics and Consumption of Public Culture in India*. New Delhi: Oxford University Press.

Dwyer, Rachel, and Jerry Pinto, eds. 2011. *Beyond the Boundaries of Bollywood: The Many Forms of Hindi Cinema*. New Delhi: Oxford University Press.

Farred, Grant. 2004. "The Double Temporality of *Lagaan*: Cultural Struggle and Postcolonialism." *Journal of Sports & Social Issues* 28(2) (May): 93-114.

Fischer, Michael M. J., and Mehdi Abedi. 1990. "Bombay Talkies, the Word and the World: Salman Rushdie's *Satanic Verses*." *Cultural Anthropology* 5(2) (May): 107-159.

Fletcher, D. M., ed. 1994. *Reading Rushdie: Perspectives on the Fiction of Salman Rushdie*. Cross/Cultures 16. Amsterdam-Atlanta: Rodopi.

Forster, E. M. [1924] 2005. *A Passage to India*. London: Penguin.

Gabriel, Karen. 2010. *Melodrama and the Nation: Sexual Economies of Bombay Cinema, 1970-2000*. New Delhi: Women Unlimited.

Gandhy, Behroze, and Rosie Thomas. 1991. "Three Indian Film Stars." In *Stardom: Industry of Desire*, edited by Christine Gledhill, 107-131. London: Routledge.

Gehlawat, Ajay. 2010. *Reframing Bollywood: Theories of Popular Hindi Cinema*. New Delhi: Sage.

Ghosh, Bishnupriya. 1999. "An Invitation to Indian Postmodernity: Rushdie's English Vernacular as Situated Cultural Hybridity." In *Critical Essays on Salman Rushdie*, edited by M. Keith Booker, 129-153. New York: G. K. Hall.

———. 2004. *When Borne Across*. New Brunswick, New Jersey, and London: Rutgers University Press.
Gillespie, Marie. 1995. *Television, Ethnicity and Cultural Change*. London: Routledge.
Gledhill, Christine, ed. 1991. *Stardom: Industry of Desire*. London: Routledge.
Gopal, Sangita, and Sujata Moorti, eds. 2008. *Global Bollywood: Travels of Hindi Song and Dance*. Minneapolis: University of Minnesota Press.
*Guardian, The*. 2000. "Raoúl Ruiz to direct Rushdie adaptation." March 16. Accessed September 21, 2006. http://film.guardian.co.uk/News_Story/Exclusive/0,4029,147449,00.html.
———. 2012. "Deadly attack on Kashmir military convoy." October 20. Accessed October 28, 2012 http://www.guardian.co.uk/world/2012/oct/20/deadly-attack-kashmir-military-convoy?INTCMP=SRCH.
Gurnah, Abdulrazak. 1995. "Displacement and Transformation in *The Enigma of Arrival* and *The Satanic Verses*." In *Other Britain, Other British: Contemporary Multicultural Fiction*, edited by Robert A. Lee, 5–20. London: Pluto Press.
———, ed. 2007. *The Cambridge Companion to Salman Rushdie*. Cambridge: Cambridge University Press.
Hall, Stuart. [1990] 1993. "Cultural Identity and Diaspora." In *Colonial Discourse and Post-colonial Theory: A Reader*, edited by Patrick Williams and Laura Chrisman, 392–403. Harlow: Longman.
Hjort, Mette, and Scott MacKenzie, eds. 2000. *Cinema and Nation*. London and New York: Routledge.
Innes, C. L. 2007. *The Cambridge Introduction to Postcolonial Literatures in English*. Cambridge: Cambridge University Press.
Jaikumar, Priya. 2006. *Cinema at the End of Empire: A Politics of Transition in Britain and India*. Durham and London: Duke University Press.
Jameson, Frederic, and Masao Miyoshi, eds. 1998. *The Cultures of Globalization*. Durham and London: Duke University Press.
Jolly, Gurbir, Zenia Whadwani, and Deborah Barretto. 2007. *Once Upon a Time in Bollywood: The Global Swing in Hindi Cinema*. Toronto: TSAR.
Kaarsholm, Preben, ed. 2004. *City Flicks: Indian Cinema and the Urban Experience*. Calcutta and New Delhi: Seagull Books.
Kabir, Ananya Jahanara. 2002. "Subjectivities, Memories, Loss: Of Pigskins, Silver Spittoons and the Partition of India." *Interventions* 4(2): 245–264.
Kabir, Nasreen Munni. 2001. *Bollywood: The Indian Cinema Story*. London: Channel 4 Books.
Kaur, Raminder, and Ajay J. Sinha. 2005. *Bollyworld: Popular Indian Cinema through a Transnational Lens*. New Delhi: Sage.
Khair, Tabish. 2008. *Filming*. London: Picador.
Khilnani, Sunil. 1999. *The Idea of India*. New Delhi: Penguin Books India.
Kumar, Amitava. 2001. "The bend in their rivers." *The Nation*, November 26: 32–38.
———. 2002. *Bombay London New York*. New York and London: Routledge.
Lal, Vinay, and Ashis Nandy, eds. 2006. *Fingerprinting Popular Culture: The Mythic and the Iconic in Indian Cinema*. New Delhi: Oxford University Press.
Laqueur, Walter. 2003. *Terrorism in the Twenty-First Century*. New York: Continuum.
Lazarus, Neil, ed. 2004. *The Cambridge Companion to Postcolonial Literary Studies*. Cambridge: Cambridge University Press.
Lee, A. Robert. 1995. *Other Britain, Other British: Contemporary Multicultural Fiction*. London: Pluto Press.
Lele, Jayant. 1996. "Saffronization of the Shiv Sena: The Political Economy of City, State and Nation." In *Bombay: Mosaic of Modern Culture*, edited by Sujata Patel and Alice Thorner, 185–212. Bombay: Oxford University Press.

Manto, Saadat Hasan. 2010. *Stars from Another Sky: The Bombay Film World of the 1940s*. New Delhi: Penguin.

Mars-Jones, Adam. 2001. "Torn apart in the USA." Review of *Fury* by Salman Rushdie. *The Observer*, August 26. Accessed September 21, 2006. http://books.guardian.co.uk/reviews/generalfiction/0,6121,542404,00.html.

Mazumdar, Ranjani. 2000. "From Subjectification to Schizophrenia: The 'Angry Man' and the 'Psychotic' Hero of Bombay Cinema." In *Making Meaning in Indian Cinema*, edited by Ravi S. Vasudevan, 238–264. New Delhi: Oxford University Press.

———. 2007. *Bombay Cinema: An Archive of the City*. Minneapolis: University of Minnesota Press.

Mehta, Suketu. 2004. *Maximum City: Bombay Lost and Found*. London: Review.

Mishra, Vijay. 2002. *Bollywood Cinema: Temples of Desire*. New York: Routledge.

———. 2007. "Rushdie and Bollywood." In *The Cambridge Companion to Salman Rushdie*, edited by Abdulrazak Gurnah, 11–28. Cambridge: Cambridge University Press.

Mishra, Vijay, and Bob Hodge. 1993. "What is Post(-)colonialism?" In *Colonial Discourse and Post-colonial Theory: A Reader*, edited by Patrick Williams and Laura Chrisman, 276–290. Harlow: Longman.

Mittapalli, Rajeshwar, and Joel Kuortti, eds. 2003. *Salman Rushdie: New Critical Insights*, vol. 2. New Delhi: Atlantic.

Morton, Stephen. 2008. *Salman Rushdie: Fictions of Postcolonial Modernity*. New British Fiction. Basingstoke: Palgrave.

Moss, Laura. 1998. "'Forget Those Damnfool Realists!' Salman Rushdie's Self-Parody as the Magic Realist's 'Last Sigh'." *ARIEL* 29(4) (October): 121–139.

Mukherjee, Meenakshi. 2000. *The Perishable Empire: Essays on Indian Writing in English*. New Delhi: Oxford University Press.

———, ed. 2003. *Rushdie's Midnight's Children: A Book of Readings*. Delhi: Pencraft International.

Nair, Rukmini B., and Rimli Bhattacharya. 1990. "Salman Rushdie: Migrant in the Metropolis." Beyond the Rushdie Affair Special Issue. *Third Text* 11 (Summer): 17–30.

Nandy, Ashis. 2001. *An Ambiguous Journey to the City: The Village and Other Odd Ruins of the Self in the Indian Imagination*. New Delhi: Oxford University Press.

———, ed. [1998] 2002. *The Secret Politics of Our Desire: Innocence, Culpability and Indian Popular Cinema*. New Delhi: Oxford University Press.

———. 2003. *The Romance of the State and the Fate of Dissent in the Tropics*. New Delhi: Oxford University Press.

Nasta, Susheila. 2002. *Home Truths: Fictions of the South Asian Diaspora in Britain*. Basingstoke: Palgrave.

———, ed. 2004. *Writing Across Worlds: Contemporary Writers Talk*. London and New York: Routledge.

Natarajan, Nalini. [1994] 2003. "Woman, Nation, and Narration in *Midnight's Children*." In *Rushdie's Midnight's Children: A Book of Readings*, edited by Meenakshi Mukherjee, 165–181. Delhi: Pencraft International.

Naughtie, James. 2012. *The New Elizabethans: Sixty Portraits of Our Age*. London: Harper Collins.

Nehru, Jawaharlal. 1997. "Tryst with Destiny." In *The Vintage Book of Indian Writing 1947–1997*, edited by Salman Rushdie and Elizabeth West, 1–2. London: Vintage.

———. [1946] 2004. *The Discovery of India*. New Delhi: Penguin Books India.

Ondaatje, Michael. 2003. *The Conversations: Walter Murch and the Art of Editing Film*. London: Bloomsbury.

Parry, Benita. 2004. "The Institutionalization of Postcolonial Studies." In *The Cambridge Companion to Postcolonial Literary Studies*, edited by Neil Lazarus, 66–80. Cambridge: Cambridge University Press.
Patel, Sujata, and Alice Thorner, eds. 1995. *Bombay: Mosaic of Modern Culture*. Bombay: Oxford University Press.
———, eds. 1996. *Bombay: Metaphor for Modern India*. New Delhi: Oxford University Press.
Pauwels, Heidi R. M. ed. 2007. *Indian Literature and Popular Cinema: Recasting Classics*. Routledge Contemporary South Asia. Abingdon: Routledge.
Pinto, Jerry, and Naresh Fernandes. 2003. *Bombay, Meri Jaan: Writings on Mumbai*. New Delhi: Penguin Books India.
Pirbhai, Miriam. 2001. "The Paradox of Globalization as an 'Untotalizable Totality' in Salman Rushdie's *The Ground Beneath Her Feet*." *The International Fiction Review* 28(1–2): 54–66.
Prasad, M. Madhava. 1998. *Ideology of the Hindi Film: A Historical Construction*. New Delhi: Oxford University Press.
———. 2003. "This Thing Called Bollywood." *Seminar 525* (May). Accessed February 12, 2013. http://www.india-seminar.com/2003/525/525%20madhava%20prasad.htm.
———. 2004. "Realism and Fantasy in Representations of Metropolitan Life in Indian Cinema." In *City Flicks: Indian Cinema and the Urban Experience*, edited by Preben Kaarsholm, 83–99. Calcutta and New Delhi: Seagull Books.
Pynchon, Thomas. [1965] 2000. *The Crying of Lot 49*. London: Vintage.
Rai, Mirdu. 2004. *Hindu Rulers, Muslim Subjects: Islam, Rights and the History of Kashmir*. London: Hurst and Company.
Rajadhyaksha, Ashish. 1993. "The Epic Melodrama: Themes of Nationality in Indian Cinema." *Journal of Arts and Ideas* 25–26: 55–70.
———. 2003. "The 'Bollywoodization' of the Indian Cinema: Cultural Nationalism in a Global Arena." *Inter-Asia Cultural Studies* 4(1): 25–39.
———. 2009. *Indian Cinema in the Time of Celluloid: From Bollywood to the Emergency*. South Asian Cinemas. Bloomington and Indianapolis: Indiana University Press.
Rajadhyaksha, Ashish, and Paul Willemen. 2002. *Encyclopaedia of Indian Cinema*. 2nd ed. London: British Film Institute.
Rao, Raja. [1938] 1989. *Kanthapura*. 2nd ed. New Delhi: Oxford University Press.
Ray, Satyajit. 1976. *Our Films, Their Films*. Hyderabad: Orient Longman.
Reder, Michael, ed. 2000. *Conversations with Salman Rushdie*. Jackson: University Press of Mississippi.
*Reuters*. 2008. "India Revises Kashmir Death Toll to 47,000." November 21. Accessed December 10, 2008. http://in.reuters.com/article/2008/11/21/idINIndia-36624520081121.
Reynolds, Margaret, and Jonathan Noakes. 2003. *Salman Rushdie: The Essential Guide*. Vintage Living Texts. London: Vintage.
Robertson, Roland. 1992. *Globalization: Social Theory and Global Culture*. London: Sage.
Rollason, Christopher. 2003. "Rushdie's Un-Indian Music: *The Ground Beneath Her Feet*." In *Salman Rushdie: New Critical Insights*, vol. 2, edited by Rajeshwar Mittapalli and Joel Kuortti, 89–125. New Delhi: Atlantic.
Rombes, Jr., Nicholas D. 1993. "*The Satanic Verses* as a Cinematic Narrative." *Literature/Film Quarterly* 11(1): 47–53.
Rooney, Caroline. 2000. *African Literature, Animism and Politics*. Routledge Research in Postcolonial Literatures. London and New York: Routledge.
Roy, Anjali Gera, and Chua Beng Huat, eds. 2012. *Travels of Bollywood Cinema: From Bombay to LA*. New Delhi: Oxford University Press.

Rushdie, Salman. 1981. *Midnight's Children*. London: Jonathan Cape.
———. 1982a. "The Empire writes back with a vengeance." *The Times*, July 3: 8.
———. 1982b. "Imaginary Homelands." *London Review of Books* 4(18) (October 7–20): 18–19.
———. 1985a. "An Interview with Salman Rushdie." *Scripsi* 3 (2–3): 107–126.
———. 1985b. "The Location of Brazil." *American Film* 10(10) (September): 50–53.
———. 1985c. "Outside the Whale." *American Film* 10(4) (January–February): 16, 70–74.
———. 1987. *The Jaguar Smile: A Nicaraguan Journey*. London: Pan, in association with Jonathan Cape.
———. 1990. "Homage to Satyajit Ray." Review of *Satyajit Ray: The Inner Eye* by Andrew Robinson. *London Review of Books* 12(5) (March 8): 9.
———. [1990] 1991. *Haroun and the Sea of Stories*. Harmondsworth and London: Penguin/Granta.
———. 1992a. *Imaginary Homelands: Essays and Criticism 1981–1991*. 2nd ed. Harmondsworth and London: Penguin/Granta.
———. 1992b. *The Wizard of Oz*. BFI Film Classics. London: The British Film Institute.
———. 1994. *East, West*. London: Jonathan Cape.
———. [1981] 1995a. *Midnight's Children*. London: Vintage.
———. [1983] 1995b. *Shame*. London: Vintage.
———. [1975] 1996a. *Grimus*. London: Vintage.
———. [1995] 1996b. *The Moor's Last Sigh*. London: Vintage.
———. 1997a. "Crash: Was the fatal accident a cocktail of crash and desire?" *New Yorker*, September 15: 68–69.
———. 1997b. "Notes on Writing." *Harpers* 295(1768) (September): 22–24.
———. [1988] 1998. *The Satanic Verses*. London: Vintage.
———. 1999. *The Screenplay of Midnight's Children*. London: Vintage.
———. [1999] 2000. *The Ground Beneath Her Feet*. London: Vintage.
———. [2001] 2002a. *Fury*. London: Vintage.
———. 2002b. "In Kashmir déjà-vu is a way of life." *The Guardian*, June 1. Accessed December 10, 2012. http://books.guardian.co.uk/review/story/0,12084,725509,00.html.
———. [2002] 2003. *Step Across This Line: Collected Non-fiction 1992–2002*. London: Vintage.
———. [1981] 2006a. *Midnight's Children*. 25th anniversary ed. London: Vintage.
———. [2005] 2006b. *Shalimar the Clown*. London: Vintage.
———. 2007. "The Line of Beauty." *The Guardian Review*, February 17: 12–13.
———. 2008. *The Enchantress of Florence*. London: Jonathan Cape.
———. 2009. "A fine pickle." *The Guardian Review*, February 28: 2–4.
———. 2012. *Joseph Anton*. London: Jonathan Cape.
Rushdie, Salman, Simon Reade and Tim Supple. 2003. *Salman Rushdie's Midnight's Children*. London: Vintage.
Rushdie, Salman, and Elizabeth West, eds. 1997. *The Vintage Book of Indian Writing 1947–1997*. London: Vintage.
Rushdie, Salman, interviewed by John Clement Ball. [1988] 2000. "An Interview with Salman Rushdie." In *Conversations with Salman Rushdie*, edited by Michael Reder, 101–109. Jackson: University Press of Mississippi.
Rushdie, Salman, interviewed by Peter Catapone. 2002. "A New York state of mind." *Salon*, October 1. Accessed June 24, 2013. http://www.salon.com/2002/10/01/rushdie_4/.
Rushdie, Salman, interviewed by Ginny Dougary. 2005. "The incredible lightness of Salman." *The Times*, August 20. Accessed January 14, 2006. http://www.ginnydougary.co.uk/2005/08/20/the-incredible-lightness-of-salman/.
Rushdie, Salman, interviewed by Rani Dube. [1982] 2001. "Salman Rushdie." In *Salman Rushdie Interviews: A Sourcebook of His Ideas*, edited by Pradyumna S. Chauhan, 7–19. Westport: Greenwood Press.

Rushdie, Salman, interviewed by Terry Gross. [1999] 2001. "*Fresh Air*: Salman Rushdie." In *Salman Rushdie Interviews: A Sourcebook of His Ideas*, edited by Pradyumna S. Chauhan, 267–277. Westport: Greenwood Press.
Rushdie, Salman, interviewed by Peter Kadzis. [1999] 2000. "Salman Speaks." In *Conversations with Salman Rushdie*, edited by Michael Reder, 216–227. Jackson: University Press of Mississippi.
Rushdie, Salman, interviewed by Ramona Koval. 2005. Interview. Edinburgh International Book Festival, August 27. Accessed January 14, 2006. http://www.edbookfest.co.uk/readings/archive.html#13.
Rushdie, Salman, interviewed by T. Vijay Kumar. [1983] 2001. "An Author of New Times." In *Salman Rushdie Interviews: A Sourcebook of His Ideas*, edited by Pradyumna S. Chauhan, 33–38. Westport: Greenwood Press.
Rushdie, Salman, interviewed by Jack Livings. 2005. "Salman Rushdie: The Art of Fiction No. 186." *The Paris Review* 174 (Summer): 107–143.
Rushdie, Salman, interviewed by Alvaro Vargas Llosa. [1996] 2001. "The Last Sigh of Diversity." In *Salman Rushdie Interviews: A Sourcebook of His Ideas*, edited by Pradyumna S. Chauhan, 209–212. Westport: Greenwood Press.
Rushdie, Salman, interviewed by Colin MacCabe. 1996. "Salman Rushdie Talks to the London Consortium about *The Satanic Verses*." *Critical Quarterly* 38(2) (Summer): 51–70.
Rushdie, Salman, interviewed by Alastair Niven. [1994] 2004. "Salman Rushdie with Alastair Niven." In *Writing Across Worlds: Contemporary Writers Talk*, edited by Susheila Nasta, 125–133. London and New York: Routledge.
Rushdie, Salman, interviewed by Chandrabhanu Pattanayak. 1983. Interview. *The Literary Criterion* XVIII(3): 19–22.
Rushdie, Salman, interviewed by Jean W. Ross. 1984. *Contemporary Authors* interview. *Contemporary Authors*, vol. 111, 414–417. Detroit, Michigan: Gale Research Company.
Rushdie, Salman, interviewed by Kumkum Sangari. 1984. "Salman Rushdie: A Literary Conversation." *The Book Review* VIII(5) (March/April): 247–253.
Rushdie, Salman, interviewed by Michael Silverblatt. [1996] 2001. "Bookworm with Michael Silverblatt, Guest: Salman Rushdie." In *Salman Rushdie Interviews: A Sourcebook of His Ideas*, edited by Pradyumna S. Chauhan, 199–212. Westport: Greenwood Press.
Rushdie, Salman, interviewed by Salil Tripathi and Dina Vakil. [1987] 2000. "Angels and Devils are Becoming Confused Ideas." In *Conversations with Salman Rushdie*, edited by Michael Reder, 79–86. Jackson: University Press of Mississippi.
Rushdie, Salman, interviewed by Eleanor Wachtel. [1992] 2001. "Salman Rushdie." In *Salman Rushdie Interviews: A Sourcebook of His Ideas*, edited by Pradyumna S. Chauhan, 121–135. Westport: Greenwood Press.
Sahgal, Nayantara. 2010. *Jawaharlal Nehru: Civilizing a Savage World*. New Delhi: Viking.
Said, Edward. 1994. *Culture and Imperialism*. London: Vintage.
———. [1978] 1995. *Orientalism: Western Conceptions of the Orient*. Harmondsworth: Penguin.
Schofield, Victoria. 1996. *Kashmir in the Crossfire*. London: I. B. Tauris.
Sen, Amartya. 2006a. *The Argumentative Indian: Writings on Indian Culture, History and Identity*. London: Penguin.
———. 2006b. *Identity and Violence: The Illusion of Destiny*. New York: W. W. Norton.
Sen, Satadru. 2001. "Enduring Colonialism in Cricket: From Ranjitsinhji to the Cronje Affair." *Contemporary South Asia* 10(2): 237–249.
Sharma, Kalpana. 1996. "Chronicle of a Riot Foretold." In *Bombay: Metaphor for Modern India*, edited by Sujata Patel and Alice Thorner, 268–286. New Delhi: Oxford University Press.

Shiel, Mark, and Tony Fitzmaurice, eds. 2001. *Cinema and the City: Film and Urban Societies in a Global Context*. Oxford: Blackwell.
Sidhwa, Bapsi. [1988] 1989. *Ice-Candy-Man*. New Delhi: Penguin Books India.
Spivak, Gayatri Chakravorty. 1985. "The Rani of Sirmur." In *Europe and Its Others: Proceedings of the Essex Conference on the Sociology of Literature*, edited by Francis Baker et. al. Colchester: University of Essex.
———. 1990. "Reading *The Satanic Verses*." Beyond the Rushdie Affair Special Issue. *Third Text* 11 (Summer): 41–69.
Stadtler, Florian. 2009. "Terror, Globalisation and the Individual in Salman Rushdie's *Shalimar the Clown*." *Journal of Postcolonial Writing* 45(2) (Summer): 191–199.
———. 2012. "Rushdie's Hero as Audience: Interpreting India through Indian Popular Cinema." In *Postcolonial Audiences: Readers, Viewers and Reception*, edited by Bethan Benwell, James Procter and Gemma Robinson, 115–127. New York: Routledge.
Stam, Robert, and Toby Miller, eds. 2000. *Film and Theory: An Anthology*. Oxford: Blackwell.
Suleri, Sara. [1992] 2005. *The Rhetoric of English India*. New Delhi: Penguin Books India.
Sundaram, Vivian, and Chris Dercon, eds. 2007. *Amrita Sher-Gil: An Indian Artist Family of the Twentieth Century*. Munich: Schirmer/Mosel. Published in conjunction with the exhibition 'Amrita Sher-Gil' at Haus der Kunst, Munich, and Tate Modern, London.
Sunder Rajan, Rajeswari. 1993. *Real and Imagined Women: Gender, Culture and Postcolonialism*. London and New York: Routledge.
Sutherland, John. 2001. "The sound and the fury." Review of *Fury* by Salman Rushdie. *The Guardian Saturday Review*, August 25. Accessed September 21, 2006. http://books.guardian.co.uk/reviews/generalfiction/0,6121,541854,00.html.
Swarup, Vikas. 2005. *Q and A*. London: Doubleday.
Swift, Jonathan. [1726] 1985. *Gulliver's Travels*. Harmondsworth: Penguin.
Teverson, Andrew. 2007. *Salman Rushdie*. Contemporary World Writers. Manchester: Manchester University Press.
Tharoor, Shashi. 1994. *Show Business: A Novel*. New Delhi: Penguin Books India.
Thomas, Rosie. 1985. "Indian Cinema: Pleasure and Popularity." *Screen* 26(3–4): 116–131.
———. 1989. "Sanctity and Scandal: The Mythologization of Mother India." *Quarterly Review of Film & Video* 11: 11–30.
———. 1995. "Melodrama and the Negotiation of Morality in Mainstream Hindi Film." In *Consuming Modernity: Public Culture in a South Asian World*, edited by Carol A. Breckenridge, 157–182. Minneapolis: University of Minnesota Press.
Trivedi, Harish. 1999. "Salman the Funtoosh: Magic Bilingualism in *Midnight's Children*." In *Rushdie's Midnight's Children: A Book of Readings*, edited by Meenakshi Mukherjee, 69–94. Delhi: Pencraft International.
———. 2006. "All Kinds of Hindi: The Evolving Language of Hindi Cinema." In *Fingerprinting Popular Culture: The Mythic and the Iconic in Indian Cinema*, edited by Vinay Lal and Ashis Nandy, 51–86. New Delhi: Oxford University Press.
Vasudevan, Ravi. 1989. "The Melodramatic Mode and the Commercial Hindi Cinema: Notes on Film History, Narrative and Performance in the 1950s." *Screen* 30(3) (Summer): 29–50.
———. [1995] 2000a. "Addressing the Spectator of a 'Third World' National Cinema: The Bombay 'Social' Film of the 1940s and 1950s." In *Film and Theory: An Anthology*, edited by Robert Stam and Toby Miller, 381–402. Oxford: Blackwell.

narrative tropes of Indian popular cinema; 'social' film; women: role in Indian popular cinema
'Islamicate' film, 164
Islamic fundamentalism. *See* fundamentalism: Islamic

## J
*Jagte Raho* (1956), 15, 24–5. *See also* Kapoor, Raj
Jaikumar, Priya, 34–5
Jameson, Frederic, 144–5
Jinnah, Muhammad Ali, 47

## K
Kabir, Nasreen Munni, 26, 78
Kapoor, Raj, 14–15, 23–5, 29–30, 61, 69, *91*, 94, 116. See also *Awaara*; *Shree 420*
Kashmir, 5, 70–1, 154–64, 167–74, 194n3, 194n5, 195n15
*Kashmiriyat*, 155, 157, 161–4, 168, 172, 173, 194n3
Khan, Aamir, 2
Khan, Mehboob, 14, 23, 117. See also *Mother India*
Khilnani, Sunil, 46–7
Kipling, Rudyard, 71
Kumar, Amitava, 152

## L
*Lagaan* (2001), 122–3, 164, 194n11
London, 12, 13, 18, 72–3, 85, 87, 103–9, 121, 180–1

## M
Madhubala, 23, *163*
Magical Realism, 36, 184n1
*Mahabharata*, the, 41, 87, 99, 183n4. *See also* Hindu mythology; 'mythological' film; Indian narrative traditions; Rushdie, Salman: use of myth
male gaze, 30, 57, 100, 143
*Manchurian Candidate, The* (1962), 175, 176
Mazumdar, Ranjani, 9
Mehrotra, Rahul, 14, 135
Mehta, Deepa. See *1947-Earth*; *Midnight's Children* [film adaptation]
Mehta, Suketu, 172, 178
melodrama, 28–35, 40–1, 50, 59, 83, 87, 95, 134
memory, 38, 63–5, 88, 109, 139
*Midnight's Children* (2012) [film adaptation], 37, *38*, *55*, 58, 73, 80–4, *81*, *83*

migrancy, 17, 22, 45–6, 85–93, 103–9, 140–2, 145, 180–1. *See also* diaspora; identity: diasporic
Mishra, Vijay, 18, 27, 29–30, 33–4, 95, 118, 149–50, 179, 183n7
*Mission Kashmir* (2000), 172, 178
*Mr. India* (1987), 110, 120, 129–31, *129*
Moorish Spain, 121–4, 131–2
*Mother India* (1957), 14, 22, 28, 34, 67, 73, 81, 95, 109, 110–20, *115*, 126–7, 128, 130, 132, 172, 179, 181. *See also* Khan, Mehboob
Mother India. *See* women: role in nationalist discourse
*Mughal-e-Azam* (1960), 28, 67, 73, 96, 155, 161–7, *163*, 175, 177, 179, 181, 188n7
Mughal India, 5, 124, 155, 157, 159–162, 164–6, 194n7, 194n8
Mumbai. *See* Bombay
'mythological' film, 3, 5, 8, 27–8, 31, 34–5, 42, 87, 99, 100, 142
mythology. *See* Hindu mythology; *Mahabharata*, the; 'mythological' film; *Ramayana*, the; religion; Rushdie, Salman: use of myth

## N
Naipaul, V. S., 148, 188n13
Nanavati, Kawas Manekshaw, 41–2
Nandy, Ashis, 15–16, 114
Nargis, 23, 61, 95, 112, *115*, 115–20, 191,nn20–21. See also *Mother India*
nationalism, 171, 180; Hindu, 20, 46–7, 70, 95, 110–11, 128, 171, 189n2; Indian, 17, 19–21, 110–14, 123, 160, 171; use of history, 46, 49, 112; and women's position, 49, 54–5, 57. *See also* anti-colonialism; communalism; fundamentalism; independence; Shiv Sena; women: role in nationalist discourse
Nehru, Jawaharlal, 21, 34, 37, 39, 40, 43–4, 61–2, 66, 68, 123, 128, 131–2, 161, 164, 186n17, 189n10. *See also* anti-colonialism; independence; secularism; socialism: Nehruvian vision of India
New York, 12, 13, 18, 121, 137, 147, 180–1

## P
Pakistan, depiction in literature, 45–9, 52–5
Parry, Benita, 18
Parsee theatre, 9

Partition, 21, 25, 39, 42, 44–8, 50, 55, 56, 71, 123, 157, 160–1, 165, 184n9. *See also* communalism; Hindu–Muslim relations
Patel, Divia, 7
patriarchy, 30–2, 45, 49–50, 54, 116, 119, 130–1, 166. *See also* women: position in society
plurality, of India, 37, 41–4, 110–11, 120–5, 132, 162, 171, 179
postcolonialism: postcolonial aesthetics, 17–22, 26, 182; postcolonial criticism, 3, 17–22; postcolonial politics, 3, 20–1, 31, 45, 48–9, 89, 95, 112, 136, 154, 181
postmodernism, 17–22, 26–7, 133, 183n7
Powell, Enoch, 109, 188n14
Prasad, M. Madhava, 10, 16–17, 30

# R

radical Islam. *See* fundamentalism: Islamic
Rahman, A. R., 2, 79, 97
Raj. *See* colonialism
Rajadhyaksha, Ashish, 10, 29, 31
*Raja Harishchandra* (1913), 8, 34, 87
Rajan, Rajeswari Sunder. *See* Sunder Rajan, Rajeswari
*Ramayana*, the, 41–2, 87, 99, 159–60, 183n4. *See also* Hindu mythology; 'mythological' film; Indian narrative traditions; Rushdie, Salman: use of myth
Rao, Raja, 12, 183n4
Ratnam, Mani, 101, 172–3, 195n14. *See also Dil Se*
Ray, Satyajit, 12, 90, 125–6, 184n11, 187n3, 191nn21–22.
realism, 21, 26–9, 31, 101–2, 125, 164–5. *See also* Magical Realism
religion, 20, 41, 70, 87–8, 95, 97–102, 113–14, 188n11. *See also* communalism; fundamentalism; plurality of India; religious tolerance; secularism; women: role in religious discourse
religious tolerance, 43–4, 122–4, 158–62. *See also* Hindu–Muslim relations; plurality of India; secularism
*Reluctant Fundamentalist, The* (2012) [film adaptation], 1
rural India. *See* village, the
Rushdie, Salman: *Anatagonist, The*, 36, 68; documentaries by, 69–71; *East, West*, 72, 122, 185n5; *Enchantress of Florence, The*, 124, 166; *fatwa*, 86, 141, 153, 180; film adaptations, 72–84; *Fury*, 12, 21, 46, 121, 133, 145–8, 150–3, 169, 185n11; *Grimus*, 36, 85, 142; *Ground Beneath Her Feet, The*, 11, 19, 20–1, 24, 29, 31, 72, 133–46, 151–3, 169, 190n19, 192n3; *Haroun and the Sea of Stories*, 72, 78, 156, 157–8, 191n22, 191n25; 'Imaginary Homelands', 11–12, 134; *Joseph Anton*, 72, 86, 153; literary influences, 23, 36; *Madam Rama*, 36, 68–9; *Midnight's Children*, 11, 15, 17, 19–23, 25–8, 31–3, 36–66, 68–9, 73–84, 99, 103–5, 121, 125, 126, 133–4, 147, 156–7, 161, 166, 178, 184n10, 184n1, 185n13, 186n18, 187n3, 187n6, 189n7; *Moor's Last Sigh, The*, 7, 11, 13, 17, 19–21, 23–4, 26, 28, 31–3, 50, 69, 105, 109, 110–32, 134, 147, 155, 161, 162, 167, 169, 173, 185n13, 186nn16–17, 188n8; *Satanic Verses, The*, 12, 13, 19, 21–3, 28, 45, 57, 71, 85–109, 121, 124, 133–4, 140–2, 146, 147, 153, 155, 180, 183n5, 183n7, 188n14, 191n25; screenplays by, 71; *Shalimar the Clown*, 20, 21, 71, 124, 148, 151–2, 154–77, 180–1, 188n7, 193n2; *Shame*, 21, 31, 36–7, 45–57, 69, 125, 166, 184n10, 186n16, 189n7; theatre adaptations, 78–9; unpublished novels, 36, 68–9; use of cinematic style, 1, 3, 7, 25–30, 34, 37–8, 40, 50, 57–60, 67–9, 87, 100–103, 106–7, 120, 126, 139, 151, 177, 179–80; use of films as intertexts, 22–5, 27–8, 38–9, 40–1, 42–3, 67, 73, 89–93, 96, 99, 114–16, 129–32, 151, 155, 161–2, 167, 175–7, 179; use of language, 57, 92, 144; use of narrative tropes of Indian popular cinema, 27–35, 37, 40, 53, 58–61, 69, 86–7, 96, 98–103, 112, 125, 130, 151, 179; use of myth, 27, 41–2, 44, 119, 128, 133, 139, 142–3, 185n8, 193n9

# S

sectarianism. *See* communalism
secularism, 41–2, 70–1, 95, 114, 119, 121, 123, 157, 161–2, 169. *See also* religious tolerance
Sen, Amartya, 162
Sharma, Kalpana, 111
Sher-Gil, Amrita, 118–19

Shiv Sena, 70, 110–11, 183n1, 188n1. *See also* nationalism: Hindu; Thackeray, Bal
*Shree 420* (1955), 15, 22, 24–5, 28, 40–1, 67, 73, 81, 85–109, *91*, 150, 179, 181. *See also* Kapoor, Raj
Sikh separatism, 169
*Slumdog Millionaire* (2008), 2
'social' film, 3, 8, 31–5, 99, 165
socialism, 19–21, 43, 95, 126–8, 131
Spain. *See* Moorish Spain
Spivak, Gayatri, 49
*Star Wars* (1977), 130, 174
Suleri, Sara, 52–3, 57, 98–100, 188n10
Sunder Rajan, Rajeswari, 62–3

**T**

terrorism, 155, 169–74
Thackeray, Bal, 122, 190n17. *See also* nationalism: Hindu; Shiv Sena
Thomas, Rosie, 9, 31–2, 41, 116
Trivedi, Harish, 64

**U**

unreliable narrators, 39, 50, 63–4, 68–9, 78, 118, 139

urban India. *See* city, the
urbanisation, 16. *See also* city, the; village, the

**V**

Vasudevan, Ravi S., 9, 11, 32–3
*Vertigo* (1958), 175, 177
village, the, 12, 14–16, 113–115, 118, 183n4
voyeurism. *See* male gaze

**W**

Williams, Raymond, 13
*Wizard of Oz, The* (1939), 23–5, 38–9, 125, 137
women: position in society, 45, 49–57, 116–17; role in Indian popular cinema, 30, 45, 57, 98–9, 131, 166–7; role in nationalist discourse, 53–5, 57, 62–3, 98–100, 111–20, 128; role in religious discourse, 98–100. *See also* nationalism: and women's position; patriarchy

**Z**

Zia-ul-Haq, 45, 52–3